Michael Higgins'
EXPLORING WINE REGIONS™

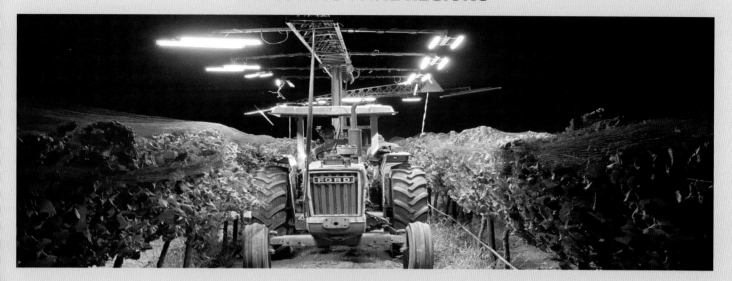

México

Written & Photographed by

Michael C. Higgins, PhD
Author, Photojournalist & Publisher

The Foreword by

María Isabel Ramos, PhD, Professor, Universidad Anáhuac México and Le Cordon Bleu México City
Ricardo Vega Cámara, Founder, Cuna de Tierra winery and Pioneer of the Guanajuato Wine Regions
Camillo Magoni, Founder/Winemaker, Bodegas Magoni and a Pioneer in Valle de Guadalupe

Dear Judge, Please enjoy my book, Michael

Published by
International Exploration Society
United States of America

On The Cover: The courtyard fountain at Adobe de Guadalupe in Valle de Guadalupe
Above: Nighttime harvest at Monte Xanic in Valle de Guadalupe
Next Page: The view from the Monte Xanic winery over their lake and vineyards in Valle de Guadalupe

ExploringWineRegions.com

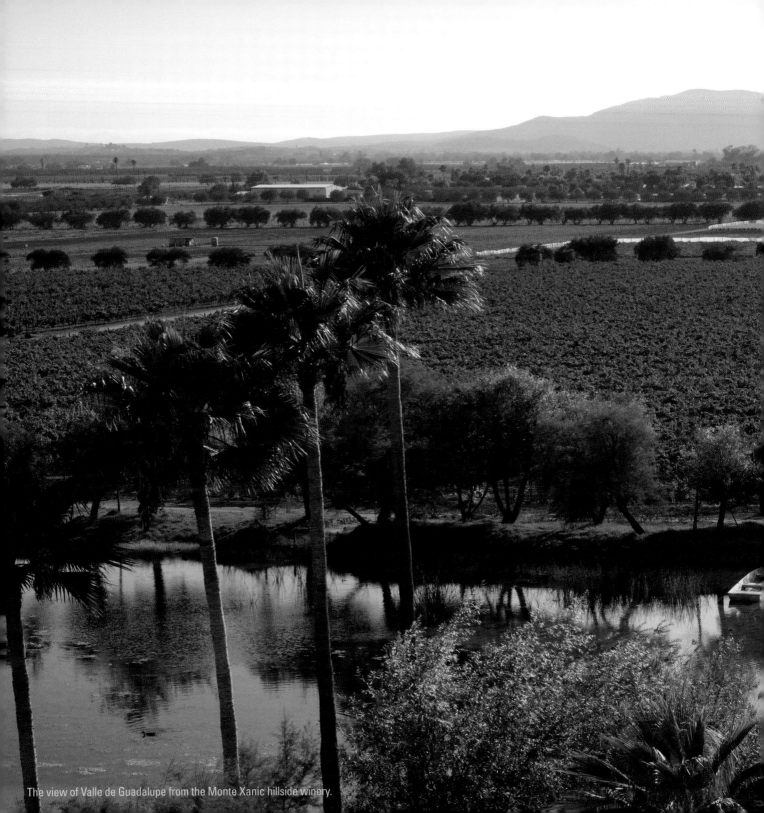

The view of Valle de Guadalupe from the Monte Xanic hillside winery.

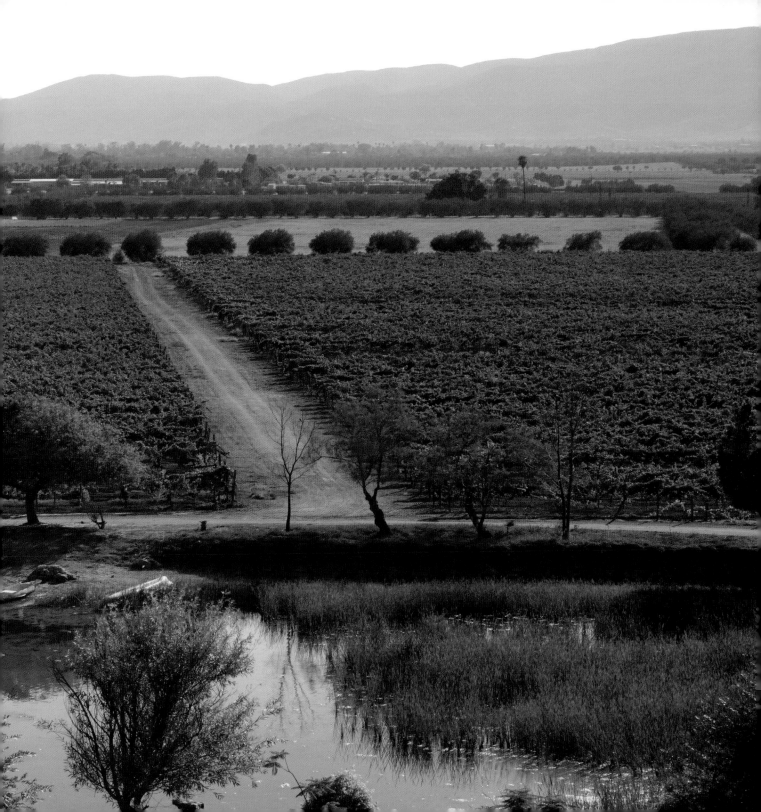

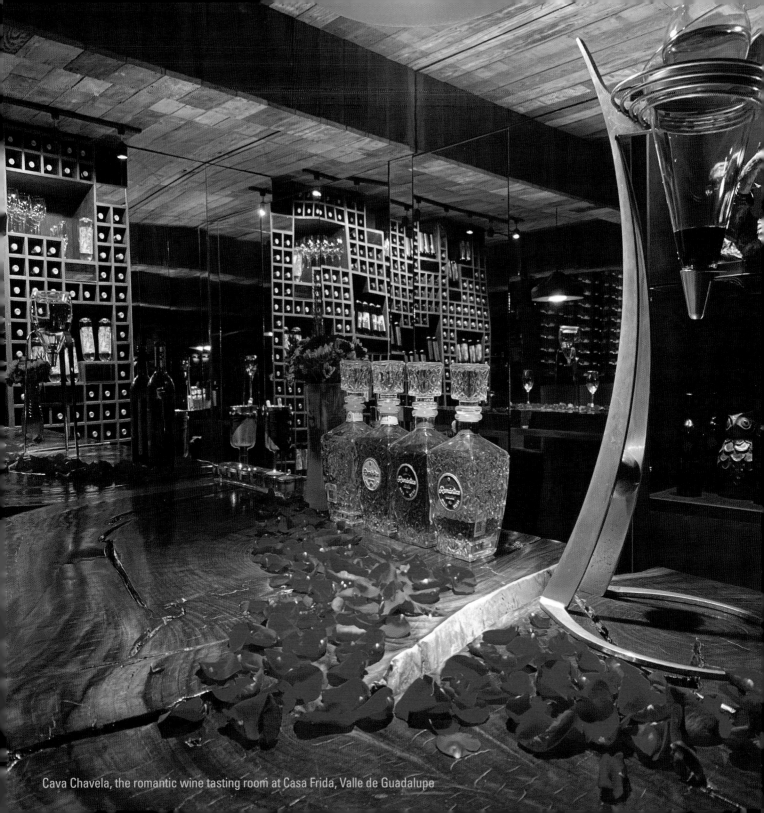

Cava Chavela, the romantic wine tasting room at Casa Frida, Valle de Guadalupe

WHY MÉXICO?

Imagine this: I have lived in Southern California all my life and while I have crossed over the Mexican border to Tijuana many times, I never drove the extra hour to Valle de Guadalupe. And I am a wine lover. What is wrong with me?

I often say that the teacher learns more than the student. That really is true when you consider how much research and planning a professor puts into delivering quality material to their students. I find myself in the same situation of conducting lots of research (oh do I love this part, someone has to enjoy all that great food and wine). Imagine learning there is an excellent wine region just south of the USA/California border and you have lived close by all your life.

When I started our California book, I initially planned on encompassing all of California, so I included the Valle de Guadalupe wine region in Baja California. It is still California, different country. When I focused on the Central Coast of California, Valle de Guadalupe no longer fit.

The great news is that I had already spent a month in Valle de Guadalupe and discovered what I had been missing and what you have likely been missing as well. Valle de Guadalupe has the same excellent terroir that we find in the wine regions all along California. The cold Pacific Ocean enters the hot Guadalupe Valley creating the essential diurnal effect necessary to produce excellent wine grapes. It is also on the magical Pacific Plate soil that the California Central Coast shares with them, and to discover that this wine region is attracting excellent winemakers from all over the world, particularly from France, Italy, Argentina and California.

You might say I was quite surprised – and a bit embarrassed, that I had no idea what an excellent wine region Valle de Guadalupe is. The wines, gourmet foods and luxurious accommodations in Valle de Guadalupe surprise me. Just like any wine region, there are good wines and not so good wines, so I point you to the wineries that have both good wines and tourism. Just wait until you see the restaurants I discovered. I am salivating just thinking about them.

This is what has inspired this México book; however, I needed to explore more. I found myself in the Mexican state of Guanajuato. There are more than forty wineries there making quality wines. And in the middle of these wine regions is San Miguel de Allende, a colonial-era village of cobblestone streets that have been kept to its original conditions of 250 years ago. Then on to the state of Querétaro Wine Regions where they are known for their excellent sparkling wines. They have attracted winemakers from Champagne, France and Cava, Spain. México has a lot to offer us in delicious wine and tourism.

My journeys through the México Wine Regions have taught me a lot. And now I share all these with you. I am ready to go back, anytime! It is important to remember that wineries continue to introduce new wines and restaurants change menus. Things will change, but you will get the essence of what each winery, restaurant and lodging will be able to offer. This is a survey, not a census. It is my subjective journey through these wine regions giving you a snapshot of what is amazing here. If you find a mistake in these 340 pages, I will cringe, and would still like to hear from you.

As usual, everything I cover in this book is from my own personal experiences. I was there. The photos are authentic from my camera and my eye. Everything I write is from my journeys.

So now it is time to go explore and go enjoy the journey.

Happy Tasting,

Michael C. Higgins, PhD

Michael C. Higgins, PhD
Author, Photojournalist & Publisher

For more than twenty years, author, photographer and wine expert Michael C. Higgins has been the publisher of *Flying Adventures*, a lifestyle travel magazine for food and wine lovers who own and travel on private airplanes. As a private pilot, travel enthusiast and food and wine lover himself, Higgins continues to live the story he's been sharing for decades.

Between the magazine and this book series, Higgins has participated in some of the most extraordinary experiences. He has virtually done it all: from pruning vines, picking grapes, working alongside winemakers, to participating in blind tastings, food and wine pairings, judging Cru Bourgeois wines, and sharing many meals with world-renowned winemakers over countless hours, discussing everything wine. His time in wine regions adds up to thousands of days and counting. And as an accomplished photographer, he has captured even more spectacular images of the wine world.

Higgins has participated in many unique wine experiences, indulged in the most exclusive culinary affairs, been pampered in highly luxurious destinations and jumped into the wildest of adventures. His goal is to inspire his readers to join him in exploring the wine regions of the world and experiencing the unimaginable. Higgins has a BA in Commercial Art, an MBA and a PhD in Business Administration. He is a California native and lives in Pasadena, California.

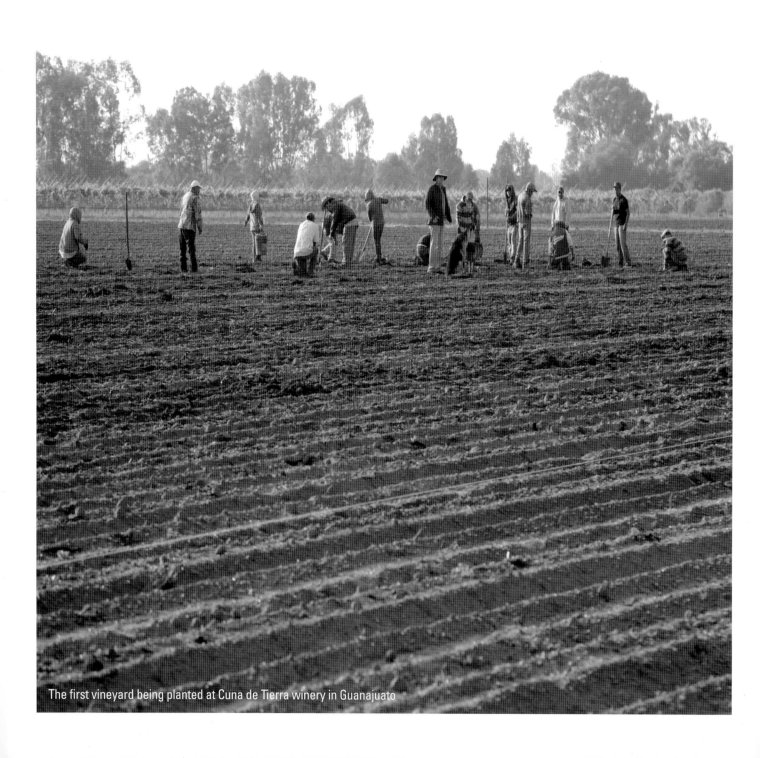

The first vineyard being planted at Cuna de Tierra winery in Guanajuato

THE FOREWORD
The History and Future of Mexican Wine

In my quest to find knowledgeable and interesting pioneers to enlighten us on the history of viticulture in México, to set-the-stage for the value of this book, and to open our eyes to the wonderful things going on with Mexican wines and the wine regions of México... I was introduced to Doctora Marisa Ramos by Guanajuato's wine pioneer Ricardo Vega (we will hear more from him later). How I was introduced was by reading some of her literary work. I was blown away. The quality of her writing style is astonishing. Her insight into wine, food and tourism in México is enlightening. I knew you would want to hear from her. I had to meet her.

So let me introduce you to **María Isabel Ramos Abascal, PhD**. Dr. Ramos is considered by many as the international expert on gastronomic tourism. She has collaborated in projects to promote México's gastronomic culture in such countries as Argentina, Malta, Moldova, Russia, Saudi Arabia, Spain, and the United States, among others. She has a masters degree in Tourism Business Upper Management from the Universidad Anáhuac México, and a doctorate degree in Tourism from the Spanish University Antonio de Nebrija. She is currently a Professor at the Universidad Anáhuac México and Le Cordon Bleu México City.

– María Isabel Ramos, PhD
Professor, Universidad Anáhuac México and Le Cordon Bleu México City

This is what Professor Ramos shares with us.

There are pleasures that when combined manage to create extraordinary experiences, collecting these unique moments in memory transforms us not only into happier people, but also wiser, making life worth living and, above all, sharing. The two pleasures that Michael C. Higgins, PhD shares with us in his repertoire of books are the appreciation of wine culture and the joy of traveling with intention. This idea never fails to bring to mind the mythical Bacchus in his chariot pulled by powerful beasts traveling along the coasts of the Mediterranean with the intention of propagating wine culture.

On this occasion, Michael Higgins has chosen a destination that is probably not well known in the wine world yet, but that paradoxically has a leading role in the history of wine and is also home to labels of extraordinary quality. It is México, a place where the first commercial winery on the American continent was founded in 1597 and which still remains active in Parras, Coahuila.

México does not initially appear as a desired destination for wine lovers; however, this is precisely what makes the proposals valuable that you will find in the invitation that the author extends to us. This book is the result of the search and discovery of unexplored treasures, and visionary proposals that will be on the lips of connoisseurs in a few years.

The value of wine in this country dates back almost half a millennium ago. In this territory, wine was made before it was called México, even before the political border divided Las Californias. This is where, for religious purposes, it was necessary to have wine for the celebration of the Holy Mass. Vineyards and olive groves were planted. In New Spain (México),

THE FOREWORD
The History and Future of Mexican Wine

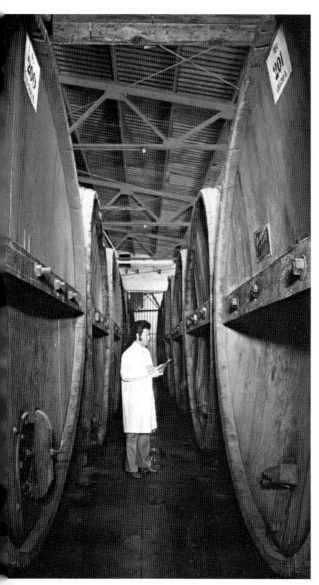

the different religious orders took on the task of spreading viticulture, building missions to shelter travelers and vineyards to produce wines along all the important roads where the territory and climate were benevolent to the newcomer Vitis Vinifera.

As in all stories worth telling, the chapter on wine in America has many passages of prosperity and setbacks. We know that an attempt was made to grow vines on the slopes of the Chapultepec hill in what is now México City, but the climate forced them to look for more favorable territories. By the order of the great conquistador Hernán Cortés, he issued a law in 1524 that required the planting of a thousand vines for every 100 natives at the service of the Crown, giving an extraordinary blossoming to wine in México.

In such a vast territory, the vineyards had to be strategically located, connecting them with roads that are the routes of the ecclesiastical missions, trails along which everything valuable was transported: gold, silver and of course wine. These routes connected and protected the transit of people and goods in the states of Querétaro, Guanajuato and California, which are precisely the ones presented in this book. The quality of the wine and the ease of transportation led to it being exported to Europe where they were very well received.

The popularity and success of wine from New Spain caused Spaniards to protect their own interests, leading to a decree issued by the Spanish Crown in 1728, imposing a high tax on New Spain´s wine that were sold in Europe. This discouraged many producers who had their vineyards as a new vocation, decreasing production as a consequence.

Taxes continued to escalate until a demonstration by the winegrowers of the state of Guanajuato, led by Priest Miguel Hidalgo, defended their lands with such zeal that it went way beyond achieving fair taxes; they achieved independence from the Spanish Empire and the birth of the Mexican Republic in 1821.

In the mid-nineteenth century, two-thirds of European vineyards were devastated by the plague of phylloxera. This chapter in the history of México´s wine role had a very fortunate benefit back to Europe. Now it was necessary to graft Mexican rootstocks to the vines in Europe.

So many centuries of history and so many adventures, we believe, give us the authority to proclaim the Mexican nature of wine, which, like many other ingredients from distant lands, has found in this country a unique and particular expression, which we call: The Mexican Wine.

That is why the effort made by Dr. Higgins is valuable. With the same festive spirit as Bacchus, he has taken on the task of traveling to find good wines. Perhaps his vehicle is not as exotic as that of that mythical being. He uses his own plane to go where few dare, he bravely ventures into little-discussed territories to find, among many, those wines that are worth sharing, getting ahead of many and opening the cellars to the most audacious. I would define his spirit like a real winederlust.

His task, although at first glance it seems simple, is not; it requires great knowledge and analysis. His endeavors as a PhD give him the tools to choose, experience and finally recommend wines, food, and a lifestyle.

THE FOREWORD
The History and Future of Mexican Wine

His flights have taken him to different continents. They have sat him at the table with people from many diverse cultures, and he is an example of cultural generation and exchange. He receives much appreciation for directing them to places where a lack of knowledge or distrust keeps them from going. Today his brave audacity removes the corks from the bottles of Mexican wines to offer them to the world.

The author's work is very similar to those who dedicate their lives to cultivating the vine, making wine and caring for the vineyards. They have in common the fact that they are aware that today's work will bear fruit later and far beyond the future, in times that they have to witness. Their legacy is a gift for ongoing generations.

This particular book is a promise kept because, when presenting the California book in 2023, he had offered to continue the adventure to the south; honoring his word, here is this magnificent copy, exhibiting a new proposal with an old tradition, showing Mexican wine as part of Mexican gastronomy, since here you will also find exquisite suggestions to enjoy the true gastronomy of this country.

Continuous historical and archaeological discoveries cause the history of wine to be constantly written and rewritten; wine tourism is probably the most recent chapter in this ancient saga. Today people like you and I put our trust in the suggestions of Michael Higgins to enjoy the drink that demonstrates our cultural heritage, while he literally flies to contribute to the history of wine.

Higgins' strategy is infallible. He captures moments and perspectives, with an expert eye and with enough experience to show in images the best of each destination, each winery, and each vineyard.

There is no more honest way to invite people to visit a place. The trick is to know what to see and how to see it. This is how, in a very subtle way, he shows us the way to learn to enjoy the journey, and therefore life.

The photos within this spread were taken at Bodegas de Santo Tomás winery. In 1791, the Misión of Santo Tomás de Aquino was founded, ultimately creating the very first winery in Baja México.

Analysis of wine in massive oak barrels now in the fermentation area of the Santo Tomás museum at their downtown Ensenada plaza location (photo left page); The destemming platform of the new Santo Tomás winery designed by their famous winemaker Hugo D'Acosta in the 1990s with steel doors opening to put grapes down the chute for gravity processing into the tanks below (photo below left); Bottling of sparkling wine with the latest equipment of 1950 (photo below center); The remains of the first winery of Santo Tomás back in the 1880s (photo below right).

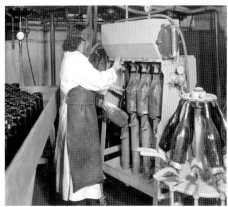

THE FOREWORD
Pioneering The State of Guanajuato

Now let's hear from Guanajuato's wine pioneer **Ricardo Vega Cámara**. In 1987, Ricardo planted wine grapes on his property with a vision that Guanajuato could be an excellent wine region. What a risk, such a visionary!

Ricardo's partner, **Juan Manchón**, went to Valencia Spain to study oenology (the science of the growing, cultivating and harvesting of grapes) to obtain educational and professional expertise to bring to this endeavor.

When Juan returned, he and Ricardo started making wine from the now six-year-old vineyards producing quality grapes. And **Cuna de Tierra** winery was born. Ricardo is the General Director, Juan the Winemaking Oenologist.

I love meeting people like Ricardo. He is a true entrepreneur. Someone who knows how to create something out of nothing. He created a brand-new industry in his state of Guanajuato. Many people have now followed his success.

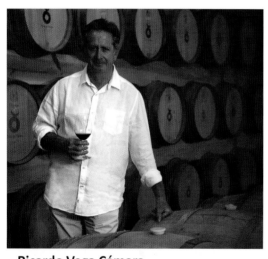

– Ricardo Vega Cámara
Founder/General Director, Cuna de Tierra winery
Pioneer of the Guanajuato Wine Regions

Let's hear from Ricardo...

Guanajuato, as a wine region, boasts several advantages for producing exceptional wines, both red and white. Despite not being situated at the typical wine latitude, its high altitude more than compensates for this difference. Nestled six thousand feet above sea level, Guanajuato's unique elevation allows for the creation of exceptionally elegant wines. The region benefits from cool nights and sunny days, which facilitate the slow maturation of grapes, preserving a desirable level of acidity without the need for corrections. Surprisingly, global warming has even played a beneficial role in this region.

If you plan to explore the Guanajuato Wine Route, I highly recommend getting this book. There is nothing else in the region that can provide such an easy and concise overview for travelers looking to embark on the Mexican wine route. It is going to be with you in your journey; as world of wine, culture and unforgettable experiences.

The mission of this guide is to not merely provide directions to the finest wineries and tasting rooms but to transport you into the heart and soul of winemaking. With each stop along the route, you'll find more than just exceptional wines; you'll discover the rich histories and passionate vintners. The wineries are surrounded by colonial cities and towns that are worth visiting in your experience.

In 1987, we took a bold step by planting our first vinifera vines. We began with five French grape varieties: Cabernet Sauvignon, Cabernet Franc, Merlot, Petit Syrah and Semillon. Planting grapes in an unknown region can feel like tossing a coin in the air, as you won't know the outcome until six years later. To our surprise, these varieties yielded excellent wines.

As pioneers in the area, we decided to expand our variety selection. We introduced Malbec, Tempranillo, Caladoc, Marselan, Sauvignon Blanc and Syrah. While we initially struggled with low Brix (sugar) levels, we now must take care not to let them become excessively high, allowing us to produce wonderfully fruitful and balanced wines. At present, the region boasts a diverse array of grape varieties, including Spanish and Italian strains like Nebbiolo, Tempranillo, Garnacha, Sangiovese, Albariño and more.

THE FOREWORD
Pioneering The State of Guanajuato

The region has earned numerous international awards at prestigious competitions in Europe, such as Decanter in England, Citadelles du Vin in France, Bacchus in Spain, and the Concours International of Brussels. Our winery alone has received around eighty-five medals, ranging from gold to bronze in these competitions.

A decade ago, the state had only eight wineries, but today, there are around forty-five wineries, with this number expected to continue growing as we are situated within a two hundred mile radius of approximately thirty million people in the Guanajuato and Queretaro areas. These two states, located in the heart of México, are rich in history, and thanks to government support, the construction of a double-lane road with facilities for bicycle rides is underway, promising an easier and safer way to experience the wine route.

Located in the heart of México's independence history, it was from the very beginning our vision for the state to make it a tourist destination for visitors. Here, you can not only savor our wines but also explore the rich culinary offerings of our international cuisine. The welcoming staff is always ready to receive you, ensuring that quality of life and the joy of sharing it with visitors seamlessly come together.

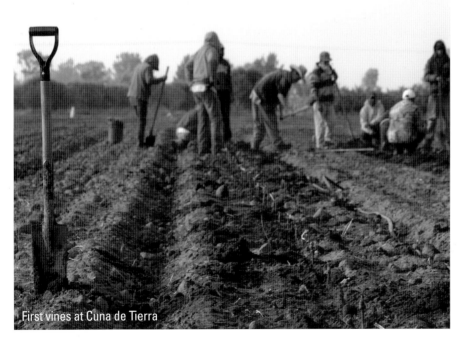

First vines at Cuna de Tierra

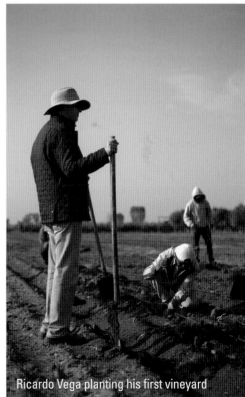

Ricardo Vega planting his first vineyard

THE FOREWORD
The Premium Wines in Valle de Guadalupe

I would like to introduce you to one of the most important pioneers of the modern-day Valle de Guadalupe, **Camillo Magoni**. I met Camillo on my very first evening arriving in Valle de Guadalupe. This was an indirect introduction. I was having dinner thinking about my expectation that the long duration of hot weather in this valley would be perfect for Cabernet Sauvignon. At dinner, I asked for their very best Cabernet Sauvignon. This nice restaurant had many choices. Oh no, I was unimpressed! Surprised, I asked the waiter: there must be a better one. He told me his favorite wine is Magoni Nebbiolo. This opened my eyes to Nebbiolo, which has turned out to be an excellent wine of this valley. And who is Camillo Magoni; I want to meet him.

After gaining his degree in viticulture and oenology from the Institute of Alba Italy, Camillo Magoni came to Valle de Guadalupe in 1965 to be the winemaker at L.A. Cetto. Cetto is the largest winery in México and is known for producing high-volume wines. In 1987, Camillo changed all that by producing a premium Nebbiolo, which went on to win numerous awards. This was the beginning, as Magoni became the pioneer of high-quality Mexican wines in this valley. He worked for Cetto for fifty years until retiring and starting his own winery Bodegas Magoni.

These are the original Nebbiolo grape vines (almost 80 years old) in which Camillo Magoni made the first premium wine in Valle de Guadalupe at L.A. Cetto winery (photo below right).

The original great grandfather of the L.A. Cetto winery family, Angelo Cetto, was planting Chenin Blanc in Valle de Guadalupe in the 1970s (photo below left).

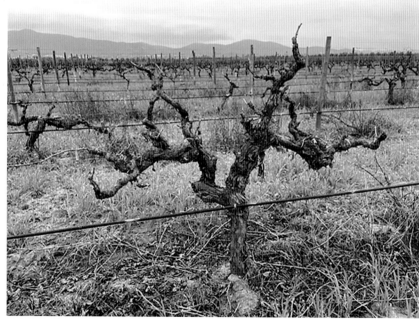

THE FOREWORD
The Premium Wines in Valle de Guadalupe

Camillo is also a great historian and author of the book: *History of Vine and Wine in Baja California*. I have asked him to share some of his thoughts.

The history of viticulture in Baja California goes back more than three hundred years, beginning at the Mission of San Francisco Javier in 1699, and continuing with thirty-four missions in Baja and twenty-one missions in California. The modern history of Baja California viticulture did not begin until 1931 thanks to the financial efforts of General Abelardo L. Rodríguez who purchased the Mission Santo Tomás and turned it into a thriving commercial winery. Rodríguez became Governor of Baja California, then President of México. Also in 1931, he hired Italian viticulturist Esteban Ferro to be the general manager and winemaker at Santo Tomás, planting French and Italian varieties in Valle de Guadalupe, introducing Baja California as a serious wine-growing region.

My participation in the development of the Valle de Guadalupe begins with the 1965 harvest; traditional vineyards, almost all dry farming, with historical varieties: Mission, Zinfandel, Alicante Bouschet, Palomino and Moscatel for the whites. There were only six wineries here at that time. I worked for the two largest as they were partners on several projects: L.A. Cetto (1965-2014) and Casa Pedro Domecq (1972-1995). The evolution and great changes began in 1972 with the planting of large vineyards of high-quality varieties: Cabernet Sauvignon, Merlot, Petit Sirah, Nebbiolo, Grenache, Tempranillo, Chardonnay, Sauvignon Blanc and Chenin Blanc. There was also an important contribution from the winemakers of the time: Dimitri Tschelicheff, Marcial Ibarra, Humberto Perez Arevalo, all of them graduates of California's prestigious wine universities of UC Berkeley and UC Davis.

There is too much conversation and confusion about the origins of the Nebbiolo grape here in Baja California. To avoid any discussion and commentary I registered the name "Nebbiolo de Baja." The cuttings were imported by Esteban Ferro from Italy around 1958 and planted in Valle de Guadalupe. The original vineyard is still producing, now owned by Cetto and myself. It was 1986 when the first Nebbiolo was released to the market.

– Camillo Magoni, Oenologist
Founder/Winemaker, Bodegas Magoni
Pioneer, Valle de Guadalupe

Today, Baja California is home to more than 90 percent of the premium vineyards and wineries that are driving the emerging Mexican wine industry. There are around 5,000 acres of grapes, more than 150 wineries, and more than 150 restaurants and hotels in Valle de Guadalupe. With a short 1.5-hour drive from the US border, Valle de Guadalupe offers an array of activities, first-class wines and amazing culinary experiences. I am pleased to see and appreciate Michael Higgins' effort to rescue our history and expose our experiences.

It is ever so satisfying to see that the efforts of those years have been consolidated with what is now the Valle de Guadalupe as an emblematic place of the Mexican wine industry. My best to author Michael C. Higgins and thank you for that effort to communicate our stories and our dreams. Surely Michael's book will transcend English-speaking readers and will be of great benefit to the producers of Valle de Guadalupe and other areas who will thus see their efforts projected into a work focused on Baja Californian wines.

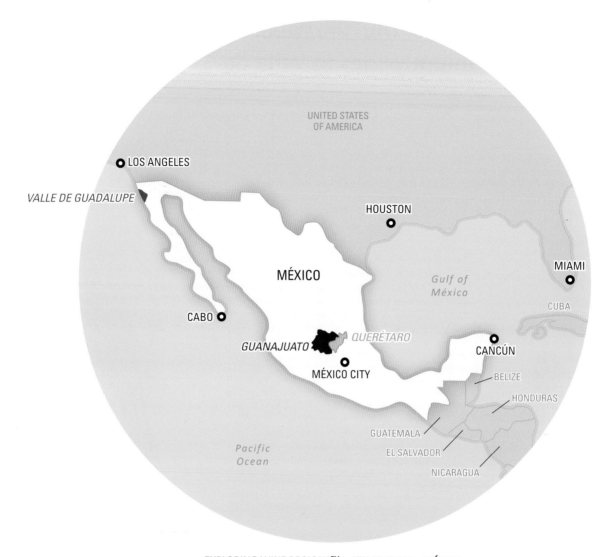

UNITED STATES
OF AMERICA

LOS ANGELES

VALLE DE GUADALUPE

HOUSTON

MÉXICO

MIAMI

*Gulf of
México*

CUBA

CABO

QUERÉTARO

GUANAJUATO

CANCÚN

MÉXICO CITY

BELIZE

HONDURAS

GUATEMALA

*Pacific
Ocean*

EL SALVADOR

NICARAGUA

EXPLORING WINE REGIONS™ • 4TH EDITION • MÉXICO

ISBN 978-0-9969660-6-1 - Printed Edition • ISBN 978-0-9969660-7-8 - eBook Travel Edition

Published by: **International Exploration Society**
Box 93613 • Pasadena, CA 91109-3613 • USA • +1 626 618 4000

CONTENTS

Last year's Tendrils, which are still twined around the trellis wires

Wine is Freedom
and you ask how so?

Wine is the very reason why
México has its independence

True

Taxes, large taxes, imposed on México's wine
Why? Because it was better than Spain's

The King could not have México show them up
So the heavy duties were imposed

And México winemakers were not happy
Well, they were more than just not happy

They were motivated to secede
to engage a revolution for freedom

and for an entire county, México
wine inspired freedom from Spain

Independence in 1821

Wine is freedom, meant to be shared
in patriotism, friendship and romance

Wine is the art of living

– Michael C. Higgins

Not sure about México wines? Understandable.

Maybe the first questions are: México makes wine? Is it any good? Do they even have the right kind of terroir to produce quality grapes?

Yes. And I will tell you why. México's primary wine region is Valle de Guadalupe in Baja California. It is located just fifty miles south of the United States border and it has the same viticulture qualities as the valleys throughout California. And México is attracting talent.

In my journeys, I met some very talented oenologists who came from leading wine-producing counties around the world. California, Argentina and France, to name a few. Bordeaux France has several very prestigious universities known for their excellence in wine education. As I explained in my Bordeaux France book, Bordeaux can be considered the center of the universe of wine.

Many winemakers I met in México arrived from Bordeaux knowing they can make great wines here. And I met Mexican winemakers who went to Bordeaux to learn to be the best. U.C. Davis is the United States' university of excellence in oenology. Many winemakers I met in México were educated at Davis. And specialists I met who learned sparkling wine in Champagne France and Cuyo Spain. Are you getting the idea now that México wineries are serious about making excellent wines?

How about "proof is in the pudding" as Mexican wines are regularly winning competitions against California and French wines. And maybe the most significant one is when a Mexican winery sent their Cabernet Sauvignon to Paris, France for the annual judging, and won first place. And another winery has their wine on the wine list at The French Laundry (a three-star Michelin restaurant consistently on "The World's 50 Best Restaurants"). Great wine really happens here.

In this book, I focus on wineries that are making excellent wines and have great tourism.

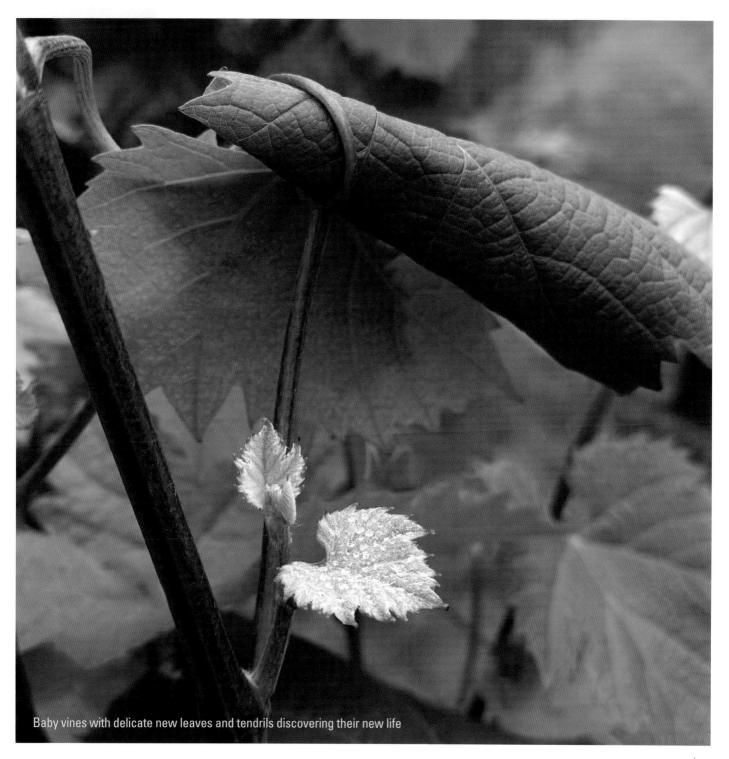

Baby vines with delicate new leaves and tendrils discovering their new life

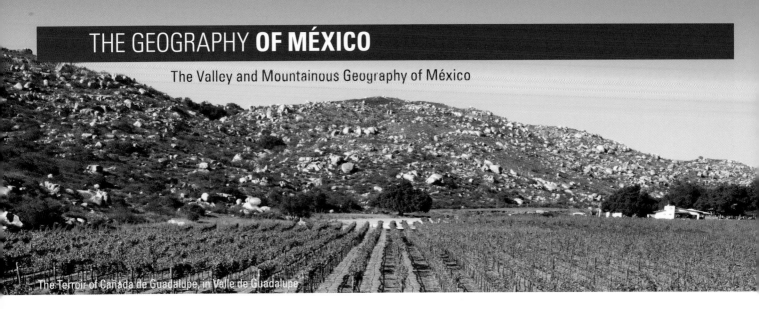

THE GEOGRAPHY **OF MÉXICO**

The Valley and Mountainous Geography of México

The Terroir of Cañada de Guadalupe, in Valle de Guadalupe

THE TERROIR OF MÉXICO

México is the thirty-sixth largest wine producing country in the world. Ahead of Isreal (#42) and United Kingdom (#53). Yes, México is a small producer of wine, as it is most famous for Tequila and Cerveza. But great things come in small sizes. Quality generally occurs in smaller batches.

Curious of the largest countries? I always love knowing the order of top tens... Italy, France, Spain, the United States of America, Argentina, Australia, Chile, South Africa, Germany and Portugal.

México started its wine production in America as it was ordered from Spain to plant 1,000 vines for every 100 people. The vines came from Spain and were planted all over México. This was an experiment as some places simply did not work, and they discovered the better regions within the country over time. And I found these places for you.

In 1597, Casa Madero was founded in the town of Santa María de las Parras (Holy Mary of the Grapevines) as the oldest winery in the Americas. It still operates today as a large winery. The vines established here were later exported to the Napa Valley and South America. I have not included Casa Madero in the book because Parras is quite remote and offers no tourism at this time.

Today, the primary wine region in México is Valle de Guadalupe in Baja California. It produces over 90 percent of all wines in México.

Valle de Guadalupe is located just fifty miles south of the California/United States border. Valle de means "valley of" in Spanish, and this valley has the same viticulture qualities as the valleys throughout California. And more so, exhibiting similar terroir as the California Central Coast.

As you read in my California book, 130 million years ago a huge tectonic plate moved from the west sliding underneath the North American continent. This began a series of events over the next 100 million years whereby this plate descended deep into the ocean and the Pacific Plate moved across its top eastwardly eventually hitting the North American plate and leaving a sliver of land along the Central Coast of California, which runs from San Francisco down the coast including all of Baja California and Valle de Guadalupe (see map on right page).

This makes Valle de Guadalupe and California Central Coast geologically distinct from the rest of California and North America, with thick layers of ocean sediment, hard granitic rock, quartz diorite, and serpentinite rocks. Excellent terroir!

Valle de Guadalupe is located at 32° latitude, which is inside the prime latitude of the world of quality vineyards (between 30° to 50° latitude).

One of the most important elements of viticulture in California is the cold Pacific Ocean. The cold moist ocean breeze blows into the hot dry valleys throughout California and including Valle de Guadalupe. This creates warm days and cool evenings. This is known as the diurnal shift. Diurnal temperature variations have major implications on the quality, structure and balance of a wine, and allow grapes to maintain higher acidity. Warmer daytime temperatures foster sugar development and cool nights preserves aromas, freshness and acidity. As quality wine drinkers, we want high diurnal shift because it leads to higher-quality wines with more balance.

In the states of Guanajuato and Querétaro, México's other quality wine-producing regions, the diurnal shift occurs because of altitude. These are mountainous states with base altitudes of 6,000' elevation. They are semi-arid desert terrain. The mountain winds also add to the diurnal effect here. All of this is necessary because they are way outside the 30° to 50° viticulture latitude.

Plus, Guanajuato and Querétaro have the altitude advantage of being closer to the sun. More intense UVrays from the sun on the grapes produce thicker skins, releasing a wide range of valuable aromatic and phenolic compounds.

One thing to make note of is that México has not established any official appellations. For example, the United States has AVA (American Viticultural Area) and France has AOC (appellation d'origine contrôlée). Without these official appellations, I have gone ahead and defined different wine regions and sub wine regions in this book to identify the unique wine-growing areas for your navigation.

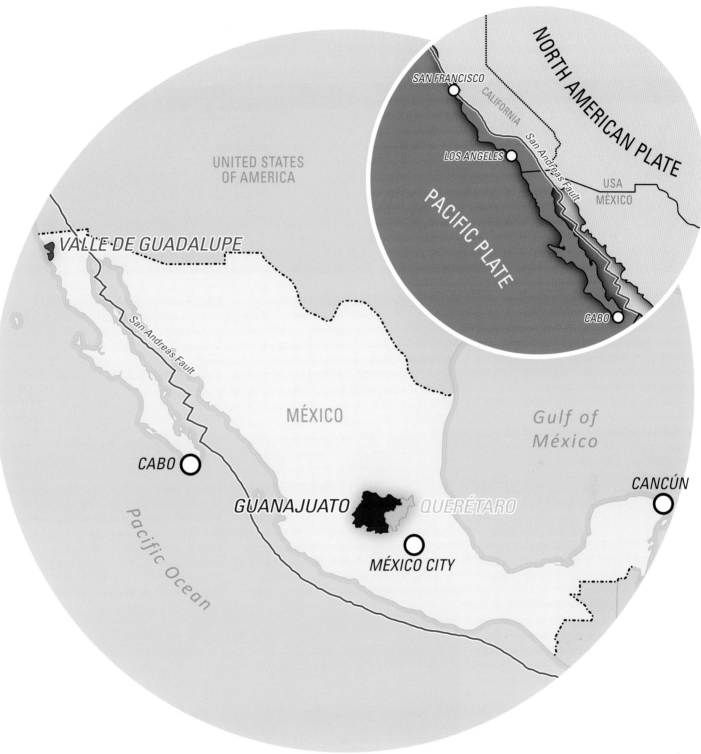

NORTH AMERICAN PLATE

SAN FRANCISCO

CALIFORNIA

LOS ANGELES

San Andreas Fault

USA
MÉXICO

PACIFIC PLATE

CABO

UNITED STATES
OF AMERICA

VALLE DE GUADALUPE

San Andreas Fault

MÉXICO

Gulf of
México

CABO

Pacific Ocean

GUANAJUATO

QUERÉTARO

CANCÚN

MÉXICO CITY

HOW TO **BEST READ THIS BOOK**

NAVIGATING MÉXICO

Being methodically organized and geographically oriented, I like maps to make it simple to navigate and easy to find places. This will help you tremendously as you make your way through this book and the México Wine Regions.

Valle de Guadalupe is an east/west valley. I organized the wineries and restaurants in order from east to west, first across the north side of the valley, then across the south side of the valley. Then along the ocean to Ensenada.

Guanajuato is organized outward from the San Miguel de Allende Village. In each direction, I start with the first winery, restaurant or hotel along the way. First is south of the village, then east of the village, and finally west and north of the village.

Querétaro is organized outward from the center of Downtown Querétaro starting with the closest winery (south) then northeast to the other wineries in distance order.

Valle de Guadalupe is the most difficult to navigate. There are many dirt and un-named roads that can make it challenging to find wineries. This is why I detailed a map to make it easier. And suggest a driver who knows where everything is located. Guanajuato and Querétaro are significantly easier to find the wineries.

No matter what, I highly suggest using GPS on your phone or tablet. Our eBook Travel Edition through Apple, offers live links to navigate.

SAFETY & COMFORT

I have traveled to México at least fifty times in my life. Living in Southern California, México is close. I feel very comfortable in México. The Mexicans are very nice people, warm and caring.

Doing the research for this book added five more lengthy trips to México. I spent ten weeks in three different wine regions, all of which made me feel very comfortable. By the way, I do not speak Spanish, and not speaking Spanish does not make me feel uncomfortable. I try when I know words. Most people in the wine regions speak English.

I bring up the topic of safety because many people are concerned about the cartels in México. And you definitely don't want to mess with the cartels. My feeling is that if you're not in the drug or the weapons business, they have no interest in you. And for extra safety, I would avoid staying in the bordering cities, which is where the problems seem to occur most.

HOW THE BOOK IS LAID OUT

I just described the geographic order of this book. Then, within each area, I distinguished the wine regions as a region or subregion. Wineries are included and presented within their respective regions.

Maps. I love maps, which is why there are twenty-three in this book. They separate and lead each wine region and subregion, followed by its own characteristics and uniqueness.

The light-gray side column provides the basics: wine region, business type, name, price range, address, phone, e-mail, website, and the days and hours they are open. For wineries, I list all their wines in this right column. I start with the red wines and order them by quality/price. Then I move on to white wines and end with sweet and sparkling wines. I also include a photo of a bottle for label recognition, and that bottle also represents my favorite wine I tasted.

ARRIVING & TRAVERSING

Here are the international airports for each of the wine regions. I considered and tried others; however, these are the best ones to use.

San Diego International Airport (SAN)
Located thirteen miles north of the US/México border, eighty miles north of the Valle de Guadalupe Wine Region and ninety miles north of Ensenada.

Tijuana International Airport (TIJ)
Located on the US/México border, sixty miles north of the Valle de Guadalupe Wine Region and seventy miles north of Ensenada.

Querétaro International Airport (QRO)
Located fifteen miles east of Downtown Querétaro, eight to thirty-two miles west and north of the Querétaro Wine Regions, respectively. Also located forty miles east of the beginning of the Guanajuato Wine Regions and fifty miles east of San Miguel de Allende Village.

México City International Airport (MEX)
Located 135 miles south of Querétaro and 160 miles south of San Miguel de Allende.

Catrina presenting a dried chili taquito at Viñedo San Miguel

WHO GOT IN?

Not everyone. With hundreds of wineries, I had to make deliberate choices on who to include.

My first priority was that every winery must be open to the public for visits. México wineries are generally known for being open; however, some are not. They make wine, leave them alone. So, I left them alone.

Next, they must make excellent wines and go beyond the step-up-to-the-bar-to-taste wine.

Tourism is key to what I look for to include in the book. They must provide wine experiences for their guests at their property. Some have become quite creative and innovative with experiences that you have never seen before. Read what I have written and find what appeals to you.

Many wineries have food experiences to go with wine tastings. Some have full-on restaurants at the winery. Others offer food and wine pairing experiences. I look for interesting experiences, like horseback riding through the vineyards, cooking with chefs, wine blending with oenologists, and overnight accommodations in the vineyards. There are a lot more of these that you might imagine, so I find them and bring them to you in this book.

Every place I have written about in this book is from my own personal, hands-on experience. No one has paid me to write any of these reviews.

Networking has been key. I worked extensively with locals, wine lovers, winemakers, publishers, travel and tourism professionals, wine councils, chefs, restaurateurs, sommeliers, government officials, and other organizations at the forefront of food, wine and tourism in México.

Who is out? If all they do is to offer a tasting? Boring! If they do not even open the doors? No way! If the wine is not excellent? Why bother? Life is too short to drink bad wine. What you can count on from me is that I was actually there, I know the experiences and I know the wines are excellent. And some will simply blow you away.

PRICING SCALE

Wineries (Price per Bottle)
$ - < $20
$$ - $20-$50
$$$ - $50-$100
$$$$ - $100-$200
$$$$$ - $200+

Culinary (Price for Entrée)
$ - < $10
$$ - $10-$20
$$$ - $20-$50
$$$$ - $50-$100
$$$$$ - $100+

Lodging (Price per Room/Night)
$ - < $100
$$ - $100-$200
$$$ - $200-$400
$$$$ - $400-$600
$$$$$ - $600+

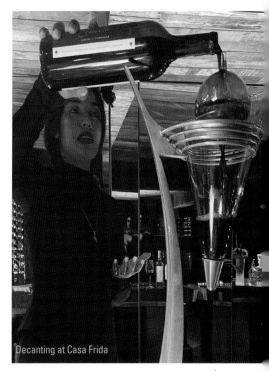
Decanting at Casa Frida

MÉXICO · BAJA CALIFORNIA **VALLE DE GUADALUPE**

Just South of the California State Border is an Evolving Wine Region of Surprising Quality

Harvest occurring in the vineyards behind Bruma Winery

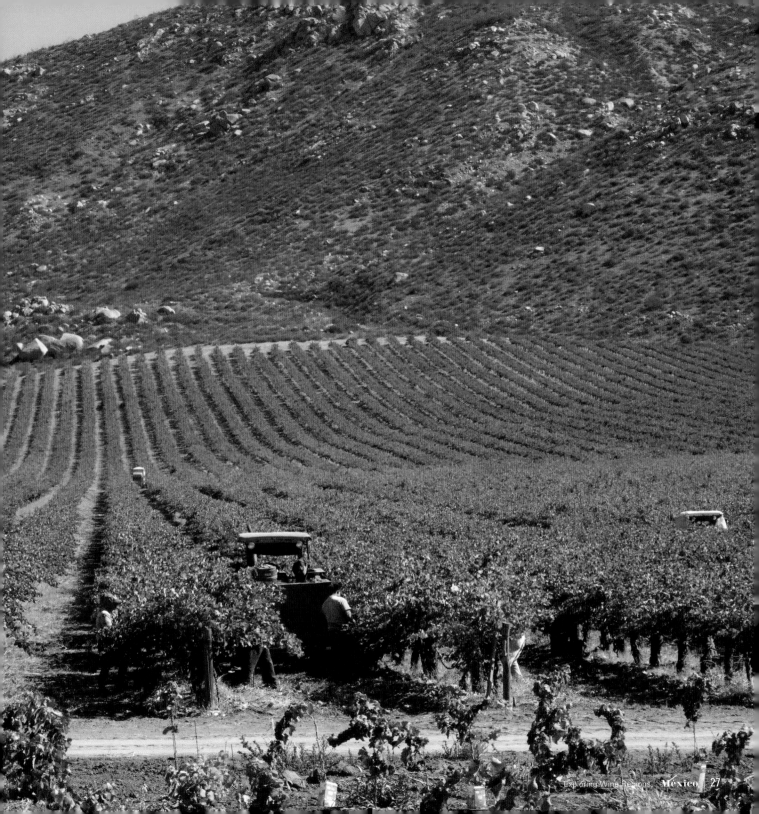

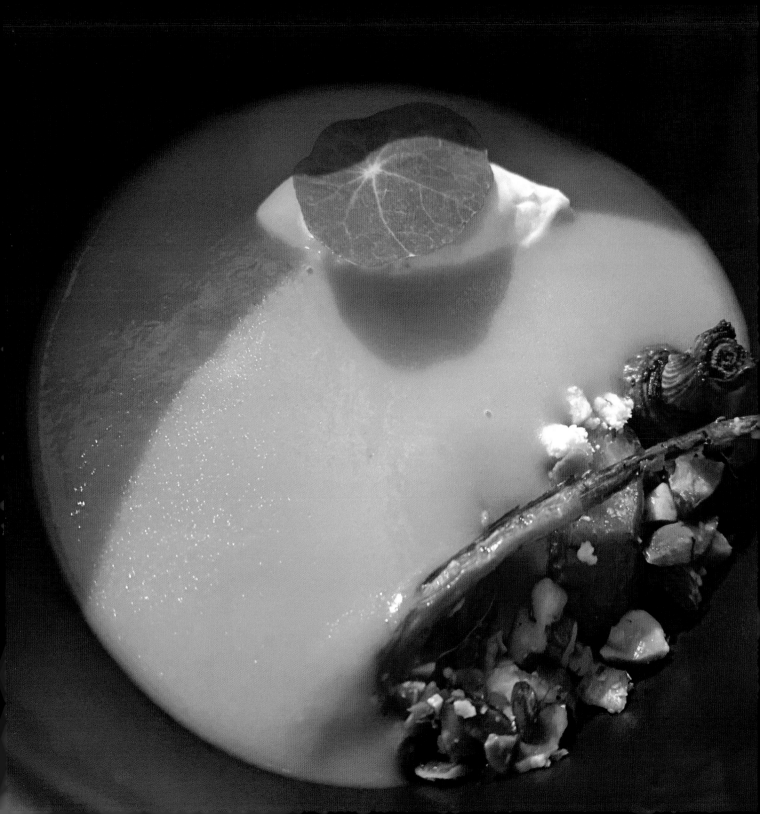

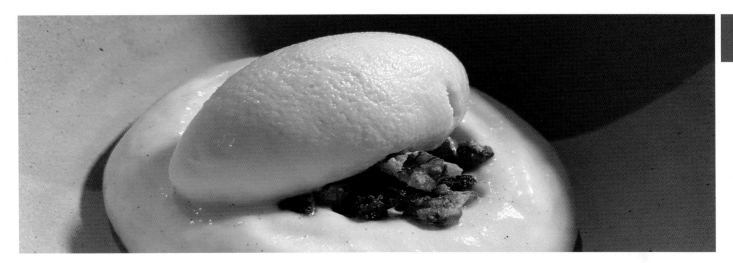

W ine may be your attraction to travel here; however, the culinary scene in Valle de Guadalupe is beyond-your-imagination extraordinary. Gastronomy is setting the stage for the future here.

VALLE DE GUADALUPE

Have you heard, as I have been reading, that the wines from Valle de Guadalupe México are getting high scores from major critics? The wineries have been hiring excellent winemakers from California, France and Spain to come elevate the qualities of their wines. And it is working!

The wines are winning competitions against California and French wines. Most characteristic to their success is that **The French Laundry** (a three-star Michelin restaurant consistently on "The World's 50 Best Restaurants") has Valle de Guadalupe wines on its wine list. Great wine is really beginning to happen here. You must go check it out.

In this small fourteen-mile-long agricultural valley, with a population of less than 7,000 people, you will find an abundance of extraordinary restaurants. I do not mean quality Mexican foods. The cuisine here is creative international gourmet dishes that you would experience in the world's largest cities by talented educated executive chefs.

It was a special occasion to start my journey by meeting Fernando Perez Castro, the owner of two wineries in Valle de Guadalupe. I was tasting with

him at his La Lomita winery. I love his wines; he loves my books. And he also loves the project of my new book about Valle de Guadalupe and Ensenada. We hit it off and became instant friends.

Fernando introduced me to some amazing restaurants. Little did I realize in that moment that he was showing me the jewels of the area: extraordinary foods. Many of these restaurants are now in this book for you to enjoy. Thank you very much Fernando.

This is an agricultural region, so produce is in abundance. The Pacific Ocean is right there, so fresh fish is prolific. Just like needing quality grapes to make great wine, you need excellent ingredients to make outstanding cuisine. This is the source here!

On my last day of this first trip, Fernando and I met for dinner at his Lunario restaurant (photos above and left) to debrief my two-week journey. The astonishment for me was the quality of food, so creative, gourmet and artistically presented. For Fernando, the extraordinary cuisine has become the inspiration, motivating winemakers to produce wines of the same exceptional caliber.

Tijuana International Airport (TIJ) is just south of the USA border, the closest airport to Valle de Guadalupe, with direct flights from sixteen US cities. **San Diego International Airport** (SAN) is the closet USA airport, only 30 min to México. Both airports have car rentals. I have a private driver to pick me up at the border (page 130). He can also do US airports.
Driving Distance to Valle de Guadalupe from...

- **San Diego, CA** 80 mi (2 hrs, 0 min)
- **Tijuana, México** 60 mi (1 hr, 30 min)
- **Ensenada, México** 10 mi (20 min)
- **Distance Across the Valle** 14 mi (25 min)

The cuisine in Valle de Guadalupe is surprisingly amazing, more than your expectations, truly extraordinary. These two gastronomic creations came from Executive Chef Sheyla Alvarado at Restaurante Lunario located in Valle de Guadalupe. **Olive Wood Smoked Carrot Soup** (photo left page) is a unique soup made from carrots smoked with olive wood, served with a rainbow of organic carrots (purple, yellow, orange, and white), topped with raw cream and a nasturtium leaf. Served with a 24-hour fermented buckwheat sourdough bread. **Corn Mousse Camembert Ice Cream** (photo above) is a sweet corn mousse, candied pecans and cacao nibs topped with ice cream made from their homemade camembert cheese.

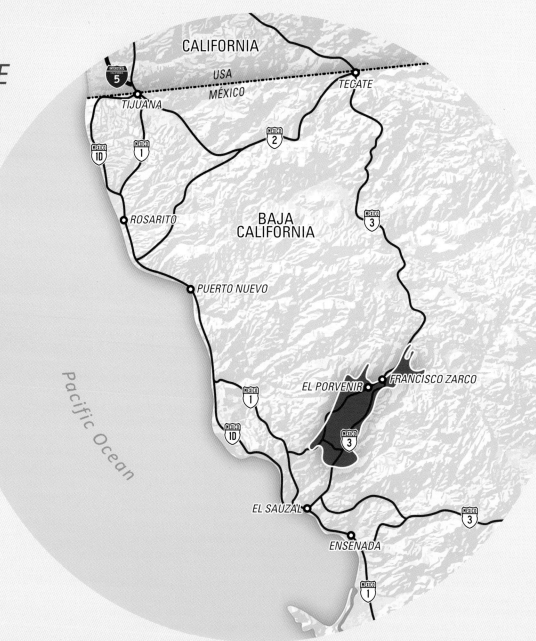

VALLE DE GUADALUPE

CALIFORNIA

USA

MÉXICO

INTERSTATE CALIFORNIA 5

TIJUANA

TECATE

MÉXICO 1D

MÉXICO 1

MÉXICO 2

BAJA CALIFORNIA

MÉXICO 3

ROSARITO

PUERTO NUEVO

Pacific Ocean

MÉXICO 1

EL PORVENIR

FRANCISCO ZARCO

MÉXICO 1D

MÉXICO 3

EL SAUZAL

MÉXICO 3

ENSENADA

MÉXICO 1

I n the past twenty years, this valley has grown from only a few wineries to hundreds of them today. Most accept visitors; many have food.

TERROIR OF VALLE DE GUADELUPE

Valle de Guadalupe is a valley benefiting from the cold Pacific Ocean influence, just as the other California coastal wine regions. They get warm days from the inland heat, followed by cool evenings from the cold ocean influx. These large diurnal temperature swings are important for viticulture. You may think this is just hot México; however, this is a real wine region with the right kind of terroir to make excellent wines.

There are no official appellations in México, yet. In Valle de Guadalupe, you can consider the valley an appellation in the sense of defining the viticulture area. Plus, three sub-areas within the valley called **Cañada de Trigo, Cañada de Guadalupe** and **Valle de Calafia**, are considered unique growing areas. You can see these on the map (next page).

Valle de Guadalupe is fourteen miles long (west/east) and five miles wide, with most of the wineries on the north side of the valley facing the sun. There is one primary road that runs through the valley. Starting at the coast, Hwy 3 is six miles to the valley, then fourteen miles through the valley, and another forty miles to Tecate at the US border.

Carretera a Francisco Zarco is the second paved road in the valley running parallel to Hwy 3 along the north. Most other roads are dirt. They are drivable and you will need to use them to reach the 100-plus wineries here. The valley is mainly flat and its edges are undeveloped hills filled with boulders.

Nobody could give me a confident number of wineries here. The range varied from 100 to 350 wineries. Why? The growth is too rapid to keep track and there are many winemakers inside other wineries, especially the small guys are hard to keep track. Anyway, the abundance here is for our enjoyment. I share with you wineries I know you can count on to be good.

I need to discuss a difficult topic: a bad taste in the wine there. It has kept people away. People there call it salty. I just don't taste salt in wine. I call it a rotten taste. I spent a lot of time trying to figure out what caused it and how to help you avoid them.

We all know México has bad water. So remember, only drink bottled water in México. It was easy to conclude that the vines drink this water and the grapes are filled with juice from the water. I found Cabernet Sauvignon the most likely to have this bad flavor, and since Cabernet needs longer growing time it is getting more México water. It made sense. Not true though.

This is not the best terroir for growing Cabernet Sauvignon, yet many people here want this number one planted grape in the world. Not all Cabernets here are bad, so the problem is not the grapes conflicting with the terroir problem either.

I explored many other theories. When I saw a winery's concrete floors being steam-cleaned to perfection and the tanks were spotless (including water spots), I realized the cleanliness is what was making the difference. All the wines there were beautiful.

Sterilization is essential at a winery! All over the world, bacteria is an important issue for winemakers. Brettanomyces is a type of yeast found in nearly every stage of the winemaking process, from the grape skins to the barrels. It can be challenging to control and eliminate because it grows into the wood of the barrel and becomes hidden.

As I travel the world and visit wineries, cleanliness is a constant activity at wineries as they keep every surface as sterile as possible. Also, oak barrels must be cleaned and sanitized. Maybe you've seen very hot steam sprayed inside the barrels to kill bacteria? This is essential! It is easy to conclude that the bacteria is creating the rotten taste in some of the wines here.

The rotten taste was most prevalent in Cabernet Sauvignon, which spends the greatest amount of time aging in the oak barrels, further supporting this theory. I also noticed that wineries that had winemakers from other countries did not have this problem. Maybe the training or standards are different. Am I correct? Who knows. I will continue my theories, and please send me feedback if you know anything further.

Considering this, I have only included wineries that have good-tasting wines, and I identified the country where each of winemakers came from or was trained.

As it is in any wine region, it is very much about the right varietals being planted in their best terroir. Here, I found the terroir worked optimally for Nebbiolo, Mourvèdre, Grenache, Tempranillo and Syrah. These wines you will definitely love.

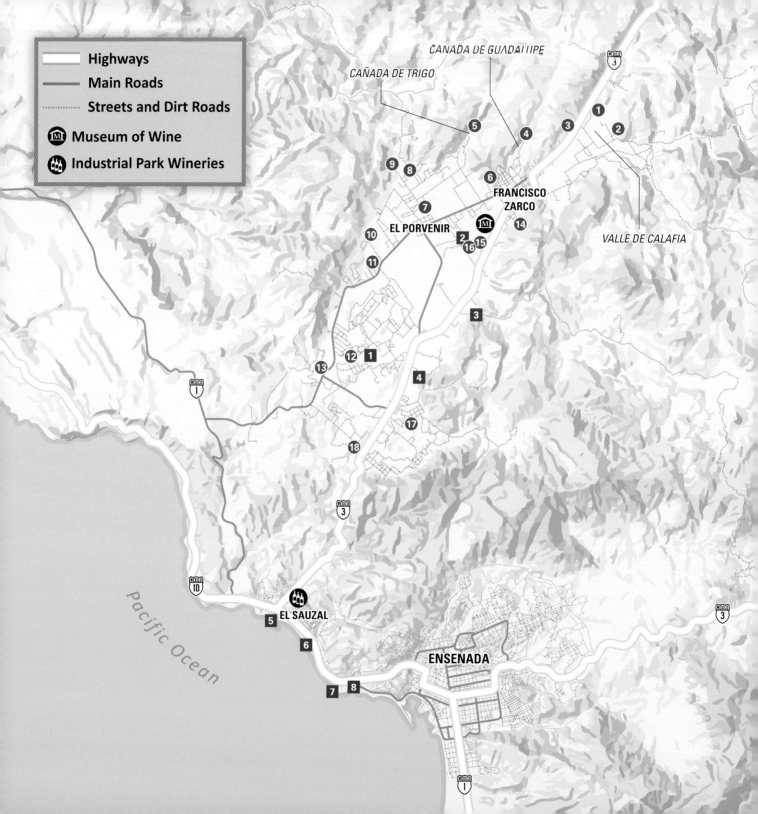

Legend

- **Highways**
- **Main Roads**
- **Streets and Dirt Roads**
- **M** Museum of Wine
- **Industrial Park Wineries**

CAÑADA DE GUADALUPE

CAÑADA DE TRIGO

MEXICO 3

FRANCISCO ZARCO

VALLE DE CALAFIA

EL PORVENIR

EL SAUZAL

ENSENADA

Pacific Ocean

MEXICO 1

MEXICO 1D

MEXICO 3

VALLE DE GUADALUPE WINERIES

	Number of Wines	Red Wines	White Wines	Rosé Wines	Sweet Wines	Sparkling Wines	Wine Shop	Boutique	Accommodations	Restaurant	Food Options	Food & Wine Pairings	Tours	Educational Workshops	Fun Activities	Italian Wines	Spanish Wines	French Wines	Other
Three Largest Wineries (in that order)																			
❷ L.A. Cetto	34	√	√	√	√	√	√	√					√			√	√	√	√
❸ Casa Pedro Domecq	9	√	√		√		√						√				√	√	
⓲ Bodegas de Santo Tomás	27	√	√				√			√	√		√	√	√	√	√	√	√
Far East Valley (Valle de Calafia)																			
❶ Bruma Winery	7	√	√	√					√	√	√	√	√				√		
❷ L.A. Cetto	34	√	√	√		√	√	√					√			√	√	√	√
❸ Casa Pedro Domecq	9	√	√		√		√						√				√	√	
Northeast Valley (Cañada de Guadalupe)																			
❹ Viñedo Solar Fortún	10	√	√	√			√		√	√	√						√		
Northeast Valley (Cañada de Trigo)																			
❺ Viña de Frannes	8	√	√	√	√		√										√	√	
North Central Valley (from east to west)																			
❻ Monte Xanic	13	√	√	√			√						√				√		
❼ Adobe de Guadalupe	10	√					√		√	√	√		√		√		√		
❽ Barón Balch'é	17	√					√		√	√	√		√		√		√		√
❾ Decantos Vinícola	59	√	√	√	√	√	√		√	√	√	√	√	√	√		√		√
❿ Finca la Carrodilla	6	√	√	√			√			√						√	√		
⓫ El Cielo Resort	22	√	√	√		√	√		√	√	√	√	√	√	√			√	√
⓬ Vinícola Sierra Vita	10	√	√	√			√						√				√	√	
⓭ Casa Frida	23	√	√	√			√		√	√	√	√				√	√	√	√
Southern Valley (from east to west)																			
⓮ Hacienda Guadalupe Winery	4	√	√	√			√		√	√	√						√	√	
⓯ Viños Lechuza	4	√	√	√	√		√		√	√	√		√		√		√	√	
⓰ Bodega Magoni	4	√	√	√	√		√				√						√	√	√
⓱ Maglén Winery Resort	4	√	√	√	√		√		√	√	√		√	√			√	√	
⓲ Bodegas de Santo Tomás	27	√	√	√	√		√			√	√		√	√		√	√	√	√

Stand-Alone Restaurants

1	Lunario
2	Animalón
3	Deckman's en el Mogor
4	Primitivo Restaurante
5	Wendlandt Cervecería
6	Aguamala Cervecería
7	Punta Morro Restaurant
8	Hotel Coral & Marina

Navigating the Valley

One of the exciting aspects of this journey is finding the wineries. Dirt roads and addresses that do not make sense. I suggest having two maps on your phone to help find places. It will be a fun adventure!

I organized the wineries from east to west across the valley. Starting from the far east, then proceeding along the north of the valley, and then along the south on Hwy 3. Afterwards, I included the Coastal Region and Downtown Ensenada. They are all plotted on the map to make finding them relatively easy.

⓿ Winery　**R** Restaurant　**L** Lodging

FOOD & WINE LOVERS PARADISE

One of the biggest surprises in Valle de Guadalupe is the quantity and quality of restaurants in this agricultural valley. Most of the restaurants are located at wineries. And the food is extraordinary. Gourmet. This is a food and wine lovers' paradise.

I have uncovered a whopping fifteen excellent restaurants in this little valley that are located at wineries. I still find this restaurant phenomena here hard to believe, and these restaurants really do make wine tasting in Valle de Guadalupe a top destination for wine and culinary lovers.

Fauna Restaurante East
AT BRUMA WINERY (page 43)

Dulce Vida NorthEast
AT SOLAR FORTÚN (page 51)

Elegant Splendor NorthEast
AT ADOBE DE GUADALUPE (page 61)

Decantos NorthCentral
AT DECANTOS VINÍCOLA (page 67)

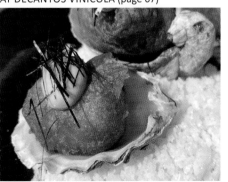

Latitude 33 NorthCentral
AT EL CIELO RESORT (page 73)

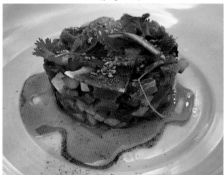

Once Pueblos CentralWest
AT SIERRA VITA (page 77)

RESTAURANTS **AT WINERIES** IN VALLE DE GUADALUPE

Corazón & D'Petra — NorthWest
AT CASA FRIDA (page 85)

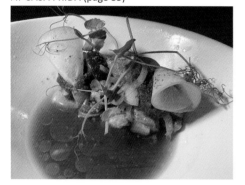

Lake Deck Oyster Bar — NorthWest
AT CASA FRIDA (page 83)

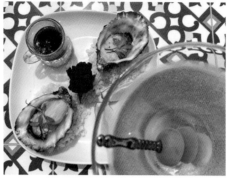

El Principal — SouthEast
AT HACIENDA GUADALUPE (page 95)

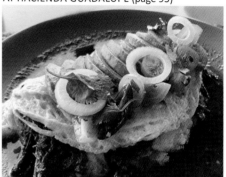

Alendaño — SouthEast
AT HACIENDA GUADALUPE (page 95)

Honôkai — SouthEast
AT VIÑOS LECHUZA (page 99)

Cantera — SouthWest
AT MAGLÉN RESORT (page 111)

Huevo Republic — SouthWest
AT MAGLÉN RESORT (page 111)

Yumano — SouthWest
AT MAGLÉN RESORT (page 111)

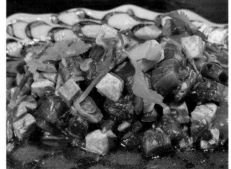

Villa Torél — SouthWest
AT BODEGAS DE SANTO TOMÁS (page 115)

FOOD & WINE LOVERS' PARADISE

As I expressed in the previous spread, one of the biggest surprises in Valle de Guadalupe is the quantity and quality of restaurants in this agricultural valley. While most of the restaurants are located at wineries, there are several stand-alone restaurants that are worth your culinary visit.

I discovered four incredibly delicious restaurants in the valley that are not at wineries. Each of them is quite special in its own creative way of delivering gourmet cuisine. Plus, I included two additional restaurants just outside the valley on the coast.

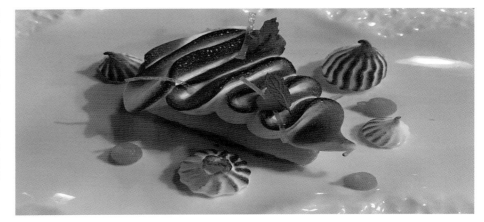

Lunario
NorthWest
Page 79

Animalón
SouthEast
Page 103

Deckman's
SouthWest
Page 105

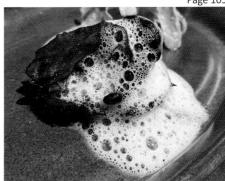

Primitivo
NorthWest
Page 107

Aguamala Cervecería
Coastal
Page 119

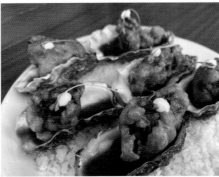

Punta Morro
Coastal
Page 121

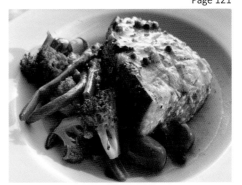

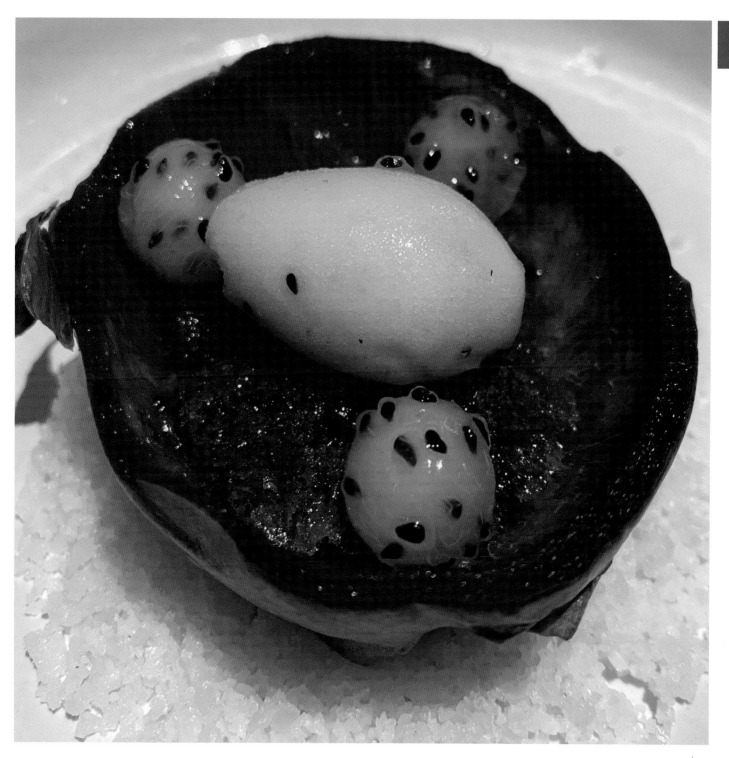

The Three Sub-Regions of Valle de Guadalupe, and their Special Terroir

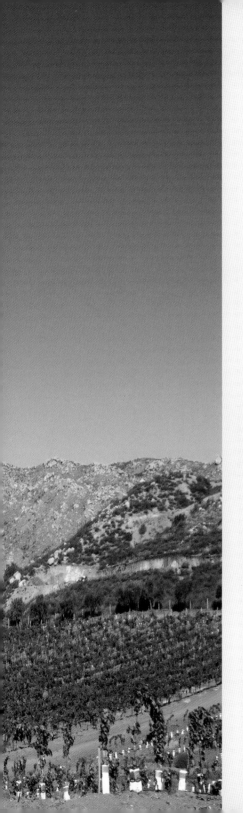

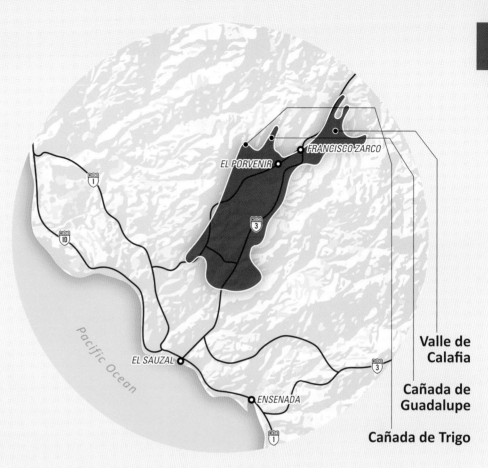

Valle de Calafia

Cañada de Guadalupe

Cañada de Trigo

Left page: Stone sculpture in the Bruma Winery vineyards.

SMALL UNIQUE REGIONS

Since there are no official appellations in México, we define Valle de Guadalupe as a region with unique terroir to its valley. Within the Valle de Guadalupe region, there are three subregions, even further unique for their special terroir.

Valle de Calafia (valley of Calafia) is the first sub-region in Valle de Guadalupe located in the most eastern section of the valley. This is where the first wineries were established in the valley: *Casa Pedro Domecq* and *L.A Cetto*.

Cañada de Guadalupe (canyon of Guadalupe "wolf valley") is a tiny box canyon located very far east and in the north of the valley. It is remote and takes some patience on dirt roads to get there. It is worth visiting as the terroir here is unique in the valley, as the terrain looks very much like Left Bank

Bordeaux, France with millions of river rocks and boulders, and dozens of oak trees.

Cañada de Trigo (canyon of wheat) obtained its name as its origin was a canyon where the Russians grew wheat a century ago. It is located to the far north and east of the valley. It is a dead-end canyon of great terroir with delicious premium wines being produced today from the two wineries here, *Viña de Frannes* and *Chateau Camou* (same ownership).

Here are the sub-regions and their wineries.

Valle de Calafia
• Bruma Winery & Hotel, page 41
• L.A. Cetto, page 47
Cañada de Guadalupe
• Viñedo Solar Fortún, page 49
Cañada de Trigo
• Viña de Frannes, page 53

BAJA **VALLE DE GUADELUPE** SUB-REGIONS ▪
Winery, Vineyards, Restaurant, Lodging
BRUMA WINERY & HOTEL

Winemaker: Bordeaux France
$-$$-$$$

Located: Far East Valley (Valle de Calafia)
Km 73.25 Carretera Tecate – El Sauzal
22760 Valle de Guadalupe, Baja California

+52 646 194 8239
VinicolaReservaciones@Bruma.mx

Bruma.mx

Tastings & Tours, RSVP Only
Open: Every Day, 10am-6pm

Excellent wines, an amazing restaurant, and super-cool luxury accommodations.

EXCELLENT WHITE WINE FOCUS

There are so many excellent things to discuss about this property. Let's start with their wines and winery. The focus here is white wines, as 70 percent of their wines are either white or rosé. Just look at the barrel room (photo above) and you see very few barrels as they produce limited red wine to age in oak.

The white wine is excellent here. My favorite is the Plan B Blanco, Sauvignon Blanc. It is clean and refreshing, has a very tropical nose to adore, with delicious grapefruit in the mouth, as you would expect from a Sauvignon Blanc. And, a delightfully long acidic finish, perfect to pair with foods.

The winery is a work of art. And 80 percent of the building materials were recycled for constructing the winery, including the vinification area, barrel room and tasting areas. For example, the structural steel beams are the steel railroad tracks, and the wood walls are from piers recycled from ports.

The design is very interesting. Everything above ground is what you see on the left page, a building for a VIP tasting room. Underground, a massive tree comes from the barrel room floor (photo above) and protrudes through the ceiling and through the pond above the winery. See the old tree in the two photos and its magnificent structure towering above the winery (left page).

The winemaker here, Lourdes (Lulu) Martinez, is from Bordeaux France. She comes with thirteen years experience at Château Brane-Cantenac, a prestigious second-growth Grand Cru Classé of 1855 in Margaux, Bordeaux, France. Lulu's Plan A was to study law in Paris; or Plan B was to study oenology in Bordeaux. We are all happy for the Plan B decision, and hence her label: Plan B. She is a partner at Bruma.

Eight childhood friends from México City created Bruma in 2015 to be the most luxurious and premium brand in Valle de Guadalupe. They have created a project that is inspiring others to elevate the quality in Valle de Guadalupe.

Bruma is located at the far east of the valley, on a huge property with vineyards, winery, a restaurant and accommodations. There are lots of open space to meander around the property for hours. Bicycles are available to guests at Casa Ocho, their B&B.

Lulu is making excellent wines. The winery is an architectural marvel. The restaurant has a very talented chef creating gourmet, fresh, chef-inspired menu everyday (see next page). And the B&B accommodations are super-creative luxury villas tucked into the landscape using all natural materials. Plus, they have private ranch homes on the hillside overlooking the valley. This is a luxury resort property.

Collection of Wines

Ocho Tinto (Cabernet Sauvignon, Petite Sirah)
Ocho Rosé (Rosé of Sangiovese)
Ocho Blanco (Carignan, Vintified as a White Wine)

Plan B Tinto (Merlot, Malbec, Mourvèdre, Grenache)
Plan B Rosé (Rosé of Grenache)
Plan B Blanco (Sauvignon Blanc)

Rosé de la Casa (Rosé of Carménère)

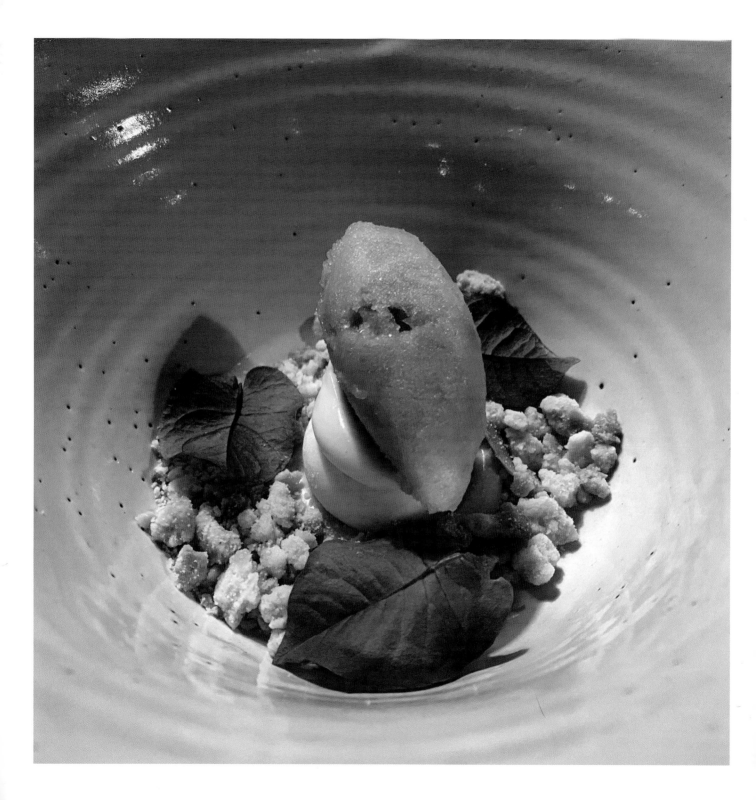

WE COOK WHAT WE FIND

This is their motto, yet the young chef will apologize for not knowing what he will serve. No apology necessary Chef David Castro, a graduate of the French Culinary Institute, as this is what I find to be the magic of your restaurant. They really do cook what they find. The magic here is that the creativity occurs in the kitchen after they have what they found. Everyday is an experiment. There is a daily menu to choose à la carte; however, I highly recommend the **Chef's Tasting Menu** and just let the chef bring his daily experiments. Come with a big appetite, I had twelve courses, plus two desserts! And they have a unique pairing; each three courses is paired with a wine, beer or cocktail.

Let's let the creative gourmet dishes speak for themselves...

Bougainvillea Lemon Curd (photo left page) sorbet on top of lemon curd and almond crumbles. Decorated with bougainvillea flowers.

Aguachile Abalone (photo below left) thinly sliced and layered abalone submerged in a broth seasoned with chili meco peppers, Savoye lime juice, cilantro, cucumber, salt and onion. Topped with pumpkin seeds and lemon zest.

Smoked Broccoli (photo below center) in a big clay oven smoked with mesquite on top of broccoli emulsion with drops of black sesame oil and tiny Chiltepin peppers from Sonora.

Scallops Slices (photo right center) in a charred eggplant and brown butter purée topped with crushed croutons.

Churro (photo below right) with homemade guava ice cream centered in a fresh churro, sitting on a thick creamy dulce de leche, with shredded sheep cheese sprinkled on top.

$$$-$$$$

+52 646 103 6403
ReservacionesFauna@gmail.com

FaunaRestaurante.mx

The Fauna Restaurant Is Next To Bruma Winery
Open: Every Day

Reservations Are A Must
Sunday-Wednesday, 1pm-9pm
Thursday-Saturday, 1pm-10pm

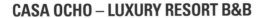

CASA OCHO – LUXURY RESORT B&B

This is a luxury resort with two options: Casa Ocho and Private Ranch Homes. The homes are hillside with views of the valley. Casa Ocho has spacious villas nestled in the valley among the vineyards and oak trees.

Casa Ocho is a full-service, resort-style bed and breakfast, nestled within vineyards, practically hidden amongst the oak trees, huge boulders, large dirt mounds, and the natural materials used for construction. Casa Ocho, translated from Spanish means "House Eight." Besides the eight owners, there are eight separately located rooms. The buildings are all made from materials found on the property (see photo left page and below). The boulders become the walls inside and outside. It is a rustically luxurious environment. Notice the glass door. This is the front-door entrance to the room. And lower right shows the inside of the glass door with a nice sitting area off the bedroom. Fresh fruit and hot breakfast are served every morning (kitchen photo below.) The endless pool and spa (photo right) are a treat overlooking the vineyards.

Seven Ranch Homes are privately situated along their hillside overlooking the valley. These are full-size luxury homes with all the furnishings, including a chef available for the kitchen.

$$$$$

+52 646 116 8031
Reservaciones@Bruma.mx

Bruma.mx

Open All Year

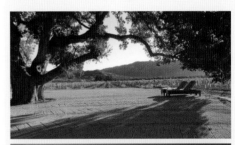

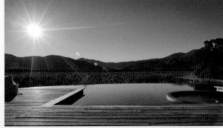

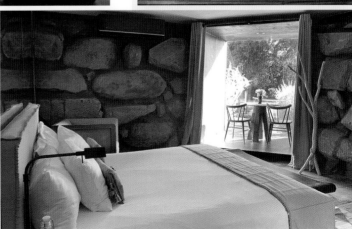

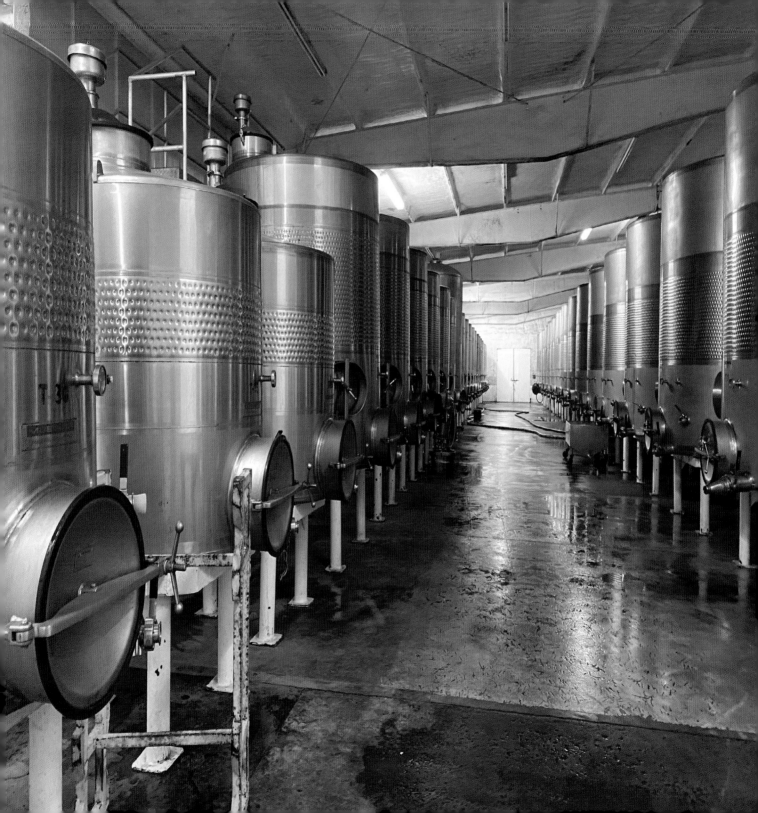

Winemaker: Mendoza, Argentina
$-$$-$$$

Located: Far East Valley (Valle de Calafia)
KM 73.5 Carretera Tecate – El Sauzal
22750 Valle de Guadalupe, Baja California

+52 686 557 3719
Reservaciones@GpoCetto.com

LACetto.mx/en

Open: Every Day, 10:00am-4:00pm

This is the largest winery in México, producing about 50 percent of all wines in México.

GOOD QUALITY, GREAT PRICES

When you consider the hundreds of wineries, in fourteen different regions, throughout México, it is amazing to think that one winery produces half the wines in México. This makes me think of the Anheuser-Busch massive size, and yes, L.A. Cetto makes low-priced wines; however, they also have good wines. I listed their good wines to the right, and you can see from my photo (right), I tasted quite a few of them. I was really surprised how many were really very good wines.

L.A. Cetto hired an Argentinian winemaker from Mendoza to produce great wines for them. This is definitely a place to stop to see what a huge winery looks like, and to taste good wines at great prices ($6.50 to $60).

L.A. Cetto recently decided to participate in the **San Francisco Chronicle Wine Competition** in 2021 to see what would happen. They won eight awards. Their 2019 Chenin Blanc ($14.99) won **Best of Class**, and their 2016 Private Reserve Nebbiolo ($22.99) won **Gold Medal**. This Best in Class is among California wines. This is a good example that wines from Valle de Guadalupe are truly becoming quality wines we all need to be checking out.

L.A. Cetto is one of the oldest wineries here, founded in 1928 by the same family who owns the winery today. Four generations! Today, they are making thirty-five labels and distributing their wines in thirty-two countries around the world.

Second generation Luis Agustín Cetto had a philosophy he spoke about often. You can see it in his initials that named this winery. Luis would say:

"Why would I charge a premium price for expensive wines when I can give them a premium wine at an affordable price?"

In 1965, Cetto hired Camillo Magoni, a very talented Italian winemaker, to make the best Mexican wines. Magoni achieved this and made a huge reputation for himself as a result.

My first wine in Ensenada was a Magoni Nebbiolo. And Cetto's first superstar wine was a Nebbiolo wine produced by Magoni in 1987. This moved L.A. Cetto from being just a volume wine producer into being the pioneer of high-quality Mexican wines.

After tasting many wines in Valle de Guadalupe, I conclude that this Italian grape Nebbiolo is one of the best wines produced here. It is similar to Malbec doing so well in Mendoza, Argentina.

Collection of Wines

Boutique Wines
Sangiovese
Syrah
Malbec
Pinot Noir
Chardonnay/Viognier/Pinot Noir

Don Luis Wines
Merlot
Viognier
Concordia (Cabernet Sauvignon, Syrah)
Terra (Cabernet Sauvignon, Merlot, Petit Verdot, Malbec)

Private Reserve Wines
Cabernet Sauvignon
Petite Sirah
Nebbiolo
Chardonnay

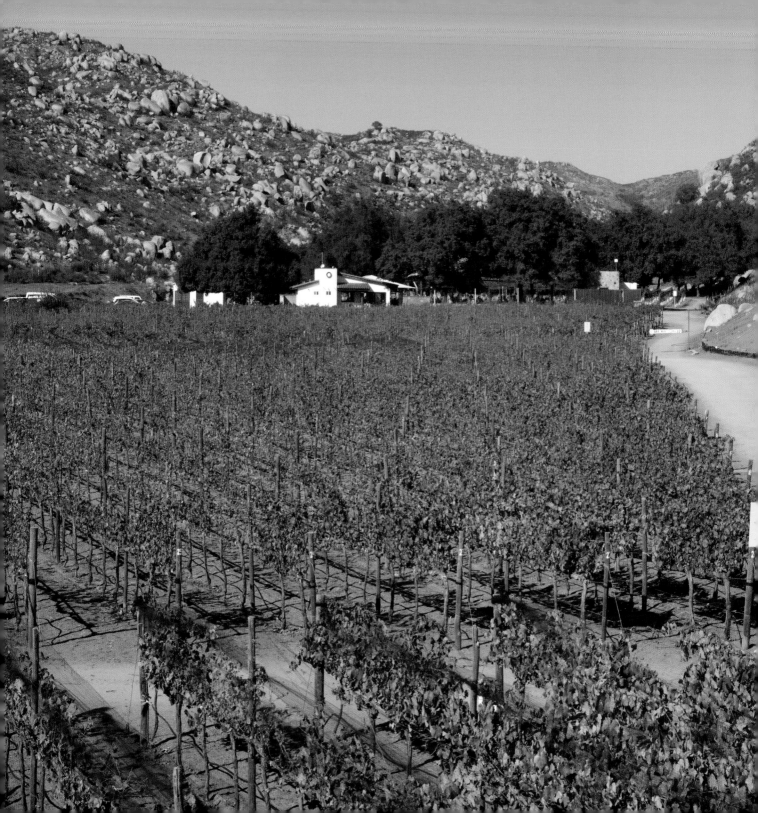

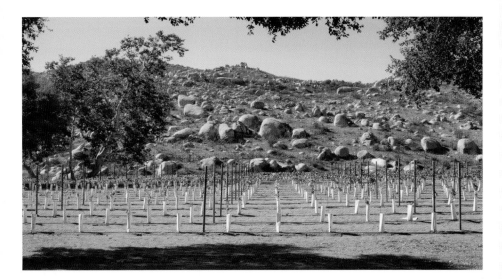

Winemaker: UC Davis, California
$-$$-$$$-$$$$

Located: Central Valley, Northeast,
Cañada de Guadalupe
Calle 10, Francisco Zarco Village
22750 Valle de Guadalupe, Baja California

+52 646 141 2048
ventas@SolarFortun.com

SolarFortun.com

Lunch and Tastings
Open: Friday-Sunday, 11am-7pm

In the back of their own canyon, a unique valley with distinctively special terroir.

CAÑADA DE GUADALUPE

While the vineyards for Solar Fortún are located in the Valle de Guadalupe, they are actually in their own special canyon, a tiny valley called Cañada de Guadalupe, located at the farthest north and east of the Guadalupe valley. The terroir here is unique to the rest of the Guadalupe Valley. They have dozens of oak trees and millions of river rocks and boulders (see photos above and left page). This is completely unlike the rest of the Valle de Guadalupe.

In addition to the unique terroir, they have their own underground stream. They harvest this water at the low point of the ravine and through a gentle pump, they slowly bring the water to the surface and then gently up to the highest point of the valley where they keep it in water tanks. This is excellent water with very low amounts of mineral salts, creating the best quality for the fruit of the vines to drink.

How did they find this hidden special valley? The founder, José Alberto López, is an astrophysicist working for the National Institute of Astronomy in Ensenada. And José loves wine! With all his travels into Valle de Guadalupe, he came across this special valley and purchased it.

At the same time, José's son, Santiago López Viana, who finished his engineering degree from Penn State and his oenology degree from UC Davis, was ready to join him in creating an amazing vineyard and beautiful wines.

They started with the best quality of vines, which came from the French Mercier Nursery in the Napa Valley. The pattern, strains and clones of the plants were specially selected for their unique terroir, micro-climate and subsoil of this canyon. The first two wines, vintage 2012, brought them two medals. They were off to a great start in producing the best quality wines.

I am not a big Cabernet Sauvignon fan from Valle de Guadalupe; however, their Elixir Cordis is an excellent Cabernet Sauvignon (photo right). I was very impressed. My favorite of their wines is their Mourvèdre, very delicious and pairs well with their famous tacos in the restaurant (next page).

Finding Solar Fortún is an adventure. Start from the little village of Francisco Zarco and drive north on the street next to La Chica (super market). You will be endlessly driving along dirt roads, and you must keep going until you get to the back of this canyon. When you get to the back of the canyon, you will see signs, and will now be ready for a glass of wine and lunch.

Collection of Wines

Premium Wines
Elixir Cordis (Cabernet Sauvignon Gran Reserva)
Cabernet Sauvignon Reserva

Blended Wines
Noble Cru (Mourvèdre, Syrah, Cabernet Sauvignon, Petit Verdot)
O Positivo (Cabernet Sauvignon, Syrah)
Confabulario (Mourvèdre, Petit Verdot)
Baya Baya (Cabernet Sauvignon, Petit Verdot)

Single Varietal Wines
Mourvèdre
Petit Verdot
Syrah
La Viña en Rosa (Rosé of Mourvèdre)

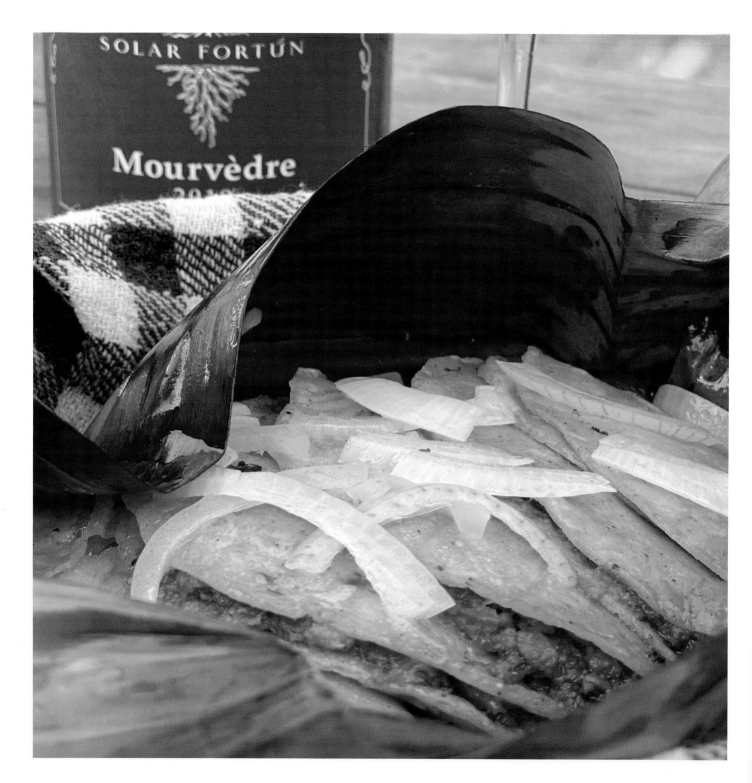

DULCE VIDA RESTAURANT AND TASTING TERRACE

When you reach Solar Fortún, you will find vineyards throughout this canyon, century-old oak trees, large hillsides filled with boulders, a beautiful outdoor wine tasting area and a restaurant called Dulce Vida. You will also notice that there is no winery here. It is at the ocean, just north of Ensenada in El Sauzal. There they have VIP barrel tastings and an oceanfront wine bar. And a restaurant is planned.

Dulce Vida is a beautiful outdoor terrace (photo upper right) designed for wine tasting and enjoying delicious foods. They also do an excellent job at pairing the wine and food together. Dulce Vida's chef is Dulce Lopez, Santiago's wife. Solar Fortún is truly a family business. Together they entered **La Noche de Cofradia**, one of the most important food and wine pairing competitions in México. They are the only ones who have won this event twice. In 2019, they won first place, where she created **Steamed Port Stewed Tacos** (photo left page) and he presented his **Mourvédre** wine for the perfect pairing (photo left page). It was the perfect pairing, as they won first place! This is a pairing you definitely want to experience. Both are excellent; together they are amazing!

Now for the delicious cuisine...

Steamed Port Stewed Tacos (photo left page) are a traditional street-side taco from central México. Their unique approach is to wrap it in banana leaf and use a red salsa macha instead of the traditional green salsa. Their award-winning pairing is Mourvédre.

Sweet Life Ceviche (photo below left) is a fresh salad of local yellowtail, horse mackerel, shrimp, octopus, cherry tomatoes and organic Persian cucumbers. Finished with their Mexicanized version of a Peruvian recipe called *leche de tigre* (tigers milk). Recommended pairing: La Viña en Rosa.

New York Steak (photo below right) is a high-quality grilled steak, a choice New York cut, with roasted vegetables, lightly mashed onions, and a mild onion sauce. Recommended pairing: Noble Cru.

$-$$

+52 646 141 2048
ventas@SolarFortun.com

SolarFortun.com

Lunch and Tastings
Open: Friday-Sunday, 11am-7pm

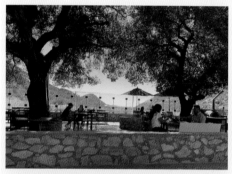

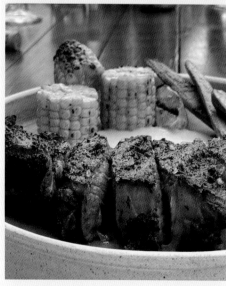

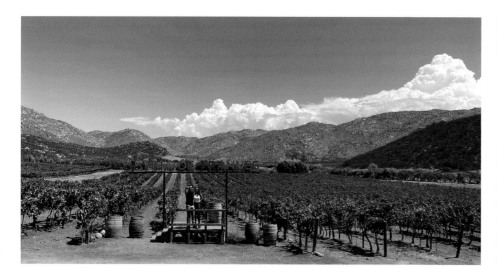

BAJA **VALLE DE GUADELUPE** SUB-REGIONS ■
Winery, Vineyards
VIÑA DE FRANNES

Winemaker: Bordeaux, France
$$-$$$

Located: Central Valley, Northeast
Camino Vecinal al Rancho Cañada del Trigo
22750 Valle de Guadalupe, Baja California

+52 646 688 1955
VentasFrannes2@gmail.com

VFrannes.com

Open: Every Day, 10am-6pm

W ith a passion for Bordeaux wines, Michel Rolland was hired to lead the winemaking team here.

CAÑADA DEL TRIGO

México City businessman/developer, Ernesto Álvarez Morphy Camou, fell in love with Bordeaux wines and became passionate about making these styles of wines in México. He hired the famous Bordeaux-based oenologist, Michel Rolland, to create and lead his winemaking team with the goal to someday produce the first 100-point wine from México.

Ernesto discovered and purchased a very special little canyon in the north east of Valle de Guadalupe known as Cañada del Trigo (photo above). Trigo means "wheat" in Spanish, as original Russian settlers grew wheat in this canyon.

The terroir here has a canyon-like micro-climate unique from the rest of the Valle de Guadalupe. Deep in this canyon, with steep valley walls and fresh breezes descending with air temperatures cooler at night so vines can rest more than the surrounding vineyards in the valley.

This canyon has first access to the water entering the valley from the north from naturally filtered water that works its way through many miles of sandstone and granite before arriving at the aquifer that lies below the vineyards here. The water is also plentiful and has fewer unwanted minerals.

Cañada del Trigo was originally planted with grapes in 1937 (one of the oldest vineyards in the valley) with soil perfect for growing Bordeaux grapes. Soils are a sandy clay marl, an earthy material rich in carbonate minerals, clays and silt which are just right for growing the different Bordeaux grapes.

All of the Viña de Frannes wines are made from the grapes grown in this canyon on their 25 hectares of vineyards of six varieties of grapes (mostly Bordeaux). It is a nice little boutique winery making only 5,000 cases a year, focusing on the ultimate quality of wine.

Every wine I tasted here was excellent. Their top-level wine is called Pater (which means "father" in Latin), a classic Bordeaux blend of Cabernet Sauvignon and Merlot. It is fermented in new French oak barrels for ten days and racked into first-use French oak barrels to be aged for eighteen months. I found the Pater to be very well balanced, yet complex with rich flavors and soft tannins.

Viña de Frannes is well off the beaten path in the back of this canyon by itself where you can enjoy the beautiful scenery and solitude. The tasting room is a Mies Van Der Rohe-style wood and glass cube building raised above the vineyards to enjoy the beauty of their natural setting from the patio or dining room (photo left page).

Collection of Wines

Pater (Cabernet Sauvignon, Merlot)
Legat Cabernet Franc (Cabernet Franc, Merlot)
Legat Merlot (Merlot, Cabernet Franc)
Legat El Tinto de Frannes (Cabernet Sauvignon,
Cabernet Franc, Merlot, Tempranillo)
Legat Rosado (Rosé of Cabernet Sauvignon,
Cabernet Franc, Merlot)
Legat Sauvignon Blanc
Legat Chardonnay

Duz Dulce Natural (Cabernet Sauvignon,
Cabernet Franc, Merlot, Tempranillo)

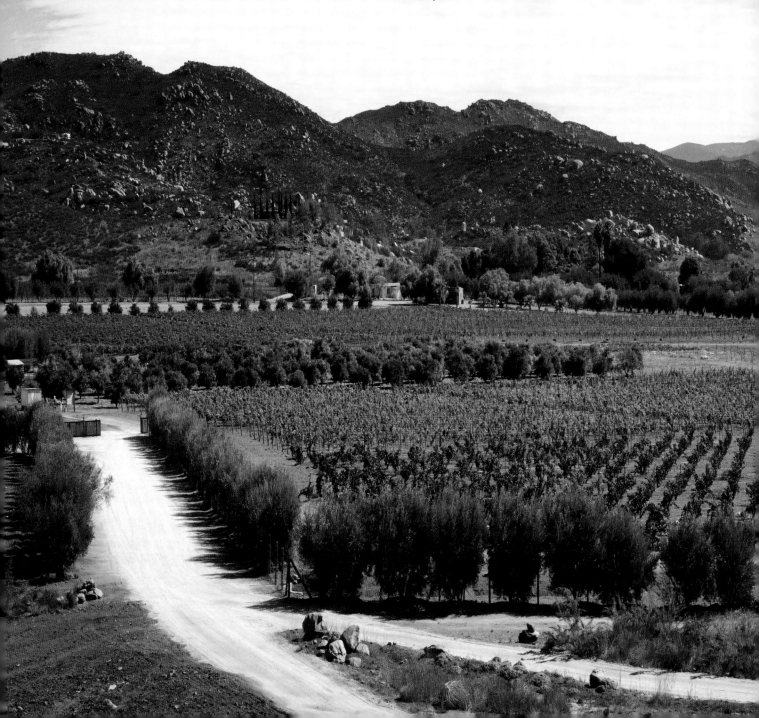

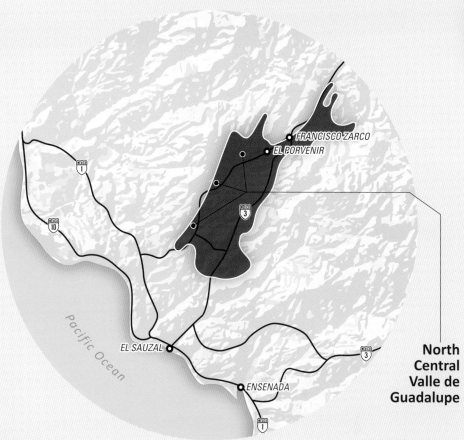

North Central Valle de Guadalupe

Left page: The view of Decantos Vinícola vineyards from their hillside winery and tasting facility

NORTH SUN-FACING REGION

The majority of wineries in Valle de Guadalupe are located on this north side of the valley. They are primarily up into the hills of the valley with a south-facing sun exposure for the vines. It is also a great view for us looking out into the valley.

There is one primary road here, *Carretera a Francisco Zarco*, which runs east/west on the north side of the valley, parallel to Hwy 3 along the south. The roads heading off of *Carretera a Francisco Zarco* are all dirt roads. The dirt roads are in good condition; however, it can be an exciting journey finding the wineries as the addresses do not always make sense. Having two map apps on your phone will help tremendously. Also, using a driver who knows the local dirt roads and wineries will make it easy.

In any case, this part of the valley is a remote fun adventure to enjoy!

I have organized the wineries in this section starting from the north east flowing to the west. Every one of the wineries in this section has a restaurant, so you can spend the entire day up here and be able to enjoy dining as well. Several of them also have lodging so you can make this an ongoing adventure.

Here are the wineries for you to explore.

- Monte Xanic, page 57
- Adobe de Guadalupe, page 59
- Barón Balch'é, page 63
- Decantos Vinícola, page 65
- Finca la Carrodilla, page 69
- El Cielo Resort, page 71
- Vinícola Sierra Vita, page 75
- Casa Frida, page 81

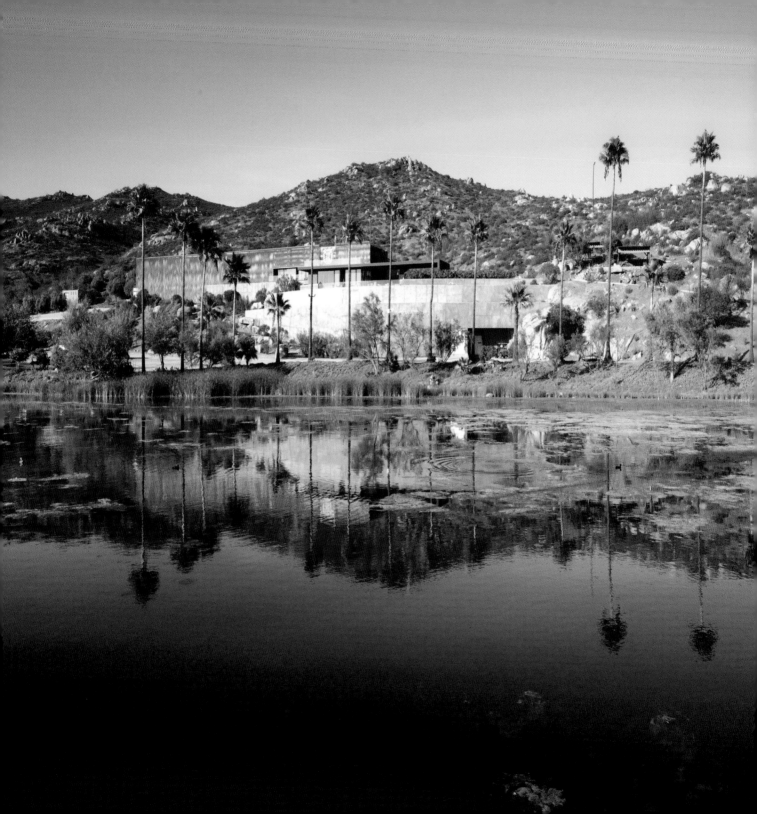

Winemaker: University of Adelaide, Australia

$-$$-$$$

Located: Central Valley, Northeast
Calle Principal a Ejido Francisco Zarco
22755 Valle de Guadalupe, Baja California

+52 646 155 2080
Ventas@MonteXanic.com/mx

MonteXanic.com.mx

Open: Every Day, 11am-5pm

Reservations: Meitre.com/Monte-Xanic

Collection of Wines

Gran Ricardo (Cabernet Sauvignon, Merlot,
Petit Verdot, Cabernet Franc)

Limited Edition Cabernet Franc
Limited Edition Malbec
Limited Edition Nebbiolo

Selección (Malbec, Cabernet Sauvignon, Merlot)
Monte Xanic Cabernet Sauvignon
Monte Xanic Cabernet Sauvignon/Merlot
Monte Xanic Merlot

Monte Xanic Rosé (Rosé of Grenache)

Monte Xanic Sauvignon Blanc Viña Kristel
Chenin Colombard (Chenin Blanc, French Colombard)
Monte Xanic Chardonnay

Hillside winery, overlooking a beautiful lake, producing ultra-premium wines.

BEST VIEW FOR WINE TASTING

Five wine-loving friends in México City had a big dream to create México's first ultra-premium wine. In 1987, Monte Xanic was born with this passion to position México on the world's map of significant wine countries. Xanic (sha-nik) means "flowers born after the first rain" in the Cora Indian language.

The CEO here studied oenology in Bordeaux France, and their winemaker, Oscar Gaona, studied oenology and bio technology in Adelaide, Australia. There is a lot of expertise, passion, art, and science going into making the best possible wines here.

Monte Xanic has three vineyards with three distinctly different terroir. Oscar makes it a priority to comprehend the scientific agronomic aspects of these vineyards to better understand the biochemical aspects of each variety in order to achieve excellence in every bottle he makes.

To make a great wine, you must bring in excellent grapes from the vineyards. And this is what is happening here. Just wait till you taste their wines and see the beautiful results. All three of their labels (sixteen wines) have received 90+ scores.

In 1994, they began harvesting the first grapes for Gran Ricardo, with the first release in 2000, achieving their dream of creating México's first ultra-premium wine. Gran Ricardo is a traditional Bordeaux blend (photo right) and has received more than fifty gold medals and has been listed in the top 1% of wines in the world. Being critical of Cabernet Sauvignon in this valley, excellence was found here.

And now for the tasting experiences. All tastings include a tour of the winery with your choice of the type of wines you would like to taste.

The exciting part is the tasting area. Outside, under their modern covered patio, or under the sky, all with a spectacular view of the valley and their beautiful lake (photos above and left page).

• **Sensory Tasting.** Sommelier-led, blind tasting, discovering how the aromas of wine evolve in the glass, in your nose, and on your palate.

• **Wine & Chocolate Experience.** Artisan chocolates from Ecuador, Madagascar, México, and Tanzania.

• **The Honey Experience.** Discover the unique flavors of honey from mesquite, raspberry, orange blossom and avocado, paired with their wines.

• **MX Experience.** Learn and celebrate the history of Monte Xanic in an exclusive and private tasting area.

• **Premium Experience.** A premium wine-flight experience in their exclusive and private tasting area with a cheeseboard included.

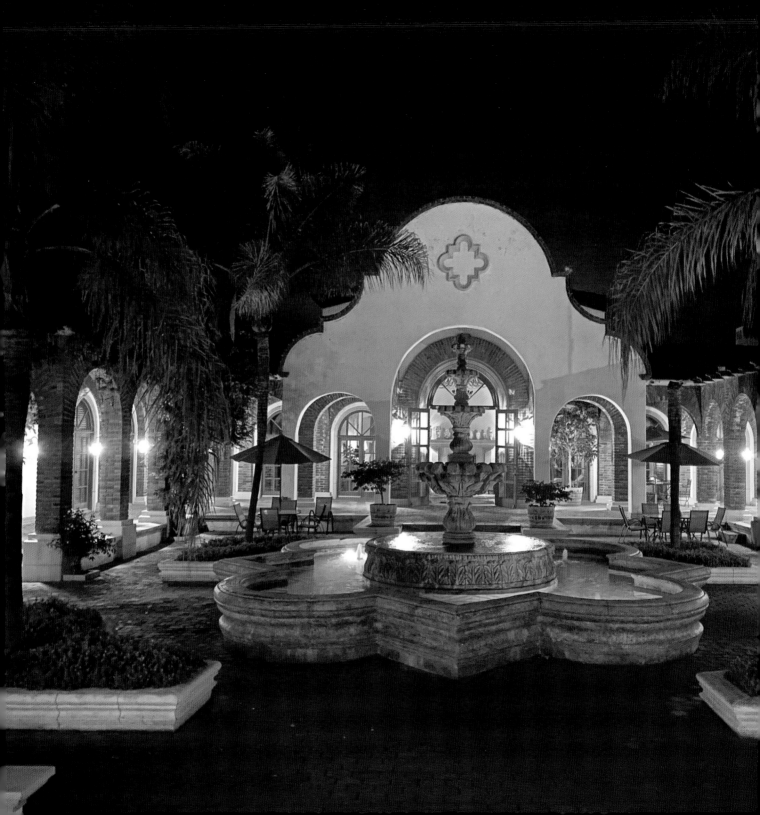

AN AUTHENTIC HACIENDA - VINEYARD & INN

I just love the authentic-style Mexican hacienda. Buildings surround a courtyard of beautiful patios and fountains in the center. The Adobe de Guadalupe courtyard has a magnificent fountain and the lighting is ever so beautiful at night (photo left page). This hacienda also has the traditional thick adobe walls finished with white stucco.

In the surrounding buildings, there are glorious hallways (photo below) that really make you feel like a noble guest and allow you to relax in understated elegance. The six rooms have no televisions and no phones. This is a place to get away and feel very comfortable.

The staff are very warm and caring people who will take very good care of you. They cook homemade meals. Full homemade breakfasts and tasting of their wines are both included for guests. They have two restaurants (see next page), one of which is a very elegant dining room inside the hacienda for an extra special experience of the hacienda.

The hacienda is surrounded by vineyards for their wines (photo upper right). They have a super elegant living room, a marble fireplace and an extensive library for you to enjoy and make your stay special.

BAJA **VALLE DE GUADALUPE** NO CENTRAL
Winery, Vineyards, Restaurant, Lodging
ADOBE DE GUADALUPE

$$$

Located: Central Valley, North
Parcela A-1 S/N, Ejido El Porvenir
22750 Valle de Guadalupe, Baja California

+52 646 155 2094
Reservaciones@AdobeGuadalupe.com

AdobeGuadalupe.com

Open: All Year, Every Day
Office Open: 8am-5pm

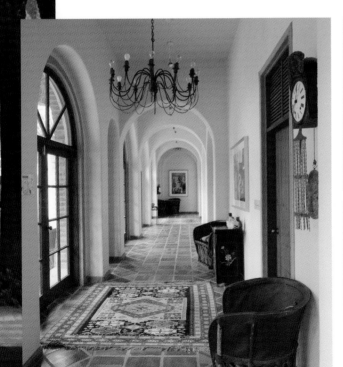

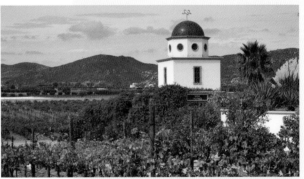

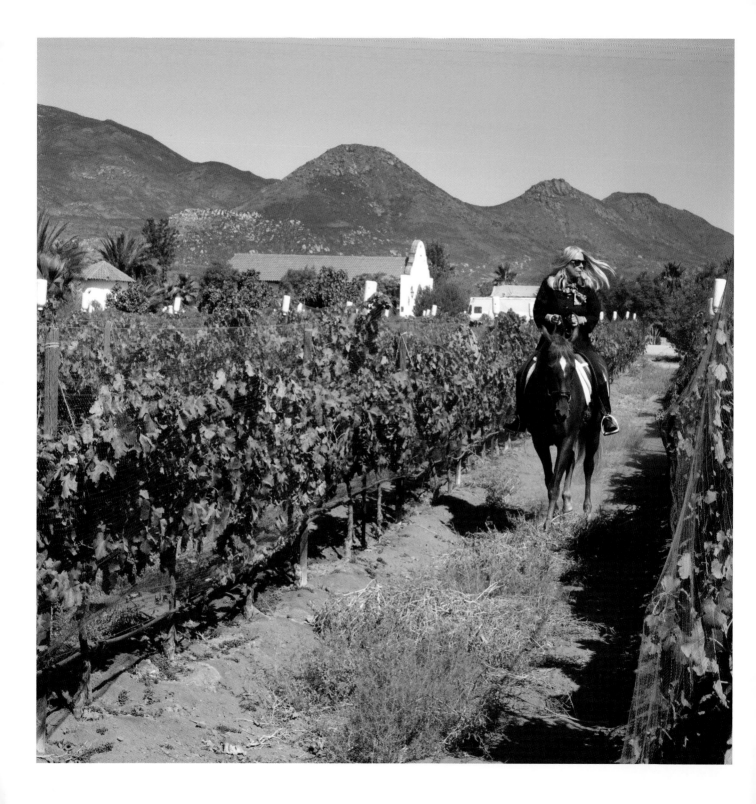

HORSEBACK RIDING

Horseback riding through vineyards is one of the greatest pleasures and such a wonderful way to view a winery's property. Adobe de Guadalupe has a large horse stable and arena and will take you horseback riding to see their property and beyond.

Just visiting their beautiful hacienda stable and seeing their quality horses are a treat. A real love for horses here; you can see their great attributes in their eyes, coat and personalities.

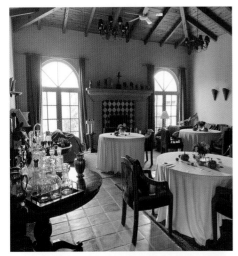

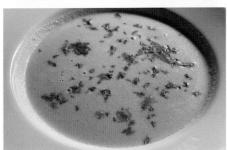

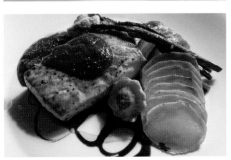

WINE TASTING & RESTAURANTS

This is a very beautiful place to visit, even if you are not staying the night. Enjoy a glass of wine in their courtyard or inside their library. Relax for the afternoon. Or plan a tour of their winery and cellar. And, of course, do a wine tasting.

The Elegant Dining Room

Inside the hacienda is an elegant dining room to enjoy luxurious lunches and dinners (photos left column). This is a preorganized dining experience, where they will create a wonderful experience for you and other guests in their beautiful dining room.

The room is dimly lit with the glamorous ambiance of flickering candles, linen tablecloths, sparkling crystal, silverware and fine china to welcome you to a special time. Dinner is a five-course experience paired with rare vintages from their cellar. This is a must-do dining experience whether you are staying at the hacienda or not.

The creative gourmet dishes will speak.

Scallop Chowder (photo left) in sautéed mirepoix, white wine (Adobe de Guadalupe Chardonnay), fish broth, and a mix of cream cheese, parmesan and mozzarella.

Seabass (photo below left) is fresh caught that morning, cooked in butter and black pepper, added sweetness of a fig sauce (harvested from the fruit trees at Adobe de Guadalupe). Sliced baked potatoes, asparagus and yellow stall squash.

Adobe Foodtruck

Before you enter the hacienda property (it is gated and guarded twenty-four hours), there is a foodtruck restaurant called Cuervo ("raven" in Spanish). Yummy tapas are their specialty. It is not just a foodtruck, there are nice outdoor and indoor dining areas (photo below). The truck is just for the tapas. Adobe Guadalupe wines are served as well.

BAJA **VALLE DE GUADALUPE** NO CENTRAL ■
Winery, Vineyards, Restaurant, Lodging
ADOBE DE GUADALUPE

Winemaker: Chile
$-$$-$$$

Adobe Guadalupe Winetasting
+52 646 155 2093
Degustacion@AdobeGuadalupe.com
Open: Every Day, 10am-5pm.

The Dining Room at Adobe Guadalupe
+52 646 155 2094
Reservaciones@AdobeGuadalupe.com
Open: Every Day, Advanced Reservations Only
Lunch 12pm-1:30pm and Dinner 7pm.

Adobe Foodtruck
+52 646 117 0627 • AdobeFoodtruck@gmail.com
Open: Monday-Thursday, 2pm-8pm

AdobeGuadalupe.com

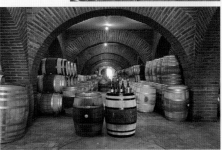

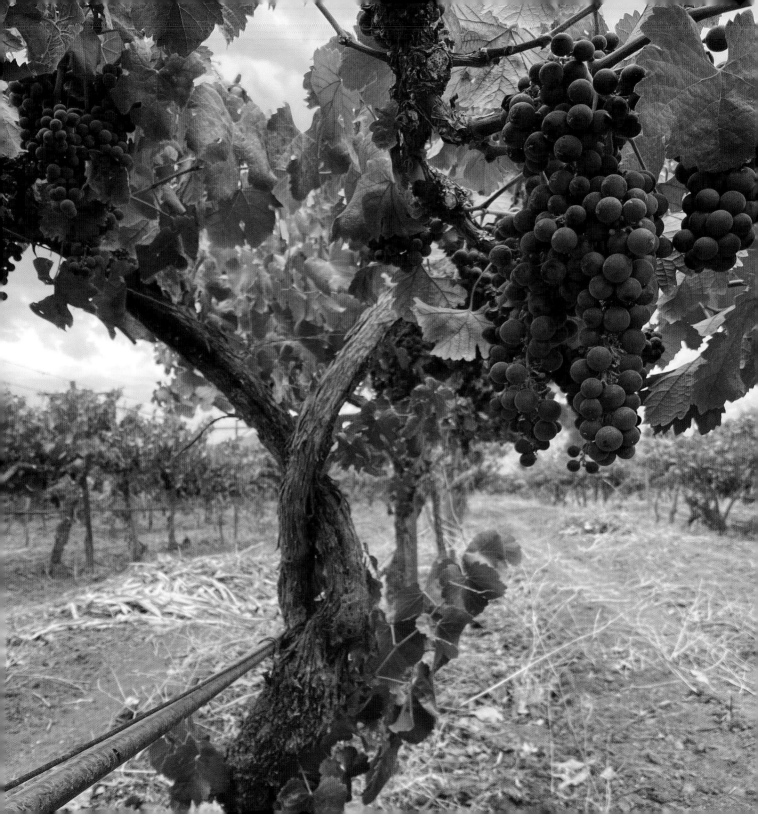

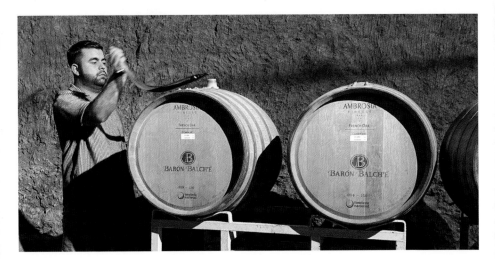

Winemaker: México

$-$$-$$$-$$$$

Located: Central Valley, Northeast
39X8+M8, Ejido El Porvenir
22750 Valle de Guadalupe, Baja California

+52 646 688 1032
Reservaciones@BaronBalche.com.mx

BaronBalche.com

Open: Every Day, 10am-7pm

C ome into the cave and smell the flavors of the wine in the moist soil here.　　　　– Juan Arturo Ríos

BIG RICH WINES

The wines here are very big, bold and flavorful. If you like big wines like this, you will be at home here as your favorite place.

It all started in 1997 when Juan Ríos (current owner) decided to restore his family's nineteenth century ranch, including thirty-two hectares of abandoned vineyards with vines now eighty to eighty-five years old. Juan resuscitated those vineyards (photo left page of Tempranillo vines/grapes) and started making wine in 2001 for himself, family and friends.

Everyone loved his amateur wine, so he realized it was because he had exceptionally great vines. Juan enlisted experts to help create a commercial winery. And the rest is history; Barón Balch'é was born.

Barón Balch'é pays tribute to the Mayan culture, as "balché" is the name of a tree whose fruits were fermented by the Mayan people to be served to high-officials in their culture. And "baron" being this noble title of honor.

The Barón Balch'é premium wines are named from the Mayan numerical symbols (photo right column). In addition to hundred-year-old vines, these premium level wines are aged for forty-eight months in new French oak barrels and then aged

another forty-eight months in bottles before they are released. When I was there, I was drinking (loving) a twelve-year-old Grenache, which was their current release in the premium line.

Experiences here are great. They have **six different wine tasting packages**: white wines, red wines, young wines, premium wines, all premium wines, etc. Something for everyone.

A special part of the experience here is the tour of the winery. All wine tasting experiences include a **guided tour of the winery**, including an underground tour of their tank room, barrel aging room, and into the underground caves. They also have **wagon tours** through their vineyards (Saturday and Sundays only).

The **cave experience** is amazing, as it's a naturally dug cavern with the original soil for its walls. You really can smell the flavors of the wine in the moist soil here. Above is Juan Arturo Ríos Somera, sharing some of his special wines from the barrels. You can see the natural clay walls behind the barrels.

The winery shop has more than just their wines. They have a full deli where you can eat snacks while you are wine-tasting, purchasing olive oil and other wine related items and souvenirs.

In the summer, they throw huge concerts in the vast area behind the winery.

Collection of Wines

Premium Wines
Balché Cero Premium (Nebbiolo)
Balché Uno Premium (Grenache)
Balché Dos Premium (Cabernet Sauvignon)
Balché Tres Premium (Merlot)
Balché Seis Premium (Tempranillo)
Balché Siete Premium (Zinfandel)
Balché Dos Mil Doce Premium (Syrah)
Balché Cien Premium (Petit Sirah, Malbec, Nebbiolo)
Dulche Premium (Grenache, Rubired)

Medium Line Wines
Reserva Especial (Cabernet Franc, Merlot, Syrah), Tempranillo/Cabernet, Zinfandel, Auro (Chardonnay), Spiral (Sauvignon Blanc)

Youth Line Wines
Mezcla de Tinto (Malbec, Cabernet Sauvignon, Grenache, Carignan), Siis Clarette (Tempranillo, Grenache, Semillon Blanc), Double Blanc (Sauvignon Blanc, Palomino, Viognier)

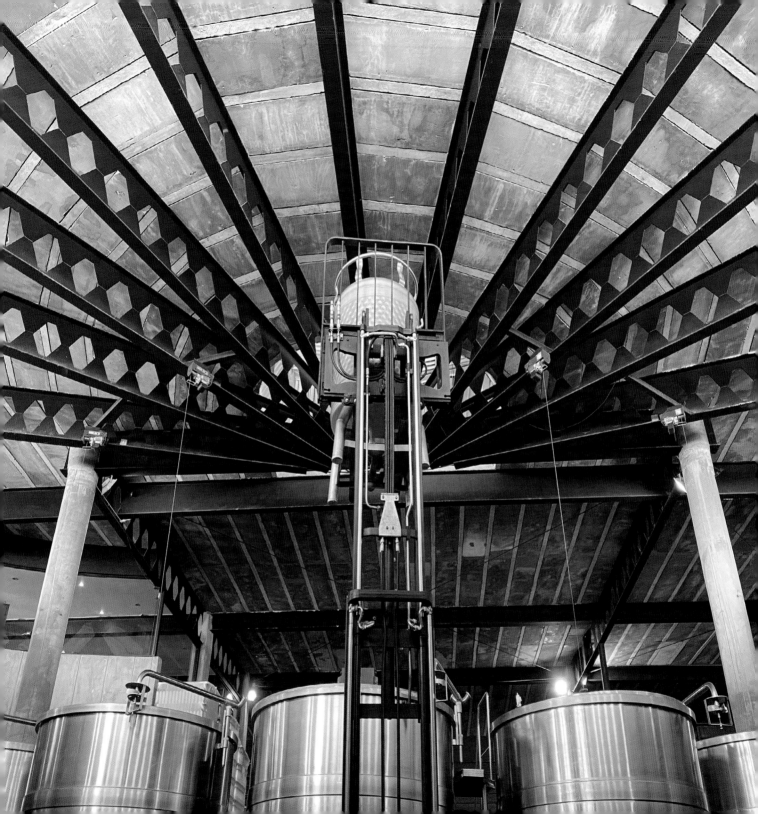

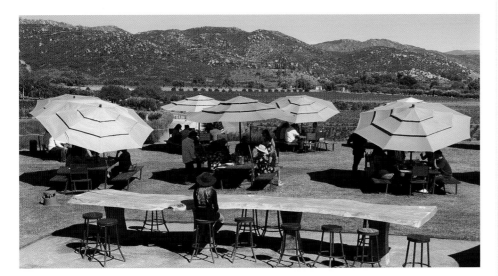

Way too much fun, all in one place!

PARTY TIME, GRAVITY STYLE

This place is more fun than you can possibly imagine for a winery. Enter this ultra-modern winery through its extensive gift shop and into a long corridor of tables and windows (photo right) with a balcony across the entire building for outside seating. Below is a massive grass park with picnic tables, umbrellas, and awesome views over the vineyards and across the valley (photo above). Complete wine and food service is available in all settings.

Imagine this. They receive 20,000 people monthly at the winery. It is a super-fun, lively environment. They have fifty-nine different wines and everything is available by the glass. In fact, they only sell their wines at the winery. I only listed their most common wines to the right; however, they have so many unusual wines to experience.

The winemaker is always experimenting and you never know what exciting new wine he is offering. When I had lunch with him, he opened **Decantos Misión**, made from the original Mission grapes planted by the missionaries when they established the California missions. It was seriously delicious. You would not believe it. I am surprised we do not see more Mission grape wines; it was so good. My favorite overall was his Mourvèdre, so smooth, elegant, fruity!

Speaking of the winemaker, Alonso Granados is the owner, winemaker and designer of this most unusual winery (photo left page). It is designed and built into the side of a hill, totally gravity-flow, and is beyond what you must already be thinking. I have seen some very innovative gravity-flow wineries; however, Alonso takes this concept to the ultimate level. So much so that he has fourteen different patents on his concepts that he puts to use in making his extraordinary wines.

Not just absent of all pumps, Alonso has invented unique equipment and new types of fittings that facilitate this process. As he sees it, he is decanting the wine from grapes to bottle, hence the winery name: Decantos. You must request a tour to see this amazing operation. Then you will know firsthand why the wines here are so delicious.

BAJA **VALLE DE GUADELUPE** NO CENTRAL ■
Winery, Vineyards, Restaurant
DECANTOS VINÍCOLA

Winemaker: Trained In La Rioja, Spain
$-$$-$$$

Located: Central Valley, North
Rancho San Miguel Fraccion A, Ejido El Porvenir
22755 Valle de Guadalupe, Baja California

+52 646 688 1019
Ventas@DecantosVinicola.com

DecantosVinicola.com/en

Lunch, Tastings & Tours
Open: Every Day, 11am-7pm

Collection of Wines

Premium Wines
Línea Premium (Nebbiolo, Syrah, Tempranillo)

Grand Reserve Wines
Carignan, Amarone (Dehydration Method of Barbera)

Reserve Wines
Cabernet Sauvignon, Cabernet Franc, Merlot, Malbec, Syrah, Nebbiolo, Mourvèdre, Tempranillo,

Blended Wines
Coupage Tinto (Nebbiolo, Tempranillo)
Coupage Blanco (Sauvignon Blanc, Chardonnay)

Young Wines
Maceración Carbónica (Carbonic Maceration of Tempranillo)
Carignan Rosé, Sauvignon Blanc, Chardonnay

Sparkling Wines
Burbuja Tinta (Sweet Sparkling Brut Natural)
Burbuja Rosa (Sparkling Mission Grape, Brut Natural)
Burbuja Blanca (Sparkling Chardonnay, Brut Natural)

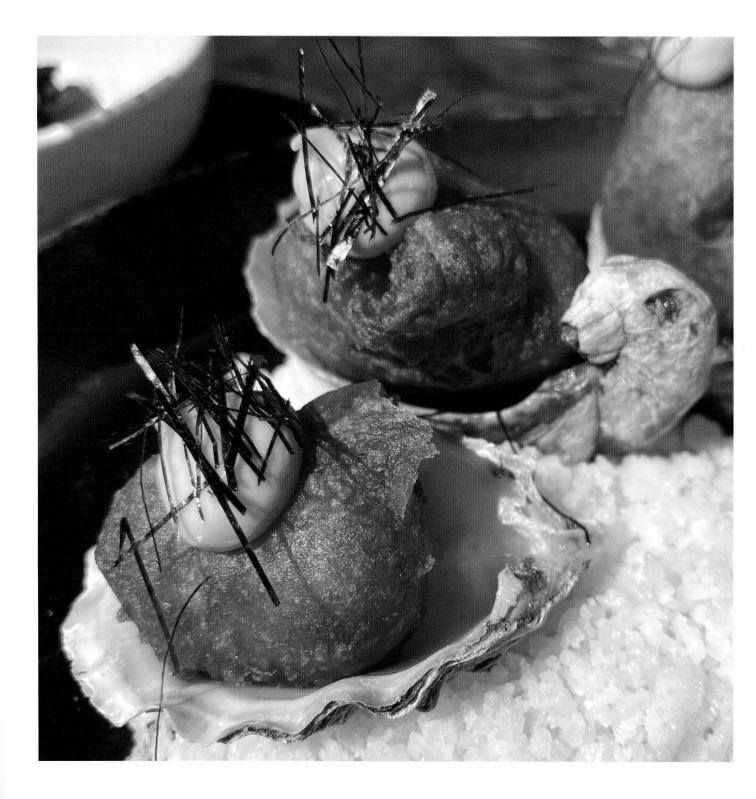

THE TASTY FOOD AND YUMMY WINES ARE FLOWING

To have this much fun at a winery, there must be an abundance of food to go with all this wine. Their chef is always creating new and interesting dishes here. Just look around these pages and see the diversity and yumminess of the cuisine. In addition to their indoor kitchen, they have an outdoor barbeque, similar to an Argentine parrilla, cooking with real wood embers. It is next to their large grass park, so you can smell the deliciousness. Into cocktails? Their bartenders make a large array of cocktails from their wines.

Fried Tempura Oysters (photo left page) from locally sourced oysters from Bahía Falsa, served with Meyer lemon Ponzu sauce, emulsion made of the same oysters, and thinly cut toasted nori seaweed sprinkled on top. If you prefer oysters cooked, this is a special treat.

Fresh Oysters (photo below left) in their shells with Mexican Serrano chili and Meyer lemon Kosho, chopped shallots, and white wine vinegar mignonette finished with olive oil sourced from the winery ranch. (Kosho is a paste originally made in Japan from Yuzu citrus peels and green chilis. Here at Decantos, the chef changes those two ingredients to Meyer lemon and Mexican Serrano chilis.) Lots of details make these raw oysters so tasty.

Panko-Breaded Shrimp (photo below center) with Wakame seaweed aïoli and local red Shisho leaves (a perilla herb commonly used in Japan with a fruity taste and aroma reminiscent of sweet mint). Such a flavorful way to eat shrimp.

Yellowtail Fish Tartar (photo below right) massaged with amberjack tartar, katsuobushi aïoli, fried capers, and locally sourced Daikon radish. This is a really unique way to enjoy raw yellowtail.

Bacon Shrimp Pizza (photo right) with fresh shrimp on a flatbread pizza, with locally sourced tomatoes, a house-made sauce, Manchego style cheese from Mexicali Valley, green scallions, and chives. This will enhance your opinion of just how good a pizza can taste.

$-$$-$$$

+52 646 688 1019
Ventas@DecantosVinicola.com

DecantosVinicola.com/en

The Decantos Restaurant Is inside the Winery
Food, Cocktails and Wine Service
Available inside, on the Balcony, and in the Park

Open: Every Day, 11am-7pm

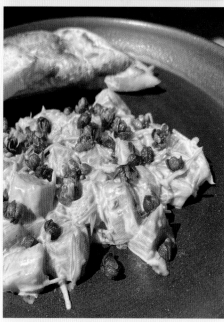

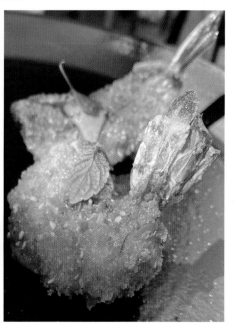

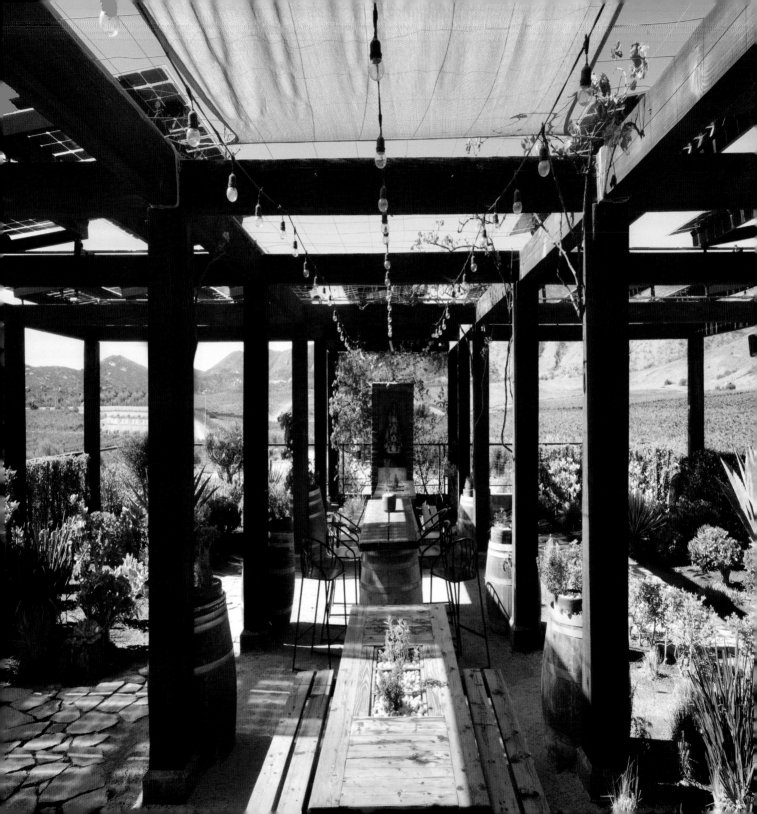

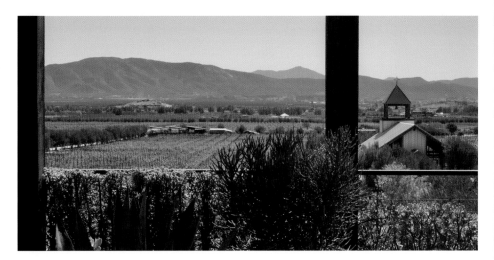

BAJA **VALLE DE GUADELUPE** NO CENTRAL
Winery, Vineyards, Cuisine
FINCA LA CARRODILLA

Winemaker: UC Davis, California
$$-$$$

Located: Central Valley, North
Parcela 99 Z1 P14, Ejido El Porvenir
22755 Valle de Guadalupe, Baja California

+52 646 156 8060
PRLaCarrodilla@gmail.com

FincaLaCarrodilla.mx

Tastings & Tours, RSVP Only
Open: Wednesday-Sunday, 10am-5pm

F irst certified organic vineyards in México, plus biodynamic farming and a UC Davis oenologist.

BEAUTIFUL PROPERTY

After two weeks visiting wineries in Valle de Guadalupe, I was so happy to complete this journey at Finca La Carrodilla. I was on a mission, as you read in the beginning, to figure out what was causing the distasteful rotten flavor found in wines in this valley, so I will be able to point you in the right direction of good wines. I had many theories. And when I saw this winery's cement floors being steam-cleaned to perfection, I realized it was the cleanliness that truly made the difference. All of the wines here, both reds and whites, were tasting beautifully.

From this beautiful farm comes these beautiful wines. The farm is also alive with animals: cows, goats, horses, chickens, dogs, cats, and bees. Plus an extensive vegetable garden, and of course vineyards. This is a new endeavor of the Perez Castro family, owners of the Lunario restaurant (page 79), which derives many of its ingredients from this farm.

The obsession here with sustainable farming has led Finca La Carrodilla to becoming México's first certified organic vineyards and to use certified biodynamic farming. There are beautiful gardens surrounding the winery and a roof-top garden (photo left page); both are special spots for wine tastings.

Their winemaker since 2015 is Gustavo González, a chemist from UC Berkley with a Master's of Oenology from UC Davis, California. Most notable is his seventeen years working for Robert Mondavi, as a lab technician rising to head winemaker. He was responsible for the Robert Mondavi Reserve Cabernet regularly receiving 95+ point scores.

Their flagship wine here is Canto de Luna (The Moon Song), a blend of Cabernet Sauvignon, Tempranillo and Syrah, that is imported to the USA. My favorite is their 100 percent Tempranillo. It is their best fruit, in my opinion, especially the delicious strawberries on the nose and cranberries in the mouth. This wine won the 2017 Grand Gold Winner at the Bacchus de Oro competition, motivating the president of México to visit the winery.

Tasting here includes fresh cheeses made from their cows and goats, freshly baked bread, and home-made jams from the fruits of their gardens.

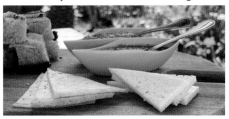

Collection of Wines

Canto de Luna (Cabernet Sauvignon, Tempranillo, Syrah)
Así Se Va a Las Estrellas (Bordeaux Blend of: Merlot, Cabernet Sauvignon, Cabernet Franc)

Carrodilla Tempranillo
Carrodilla Cabernet Sauvignon
Carrodilla Syrah

Carrodilla Chenin Blanc (Rosé of Carménère)

ALL-VILLAS HOTEL ON BEAUTIFUL LAKES

This is the most high-end, luxurious modern property I found in this entire area. Nothing compares with it. It is a large hotel of ninety-four rooms; however, it does not look like a hotel, as this is a group of villas surrounding two lakes and vineyards. It was newly built in 2019 on 121 acres against the rolling hills of the Guadalupe valley inside their vineyards.

Each villa building you see in the photos represents three suites. Upstairs has two large junior suites. Downstairs has the master suite occupying the entire ground level of the villa. A full 1,052 sq' with a full kitchen, living (photo below) and dining room. The bedrooms are beautiful and spacious (photo below right). The bathrooms are excellent; generous with two sinks and a whirlpool tub. This place is romantic, luxurious and ever so comfortable.

Outdoors, you have a large private patio terrace with a gas fireplace overlooking one of the lakes or vineyards. This is a beautiful place to walk around and enjoy the property and its natural scenery. Visit their chapel overlooking one of the lakes.

The hotel has its own restaurant, Polarus, away from the active winery and its busy Latitud 32 restaurant (next page). Restaurant Polarus is a modern local Baja restaurant for both breakfast and dinner. The Lamb Benedict was so delicious with poached eggs, hollandaise sauce, English muffin and burnt braised lamb (photo upper right).

BAJA **VALLE DE GUADALUPE** NO CENTRAL
Winery, Vineyards, Restaurant, Lodging
EL CIELO RESORT

$$$$-$$$$$

Located: Central Valley, North
Carretera Guadalupe El Tigre KM 7.5
22755 Valle de Guadalupe, Baja California

+52 646 978 0011
Reservaciones@ElCieloWineryResort.com

ElCieloWineryResort.com

Open: All Year, Every Day

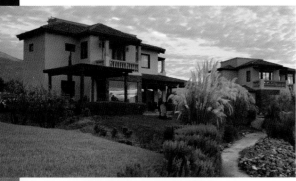

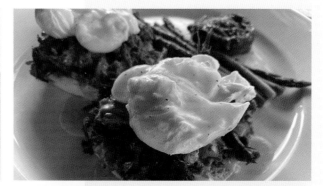

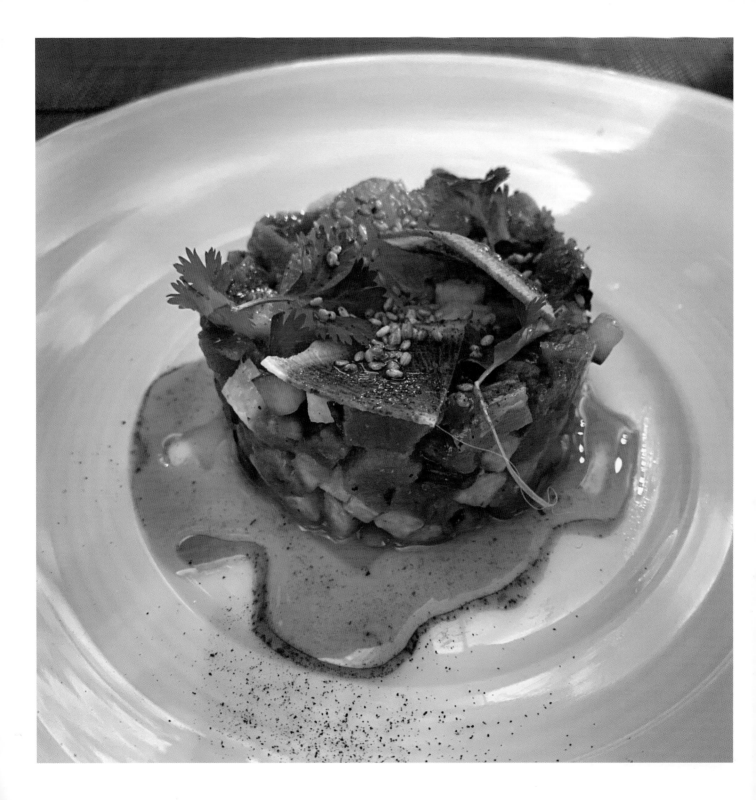

LATITUD 32 RESTAURANT

Inside the El Cielo Winery is this delicious restaurant fusing Baja- and Yucatán-style ingredients. Indoor and spacious outdoor dining with views across the vineyards (photos below).

Local Yellowtail Sashimi Stack (photo left page) is diced into small cubes, served with avocado, chives and sliced radish, mixed with a yummy miso and soy sauce, and served on top of sesame oil, citrus and coriander.

Pibil Duck Salbute (photo below) is a Mayan Yucatán traditional style slow-roasted duck in a pibil (cooking pit) served on top of a puffy masa tortilla.

Pork Belly Taco (photo bottom) is lightly braised with chilmole (a south Mexican Mayan black sauce), radish, coriander, guacamole and grilled lemon. All so delicious!

WINERY EXPERIENCES

This is a big property with a spacious winery and lots of open space to enjoy El Cielo. They have an extensive wine shop and boutique (photo below), and joining the wine club first improves your experience here, especially enjoying the luxury living-room-style Wine Club Lounge with sommelier service (photo below right).

El Cielo offers an abundance of experiences and tours to enjoy.

• **A Day in the Sky**. This is a full day experience, starting with breakfast, then explore the entire El Cielo property with lots of fun and education, and sommelier walk in vineyards (meet their vine guardian up close, a gorgeous hawk), in the winery and underground cellar (tasting from barrels). Take a golf cart for a self-guided tour of the vineyards. Lunch is a four-course pairing meal with their wines on the terrace. Finish with a wine tasting with chocolates in their exclusive Wine Club Lounge.

• **The Sky 360**. A golf cart tour with a sommelier of the vineyards, winery and underground cellar (tank and barrel tastings), while sipping lots of great wines along the way. Finish with an excellent pairing of exquisite cheeses in the exclusive Wine Club Lounge.

• **Make Your Own Wine**. Blend your own wine with advice of their sommeliers and winemaking team. Plus, tours of the vineyards, winery, cellar, wine tasting, and make a custom label for your bottle to take home.

• **Wagon Vineyard Tour**. Enjoy the outdoors in their large wood-boarded wagon, exploring the vineyards and enjoying sipping different wines.

• **Different Tastings**. Star Tasting, Constellation Tasting, Terrace Tasting, Chocolate Pairing Tasting, Cheese Pairing Tasting. And more.

• **Rentals**. Golf carts. Scooters. Bicycles.

BAJA **VALLE DE GUADALUPE** NO CENTRAL
Winery, Vineyards, Restaurant, Lodging
EL CIELO RESORT

Winemaker: México
$-$$-$$$

El Cielo Winetasting
+52 646 151 6516
Mercadotecnia@VinoElCielo.com
Open: Every Day, 11am-7pm

El Cielo Experiences
+52 646 151 6516
Mercadotecnia@VinoElCielo.com
Open: Every Day, 11am-7pm

Latitud 32
+52 646 978 0012
AYB@ElCieloWineryResort.com
Breakfast, Thursday-Sunday, 8am-11:30am
Lunch and Dinner, Every Day, 12pm-8pm

ElCieloWineryResort.com

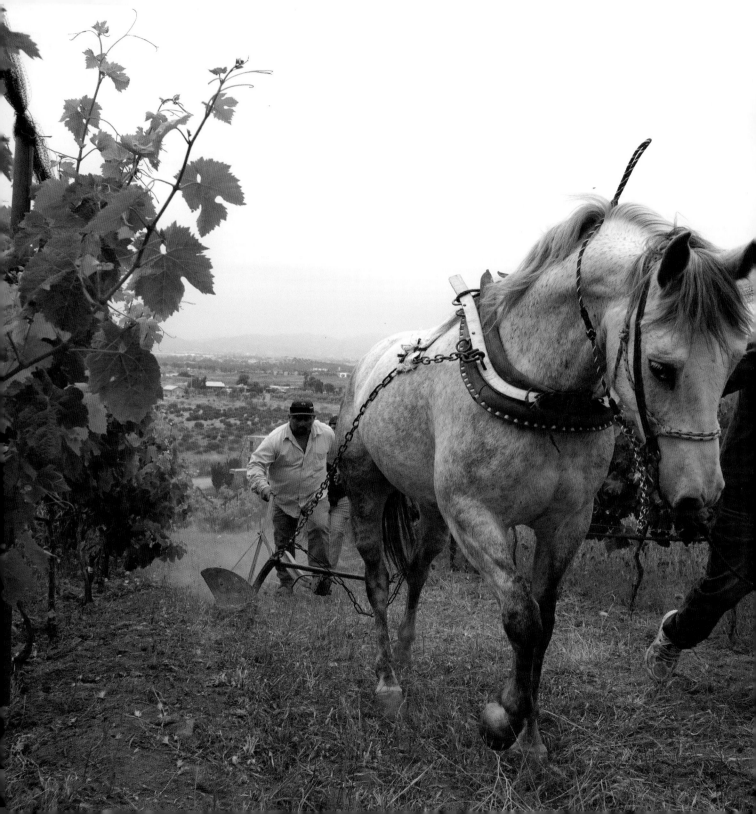

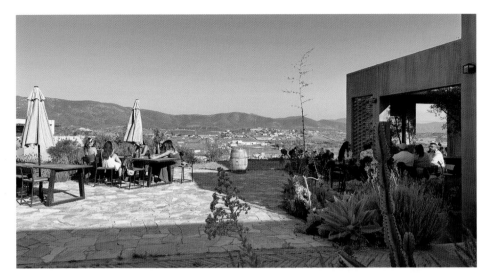

Winemaker: Bordeaux, France
$$-$$$

Located: Central Valley
Camino Vecinal, Parcela 182 Ejido El Porvenir
22755 Valle de Guadalupe, Baja California

+52 646 162 7265
SierraVitaMX@outlook.com

SierraVita.com

Open: All Year, Thursday-Saturday, 1pm-7pm (Sun 5pm)

A property of exceptional health with spectacular views of the valley.

WHITE MISSION GRAPE

This is a special property. It is farmed with deep respect for the balance of nature. This goes well beyond no pesticides and organic farming. Sierra Vita calls it "symbiotic viticulture," a focus on the care of the vineyards through love and respect for the land.

Great wines require excellent grapes. This means the vineyard must be at its optimum health to birth excellence in its grapes. This winery and its vineyards are the inspiration of Dr. Arnulfo Vazquez, a dental surgeon and third-generation of farmers. Dr. Vazquez brings a unique perspective on health and science to viticulture and maintains an agronomist (an engineer in soil management and crop production) on his team to care for the health of the vineyards.

They maintain a stable of horses and use traditional horse-drawn plowing to reduce the use of tractors (photo left page). Tractors compact the soil they are trying to till and bring exhaust into the vineyards. All considerations are for the health of the vines. No tractors for harvest either. Harvest is done by hand, and winemaking continues the handmade process.

After harvest, they seek a correction-free process in the winery to obtain an honest representation of the terroir and the highest quality of wines. And in tasting through their wines, each one of them has the quality to love.

Sierra Vita (meaning "mountain range" and "life" in Spanish) is on top of a hill in the middle of Valle de Guadalupe with 360° views of the valley (photo above). I do not know of any other wineries here that have 360 views. Imagine the sunsets here, while enjoying a glass of their delicious wine.

Are you familiar with the Mission grape? It was brought to North America by the Spanish missionaries five-hundred years ago and cultivated around the missions. Once in a while you may see a Mission wine, and it can be quite delicious. At Sierra Vita, I was introduced to the White Mission grape. I did not know it existed. Sierra Vita makes a wine called *Gran Canario*, 100 percent of this White Mission grape (photo right). Look at its beautiful golden color. The flavors are refreshing in its rich profile.

A few days later, an international blind tasting competition awarded *Gran Canario* the gold medal of white wines. Impressive, and worth your attention.

Next page is the winery's restaurant, **Once Pueblos**, where you can do food and wine pairing experiences with gourmet cuisine.

Collection of Wines

Premium Wines
Sierra Monarca (Merlot, Cabernet Sauvignon, Cabernet Franc)
Inzio (Cabernet Sauvignon, Tempranillo, Syrah, Merlot)
SierraVita Merlot
Sierra Negra (Malbec)
Sierra Real (Cabernet Franc)
Sierra Inyaa (Syrah)
SierravVita Rosé 9 (Syrah, Grenache, Nebbiolo, Malbec)

Gran Canario (Missión White/Palomino)
SierraVita Chenin Blanc
Chenin Blanc Crianza

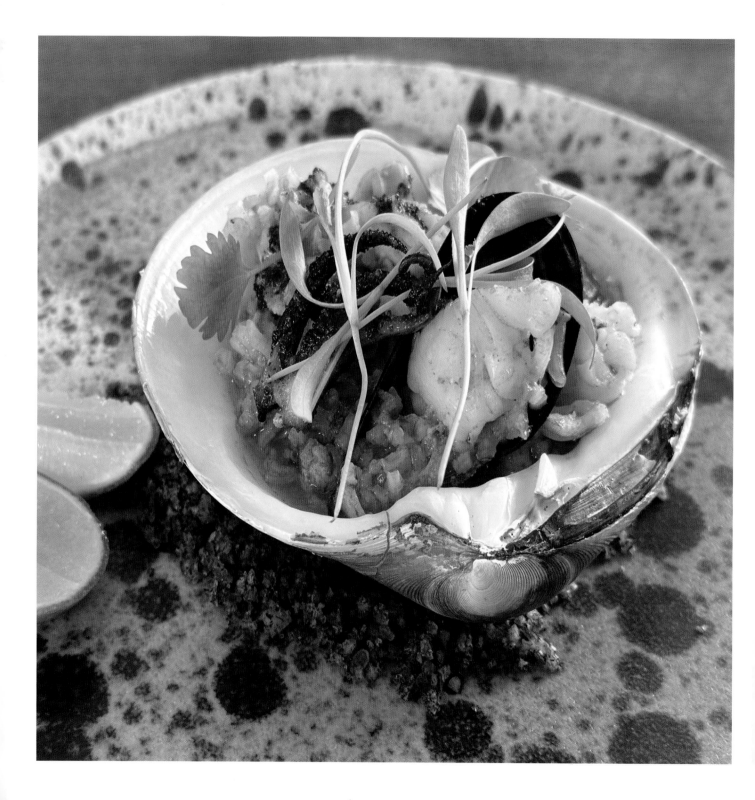

EXCEPTIONAL FOOD AND WINE PAIRINGS AT SIERRA VITA WINERY

What comes with excellent wines at Sierra Vita winery is exceptionally great food at their gourmet restaurant Once Pueblos. Now this is the way to do an exceptional food and wine pairing.

Once Pueblos is a region on the Purepecha Plateau of the Michoacán state known as *the ravine of eleven towns* (in Eraxaman native language). It is known for its exquisite gastronomy by women with wood-fire stoves and metate stones as their culinary tools. The unique ingredients of these towns are enhanced with a sense of elegance and style as Once Pueblos showcases this relatively undiscovered part of México.

Here is a little taste of their Purepecha Plateau cuisine...

Arroz a La Tumbada (photo left page) is a Mexican style rice in tomato stew with seafood. Dish originally from Veracruz, a port of important witnesses to culinary crossbreeding in México, this rice has a notorious Spanish influence with a Mexican personality.

Pasilla Pepper (photo top left) is filled with white corn (esquites) and goat cheese. The natural sweetness of the pasilla pepper brings perfect balance between crispy white corn grains and creamy goat cheese.

Duck Piloncillo (photo bottom left) is made from a mixture of smoked peppers with a final touch of piloncillo (unrefined pure cane sugar) as a sweet sauce to perfectly balance out the strong duck flavor.

Gaznate Zamorano (photo top right) is a proud example of their Chef Sandra Vazquez's commitment to rescue the long forgotten recipes typical and unique to her hometown Zamora, Michoacán. This is a delicious dessert made from freshly fried bread that is both crunchy and fluffy and served with homemade cajeta (a syrup made from a mixture of burnt whole milk and sugar).

Creamy Avocado Ice Cream (photo bottom right) is a tribute to the land of avocados: Michoacán.

$$$-$$$$

Located: Central Valley
Camino Vecinal, Parcela 182 Ejido El Porvenir
22755 Valle de Guadalupe, Baja California

+52 646 162 7265
OncePueblosMX@gmail.com

OncePueblos.com

Open: All Year, Thursday-Saturday, 1pm-7pm (Sun 5pm)

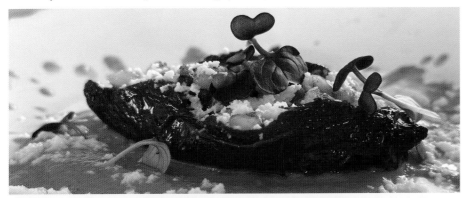

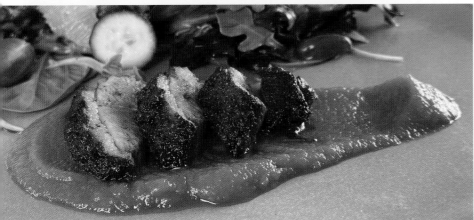

YOUNG TALENTED FUTURE OF GASTRONOMY IN GUADALUPE

This is one of the best restaurants you will experience in the Valle de Guadalupe. Chef Sheyla Alvarado is young, creatively talented with a gastronomy degree from the Universidad Autónoma de Baja California. Her style is locally fresh. She uses an abundance of seafood from the Pacific Ocean a few minutes away. All her vegetables, dairy and some of the protein come from the Finca La Carrodilla winery farm in the valley with the same ownership. Everything is organic and grown just for this restaurant. The results speak for themselves as you see in the photographs on this spread (and more photographs on the page 29 spread).

The restaurant is directly across a small dirt road from the **La Lomita winery**. Also, under the same ownership. I was fortunate to meet the owner of these two wineries and restaurant, Fernando Perez, as one of the initial people I met after I arrived in Valle de Guadalupe. Fernando was inspiring, pointing me to excellent cuisine you will find in this book. Two weeks later, we had dinner at Lunario to catch up on my journey. He shared with me that a big challenge for winery owners now is that the cuisine in this valley has become so extraordinary that it is inspiring them to create wines of the same stellar level.

Now for the extraordinary cuisine.

Kumiai Oyster, Spicy Mustard Vinaigrette (photo left) is an amuse-bouche of cold-smoked Kumiai oyster from Laguna Ojo Liebre with chile de árbol, mustard vinaigrette and the topped with nori seaweed. Divine!

Kampachi Sope with Ginger Confit (photo below) is a delicious arrangement on a blue corn dough (sope) from Tlaxcala, topped with an avocado purée with lime, cilantro, chives and lots of herbs. On top is chopped raw kampachi (yellowtail fish) in a sauce of ginger, sesame seeds, dried chile ancho and lemon. Topped with fresh slices of cucumber, then chopped cactus and cilantro. This dish is filled with flavors.

Watermelon Granita Cream (photo below right) is a semi-frozen dessert of cream infused with lemongrass and vanilla, hidden under a watermelon granita, topped with fresh watermelon chunks and mint leaves from their organic garden. It's a light, fresh way to end the evening.

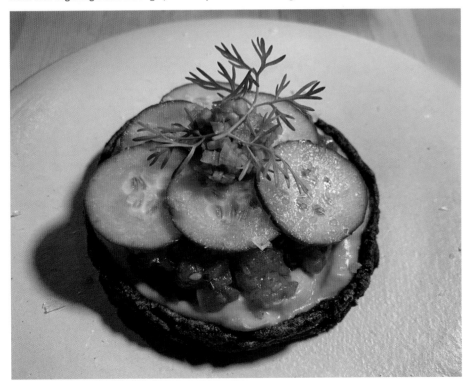

BAJA **VALLE DE GUADALUPE** NO WESTERN
Restaurant
RESTAURANTE LUNARIO

$$$

Located: Western Valley
Camino Vecinal Parcela 71 Fracc. 3 Lote 13 San Marcos
22750 Valle de Guadalupe, Baja California

+52 646 156 8649
ReservacionesLunario@gmail.com

RestauranteLunario.com

Open: All Year, Thursday-Sunday, 2:30pm-9pm

SENSORY EXPERIENCE IN ART AND WINE

This is a magical place, beyond anything you could imagine. I was amazed when I arrived. And the surprises kept coming. This place stimulates all your senses far and wide. The lighting is dramatic and colorful. Sculptures, textures and other art are creatively found everywhere. Different music creates different moods as you wander. Incense is both visually and aromatically stimulating. For the palate senses, there are three restaurants of excellent cuisine, three different brands of wines and a special line of tequilas.

This is an artistic multisensory abode, named after **Frida Kahlo**, one of the most important artists in Mexican history; worldwide, she is regarded as one of the most influential figures in **surrealist paintings**. Frida was married to the notable painter Diego Rivera, while maintaining a vibrant affair with the emotive singer **Cava Chavela**.

Frida would say about Chavela: "I wouldn't hesitate taking off my clothes before this erotic lesbian and called her a gift from heaven."

Cava Chavela - An Exclusive Experience of Passion and Premium Wines
In remembrance of Frida's intense affair with Chavela, a special underground tasting room was created to reflect their passion. To find Cava Chavela, you wander through bushes, following the scent of burning sage to discover a secret door that requires a special knock to open. Inside is a totally black room where you are welcomed to a special ambiance of love. The black drapes are opened and you are in an immersion of dark velvet and good wine, low-light intimacy, soul-rending lyrics singing of nights of love and forgetfulness. This is where you experience their ultimate wine experience (four photos here).

BAJA **VALLE DE GUADALUPE** NO WESTERN ■
Entertainment, Wine Tasting, Restaurants
CASA FRIDA

$$-$$$-$$$$

Located: North Western Valley
Rancho San Marcos S/N, El Porvenir
22755 Valle de Guadalupe, Baja California

+52 646 189 4037
+52 646 286 3895
Reservaciones@CasaFridaValle.com

CasaFridaValle.com

Open: Every Day
Monday-Thursday, 11am-9pm
Friday, 11am-Midnight
Saturday/Sunday, 9am-Midnight

FRIDA THROWS A PARTY!

Climb the stairs to the rooftop party (as you see to the far left) where you will find good-looking people, an expansive bar, unique appetizers, great views and a DJ spinning the music (photo above) for an evening of dancing and fun.

While they have a full bar, including their wines, they also make some fun and deliciously creative cocktails. Try this one: **Carajo Diego!** (photo left): Frida's unique version of the Carajillo; expresso and Licor 43, a secret blend of fruit juices, vanilla, aromatic herbs and spices, topped with bitter chocolate, hazelnut, toasted pepitas, and of course salt.

Everything at Frida is reservable on their website.

FOOD AND WINE, AND ART

Inside the Casa Frida grounds you will enjoy three restaurants, three wine-tasting rooms from three different wineries and two bars with an abundance of paintings, sculptures and creativity at every corner. This wholeheartedly reflects the famous artist's domain. Cheers Frida!

Frida's Lake Deck Oyster Bar
Overlooking the Casa Frida lake is this fresh oyster bar serving a variety of oysters right out of the Pacific Ocean just a few miles away (photo below).

Restaurants: Corazón & D'Petra
Both these restaurants (photo below) serve traditional Mexican cuisine sourced in Baja California. From the ocean and the land, seasoned with Mexican heritage chilies and spices (see more on next page).

Frida Select Tasting Room
The primary tasting room, filled with art and full of colors, has both a large bar and comfortable seating (photos lower right).

Blue Velvet Room
This is a personalized tasting experience in your own private room with devoted staff (page 88).

Casa Chavela
An ultimate wine experience (see previous page).

Secreto Wine Tasting & Gift Shop
A casual tasting of their other labels inside a huge gift shop with very interesting creative items to buy.

Winemakers: México, Italy
$-$$-$$$-$$$$

+52 646 596 6643
Reservaciones@CasaFridaValle.com

CasaFridaValle.com

Collection of Wines

There are three different wines here representing three generations of the family

Petra (Grandmother)
Wines made at her sister's winery Cava Marlot

Irma (Mom)
These wines are presented in Casa Chavela in their ultimate wine experience

Giselle (Daughter)
Wines made by Oenologist Adrián Garcia from their own Valle de Guadalupe vineyards

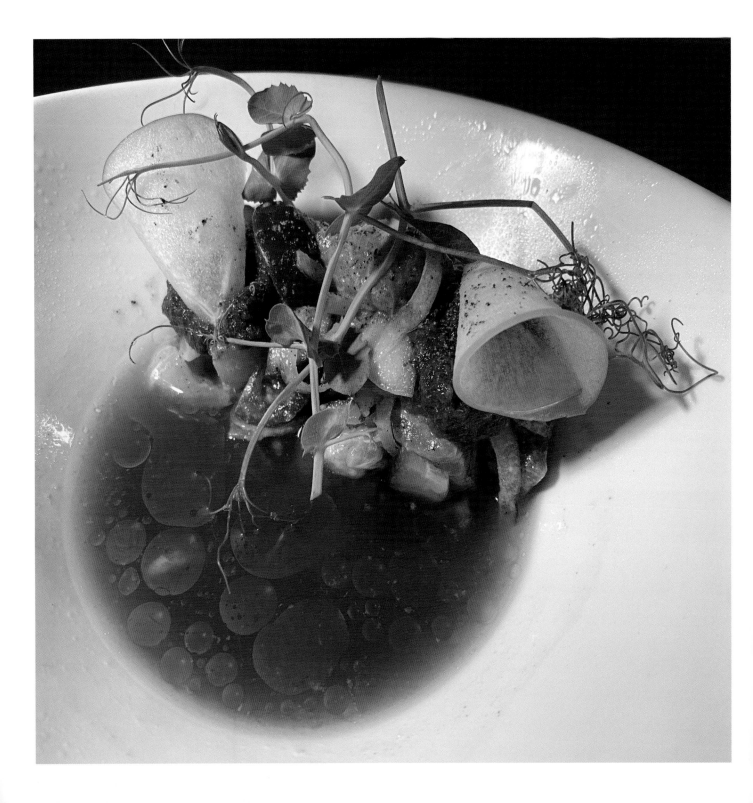

TASTE THE JOURNEY AT CASA FRIDA

Corazón & D'Petra delivers a very creative approach to traditional Mexican cuisine. Their chef, Carlos Esquivel (photo right), has brought lots of color, flavor and creativity to the cuisine here. All of his meats and vegetables come locally from Baja, the fish directly from the Pacific Ocean just a few miles away, and his chilies, spices and seasoning from the southwest of México. As you can see from the photos, he has put a lot of love and passion into his culinary arts here.

Green Ceviche Halibut (photo left page) is raw and fresh from Ensenada Bay, cured and served in a special green juice made from extracting the chlorophyll of various green leaves, principally basil, and adding yellow lemons and green apples to give it its acidity. Plus, farm-fresh cherry tomatoes, basil, cucumber, salicornia, olives and onions. It's outrageously delicious.

Tuna Tiradito (photo below, top left) is a Japanese grade of freshly sliced (tradition) raw bluefin tuna in a ponzu sauce made with a Moroccan technique, with tiny onion rings, jicama, ginger, sesame, cheater, manta and Sapporo greens.

Roasted Quail Mole (photo bottom left) is a perfectly roasted quail (local from the region), on a creole blue corn tetela (a triangular masa casing filled with beans and cheese) and served on a mole sauce.

Corn Mousse (photo below, top center) is not a savory corn, this is a sweet dessert as a result of the chef's four-month challenge to create this iconic dessert of the restaurant that brings surprise and texture with a lemon mousse and dark chocolate crumble. Enjoy the surprise and deliciousness.

French Toast (photo bottom center) is a traditionally French brioche lightly infused with lavender from their garden, cinnamon-coconut sugar, salted caramel, drizzled with dulce de leche and fresh-made whipped cream and honey. A decadent breakfast indulgence.

BAJA **VALLE DE GUADELUPE** NO CENTRAL ■
Restaurants at Casa Frida
CASA FRIDA

$-$$-$$$

Located: North Western Valley
Rancho San Marcos S/N, El Porvenir
22755 Valle de Guadalupe, Baja California

+52 646 596 6643
Reservaciones@CasaFridaValle.com

CasaFridaValle.com

Open: Every Day
Monday-Thursday, 11am-9pm
Friday, 11am-Midnight
Saturday/Sunday, 9am-Midnight

Fresh Oysters and Dirty Martinis (photos below) is perfectly dirty and the oysters are freshly shucked at your table. This is a great afternoon relaxing on Frida's Lake Deck Oyster Bar.

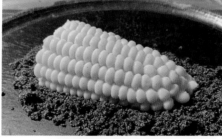

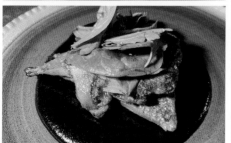

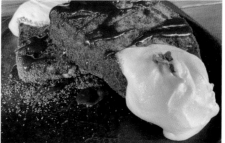

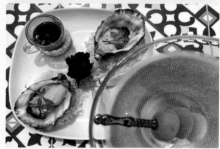

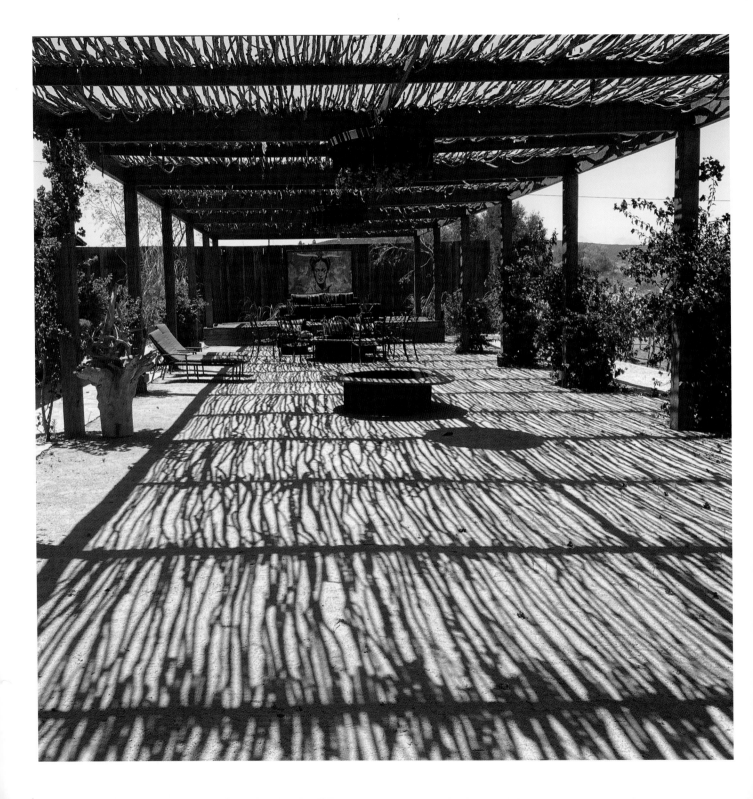

SIX NEW MODERN SUITES

Casa Frida has six brand-new modern lodging suites in different parts of their resort that they rent through Airbnb. Staying on the property puts you close to everything. Drink all you want at their nightclub, for example, and easily mosey back to your room. When you are inside the Casa Frida property, you will feel comfortable with their team of security.

Several unique suites. Studios, one-, two- and three-bedroom suites, with full kitchens. Six different suites are available. Below are photos of the Garden Suite. A beautifully hip, modern-style, as you see in the photos. This suite has a large separate living room, a fully stocked kitchen, and a spacious bedroom with a king bed and open glass shower in the bedroom. And an outside private deck.

Now that you are on the Casa Frida property next to their three unique wine-tasting rooms, three delicious restaurants and an exciting rooftop nightclub; you are amongst the vineyards; and you are in Valle de Guadalupe, close to the numerous other wineries nearby.

$$-$$$-$$$$

Located: North Western Valley
Rancho San Marcos S/N, El Porvenir
22755 Valle de Guadalupe, Baja California

+52 646 596 6643
Reservaciones@CasaFridaValle.com

CasaFridaValle.com

Huitlacoche Omelet (photo top below) is a perfectly prepared omelet with cheese, cream of red beans, a bean salad made with cilantro, serrano chilies, olive oil from the region and huitlacoche (a Mexican corn truffle).

Mimosa Flight (photo below center) starts the day with a mimosa flight. Yes, with sparkling wine and five amazing, fresh-fruit juices: grapefruit, pineapple, berries, watermelon and an original orange mimosa.

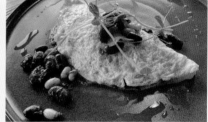

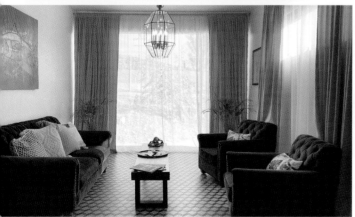

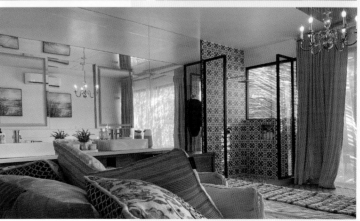

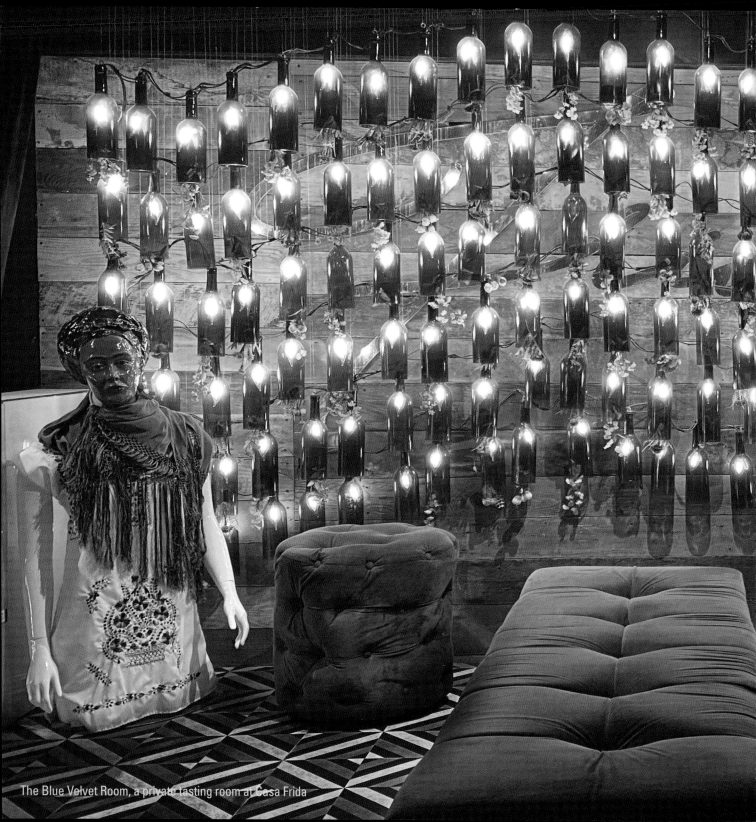

The Blue Velvet Room, a private tasting room at Casa Frida

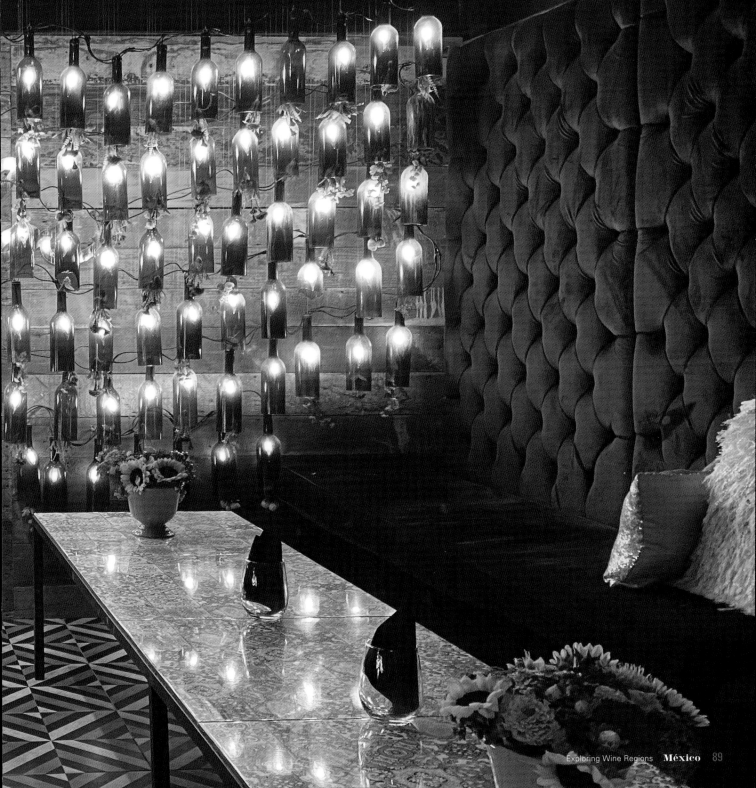

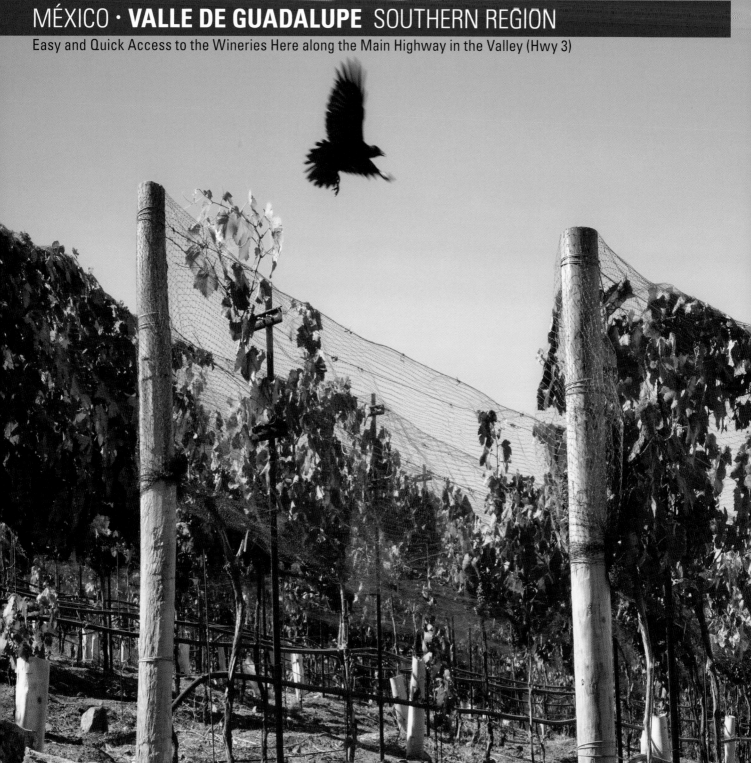

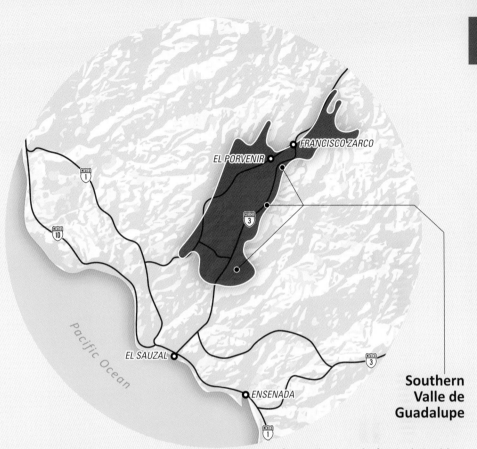

Southern Valle de Guadalupe

Left page: The vineyards of Hacienda Guadalupe are protected by nets from interested birds

EASY ACCESS TO WINERIES

Entering Valle de Guadalupe from the coast/Ensenada (from the southwest) or from Tecate (from the northeast), it is accomplished on Highway 3, which is the primary road through the full length of the southern portion of Valle de Guadalupe.

The wineries in this southern part of the valley are all right off of Highway 3, making them easy to find with quick access right off this paved highway. They are organized in this section starting from the east side of the valley, then traversing west along Highway 3 towards Ensenada.

There are also numerous restaurants, unrelated to wineries, along this southern part of the valley. I have reviewed quite a few of these restaurants as the food here is extraordinarily good.

In the same order as the wineries, and included with the wineries, these stand-alone restaurants are organized from the east along Highway 3 westward towards Ensenada: **Animalón, Deckman's en el Mogor** and **Primitivo Restaurante**.

All the wineries I reviewed for you here have food service. Bodegas Magoni has several very nice cheese and charcuterie platters. The other four wineries have full restaurants on their premises. Plus, a new modern museum here, the **Museum of Wine**.

Here are the southern wineries to discover.
- Hacienda Guadalupe, page 93
- Viños Lechuza, page 99
- Bodegas Magoni, page 101
- Maglén Winery Resort, page 109
- Bodegas de Santo Tomás, page 115

Winemaker: Chile

$-$$

Located: Southern Valley, East
Km 81.5 Carretera Ensenada-Tecate
22750 Valle de Guadalupe, Baja California

+52 646 155 2859
Reservaciones@HaciendaGuadalupe.com

HaciendaGuadalupe.com/Winery

Open: Wednesday-Monday, 10am-4pm (Fri-Sun 5pm)

W inemaker and sommelier, husband and wife team, with two restaurants to pair their crafts.

WINE, FOOD AND LODGING

This is a beautiful family-run property. Husband and wife, Daniel and Gabriele Sánchez, are the winemaker and sommelier, respectively. Their two daughters run the restaurants and hotel, all on the same property for us to enjoy.

Daniel (photo above) also hired an oenologist from Chile to help him master a great selection of seven different wines. Each of these wines is unique and special, and their focus has really brought each wine to its own success. You will love the wine here.

It is hard to choose my favorite wine here. On my first visit, it was their Merlot (photo right). Next visit it was their Nebbiolo. And both times, Gaby, their rosé of Syrah and Grenache, is just so special, fruity and delicious. I can't wait to go back and see what engages me the most next time.

Take a look at their tasting room (photo left page). Beautiful white leather chairs, white marble floors, white walls, and captivating views across the valley. Now this is a beautiful environment to taste beautiful wines. It's a four-story building: first floor is the winery, underground is the aging cellar, second floor is this tasting room, and the third floor is a massive deck to enjoy the beautiful weather and amazing views across the valley.

On the property is a hotel (see next page) with classic hacienda-style buildings, its own restaurant, pool and spa, which are separated from the winery and primary restaurant for quiet privacy.

Their primary restaurant is open every day for breakfast and lunch until late afternoon. The hotel restaurant is open Thursday through Sunday for dinner and is open for non-hotel visitors as well (see next page).

This is an excellent property to hang out with food, wine and lodging all on one property, surrounded by vineyards overlooking the Valle de Guadalupe valley.

They are located on the east side of the valley, and I noticed the advantage on my last trip. The east side of the valley gets the sun first – sometimes the only part of the valley getting sun as the cold fog comes in from the ocean into the west of the valley.

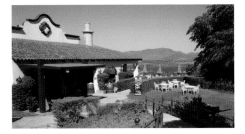

Collection of Wines

Merlot
Nebbiolo
Cabernet Sauvignon
Tempranillo
El Caporal - Mezcla de Tintos
(Nebbiolo, Tempranillo, Merlot)

Gaby (Rosé of Syrah, Grenache)

Gigi (Sauvignon Blanc)

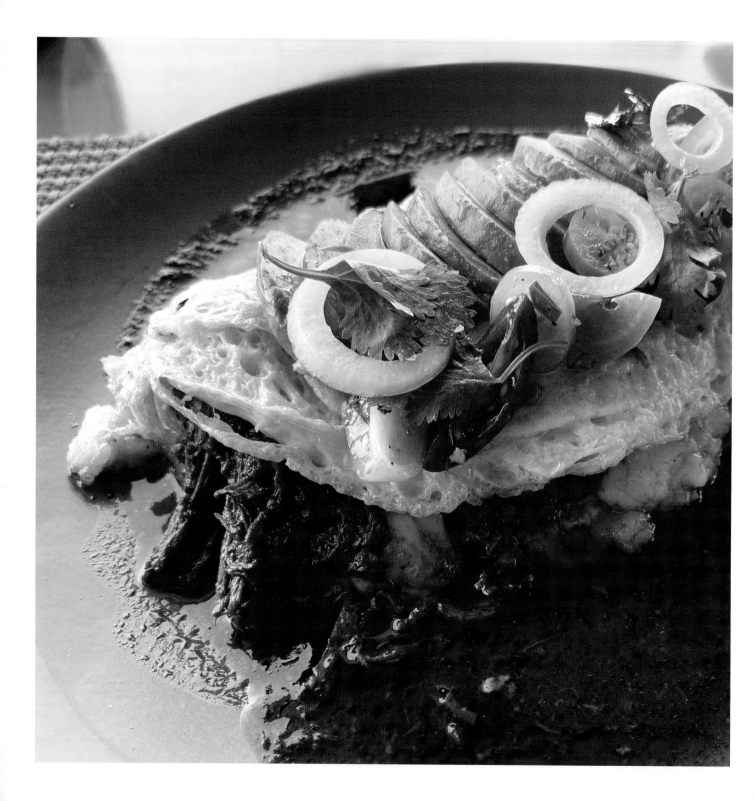

HOTEL AND RESTAURANT ON A WINERY PROPERTY

The inspiration for this winery property was the hotel's beautiful hacienda-style architecture. This was one of the first hotels in Valle de Guadalupe as owner Daniel Sánchez saw the future of this valley and the need for people to have accommodations.

The hotel is located in the east part of the valley right off of Hwy 3, where the sun shines more often. The hotel is separate from the primary restaurant and winery to give guests quiet separation. The hotel has a beautiful pool and spa (photo below) and its own restaurant, *Aledaño*, for fine dining (photos lower right). It has an open kitchen, wood-burning oven, and a covered and open outdoor setting with lots of space heaters.

They have a full bar where I created a new delicious drink that was an inspiration from a hot drink (Dirty Chai) in their primary restaurant, now a cold, frothy martini that I affectionately named "Juliana." See the super-delicious recipe in the back of the book. Or, show up at the restaurant, as they now have my new drink at the bar.

Their primary restaurant , *El Principal*, is up near the winery, and is open every day, early for breakfast and late in the day for lunch. The food is excellent; just look at the delicious breakfast on the left page. I am getting hungry just looking at its deliciousness.

Here are some tasting notes for the delicious cuisine I cannot forget.

Egg Omelet (photo left page) is stuffed with Birria de Borrego (a lamb stew slowly cooked with chili peppers in the oven for four hours), with delicious aromas and spices from their adobo marinade of guajillo chiles, oregano, cumin, bay leaves, basil and beer. Garnished with avocado, onion and cherry tomatoes from local growers. Decadently delicious!

Sopa de Tortilla (photo below right) is a special home-made house recipe for this very traditional Méxican tortilla soup, which brings out the flavors and soft spiciness of chile guajillo, onions, garlic, oregano and black pepper, plus extra flavors from sour cream and avocado, and a touch of crunchy texture of fried tortilla strips. Poured at the table and uniquely delicious.

BAJA **VALLE DE GUADELUPE** SOUTHERN ■
Winery, Lodging, Restaurant
HACIENDA GUADALUPE
HOTEL AND RESTAURANT

Hotel $$$, Restaurants $-$$-$$$

Located: Southern Valley, East
Km 81.5 Carretera Ensenada-Tecate
22750 Valle de Guadalupe, Baja California

+52 646 155 2859
Reservaciones@HaciendaGuadalupe.com

HaciendaGuadalupe.com/Hotel

Aledaño Restaurant Open:
Thursday-Sunday, 3:30pm-10pm (Sat/Sun from 1:30pm)
El Principal Restaurant Open:
Every Day, 8am-4pm (Sat/Sun 4:30pm)

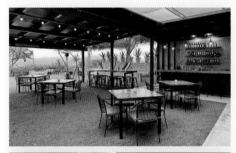

Winery Museum
CASA PEDRO DOMECQ

Winemaker: México

$-$$-$$$

Located: Far East Valley (Valle de Calafia)
Km 73 Carretera Tecate – El Sauzal
22750 Valle de Guadalupe, Baja California

+52 646 155 2249, x110
Emociones@PedroDomecq.com

PedroDomecq.com

Open: All Year, Every Day, 10am-6:00pm

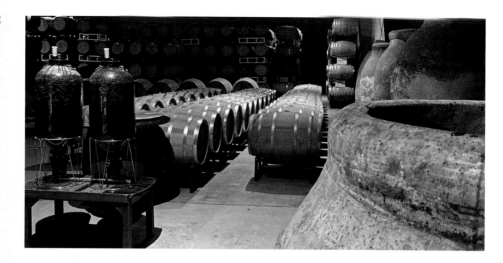

SPANISH WINERY DISCOVERS VALLE DE GUADALUPE

It all started on a train ride. A journey in which Pedro Domecq Gonzáles and Antonio Ariza Cañadilla were traveling separately across southern Spain. It was 1940. Antonio started a conversation with Pedro and told him he worked for Domecq Winery. How coincidental. The two hit it off. They exchanged numbers in this lucky encounter that created a friendship and eventually a huge business relationship.

Starting in México first in 1948, these two men built a winery and a distillation plant to produce brandy. They were processing 350,000 tons of grapes, making ten million boxes of Brandy annually. Not bad! Eventually, the consumption of table wine exceeded brandy in México, so Antonio and Pedro were quick to start bottling the wine. They introduced *Vino Tinto en Rama Los Reyes* in 1966, a red wine of Cabernet, Barbera and Carignan. In 1971, they introduced a Rosé (of Cabernet Sauvignon and Grenache) and a white wine (Chenin Blanc, French Colombard and Palomino).

With such success and desiring higher quality grapes, they discovered a much better terroir in Valle de Guadalupe and purchased their current property in 1972. Because their location was so special for growing wine grapes, the Baja California State Government named this eastern area of Valle de Guadalupe as **Valle de Calafia** for its particular characteristic of terroir. Domecq became the first wine producer in the valley to grow vineyards, have irrigation control and established the infrastructure of a winery.

This is an excellent winery for a great historic tour. This place is a museum with three tours.
- **Basic Tour**. Museum and cave tour with tasting.
- **Second Tour**. Museum and cave tour with classic or reserve tasting.
- **Top Level Tour**. Museum, cave tour, barrel tasting in the cellar and both the classic and reserve tasting.

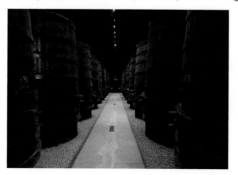

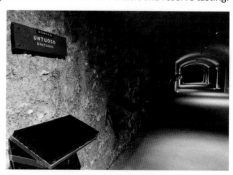

DEEP HISTORY IN VALLE DE GUADALUPE

Museo de La Vid Y El Vino (Vine and Wine Museum) is a brand-new modern museum with historic contents. It is located on the main highway (Hwy 3) in the southeast portion of Valle de Guadalupe. This is a great stop to learn about the history of this valley, as well as the beginnings of wine in the world. This is the only museum of wine in Baja México.

$

Located: Southern Valley, East
Km 81.3371 Carretera Ensenada-Tecate
22750 Valle de Guadalupe, Baja California

+52 646 156 8165
Info@MuseoDelVinoBC.com

MuseoDelVinoBC.com

Open: Tuesday-Sunday, 9am-5pm

Winemaking began here in the 1500s when Spanish conquistadors planted Baja California's first vines. The wine was produced for religious ceremonies and to ship back to Spain. Later that century, Spain halted wine production in México to protect its domestic wine production. In 1697, the Jesuits arrived in Baja California and built the **Misión of Our**

Lady of Loreto. Then in 1791, the Dominics built the **Misión of Santo Tomás de Aquino**. In 1888, the first commercial winery was established here as **Bodegas de Santo Tomás**. (pages 135 and 149) Following was **L.A Cetto** in 1928 (page 47) and **Casa Pedro Domecq** in 1972 (page 96). These historic wineries are detailed at the museum.

This museum also has antique winemaking equipment and vineyard farming tools (both inside and outside the building), numerous historic wine bottles, and artwork displayed in photography, drawings and paintings.

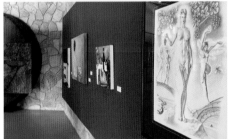

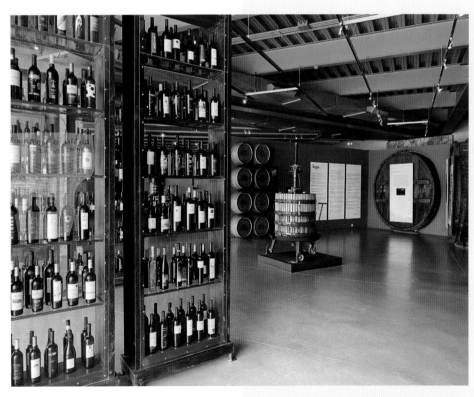

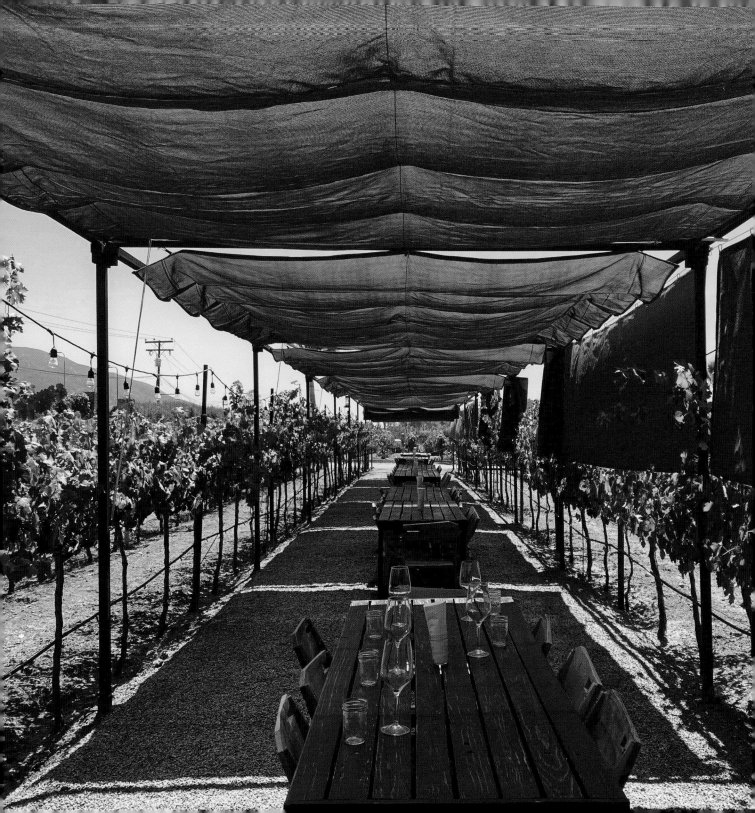

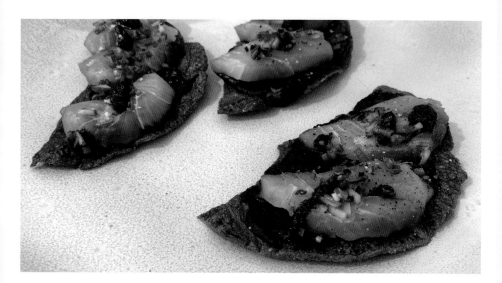

W

hat it takes to get your wines on one of the world's top fifty restaurant's wine list.

FATHER & DAUGHTER

While attending a wine industry tasting event in Valle de Guadalupe, I was introduced to Kristin Shute, the woman who achieved getting her wines into **The French Laundry** (a 3-star Michelin restaurant in Napa Valley consistently on The World's 50 Best Restaurants list). If you don't yet believe that great wines can be made in México, you need to come visit Kristin and taste her wines. This certainly got my attention, and I had to go visit Kristin to taste for myself.

Oddly enough, in 2002, Kristin's parents, Patty and Ray Magnussen, were in Ensenada and given the recommendation to have dinner at Restaurante Laja then touted to be "The French Laundry" of Baja. Now, less than twenty years later, Ray's wines are in the real Napa Valley restaurant.

It was that very impressive food and wine experience at Laja that had Ray thinking that something epic was happening in this valley and he wanted to be a part of it. This inspired Ray to come back to Valle de Guadalupe and purchase property and enrolled in the UC Davis viticulture and oenology programs.

Then in 2012, his daughter, Kirstin Shute, joined him at the winery bringing her culinary expertise to the scene. Kristin received her culinary training in Santa Barbara, California and gained hospitality experience before relocating south to join her father in this exciting new winery.

Kristin has truly integrated food and hospitality into the visiting experiences at Vinos Lechuza (which means "wines" and "barn owl" in Spanish). She has added an outdoor restaurant at the winery and brought in an excellent chef to create food to pair with the winetasting. The restaurant is *Honōkai*, a fresh Japanese raw bar plus small plates of hibachi. What I tasted was ever so delicious.

Tostada de Crudo (photo above) is raw yellowtail sashimi, smoked mussel pâté, salsa macha on top with shallots, chives, red onions and cucumber. Kristin has also created group-oriented food and wine events so you can bring lots of friends to party.

Campestre Cook Out is a barbecue of animals over an open fire, paired with wines, for 15 people.

By the barrels is a five-course food and wine pairing in their private barrel room, for 8 people.

Among the Vines is platters of Baja Med-type courses, in their vineyards, for fourteen people.

BAJA **VALLE DE GUADELUPE** SOUTHERN ■
Winery, Vineyards, Restaurant
VIÑOS LECHUZA

Winemaker: UC Davis, California
$$-$$$

Located: Southern Valley, East
Carretera Ensenada-Tecate, Km 82.5
22750 Valle de Guadalupe, Baja California

+52 646 256 4437
Reservations.VinosLechuza@gmail.com

VinosLechuza.com

Open: Wednesday-Monday, 10am-4pm

Collection of Wines

Lechuza Vineyard Nebbiolo
Lechuza Pluma (Nebbiolo)
Lechuza Vineyard Cabernet Sauvignon
Amantes (Cabernet Sauvignon, Nebbiolo, Merlot)

Royal Blush (Rosé of Cabernet, Merlot, Tempranillo)

Chardonnay - Oaked
Chardonnay - Stainless Steel
Vuelo (Sauvignon Blanc, Chardonnay)

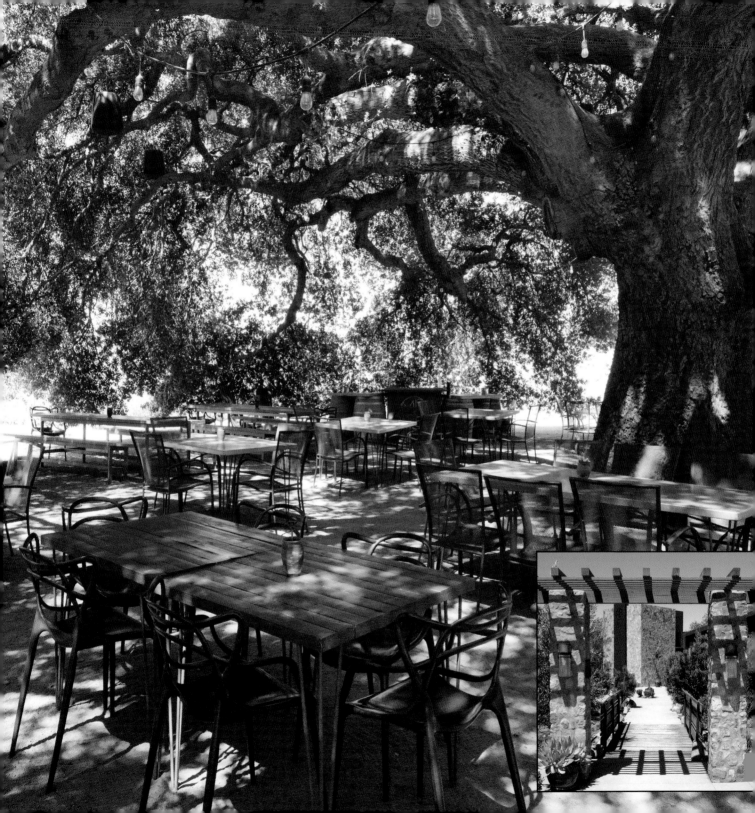

Winemaker: Piedmont Italy

$-$$

Located: Southern Valley, East
Km 83 Carretera Tecate - El Sauzal
22750 Valle de Guadalupe, Baja California

+52 646 187 0483
Reserva@CasaMagoni.com

CasaMagoni.com

Open: Every Day, 11am-5pm (Sat 6pm)

An important pioneer of Valle de Guadalupe, Camillo Magoni (above) arrived from Italy fifty years ago to help create the largest winery in México.

HIS NEW NAMESAKE WINERY

On my first trip to Valle de Guadalupe, while having dinner in a nice restaurant in Ensenada, I was eager to taste the wines here. At first, I was given a taste of a Cabernet Sauvignon. Oh no, not good. Then I needed to negotiate drinking the best wine they served in the restaurant. They brought out a Magoni Nebbiolo. Oh my gosh, extraordinary. Had I just discovered the grape that does so well here or the winemaker who really knew what he was doing? Or both? This became one of my missions.

It did not take long for me to realize that Nebbiolo was a grape doing extraordinarily well in Valle de Guadalupe. And often I would hear Camillo Magoni's name getting high regards as an important pioneer who came here from Italy over fifty years ago.

After degrees in enology and viticulture from the prestigious *Scuola Enolgica Di Alba* in Piedmont Italy, Camillo came to work for L.A. Cetto to help them build the largest winery in México. Going beyond volume wines, Magoni created Cetto's first superstar premium wine in 1987, none other than a Nebbiolo wine, which won numerous awards.

After retiring from Cetto, Magoni made his own wine to share with his family and friends. Ultimately, it was the Magoni second generation that wanted to carry on the legacy of his extraordinary wines. Today, Bodegas Magoni is operated by this second generation with all the wines inspired by, and directed through, Camillo Magoni. Camillo's daughter, Monica Magoni, is the general manager.

Enjoy tastings inside their new modern building (photo on inset left page) or outside under a massive oak tree (photo left page). They have lots of choices in tastings: white wines, red wines, mixed, and reserve tastings.

Need I remind you to taste his Nebbiolo wine? It is spectacular! Even if you don't do a tasting of the Nebbiolo, you must take a few bottles with you. Trust me, you will love them.

They have a big variety of cheese and charcuterie boards. They have a nice regional board of local ingredients, a Mediterranean board, a sheep cheese board, and an extensive charcuterie board with lots of delicious meats.

Bodegas Magoni also creates its own line of olive oil and balsamic vinegar. Look at all these tiny barrels below aging the balsamic to perfection.

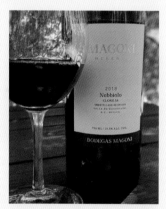

Collection of Wines

Reserva Nebbiolo (100% Nebbiolo)
Reserva Cabernet Sauvignon (Cabernet Sauvignon, Merlot, Malbec, Petite Verdot, Carmenere)
Reserva Tempranillo (Tempranillo, Graciano, Garnacha)
Reserva Syrah (Syrah, Mourvedre, Petite Sirah, Grenache)
Reserva Sauvignon Blanc (100% Sauvignon Blanc)

Nebbiolo de Baja (100% Nebbiolo)
Origen 43 (Sangiovese, Aglianico, Canaiolo, Montepulciano)
Sangiovese/Cabernet
Merlot/Malbec

Rosé (Rosé of Pinot Noir, Pinot Meunier, Grenache, Cabernet Sauvignon)

Manaz (Viogner, Fiano)
Chardonnay/Vermentino
Sauvignon Blanc

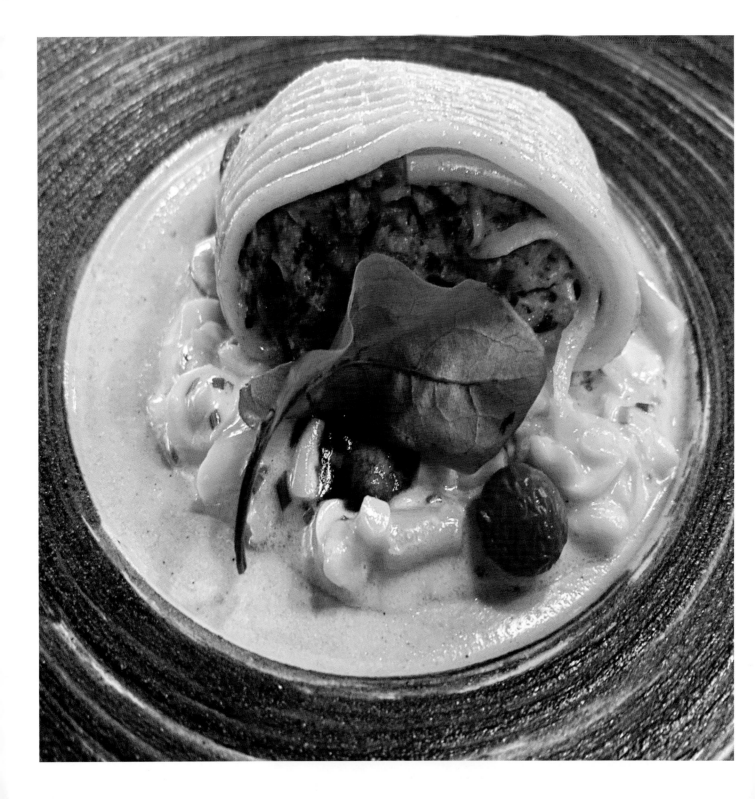

THE MOST DELICIOUS AND CREATIVE CUISINE

This is the seventh and newest restaurant in Baja California from the acclaimed Chef Javier Plascencia, and his third restaurant in Valle de Guadalupe. The other two are **Finca Altozano** and **¡LUPE!**. His most unique restaurant is on a boat in Cabo San Lucas; it is also called **Animalón** (meaning "large animal" in Spanish). It is a sunset journey in the Sea of Cortez, truly a floating restaurant. I cannot wait to experience this.

Animalón Valle de Guadalupe is a totally outdoor restaurant where guests sit under a massive 200-year-old oak tree that is full and dense to make it feel like you are inside. The food was amazing, creative, innovative, and full of unique flavors. The photos will give you a sense of the amazing experience you'll have here. I had their chef-tasting menu, a ten-course, prix fixe, food and wine pairing experience. Each surprisingly unique course was deliciously described and paired with wines from all over the world. After a day of tasting local wines, this was a great worldly experience.

Now for the extraordinary cuisine...

Tallarín de Cangrejo (photo left page) as you can see, this tallarín (noodle) is a very tedious, labor-intensive dish for them to make. It is influenced by Mediterranean cuisine and has become their signature dish. They revamp it every season with different ingredients and some small changes in the aesthetics so it feels like a new dish every season. This inspiration is made with spider crab, crème fraîche, wild mushrooms, sherry and chives. When in lobster season, it is stuffed with lobster and a demi glaze with the lobster shells.

Coctel de Almejas (photo below) is for the tasting menu that always starts with raw seafood. It is a Baja-style shellfish cocktail (a gourmet version of what you find at the seafood street carts in downtown Ensenada) with fresh seasonal shellfish, here local uni, salmon eggs, squash flowers, tomato dashi and aguachile.

Lobina Asada (photo below right) is a roasted stripped seabass cooked sous vide with fresh sweet corn and corn husk froth, corn flan on the bottom and topped with sweet corn. It is particularly delicious in the summer months as local corn is fresh and sweet.

$$$$

Located: Southern Valley, East
Carretera Tecate, Ensenada Km 83, Ejido Francisco Zarco
22750 Valle de Guadalupe, Baja California

+52 664 375 2658
Reservas@AnimalonBaja.com

AnimalonBaja.com

Open: Tuesday-Sunday, 11am-7pm

SUSTAINABILITY AND DELICIOUSNESS

Drew Beckman, originally from America, spent ten years in Europe gaining his gastronomic expertise, primarily in France, Germany and Switzerland, and was awarded a Michelin star. Drew then brought his culinary skills to Baja California and fell in love with Valle de Guadalupe.

Chef Drew set up an outdoor kitchen on Rancho Mogor with the purpose of being as sustainable as possible. For example, he created a wood-fired kitchen with everything being cooked on embers. He grows 85 percent of his organic vegetables on the ranch, and he buys the rest from his neighbors. He keeps bees on the ranch, strongly believing in propagating pollinators. Olive oil is extra virgin and from his own production. All seafood is sourced sustainably and 100 percent from the Baja Peninsula. Lamb is estate grown on Rancho Mogor, quail from Rancho Guacatay, pork from Rancho Codocana, and beef from the Family Contreras Ranch. All pasture-raised and responsible as Drew knows his vendors intimately and knows that they believe in the quality of the animals and sustainability. At Beckman's, you can feel good about the quality of the food.

When you look at the photos, do need I say more? The preparation and delivery are extraordinary. Just wait until Michelin finds him here in the Valle. His menu changes daily to accommodate the freshest of what is grown and caught here and everything is prepared to order. You can watch it all happen in the outdoor kitchen.

Now for the extraordinary cuisine.

Abalone (photo left page) is farm-raised with carrot-ginger purée and shellfish nage.

Valle de Guadalupe Quail (photo below) is with scorched zucchini, guajillo (dried form of mirasol peppers) vinaigrette.

Lemon Curd (photo top right) is a crème fraîche ice cream, caramel crisp.

Estate-Raised Lamb (photo below right) and vegetables raised and grown on their own farm.

$$$-$$$$

Located: Southern Valley, Central Ensenada-Tecate Km.85.5 San Antonio de Las Minas 22750 Valle de Guadalupe, Baja California

+52 646 188 3960
+1 619 721 4820
JoinUs@Deckmans.com

Deckmans.com

Open: Thursday-Monday, 11am-7:30pm (last sitting)

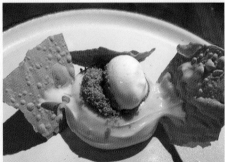

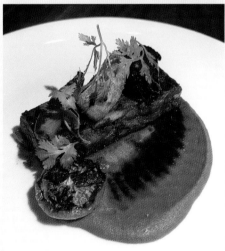

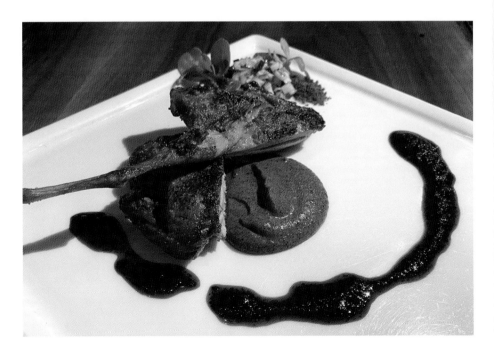

PRIMITIVE OUTDOOR DINING

The remoteness of this restaurant is part of the charm. Even though it's right off of Hwy 3, you cannot see the restaurant. You are simply exiting at a fence, going through a gate, meandering along a dirt road as it winds amongst oak trees, eventually, you will arrive at a massive oak tree that must be hundreds of years old (photo top right). The entire restaurant is under this ancient tree. It's a totally natural dirt floor. The kitchen has no gas or electricity. Cooking is solely done by live embers. Heating is in steel bins in which they put burning firewood to keep their guests warm.

Their theme is firewood, fire and iron (photo bottom right). These are the elements that make up the outdoor kitchen, next to the massive oak tree, open for us to see this lively flaming activity. This is totally unique. A natural culinary experience with exceptionally delicious gourmet cuisine. Everything is local; sourced fresh and local from the ocean, local from the farms, local from the ranchers. This means the menu is created every day based on what they get fresh.

Animals are either hung on iron hooks over wood-burning fires (photo bottom right), or cooked on top of iron grates over burning embers. With the open kitchen, you can watch this primitive cooking process before you taste this native dedication to seriously delicious food.

Now for the delicious cuisine.

Grilled Oysters (photo left page) in seafood butter served on hot coals in an iron skillet.

Crispy Chitterlings (photo below) is beef stripe inside a ring of sliced potato chips with rosemary and garlic. A savory dish of textures and flavors.

Short Ribs (photo bottom) smoked on an open fire for twenty hours, then cooked in a Dutch oven with coals. Tender and flavorful, served with their homemade focaccia on a wood cutting board.

BAJA **VALLE DE GUADELUPE** SOUTHERN ■
Stand-Alone Restaurant
PRIMITIVO RESTAURANTE

$$$-$$$$-$$$$$

Located: Southern Valley, West
Carretera Ensenada Tecate 3 Km 89
22750 Valle de Guadalupe, Baja California

+52 646 947 8523
Reservaciones@PrimitivoRestaurante.com

PrimitivoRestaurante.com

Open: Tuesday-Saturday, 1pm-7pm (Sun 12pm-5pm)

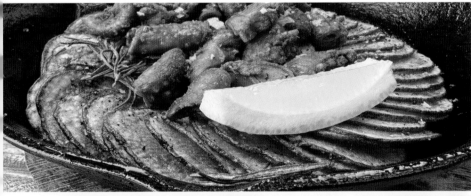

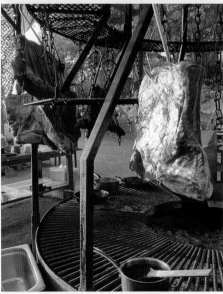

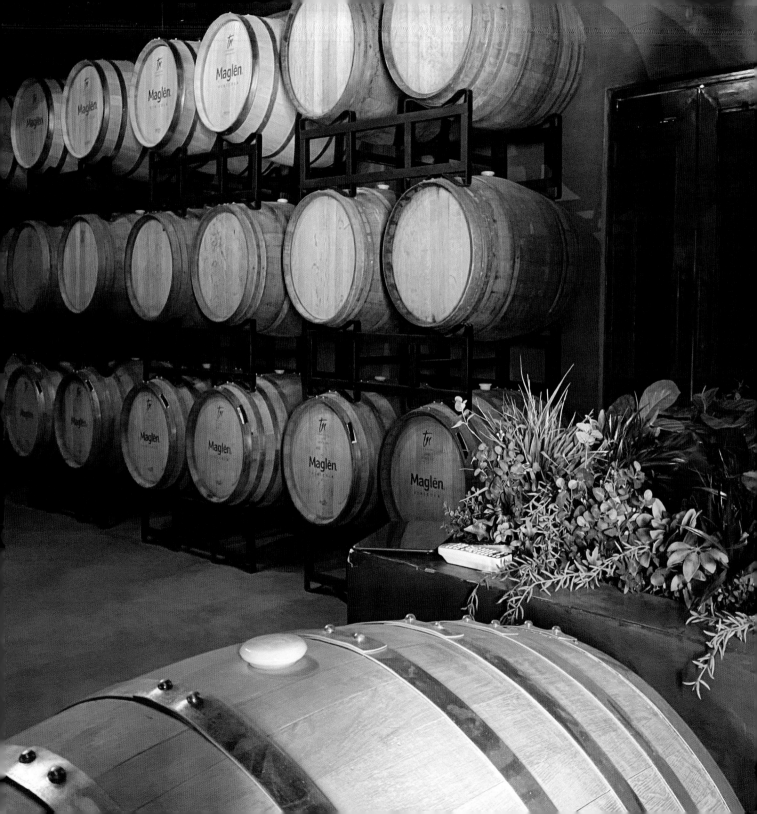

Winemaker: Sevilla, Spain

$-$$-$$$

Located: Southern Valley, West
3 Km. 90.8, Fraccionamiento Las Lomas
22755 Valle de Guadalupe, Baja California

+52 646 152 1284
Contacto@MaglenResort.com

MaglenResort.com/en

Open: Every Day, 11am-7pm
(Friday 10pm, Saturday 9am-10pm, Sunday 9am-9pm)

Gastronomy, libations and lodging on a large property with numerous and diverse options.

INDULGE

Maglén Winery Resort is one of the largest properties in Valle de Guadalupe with a complex of gastronomy, libations and lodging of an impressive magnitude. They are located right off Hwy 3 at the west end of the valley.

For gastronomy, they have three full restaurants with a huge variety of unique foods (see next page).

For libations, they have two full bars, a coffee house, a microbrewery, and an on-premise winery with a tasting room.

For lodging, they have sixty rooms in different concepts, from glamping to luxurious villas (see following two spreads).

The **Maglén Winery** is located in the Las Villas area of the property in their primary village. The tasting room is an art gallery with rotating artists in a contemporary environment (photo above). They offer different tasting experiences, including tours of the winery and aging cellar (photo left page). Oftentimes, the winemaker, Manuel Montoya, will be there and excited to share with you his passion for their wines by showing you around his winery and cellar.

It is nice when there are several wines you like at a winery. Montoya's Sauvignon Blanc was one of the best I have tasted. It has a delicious combination of sweetness and citrus. He also bottles Petit Verdot (photo right). Usually a small addition to Bordeaux wines, this 100 percent varietal is impressive.

While sitting down with Manuel, I discovered his prized wine, winning double gold medals, the Reserva Maglén, a spectacular Bordeaux blend led by Cabernet Sauvignon (photo below).

Collection of Wines

Reserva Maglén (Cabernet Sauvignon, Merlot, Petit Verdot, Cabernet Franc)
Mezcla de Tinto (Tempranillo, Nebbiolo, Petit Verdot)

Saga Nebbiolo
Saga Petit Verdot
Saga Cabernet Sauvignon
Saga Sauvignon Blanc

Selección de Tintos (Grenache, Sangiovese)
Rosado Cabernet (Rosé of Cabernet Sauvignon)

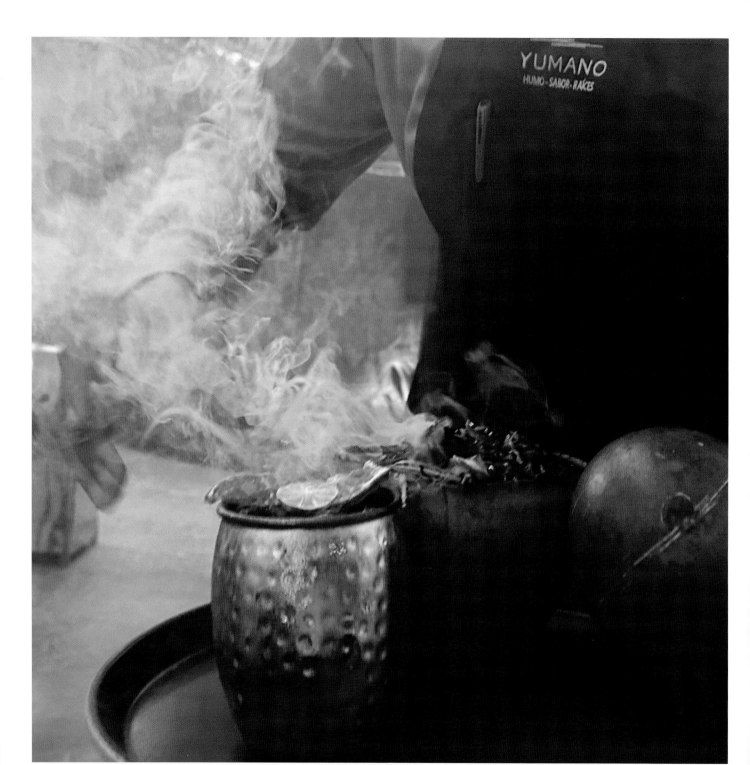

LOTS OF GASTRONOMY AND LIBATION OPPORTUNITIES

At the entrance to the Maglén Resort property is the El Encinal area with a brewery and restaurant (photo next page top right). **Ruta 90.8 Cervecería** (their address) is an on-premises artisanal brewery with many delicious beers. **Cantera Cocina del Valle** has a really nice menu. For example, a delicious vuelta style lamb (photo bottom left) and shrimp and vegetables in a savory soy sauce (photo bottom center). Both are open every day, 1pm-7pm (Wed/Thu/Sun 9pm)(Fri/Sat 11pm).

Las Villas is their primary village at the back of the property including their winery and tasting room, adjacent to the restaurants. **Huevo Republic** has a huge variety of breakfasts (every day 8am-1pm). I love big breakfasts, and had an incredibly delicious marinated lamb, tender and juicy, topped with sunny-side-up eggs, caramelized onions, queso fresco cheese, and avocado (photo below top left). At 1pm, **Yumano Restaurant** sets up for lunch and dinner (Mon/Tue 7pm, Wed/Thu/Sun 9pm, Fri/Sat 11pm). The cuisine is based on the foods of the first ethnic group of Baja California called Yumanos. Below top center, for example, is a dish of chopped raw tuna, tomatoes and avocados in an incredibly delicious combination of herbs, roots, spices, and flowers used by these natives.

Yumano also has a unique mixology inspired by these ancient native groups. The left page is an **Auka**, a cleansing drink that is served with a smoke and music dance to cleanse your soul and raise your spirits.

Aromas Coffee House is also in this village, and has likely the best coffee in the entire Ensenada area. They roast their own beans, which comes from specially selected farms. The grinding and brewing are all by hand for each cup of coffee in a slow and meticulous process (photo right). In the afternoon, **Aromas** makes cocktails, see the incredibly delicious *Espresso Martini* lower right (open every day 8am-7pm).

BAJA **VALLE DE GUADELUPE** SOUTHERN ◢
Winery, Vineyards, Lodging, Restaurants
MAGLÉN WINERY RESORT

$-$$-$$$

Located: Southern Valley, West
3 Km. 90.8, Fraccionamiento Las Lomas
22755 Valle de Guadalupe, Baja California

+52 646 152 1284
Contacto@MaglenResort.com

MaglenResort.com/en

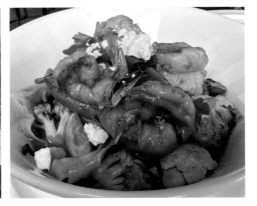

FOUR UNIQUE LODGING OPTIONS

This is a huge resort of four separate areas with four completely unique styles of lodging. All areas come with pool, jacuzzi and gardens.

• **Airstream Glamping** is a fully restored classic Airstream travel trailers up next to their vineyards.

• **El Encinal** is a rustic wooded lodging in a forest of dense oak trees.

• **Tesela** is a unique style of modern architecture (photo left page) with floor-to-ceiling windows in front of the bed to watch the beautiful sunsets from the westward facing rooms.

• **Las Villas** is the most luxurious of the four offerings at Maglén Resort, located in the primary village with their winery, tasting room, two restaurants, oyster bar, coffee house, gift shop, and outdoor gym. These rooms are larger and significantly more luxurious (photos below).

BAJA **VALLE DE GUADELUPE** SOUTHERN
Winery, Vineyards, Lodging, Restaurants
MAGLÉN WINERY RESORT

$$-$$$-$$$$

Located: Southern Valley, West
3 Km. 90.8, Fraccionamiento Las Lomas
22755 Valle de Guadalupe, Baja California

+52 646 152 1284
Contacto@MaglenResort.com

MaglenResort.com/en

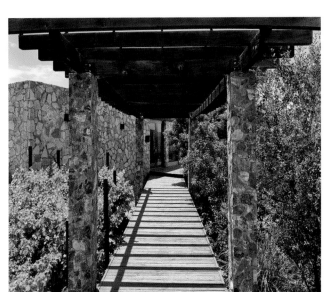

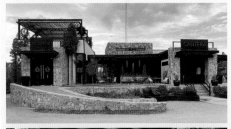

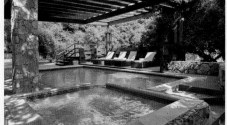

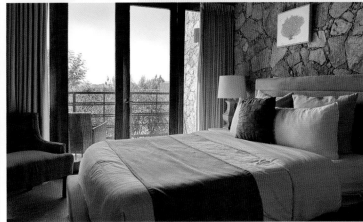

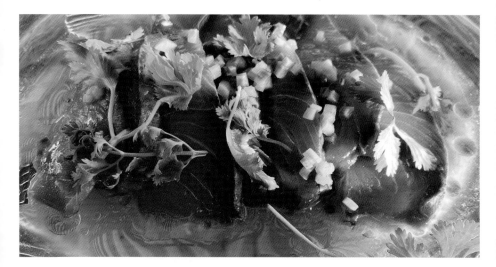

Winemaker: Rioja, Spain
$-$$-$$$

Valle de Guadalupe – Cava San Antonio
Located: Southern Valley, West
3 KM 94, 22800 Villa de Juárez, B.C
Valle de Guadalupe, Baja California

Downtown Ensenada – Cava Miramar
Ave Miramar 666, Zona Centro, Ensenada

Santo Tomás Winery – Santo Tomás Valley
KM 49 Carretera Federal No. 1, Ensenada-La Paz

+52 664 320 9558
ReservationsBST@GrupoPando.com

Santo-Tomás.com

T he oldest winery here has its newest facility in Valle de Guadalupe, complete with restaurant.

VALLE DE GUADALUPE TASTING

In 1791, the Misión of Santo Tomás de Aquino was founded in the town of Santo Tomás (one hour drive south of Ensenada) within the Santo Tomás Valley, where the vineyards were planted, ultimately creating the very first winery in Baja México in 1888 as Bodegas Santo Tomás.

In its 135 years, Bodegas Santo Tomás has grown significantly. They established a huge winery and cellar in downtown Ensenada that remains their executive offices today. This grand facility has now become a museum (open to visitors) and Bodegas Santo Tomás built a new, modern winery in the middle of their vineyards in the Santo Tomás Valley (also open for visitors).

Downtown Ensenada – Museum, Wine Tasting
This original winery is in the oldest buildings in Ensenada surrounding a street closed off just for Santo Tomás, with numerous shops, restaurants and wine tasting in the square. The historic buildings and cellar are open for tours, as well as wine tastings, with advanced reservations (see page 135).

Santo Tomás Valley – The Winery
This is where Santo Tomás makes their wines. You can visit the winery and vineyards, and see inside the innovative operations (see page 147). RSVP necessary.

Valle de Guadalupe Tasting Room & Restaurant
Bodegas Santo Tomás has numerous vineyards at the west end of Valle de Guadalupe. They built a tasting room with indoor and outdoor areas with beautiful views. They have walking tours to learn about the Santo Tomás philosophies while strolling around the property sipping wine.

Villa Torél Restaurant
+54 646 267 6688 • Hola@VillaTorel.com
Open: Wednesday-Monday, 12pm-7pm
Underneath the Santo Tomás tasting room is a small restaurant called Villa Torél with covered outdoor seating (photo below), natural sand flooring and an open kitchen serving fresh seasonal ingredients.

Check out the beautiful **Crudo de Atún** that I enjoyed (photo above). It is a tuna sashimi in a savory oil sauce, topped with parsley and chopped onions. Very fresh and full of flavors.

Collection of Wines

Premium Wines
Único (Cabernet Sauvignon, Merlot)
Eikon (Cabernet, Barbera, Tempranillo, Syrah, Carignan, Misión)
Cierzo (Cabernet Sauvigno)
Duetto (Tempranillo, Cabernet Sauvignon)
Xaloc (Tempranillo)
Sirocco (Syrah)

Classic Wines
Cabernet Sauvignon, Tempranillo, Syrah, Merlot, Tempranillo/Cabernet, Barbera, Blanca México (Misión)
Chenin Blanc, Chardonnay, Viognier, Sauvignon Blanc

MÉXICO · **VALLE DE GUADALUPE** COASTAL REGION

The Beautiful Beach North of Ensenada, West of Valle de Guadalupe.

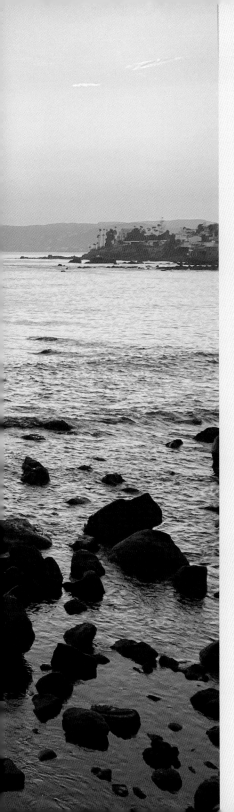

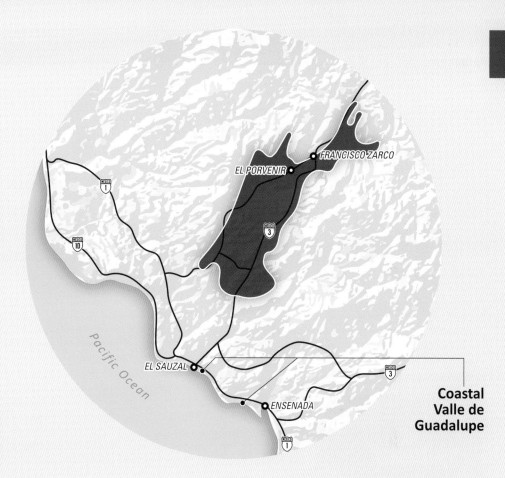

**Coastal
Valle de
Guadalupe**

Left page: Sunset from the
Punta Morro seaside restaurant

FISHING PORT AND SEASIDE

El Sauzal is the town where Highway 3 from Valle de Guadalupe intersects with the coastal Highway 1, six miles north of Ensenada. At this intersection is Puerto El Sauzal, a medium-sized port with 40 percent of its activity being fishing vessels. This is a huge benefit of lots of fresh fish to the restaurants here.

Along this six-mile beautiful coast (photo left page) between Ensenada and El Sauzal, are restaurants, breweries and hotels. One of the breweries, **Wendlandt Cervecería**, is located in the Harbor right on the water. The other brewery along the coast here is **Aguamala Cervecería**.

Also, along this six-mile coast is a beautiful marina filled with motor and sailing yachts, and a large hotel, **Hotel Coral & Marina**, offering numerous water sports in the marina.

How about romantic dining right over the water, watching a beautiful sunset while enjoying gourmet food? Check out the **Punta Morro Restaurant**.

Lodging along the coast here has several benefits. Being just north of Ensenada gives quick access to the city, its culinary and other opportunities, and easy access to the Valle de Guadalupe wineries avoiding any city traffic.

Brewery and Beer Garden
WENDLANDT CERVECERÍA

$-$$-$$$

Located: Coastal Valle de Guadalupe
Calle Diez 385-B, El Sauzal
22760 El Sauzal, Baja California

+52 646 174 7060
Info@Wendlandt.com.mx

Wendlandt.com.mx

Open: *Monday-Thursday: 2pm-10pm (Friday 11pm)*
Saturday: 1pm-11pm (Sunday 10pm)

Wendlandt Brew Pub – Downtown Ensenada
Boulevard Costero 248 • +54 646 178 2938
Open: Tuesday-Sunday: 5pm-Midnight (Sunday 11pm)
Friday/Saturday: 3pm-Midnight

Collection of Beers

Harry Polanco (Red Ale)
Vaquita Marina (Pale Ale)
Pedro Del Mar (India Pale Ale)
Tuna Turner (Session IPA)
Vera Niega (Mexican Blonde Ale)
Foca Parlante (Stout stout)

Seasonal Beers
Dancing Willy (DDH Hazy Pale Ale)
Pink Flaminga (West Coast IPA)
Flying Jerry (Hoppy Lager)

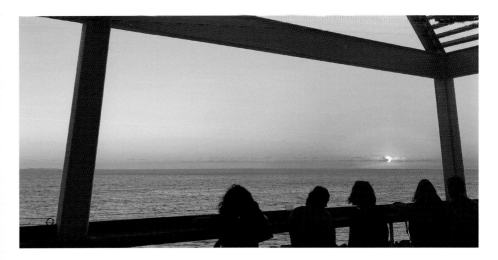

ROOFTOP BEER TASTING

The Wendlandt Brewery and tasting room is located inside the El Sauzal Harbor near the intersection of Hwy 3 and Hwy 1. Coming out of Valle de Guadalupe westbound, Hwy 3 ends in the El Sauzal Harbor. Continue into the harbor all the way to the ocean and this is where Wendlandt Brewery is located.

On the second floor of the brewery is their rooftop deck overlooking the ocean (photo above). Since they are right on the ocean, the views are unobstructed and beautiful. I highly recommend a glass of delicious beer while you watch the beautiful sunset over the Pacific Ocean.

Wendlandt opened in 2012 and has expanded significantly (see tanks below) as people love their beers. They won the award for **Best Brewery in México** twice already. They have over thirty employees with distribution throughout México and the United States.

They opened a kitchen in the brewery and provided a vast array of food options. And they serve a lot more than beer, as they carry local wines as well as a full bar with cocktails. Wendlandt focuses on six beers, most of which are **ales**. They always have a variety of specialty beers which changed through the seasons.

When you are in downtown Ensenada, check out their other location, Wendlandt Brew Pub.

$

Located: Coastal Valle de Guadalupe
Km 104.5 Carretera Tijuana-Ensenada
22760 El Sauzal de Rodríguez, Baja California

+52 646 174 6068
Info@Aguamala.com.mx

Aguamala.com.mx

Open: Every Day, 2pm-Midnight (10pm Sunday)

Microbrewery and tastings inside a maze of artistically designed shipping containers.

This is a small local brewery making a variety of super-creative beers. Being inventive and experimental are good descriptions of these fun folks. Just look at the menu in the right column to get a taste. And this is just the beginning. They always have something new and creative on tap. When I was there, they were exploring the harmony among grapes, barley and malt to create a wine-grape lager beer. Excellence! (photo right)

There must be at least a hundred used cargo containers here, stacked on top of each other, side-by-side, opened up into mazes of brewing, cooking and tasting areas. The food is just as creative and tasty (see Tempura Oysters below).

They started in 2005, and Aguamala considers itself like the marine world: diverse, exciting, inviting, full of surprise and mystery.

Collection of Beers

Mar Y Estrellas (grape lager)
Navideña (nuts, caramel, vanilla)
Hierba Santa (herbs, citrus, honey)

Vieja (amber lager: toast, malt, fruit)
Fugu (Japanese lager: Peach, malt, rice)

Mantarraya (oatmeal stout: cocoa, espresso, vanilla)
Lobo Marino (bourbon barrel stout: maple, espresso, wood)

Session IPA (light golden IPA: hoppy, savory)
Marea Roja (red IPA: malt, caramel, flowers)
Astillero (imperial IPA: tropical fruits, herbs, caramel)
Mako (pale ale IPA: hoppy, roasted malt, citrus)
Sirena (pilsner: white flowers, honey, fruit)

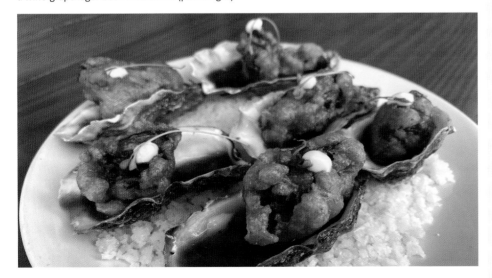

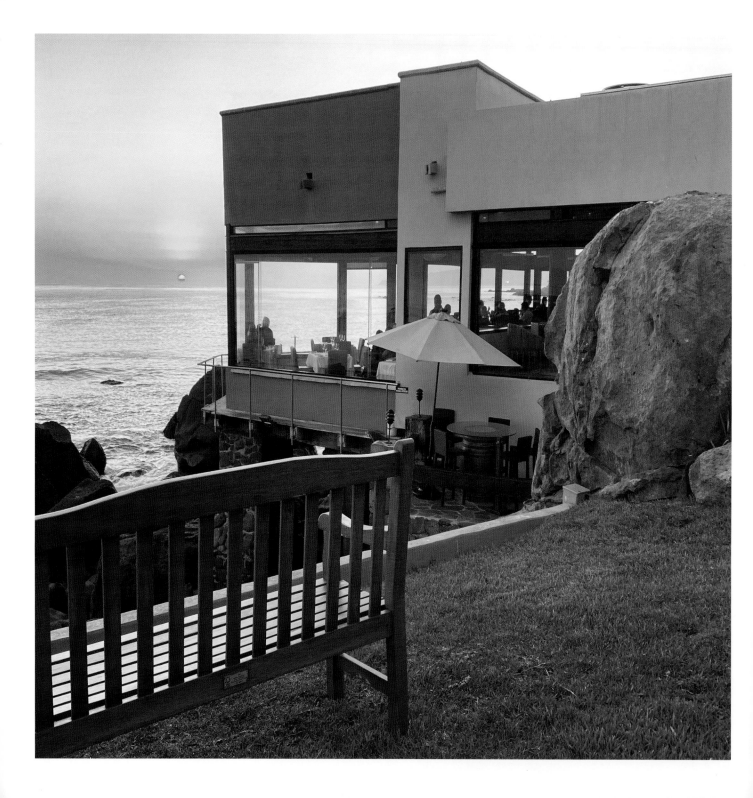

OCEANFRONT FINE DINING

$$$$

Located: Coastal Valle de Guadelupe
Carretera a Tijuana Km 106 El Sauzal
22860 Ensenada, Baja California

+52 646 178 3507
WhatsApp Reservations: +52 646 119 4032
Reservas@HotelPuntaMorro.com

HotelPuntaMorro.com

Open: Every Day, 8am-10pm (Fri/Sat 11pm)

The restaurant is literally over the rocks protruding into the ocean for an ultimate view of fine dining. And for more romance, make your reservation to include sunset (as you see on the left page) for an extra beautiful evening with your special one.

Expect white tablecloth dining, waiters in suits, an extensive wine list of some of the best local wines, and a menu that will make it difficult to choose from so many interesting dishes.

Punta Morro is adjacent to the Hotel Punta Morro, only three miles north of downtown Ensenada and just a couple of minutes north of Hotel Coral & Marina.

Now for a little bit of the cuisine.

Punta Morro Salad (photo below) where all they tell you is that this is a mixed salad with grilled shrimp kebab and blue cheese dressing. Then it arrives in a sourdough bowl with lots of colorful vegetables mixed with leafy greens, plus a towering kebab of grilled shrimp giving uniqueness and alluring creativity to this beautiful salad.

Grilled Swordfish (photo below right) in white wine, butter and caper sauce, with perfectly cooked vegetables of broccoli, green beans and cherry tomatoes.

Vanilla Ice Cream (photo top right) with fresh chopped strawberries. Yum.

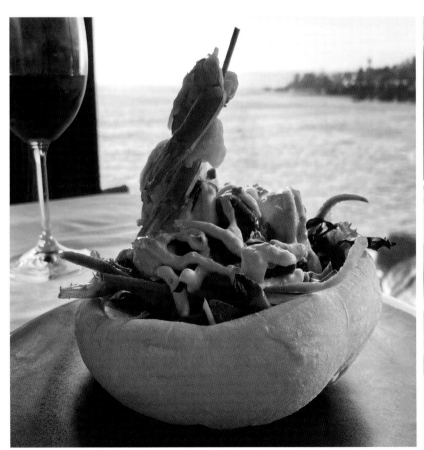

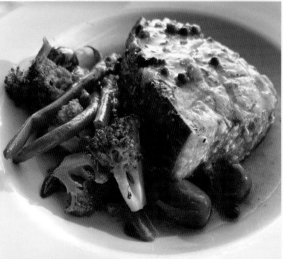

OCEANFRONT HOTEL AT THE MARINA

BAJA **VALLE DE GUADELUPE** COASTAL ■
Hotel, Restaurant, Spa, Wine Tasting
HOTEL CORAL & MARINA

$$-$$$

Located: Ensenada Marina
KM 103, Carretera Tijuana-Ensenada
22860 Ensenada, Baja California

+52 646 175 0000
USA 800 862 9020
WhatsApp: +52 646 143 4317
Reservations@HotelCoral.com

HotelCoral.com

Open: All Year, Every Day
Bistro & Cava Restaurant: 7am-11pm
Wine Tastings: 9am-6pm
C Spa: 8am-8pm

There is so much to like about this hotel. The location is excellent, right on the marina with beautiful views of the yachts, sailboats and the calm bay. Located just a couple of minutes north of downtown Ensenada, walkable to shops and restaurants, and being north of the city, this hotel gives you easy access to the wine valley without dealing with city traffic.

On two of my visits, I stayed in one of their "smaller" rooms: a junior deluxe suite. It was over 700 sq'. with living room (photo below left) separate from the bedroom, and a large deck (photo below right) overlooking the resort, marina and ocean.

Hotel Coral & Marina has an excellent restaurant **Bistro & Cava Restaurant**. Plus, **wine tasting** right in the hotel with a host of local wines. They have indoor and outdoor **pools**, a luxurious **spa**, numerous **water activities** in the marina, and a **lounge** to enjoy cocktails while you take in a **beautiful sunset** across the ocean in front of the hotel.

Their **C Spa** is very professional with numerous creative treatments. The most appropriate one to us wine lovers is their **Wine Therapy Treatment**. This is an antioxidant therapy to prevent premature aging. How about a youthful-looking skin when you are wine-tasting? Next to the ocean, they have a **Seaweed Treatment** to adds lots of minerals and anti-inflammatory properties to nurture our skin. I love strong massages, and they have a great **Deep Tissue Massage** and **Reflexology**.

They have a private transportation service from either San Diego or Tijuana airports. Then you rent a car at the hotel or contact my private driver (page 130). This hotel is very accommodating to foreign travelers.

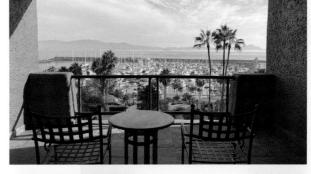

DELICIOUS CUISINE AND WINE TASTINGS ON THE PREMISES

The **Bistro & Cava Restaurant** opened my eyes on how good fresh tuna can taste right out of the ocean. I love fish, never a big fan of tuna though. The waiter insisted. I was surprised. Best grilled tuna I have ever tasted (photo left page)! It was juicy, flavorful, thick and so tender that I could cut it with a fork. I would go back just for that tuna, and the wine. Below is a traditional Mexican-style tapatío plate: chile relleno de queso, golden chicken taco, beef enchilada, beans, rice and guacamole.

This hotel has a wine cellar with **wine tastings** every day next to the restaurant (photo below). They feature local wines from numerous wineries. This is a nice place to taste a huge variety of wineries in one location. And they have kept their wine prices the same as at the wineries.

This was my first evening and first dinner in this wine region. I came with the perception that Cabernet Sauvignon, which I love, would be very good here. My first tasting was not very exciting. The waiter recommended a Nebbiolo from Bodegas Magoni by the glass (photo right). It was excellent and opened my eyes to the possibility of other interesting wines doing well here. They have numerous wines by the glass and by the bottle. Do a tasting!

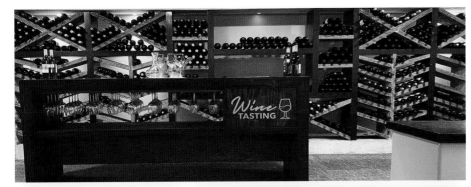

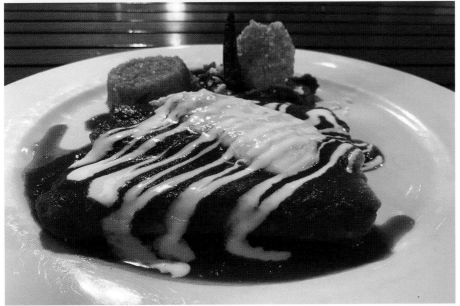

BAJA **VALLE DE GUADELUPE** COASTAL
Hotel, Restaurant, Spa, Wine Tasting
HOTEL CORAL & MARINA

Located: Ensenada Marina
KM 103, Carretera Tijuana-Ensenada
22860 Ensenada, Baja California

+52 646 175 0000
USA 800 862 9020
WhatsApp: +52 646 143 4317
Reservations@HotelCoral.com

HotelCoral.com

Open: All Year, Every Day
Bistro & Cava Restaurant: 7:00am-11:00pm
Wine Tastings: 9:00am-6:00pm

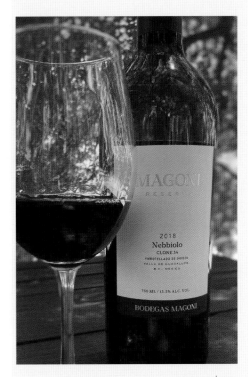

WATER SPORTS

Hotel Coral has its own marina, which is beautiful and clean (photo below). If you would like to arrive by boat, they are ready with 350 slips and full access to the amenities of the hotel. They can accommodate from small 30' boats to 109' yachts. And the marina is embellished with beautiful sailing yachts (photo left page).

If you did not arrive by boat, they can rent you boats with or without skippers. Plus, they have aquatic rentals of **stand-up paddleboards**, **kayaks** (photo below) and **hydrobikes** (photo below). Having the calm water of their own marina makes these water sports a peaceful afternoon in a beautiful environment.

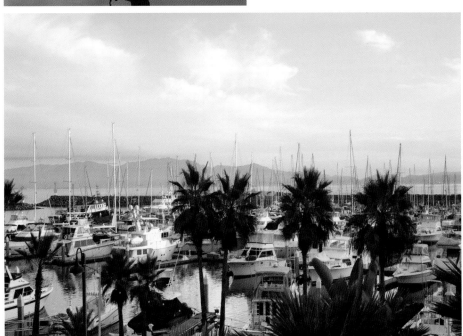

BAJA **VALLE DE GUADELUPE** COASTAL ▪
Hotel, Restaurant, Spa, Wine Tasting
HOTEL CORAL & MARINA

Located: Ensenada Marina
KM 103, Carretera Tijuana-Ensenada
22860 Ensenada, Baja California

+52 646 175 0000
USA 800 862 9020
WhatsApp: +52 646 143 4317
Reservations@HotelCoral.com

HotelCoral.com

Open: All Year, Every Day
Marina Open: 24/7, and 24/7 Security
Aquatics Rentals Open: 9am-4pm
Direct Phone: +52 646-175-0050

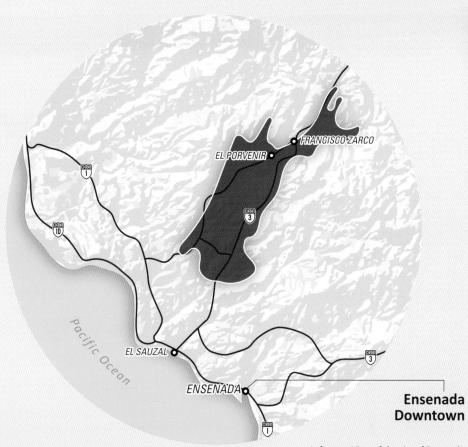

FRANCISCO ZARCO

EL PORVENIR

EL SAUZAL

ENSENADA

Ensenada Downtown

Left page: View of the city of Ensenada downtown and its very active harbor

THE BIG CITY HERE

The city of Ensenada is the primary metropolis nearest to Valle de Guadalupe (about a thirty-minute drive from the west entrance of the valley) with a population of 350,000. Ensenada is located along the Coastal Hwy 1 at the Pacific Ocean alongside of All Saints Bay. **Gray whales** migrate the waters offshore here from January through April.

Ensenada has a very active harbor for commerce, cruise ships and tourism, and is also the primary port city on México's Baja California peninsula. At its heart is the harbor and waterfront area with the **Malecón** promenade. Once a casino, the **Riviera de Ensenada** is now a cultural center. The nearby Museum of History and the **Regional Historical Museum** trace the area's people and past. Migrating gray whales visit the waters offshore.

Ensenada is a peaceful town with a big mix of delicious restaurants. **Manzanilla** is an amazing restaurant hidden in the harbor; **Muelle 3** is a fresh fish restaurant on the harbor's Malecón; **Il Massimo** is an authentic Italian restaurant downtown; **Sano's Steakhouse** is grilling delicious meats; the **street food carts** have an abundance of fresh raw seafood cocktails and visit the street **taco stands** where the fish taco was made famous.

There is one winery in downtown Ensenada, as this is the headquarter of the **Bodegas de Santo Tomás** with a closed-off street surrounded by the winery's museum, numerous shops, restaurants, and wine tasting in the square.

Here is the one winery in downtown Ensenada.
• Bodegas de Santo Tomás, page 135

DOWNTOWN ENSENADA

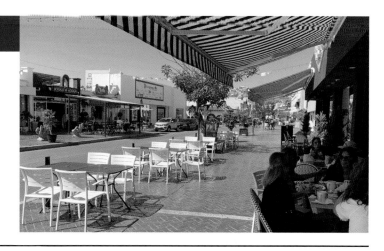

While Ensenada is a large city (pop 350,000), it feels very safe. The downtown area is a big tourist destination for the cruise ships. Large cruise ships dock here regularly (photo previous page).

The Malecón is on the wharf where the fishermen bring in their fresh catch, where there are fish markets and restaurants.

Av Adolfo López Mateos is a beautiful street to wander and enjoy the numerous shops and restaurants (photo right).

There is a closed off street for Bodegas de Santo Tomás with a winery museum, numerous shops, restaurants, and wine tasting in the square.

Excellent restaurants in the city as well. I point you to a few of them.

■ BAJA CALIFORNIA **ENSENADA**
Private Transportation, Personalized Driver
PERZABAL VINEYARD AND WINERY TOURS

Serving Ensenada, Valle de Guadalupe, Tijuana, San Diego, LAX Airports
Agustin Direct: +52 646 151 0001 • Agustin.Perzabal@iCloud.com
WhatsApp is his preferred communication, Text is also good, email is slower

PerzabalTour.mx

When first traveling somewhere, we really do not know our way around yet. And Valle de Guadalupe can be complicated to meander dirt roads. It is helpful to have a local driver. I used Agustín Perzabal, a native here and owner of Perzabal Tours. Now you have his direct phone and email above to reach him.

Agustín picked me up at the US border, drove me to my hotel and was with me every day thereafter for two weeks. He was indispensable, knowing the area, how to find things and the people to contact. While I give you maps, instructions and contacts so you can do this yourself, I can tell you I used Agustín for my second and third trips even though I was familiar.

■ BAJA CALIFORNIA **ENSENADA** DOWNTOWN
Taco Stand Taco Stand
TACOS FENIX TACOS CORONA

On Ave Espinoza at Ave Juárez, Zona Centro, Ensenada
+52 646 977 1191 • +52 646 188 0316
Open: Every Day, 7am-8pm • *Open Every Day, 7:30am-6:30pm*

These two taco stands are right across a small street from each other. Imagine this, they both started in 1970. Tacos Fenix is credited with making fish tacos famous. Maybe not the first taco stand; however, it has created quite the buzz and popularity amongst the locals.

They both are very busy and rapidly making tacos with two choices: fish or shrimp. Their customers eat the tacos right on the sidewalk. Lots of condiments as you can see in the photo below (photo at Tacos Corona).

Ready for a rustic culinary adventure? Ensenada has street food carts downtown that serve fresh raw fish and in many delicious ways. I'm sure you may wonder, as I did, how fresh as the fish? Well, the ocean is right there, and they buy directly from the fisherman every morning. The later you show up at the carts, the less fish they have to serve you. They run out of their favorites fast. Sometimes by noon. And there are always lines! Imagine street carts getting ratings as the third best fish restaurant in the city and Anthony Bourdain considering the seafood as Michelin quality. Excellence here!

ENSENADA DOWNTOWN ▪
Street Food Cart
MARISCOS EL GORDITO

CORNER OF: Virgilio Uribe at Ruiz
+52 646 151 8523
Open: Everyday, 11am-3pm

ENSENADA DOWNTOWN ▪
Street Food Cart
LA GUERRERENSE

CORNER OF: Alvarado at First Street
+52 646 174 0006
Open: Wednesday-Monday, 10am-5pm

ENSENADA DOWNTOWN ▪
Street Food Cart
EL GÜERO

CORNER OF: Alvarado at Carretera Escénica
+52 646 277 1941
Open: Everyday, 10am-6pm

The **Seafood Cocktail** (photo below) is out of this world, so fresh and flavorful. It is made to order as you stand there. It takes a while as they make it to perfection. They make a special juice that they taste themselves along the way just to be sure it is excellent. I could eat one of these seafood cocktails every day. It was so delicious.

El Gordito started on the streets of Ensenada in the 1960s and is now ranked number three for all seafood restaurants in Ensenada (including the regular sit-down restaurants).

The **Sea Urchin Ceviche & Clam Tostada** (photo below) is a complicated dish with nuts, fruits, vegetables and other fresh fish. It is rich, flavorful and filling.

Sea urchin is the traditional Japanese delicacy uni, a spiny globular echinoderms caught on the floor of the ocean.

Also starting in 1960, Sabina Bandera has built her street food cart business into an international acclaim. **Anthony Bourdain** says: La Guerrerense is the best street food on the planet, comparing it to Michelin-quality seafood.

The **Raw Shrimp Tostada** (photo below) is more than just shrimp if you would like to add more. I did. I saw so much fresh raw seafood. They add fresh clams and octopus with vegetables and their secret salsa sauce. Their special dish is seven different raw fish masterfully blended on top of a tostada with their special salsa.

This street cart attracts high attention as it is right on Highway 1 (Carretera Escénica) at Alvarado, two of the primary streets in downtown. Here you are right in the middle of the downtown action.

MALECÓN ENSENADA

The Malecón of Ensenada is a nice place to walk around, see the fishermen come in with their catches, visit the largest fish market in northern Baja California, have a fresh seafood lunch at a rustic fish restaurant (photo below), see interesting bronze sculptures (photo below) and look overhead for a majestic Mexican flag on a 350-foot pole blowing in the wind.

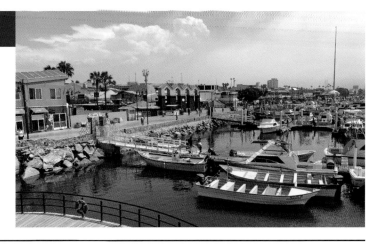

■ BAJA CALIFORNIA **ENSENADA**
Fish Restaurant on the Malecón
MUELLE 3, COCINA DEL MAR

Sobre el Malecón, Paseo del Náutico, Paseo Olas Altas 187, Centro, Ensenada
+52 646 174 0318
Open: Tuesday-Saturday, Noon-6pm

Muelle-3-Restaurant.Negocio.site

As their name translates from Spanish, it is a "kitchen of the sea," on "Pier 3." It is located on the far north side of the Malecón, just north of the large fish market and facing the boats. Muelle 3 is a very small place, with a few seats for inside and outdoor dining. It is a rustic fish restaurant, so don't expect anything fancy... except for the fish. It is delicious. Fresh from the sea.

The ceviche was excellent. It is amazing how delicious a fish can be when it is right out of the ocean. Shrimp, tuna, yellowtail, clams, octopus, tomato, onions, cucumber, and avocado, in a lime, olive oil and tomato sauce. Yum!

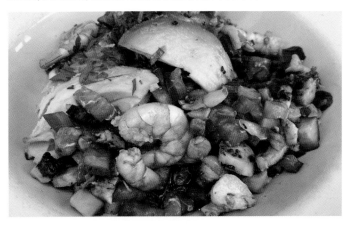

■ BAJA CALIFORNIA **ENSENADA** DOWNTOWN
Steak Restaurant
SANO'S STEAK HOUSE

Carr. Tijuana-Ensenada Km 108.5, Zona Playitas, Ensenada
+52 626 174 4061 • Services@SanosRestaurant.com
Open: Every Day, 1pm-11pm

SanosRestaurant.com

This is a very big restaurant with both inside and outdoor patio seating. It has private rooms and a huge bar with live music. Because of ample space, you will most likely not need reservations.

This is a steakhouse, so you can imagine what they specialize in. And the steaks are excellent. Fish too. Awesome service. They have a very nice wine list to pair with your steaks. Plus, a large selection of micro-beers.

Beyond the great restaurants and delicious wines, Ensenada has a lot of nightlife. Many of the cantinas and nightclubs have great history too. Hussong's Cantina is the oldest bar, sporting over a 130 years of Old West history. Papas&Beers has forty years of crazy fun, live music and an uninhibited atmosphere. Bar Andaluz brought in the thirties with high-life class and style, and invented the famous drink Margarita (photo left). There are so many places in downtown Ensenada to have fun.

ENSENADA DOWNTOWN ∎
Quiet Classy Bar
BAR ANDALUZ

Riviera de Ensenada, Zona Centro, Ensenada
+52 646 176 4310
Open: Tuesday-Sunday, 10am-1am (Sun 8pm)

ENSENADA DOWNTOWN ∎
Nightclub & Cantina
PAPAS&BEER

Primera 335, Zona Centro, Ensenada
+52 646 174 0532
Open: Every day, 10am-4am

ENSENADA DOWNTOWN ∎
Cantina
HUSSONG'S CANTINA

Ave Ruiz 113, Zona Centro, Ensenada
+52 646 178 3210
Open: Every Day, 11:30am-1am (Fri/Sat 1:30am)

The 1940s gave birth to the **margarita** here, inside the former *Hotel Playa y Casino*, when a bartender created this original drink for the new owner of the hotel. And you guessed it, her name was Margarita. Now a cultural center and museum of this heyday hotel of the rich and famous.

Bar Andaluz is a classic bar with rich hardwoods, paintings, ceramic floors and marble tables, a magnificent atmosphere to chill over México's most international cocktail. It is a relatively quieter place to sip a margarita than a landmark bar in the city.

It was 1983 when two friends had a vision of creating a lively environment filled with music, ice-cold mugs of beers, large plates of French fries, and where freedom is allowed with no judgment. This was over a few beers and a plate of potato skins, hence the name Papas&Beer.

They acquired an abandoned two-story hotel in downtown Ensenada and converted it into an exciting nightclub and party atmosphere for both locals and visitors. Arrive uninhibited, as what happens here stays here.

Hussong's Cantina is the oldest and most well-known cantina in Baja México. The original Hussong's is located in downtown Ensenada and started in 1892. A second Hussong's Cantina was franchised and is now in the Mandalay Bay hotel in Las Vegas.

This is a four-generation family business with grandson Ricardo Hussong owning and running the bar today. This is strictly a bar with no food, and just lots of drinks and cantina fun. It has retained its historic Old West bar atmosphere. Bring your horse!

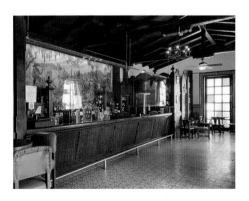

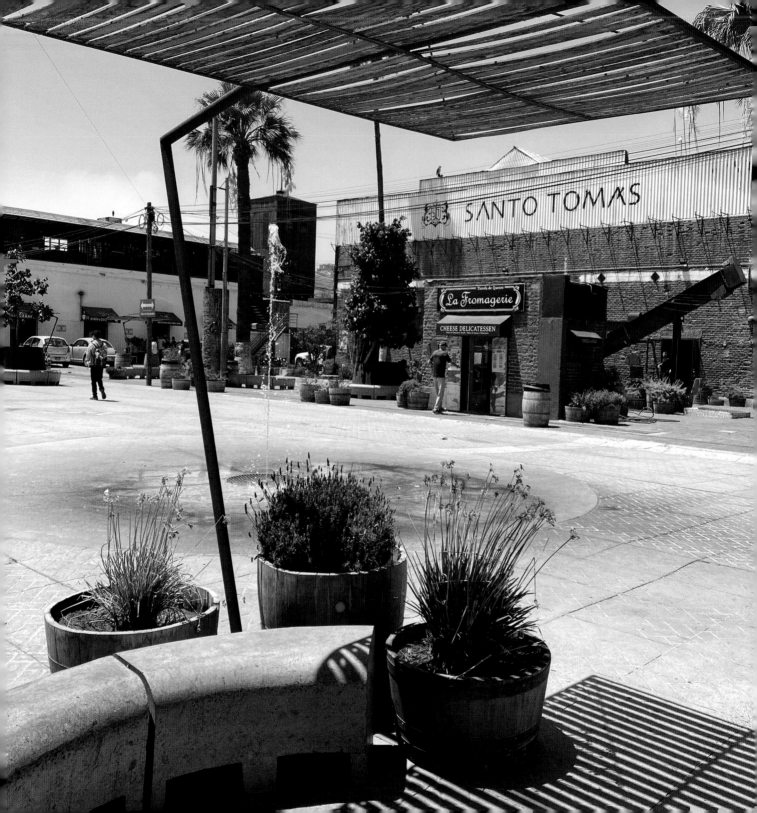

Winemaker: Rioja, Spain

$-$$-$$$

Valle de Guadalupe – Cava San Antonio
Located: Southern Valley, West
3 KM 94, 22800 Villa de Juárez, B.C
Valle de Guadalupe, Baja California

Downtown Ensenada – Cava Miramar
Ave Miramar 666, Zona Centro, Ensenada

Santo Tomás Winery – Santo Tomás Valley
KM 49 Carretera Federal No. 1, Ensenada-La Paz

+52 664 320 9558
ReservationsBST@GrupoPando.com

Santo-Tomas.com

I n 1888, this was the first winery established here, today it is a museum, wine tasting and restaurants.

ENSENADA DOWNTOWN MUSEUM

This is the oldest winery in Baja México beginning in 1791 with vineyards planted by Misión of Santo Tomás an hour south of Ensenada. In 1888, Bodegas de Santo Tomás became a commercial winery, and in 1937, they established a huge winery and cellar in downtown Ensenada that has remained as their executive offices today.

This downtown winery is in the oldest buildings in Ensenada, surrounding a closed off street just for Santo Tomás, with numerous shops, restaurants and wine tasting in the square. These historic buildings and cellar are open for tours and wine tasting with advanced reservations.

This grand facility has now become a museum (open to visitors) and Bodegas Santo Tomás built a new modern winery in the middle of their vineyards back south in the Santo Tomás Valley (photo upper right, and see page 149). RSVP is necessary.

Wine tasting downtown includes a tour of the museum of buildings, winemaking facilities, barrel aging cellars, production, bottling and a large display of historic photos.

In the street square are numerous libation and culinary opportunities: wine shop, cheesemonger, several bars and restaurants, ice cream parlor, etc.

Santo Tomás Valley – The Winery (see page 149)
This is where Santo Tomás makes their wines today.

Valle de Guadalupe – Tasting Room & Restaurant
Bodegas Santo Tomás has numerous vineyards at the west end of Valle de Guadalupe. They built a tasting room with indoor and beautiful outdoor views. They have walking tours to learn about the Santo Tomás philosophies while you stroll around the property sipping wine. Underneath the tasting room is Villa Torél, a small open-kitchen restaurant serving fresh seasonal ingredients (see page 115).

Collection of Wines

Premium Wines
Único (Cabernet Sauvignon, Merlot)
Eikon (Cabernet, Barbera, Tempranillo, Syrah, Carignan, Misión)
Cierzo (Cabernet Sauvigno)
Duetto (Tempranillo, Cabernet Sauvignon)
Xaloc (Tempranillo)
Sirocco (Syrah)

Classic Wines
Cabernet Sauvignon, Tempranillo, Syrah, Merlot, Tempranillo/Cabernet, Barbera, Blanca México (Misión)
Chenin Blanc, Chardonnay, Viognier, Sauvignon Blanc

AUTHENTIC ITALIAN CUISINE

It was an extra special treat to have dinner with Chef Massimo's father, Giancarlo Zaretti, a friend from California who is an icon in Italian cuisine, with celebrities waiting in line to dine in his restaurants in Beverly Hills and Las Vegas. Both as natives of Rome Italy, authentic high-quality Italian cuisine is in the Zaretti blood. And Massimo has brought the very best to Ensenada.

Chef Massimo Zaretti has traveled the world working for five-star hotel restaurants. He knows how to deliver ultimate service and extraordinary cuisine. Truly authentic Italian, Massimo imports Italian '00' flour to make fresh handmade pasta daily. The pasta here is perfect in flavor and texture. He also uses Calabrian chiles and Italian tomatoes, both imported directly from southern Italy.

Il Massimo is a special little place where Chef Massimo is in the dining room personally engaging his guests in a warm and passionate atmosphere of culinary excellence.

Now for the extraordinary cuisine.

Mediterranean Style Pan-Seared Octopus (photo left page) seared on the outside, tender on the inside, served with fresh lemon, fried leeks and a Calabrian chili oil made in-house.

Bucatini with a Cream of Black Truffle and Crispy Pancetta (photo below) is made in-house (semolina and water). It resembles a thick spaghetti with a whole running through the middle. Finished with a cream of black truffle and crispy pancetta (Italian bacon).

Volcán de Limón (photo upper right) is a gooey lemon curd center, topped with a torched meringue.

Housemade Mascarpone Gelato and Amarena Cherries (photo below right) is made fresh daily, served with crushed pistachios and Amarena cherries, a special, intensely flavored cherry from Bologna.

BAJA CALIFORNIA **ENSENADA** DOWNTOWN ▪
Italian Restaurant
IL MASSIMO CUCINA ITALIANA

$$-$$$

Blvd Costero, Lázaro Cárdenas 987, Zona Centro
22800 Ensenada, Baja California

+52 646 977 7089
IlMassimoEnsenada@gmail.com

IlMassimoEnsenada.com

Open: Friday-Wednesday, 2pm-10pm

EXQUISITE SEAFOOD

As food is as unique as the location. You must enter the port and speak to the harbor police at the barricade, then find your way to a ship mechanic's warehouse with ivy growing on its walls, no sign. You will be greeted with classic piano music, friendly people and a large octopus painting in the center of a majestic wood-carved bar.

The owners/chefs, Benito Molina and Solange Muris, are considered pioneers in gastronomy in Baja México, creating this Manzanilla restaurant in 1996. Both trained in France, they create Mexican cuisine with a Mediterranean flair using French styles of cooking; fusing styles, flavors and textures in their designs, preparation and presentation of each dish. Just look at the photos, this place is awesome!

When you have excellent chefs with a creative style, it's always exceptional to choose the tasting menu to experience the extraordinary. Here, six or eight courses are available. Indeed, I indulged. In the end, I must say this is one of my favorite restaurants in all of Ensenada and Valle de Guadalupe. I cannot wait to be back.

Now for some amazing cuisine.

Pig Cheek Taco (photo left page) is marinated with achiote, served with grilled pineapple, pickled onion, and a green sauce made with avocado and coriander sprouts, served on a homemade tortilla.

Rockfish (photo below) is baked and served over black beans cooked in a delicious fish soup and cured nopalitos (chopped and cooked prickly pear cactus paddles).

The Casual Book of Cocktails: Tasted, Tested & Perfected (photo right) for Manzanilla, has its own very remarkable cocktail book. Often times, they like to pair their cuisine with special cocktails, instead of wine, to give the ultimate pairing. For me it was an experience of **Naked & Famous**, fortunately not too famous.

$$-$$$-$$$$

Located: Downtown Ensenada, Harbor
Teniente Azueta 139, Recinto Portuario 22800
Ensenada, Baja California

+52 664 175 7073
RestauranteManzanilla@gmail.com

RManzanilla.com

Open: Wednesday-Sunday, 1pm-11pm (Sun 6pm)

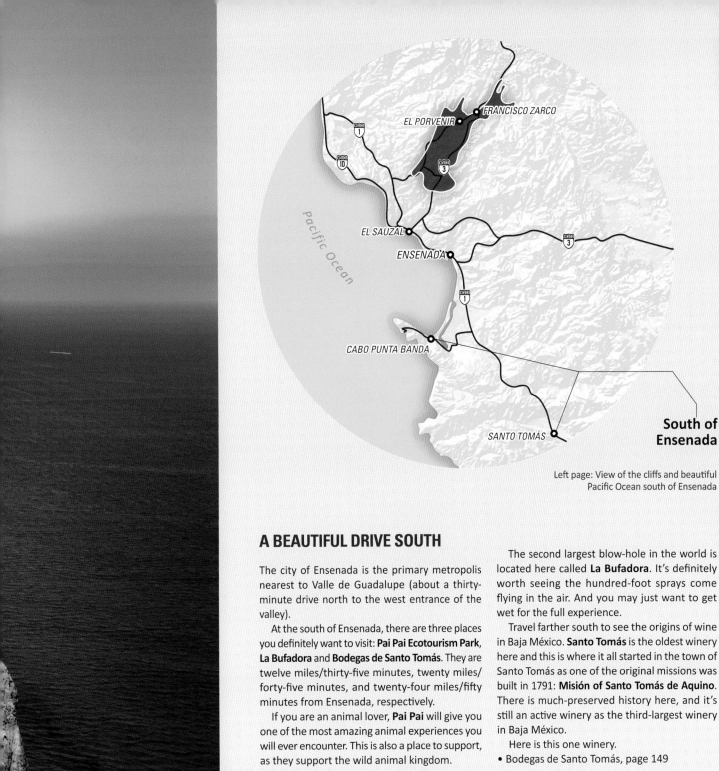

FRANCISCO ZARCO

EL PORVENIR

EL SAUZAL

ENSENADA

Pacific Ocean

CABO PUNTA BANDA

SANTO TOMÁS

South of Ensenada

Left page: View of the cliffs and beautiful
Pacific Ocean south of Ensenada

A BEAUTIFUL DRIVE SOUTH

The city of Ensenada is the primary metropolis nearest to Valle de Guadalupe (about a thirty-minute drive north to the west entrance of the valley).

At the south of Ensenada, there are three places you definitely want to visit: **Pai Pai Ecotourism Park**, **La Bufadora** and **Bodegas de Santo Tomás**. They are twelve miles/thirty-five minutes, twenty miles/forty-five minutes, and twenty-four miles/fifty minutes from Ensenada, respectively.

If you are an animal lover, **Pai Pai** will give you one of the most amazing animal experiences you will ever encounter. This is also a place to support, as they support the wild animal kingdom.

The second largest blow-hole in the world is located here called **La Bufadora**. It's definitely worth seeing the hundred-foot sprays come flying in the air. And you may just want to get wet for the full experience.

Travel farther south to see the origins of wine in Baja México. **Santo Tomás** is the oldest winery here and this is where it all started in the town of Santo Tomás as one of the original missions was built in 1791: **Misión of Santo Tomás de Aquino**. There is much-preserved history here, and it's still an active winery as the third-largest winery in Baja México.

Here is this one winery.

• Bodegas de Santo Tomás, page 149

Located: 12 miles/35 minutes from Ensenada
La Bufadora km6, Ensenada - Lázaro Cárdenas
22790 Ensenada, Baja California

+52 646 246 6200
WhatsApp: +52 646 107 2377
PaiPaiEns@gmail.com

PaiPaiEcotourismPark.com/en

Open: Wednesday-Monday, 9am-6pm (Sat/Sun 7pm)

An animal lover's paradise. This is a very caring and quite admirable animal conservation center.

Top left: Meet Pánfilo, a thirteen-year-old crocodile who greets you at the entrance of the park

A PLACE OF LOVE AND SUPPORT

Are you an animal lover, like I am? Pai Pai Ecotourism Park is a very special place that takes in and actively rescues animals from all over México. This place is worthy of your support. And it's a beautiful place to connect with animals that we love so dearly.

There are numerous activities available here. Zip-lining over the park (photo right), traditional dances by Pai Pai natives (photo far right), horseback riding, and most activities that involve very close interactions with the animals. These experiences are both educational and full of animal love. Plan on a full day to enjoy this place.

Animals have a forever special place in my heart. I have always had the ability to connect with them, look in their eyes, and share feelings and love. Pai Pai is a great place to connect with nature through animals as you will be able to touch and connect with them as closely as you desire.

Meet my girlfriend, Rebecca (photo left page). It was love at first sight. Isn't she beautiful? Just look at her delicate eyes and the kind soul inside. We enjoyed a beautiful love affair, as long as the time would allow us. When it was time to go, she would not let that happen. She held close and kissed me. And even food would not entice her away from me.

BAJA CALIFORNIA **ENSENADA** SOUTH ◼
Preservation, Attraction
PAI PAI ECOTOURISM PARK

Located: 12 miles/35 minutes from Ensenada
La Bufadora km6, Ensenada - Lázaro Cárdenas
22790 Ensenada, Baja California

+52 646 246 6200
PaiPaiEns@gmail.com

PaiPaiEcotourismPark.com/en

Open: Wednesday-Monday, 9am-6pm (Sat/Sun 7pm)

MORE AND MORE ANIMALS

Are you a kitty lover like I am? I love them all, big and small. I have spent a lot of time in Africa in the bush, observing and photographing lions. My friends always remind me before I go to not pet or kiss the big kitties. So, meeting Cesaro (photo left page) was an exciting experience to play with a nine-month-old African male lion. As a kitten, he was a bit rough in his playfulness. I loved it though.

Later, I was asked to put my hand in an enclosed box and find an animal inside. Then tell them what is the animal? A hedgehog! And I thought it was a baby porcupine. Meet Somi (photo above).

There are so many more animals to learn about here. Do you know the difference between a turtle and a tortoise (photo upper right)? Can you imagine how a lemur made its way from Madagascar to México (below right)? Ready to experience the playfulness of a squirrel monkey (below center)? Imagine how exciting it is to get really close and see the details of predatory birds (below left).

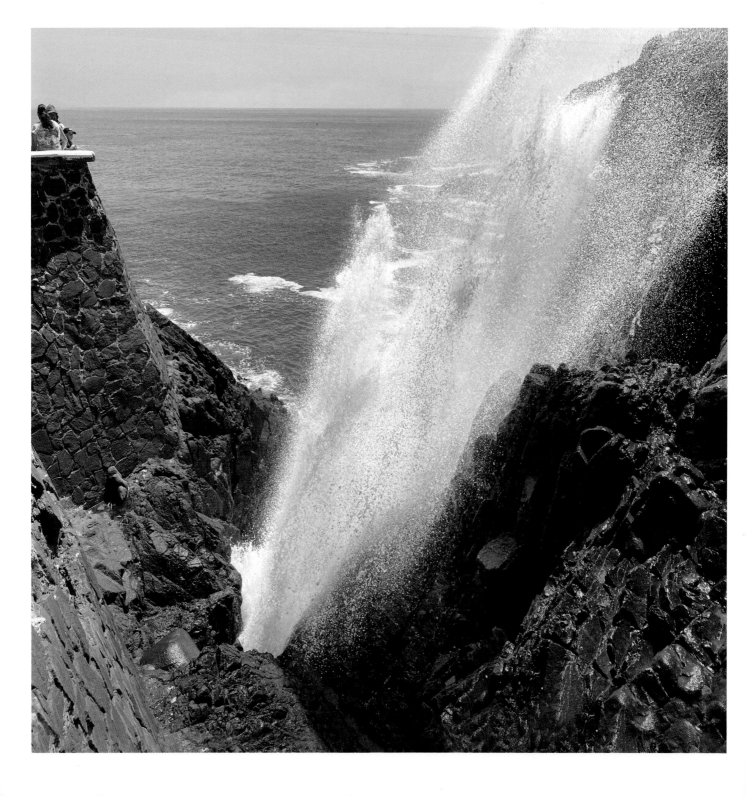

Free

Located: 20 miles/45 minutes from Ensenada
Península de Maneadero, Punta Banda I
22794 Ensenada, Baja California

+52 646 152 0115
facebook.com/labufadora.ensenada

Open: Every Day, 24 Hours

A NATURAL MARINE GEYSER

La Bufadora is a natural marine geyser that has become a popular tourist attraction about one hour south of Ensenada on the Punta Banda Peninsula (15 minutes past Pai Pai). La Bufadora is considered the second-largest marine geyser in the world (the largest is at Makapuu Point in Oahu Hawaii).

La Bufadora is formed by a partially submerged sea cave affected by the tidal flow along the coast. This marine geyser phenomenon is caused by ocean waves being forced into this partially submerged sea cavern, creating great amounts of air and water pressure to build and get trapped until it is forced through an opening at the top. The results are these spectacular water sprays you can see in the photos (left page and below).

The original tale. La Bufadora translates to "The Blowhole" in Spanish. The name came from a local legend that says a baby whale entered the underwater cave over a century ago and got stuck. As the whale grew, he could not get out. So today, the spout of water is from the now-grown whale's blowhole. Interesting.

The geyser regularly shoots up to 100 feet in the air. You can get right up close along the cliff (photo below). Even on a calm day, you can get wet from the spray; however, the best time to visit is when the waves are high making the sprays most impressive.

The entrance road down to La Bufadora (photo top left) brings you into an extensive shopping center that curves along a roadway down to the cliffs to see the geyser. There are numerous food vendors, restaurants, handmade souvenirs and shops where you can haggle more than you can in town (photo below).

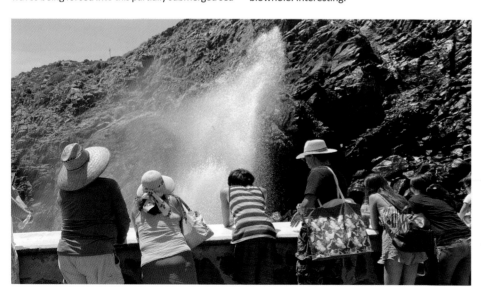

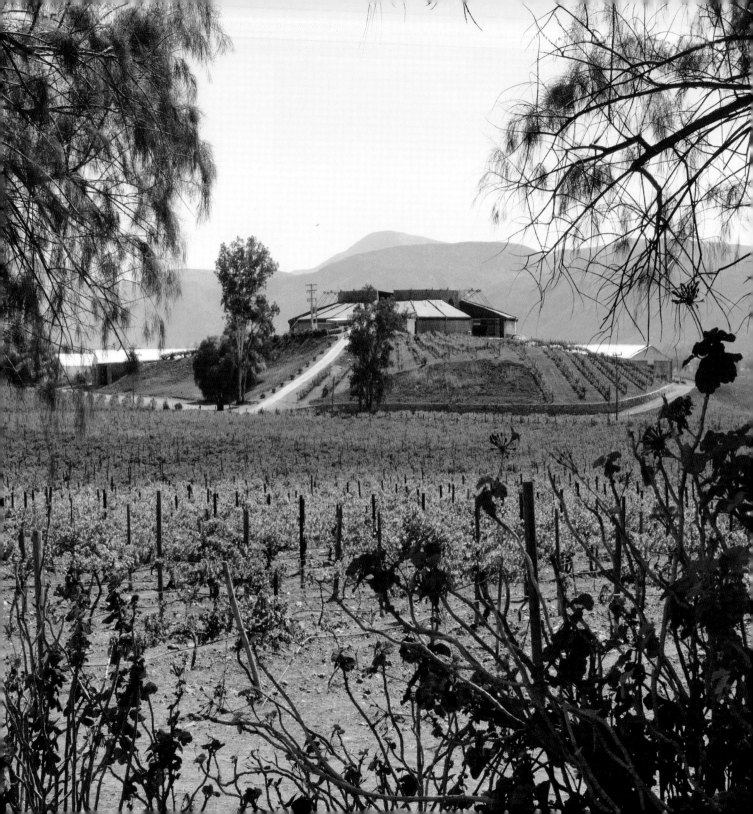

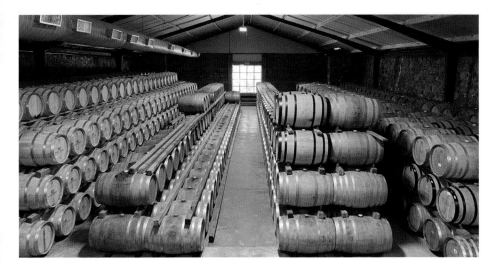

Winemaker: Rioja, Spain

$-$$-$$$

Located: 24 miles/50 minutes from Ensenada

Valle de Guadalupe - Cava San Antonio
Located: Southern Valley, West
3 KM 94, 22800 Villa de Juárez, B.C
Valle de Guadalupe, Baja California

Downtown Ensenada - Cava Miramar
Ave Miramar 666, Zona Centro, Ensenada

Santo Tomás Winery - Santo Tomás Valley
KM 49 Carretera Federal No. 1, Ensenada-La Paz

+52 664 320 9558
ReservationsBST@GrupoPando.com

Santo-Tomas.com

I n 1888, this was the first winery established here, today they have three locations for us to enjoy.

NEW WINEMAKER IN 2019

When you are over 135 years old, it is important to remember to stay up to date. The current family president of Santo Tomás hired a very talented winemaker Christina Pino, from Badajoz Spain, to take over in 2019. In 2003, he was also known for hiring the first female winemaker in México. This is an old winery, staying new and innovative.

Christina is focused on creating the highest quality and elegance in her wines. She is achieving this by modifying the vineyards here towards organic farming, reducing their yields, having tighter grape selection, bringing in new technology into the winery, and insisting on cleanliness everywhere.

As a critic of Guadalupe Cabernet, I wanted to taste her 2019 waiting in a tank ready for blending. Impressive! She has brought this grape a very long way. She is personally a fan of her 2019 Syrah. I could not stop drinking it, it was so delicious.

I expect this winery to come a long way as Christina gets more and more involved with improving everything from the vineyards to winemaking.

You can visit the winery and vineyards (photo left page and above), and go inside to see the innovative operations. It is one hour south of Ensenada in Santo Tomás Valley. RSVP is necessary.

Downtown Ensenada

This original winery is in the oldest buildings in Ensenada surrounding a street closed off just for Santo Tomás, with numerous shops, restaurants and wine tasting in the square. The historic buildings and cellar are open for tours, as well as wine tastings, with advanced reservations (see page 135).

Valle de Guadalupe – Tasting Room & Restaurant

Bodegas Santo Tomás has numerous vineyards at the west end of Valle de Guadalupe. They built a tasting room with indoor and beautiful outdoor views. They have walking tours to learn about the Santo Tomás philosophies while you stroll around the property sipping wine. Underneath the tasting room is Villa Torél, a small open-kitchen restaurant serving fresh seasonal ingredients (see page 115).

Collection of Wines

Premium Wines
Único (Cabernet Sauvignon, Merlot)
Eikon (Cabernet, Barbera, Tempranillo, Syrah, Carignan, Misión)
Cierzo (Cabernet Sauvigno)
Duetto (Tempranillo, Cabernet Sauvignon)
Xaloc (Tempranillo)
Sirocco (Syrah)

Classic Wines
Cabernet Sauvignon, Tempranillo, Syrah, Merlot,
Tempranillo/Cabernet, Barbera, Blanca México (Misión)
Chenin Blanc, Chardonnay, Viognier, Sauvignon Blanc

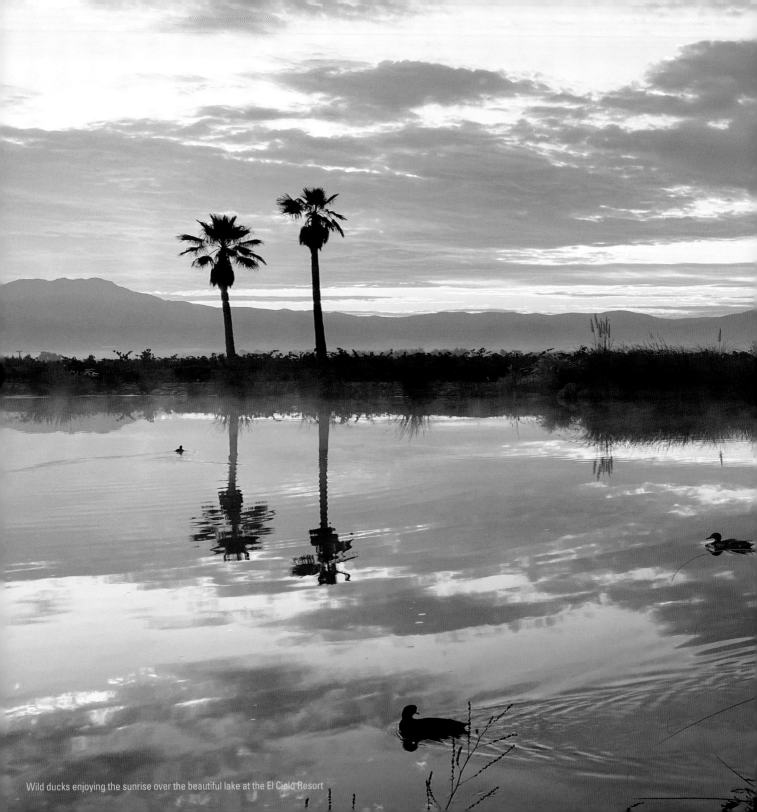

Wild ducks enjoying the sunrise over the beautiful lake at the El Cielo Resort

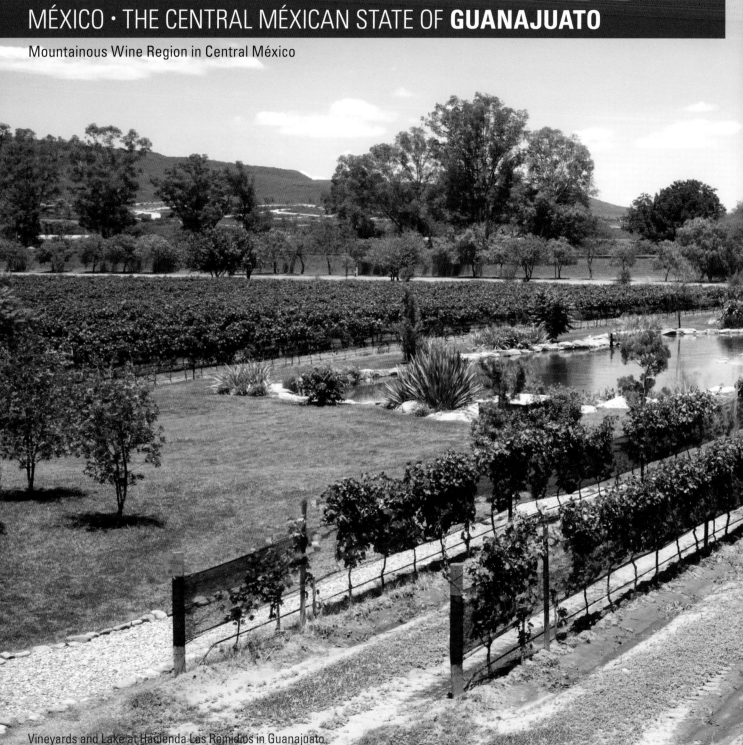

Vineyards and Lake at Hacienda Los Remidios in Guanajuato.

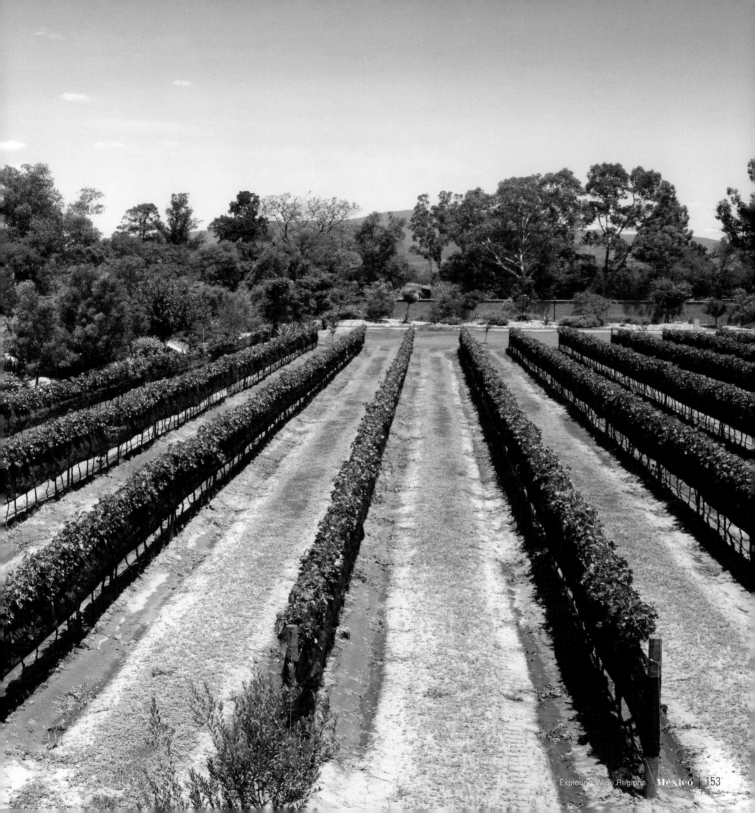

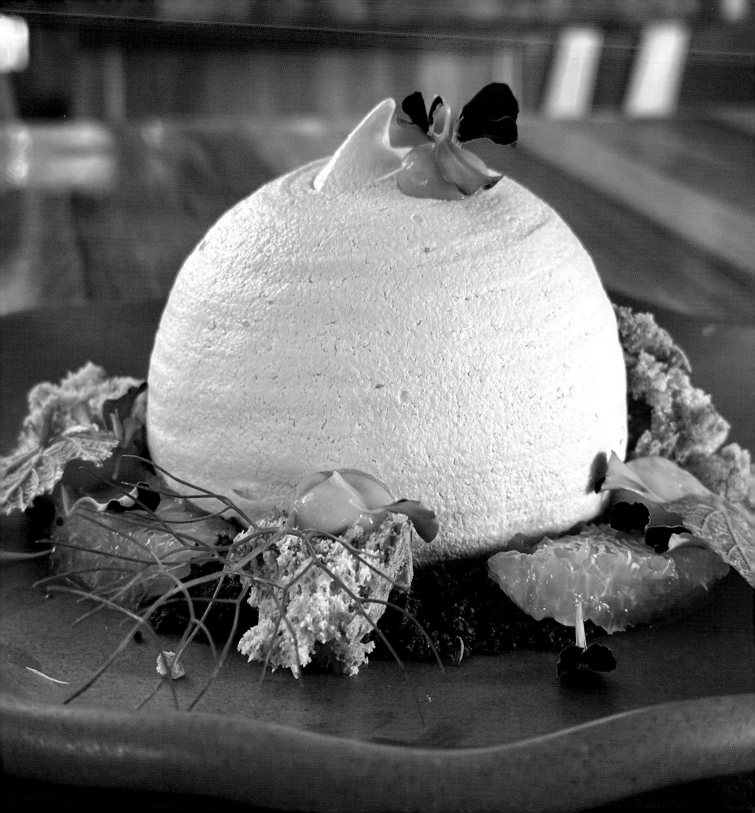

I n the mountainous region of central México is this land of wineries, cobblestone villages, colonial and baroque architecture, and internationally inspired gourmet cuisine.

THE STATE OF GUANAJUATO

Guanajuato is one of the smaller states in México, located in the mountainous region of México northwest of México City. In these Sierra Madre Oriental Mountains, this state has an average elevation of about 6,000 feet.

Guanajuato is also the name of the capital city of the state. It is at the far western edge of the state adjacent to the city of León where the Guanajuato International Airport is located.

The wine regions of Guanajuato are in the eastern part of the state, a long distance from Guanajuato city and its airport. A closer airport to the Guanajuato Wine Regions is Quetéraro Intercontinental Airport and Quetéraro offers excellent wine regions as well.

San Miguel de Allende is a stunningly beautiful colonial-era town, central to the Guanajuato Wine Regions. See the map on the next page; the wine regions are east, south and west of San Miguel de Allende. San Miguel is perfect as a reference point to navigate to each winery.

Specifically, I chose the intersection of Hwy 51 (going west and south) and Hwy 111 (going east) as the official point for all references provided.

So, at the far west of the state, 105 miles (two hours drive) west of San Miguel de Allende, is the capital city of Guanajuato, León and the Guanajuato International Airport (BJX).

East of the state of Guanajuato is the state of Querétaro with Santiago de Querétaro being its capital city. San Miguel de Allende is eighty miles (1.25 hours drive) west of Querétaro city, and the Querétaro, Intercontinental Airport (QRO).

Querétaro Intercontinental Airport (QRO) This is the closest and best airport to use to fly into the Guanajuato Wine Regions and Querétaro Wine Regions. It is the closest, most practical and has flights from numerous cities in the United States and México.

Guanajuato International Airport (BJX) Unless you plan to visit Guanajuato or León, this airport is farther away and not as nice as the Querétaro airport.

México City International Airport (MEX) is farther away from the Guanajuato Wine Regions; however, there are excellent culinary and cultural opportunities in México City that could be added to your trip where this airport would be valuable.

Driving Distance to San Miguel de Allende from...
- **Querétaro Airport** 80 mi (1 hr, 25 min)
- **Guanajuato Airport** 105 mi (2 hrs, 0 min)
- **México City Airport** 160 mi (4 hrs, 0 min)

The cuisine in Guanajuato, San Miguel de Allende and at the wineries of Guanajuato is outstanding. Better than you would imagine...
Pavlova Rellena de Crema (photo left page) is from Chef Ricardo Luna at Cuna de Tierra, a meringue shell with a delicate crispy exterior and pillowy soft marshmallow inside. It is filled with diplomatic peach cream on cocoa crumble, grapefruit and orange segments, pistachio sponge cake and orange peel gel.
Ultimate Cheese Board (photo above) is from Chef David Quevedo at Viñedo San Miguel, piled high with four cheeses and seasonal fruits; gouda cheese, provolone cheese, goat cheese, and Edam cheese, accompanied by aged salami and serrano ham, strawberries and caramelized figs, with toasted bread and mesquite smoked olives.

GUANAJUATO

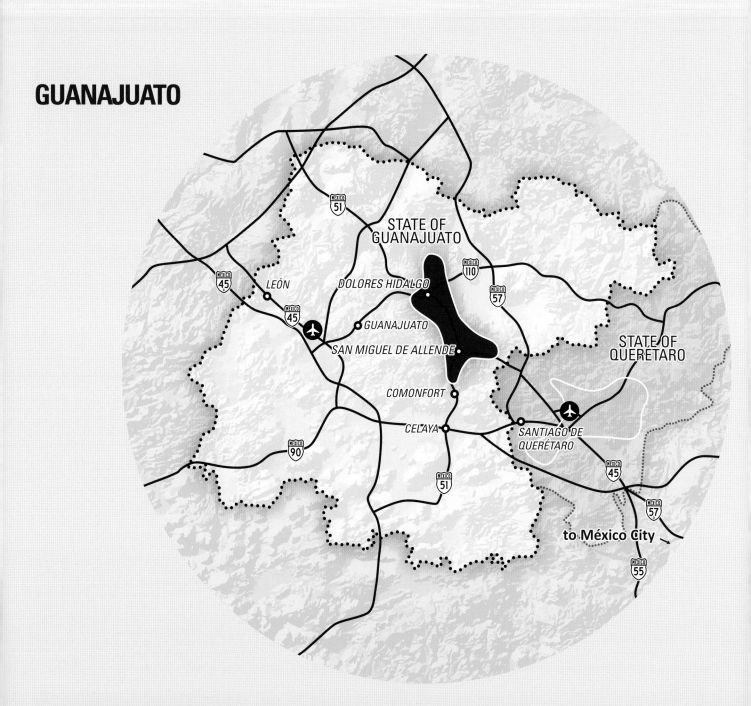

STATE OF
GUANAJUATO

MEXICO 51

MEXICO 45

LEÓN

MEXICO 45

DOLORES HIDALGO

MEXICO 110

MEXICO 57

GUANAJUATO

SAN MIGUEL DE ALLENDE

STATE OF
QUERÉTARO

COMONFORT

CELAYA

SANTIAGO DE
QUERÉTARO

MEXICO 90

MEXICO 51

MEXICO 45

MEXICO 57

to México City

MEXICO 55

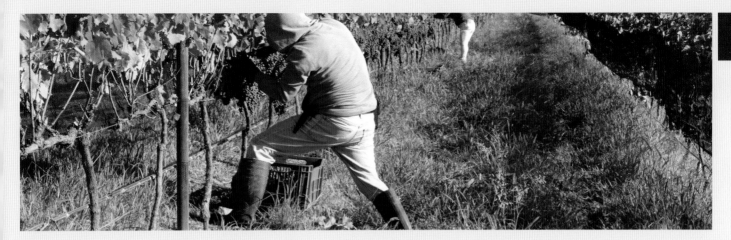

I n the past twenty years, this valley has grown from only a few wineries to hundreds of them today. Most accept visitors, many have food.

TERROIR OF GUANAJUATO

You must be wondering, Guanajuato is way outside the wine-growing latitudes. It is almost always necessary for Vitis vinifera (the grape variety that makes virtually all quality wine) to be growing in the wine-growing latitudes in order to make good wines. The Guanajuato Wine Regions are an exception.

Vitis vinifera grows best in a relatively narrow band that circles earth... between latitudes 30° and 50° in both the northern and southern hemispheres. For example, Napa California is at latitude 38°. Bordeaux France is 45°. In the south, Mendoza Argentina is at 33°. This is one of the reasons why these wine regions produce excellent wines.

The northern hemisphere is by far the largest producer because the band covers a lot more land. In the southern hemisphere, it has much fewer vineyards because so much of this band is over oceans. The closer you get to the equator, the hotter and more humid it becomes, and as you go farther away from the equator, the reverse happens and it gets too cold. These are not conducive for growing excellent wine grapes.

So here we are in San Miguel de Allende where the latitude is 21°, far outside the wine band; however, the Guanajuato Wine Regions have factors

though that give the grapes what they require. The largest benefit is that it has high elevation of 6,000 feet, bringing the grapes closer to the sun. This gives them the higher solar radiation they need to mature and ripen properly. This mountain desert makes the temperatures hot during the day and cools at night, giving the diurnal effect essential for growing quality grapes.

The increased solar radiation also produces thicker skins on the grapes. As we know, grape skins play a pivotal role in producing red wines, as the phenolic compounds found in them will contribute key coloring compounds as well as flavor, mouthfeel and structure to the finished wine. Plus, resveratrol, the antioxidant that helps protect us against cardiovascular diseases, cancer, liver diseases, obesity, diabetes, Alzheimer's disease, and Parkinson's disease. Cheers to the thick skins of Guanajuato!

This is a semi-arid desert, with a mild climate and low humidity. Rainfall is unusual here. Generally, there is no rain in winter or spring; hail occurs during the summer months; and rain happens during the harvest months. This is a benefit to the vines, as well as a challenge to the farmers with rain during harvest.

In the end, all these factors, make for outstanding terroir for growing excellent grapes to make high quality wines.

The Guanajuato Wine Regions can be divided into three areas which I have prepared in this book to make it easier for you to orient. Below is the order in which the regions are presented.

Southern Comonfort Region

I start with the wine region south of San Miguel de Allende located just before the town of Comonfort on Hwy 51. There are two wineries and two restaurants (in the wineries) here that you should visit.

Eastern San Miguel Region

The wine regions east of San Miguel de Allende run along Hwy 111 going towards Querétaro and are located in San Miguel County. There are four wineries, five restaurants and three hotels here that you should visit.

Northwestern Dolores Hidalgo Region

The wine regions going west and north from San Miguel de Allende run along Hwy 51 which connects the two primary cities here of San Miguel and Dolores Hidalgo. This wine region is farther away from San Miguel; however, there are six wineries, seven restaurants and four hotels here that are worth your visit.

For each of these wine regions, planting the right varietals in this terroir are essential. Here, I found the terroir that works best for Cabernet Franc, Malbec, Cabernet Sauvignon and Tempranillo. You would definitely love these wines.

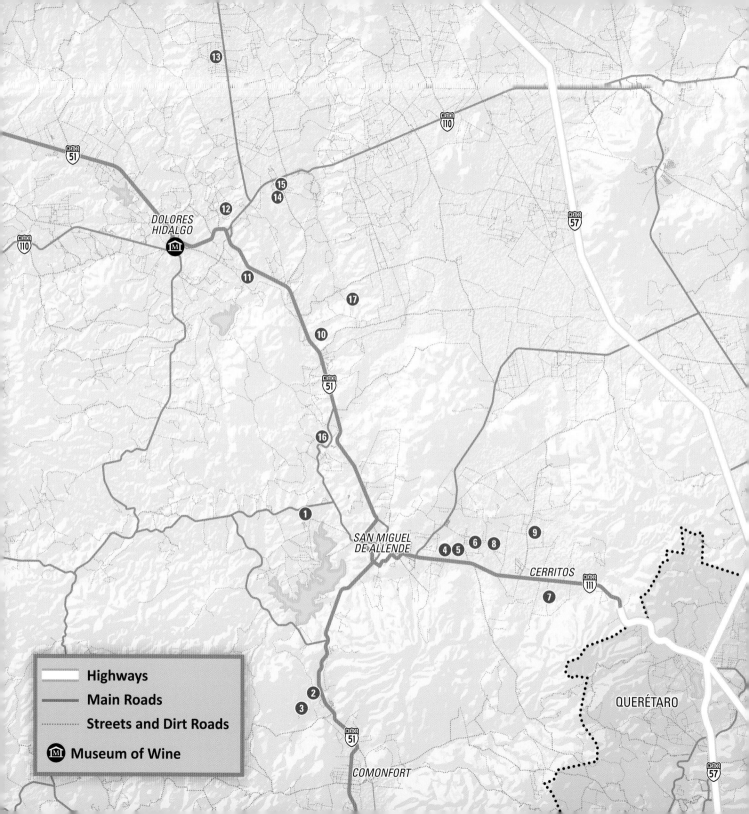

Highways

Main Roads

Streets and Dirt Roads

Museum of Wine

GUANAJUATO WINERIES

	Number of Wines	Red Wines	White Wines	Rosé Wines	Sweet Wines	Sparkling Wines	Wine Shop	Boutique	Accommodations	Restaurant	Food Options	Food & Wine Pairings	Tours	Educational Workshops	Fun Activities	Spanish Wines	French Wines	Italian Wines	Other
Central San Miguel Region																			
① Hacienda San Jose Lavista	9	√	√	√	√		√	√				√				√			
Southern Comonfort Region																			
② Viñedo San Miguel	13	√	√	√		√	√	√		√	√	√	√		√	√	√	√	
③ Rancho Los Remedios	5	√	√	√	√		√	√		√	√	√	√			√			√
Eastern San Miguel Region																			
④ Viñedos Dos Búhos	10	√	√	√		√	√			√	√		√			√	√		
⑤ Viñedos Toyan	8	√	√	√			√						√						
⑥ Viñedos San Lucas	5	√	√	√		√	√	√	√	√	√		√						
⑦ Casa Anza	7	√	√	√			√			√			√						
⑧ Viñedos San Francisco (Hotel & Restaurant)																			
⑨ Viñedos Santa Catalina (Hotel & Restaurant)																			
Northwestern Dolores Hidalgo Region																			
⑩ Viñedo Tres Raíces	13	√	√	√			√	√	√	√	√		√	√	√	√	√		
⑪ La Santísima Trinidad	11	√	√	√	√	√	√	√	√				√	√	√				
⑫ Viñedos San Bernardino	6	√	√				√			√			√		√		√	√	√
⑬ Viñedo Los Arcángeles	7	√	√	√			√	√	√	√	√	√	√		√	√			
⑭ Viñedo Cuna de Tierra	14	√	√	√	√		√		√	√	√	√	√	√					
⑮ Cavas Manchón	5	√	√		√		√									√	√		
⑯ Hotel Virvana Restaurant & Retreat (Hotel & Restaurant)																			
⑰ Hotel Viatura Omún (Hotel & Restaurant)																			

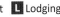

⓿ Winery **R Restaurant** **L Lodging**

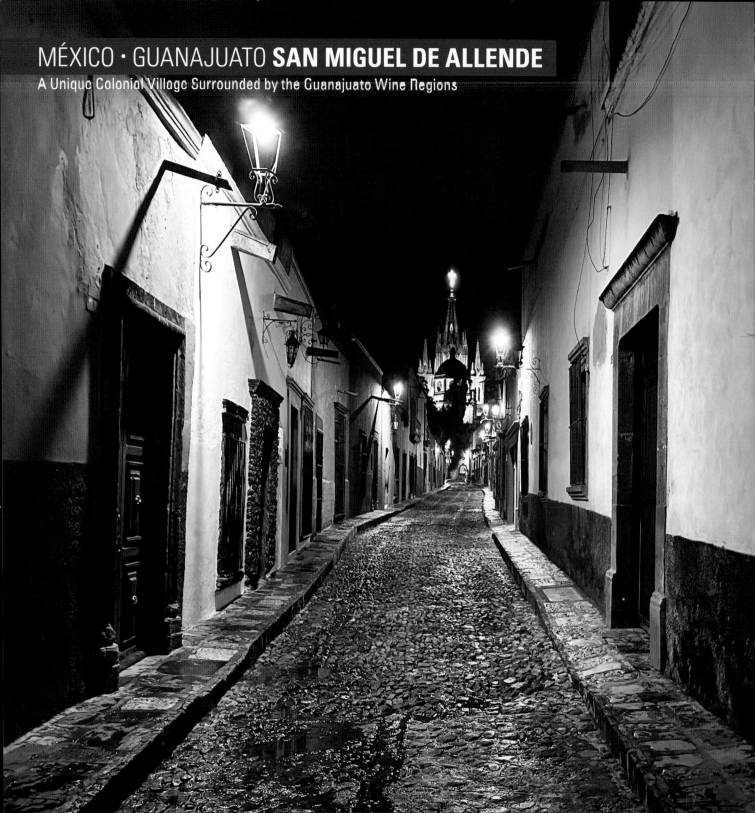

MÉXICO · GUANAJUATO **SAN MIGUEL DE ALLENDE**

A Unique Colonial Village Surrounded by the Guanajuato Wine Regions

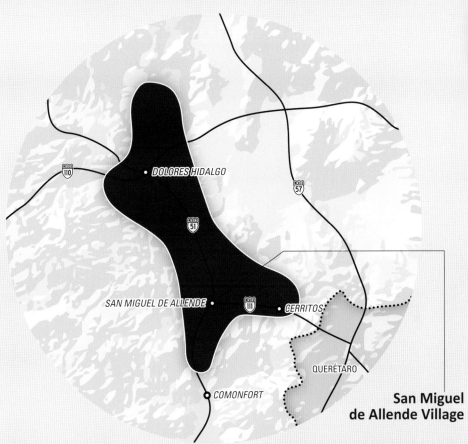

DOLORES HIDALGO

SAN MIGUEL DE ALLENDE

CERRITOS

QUERÉTARO

COMONFORT

**San Miguel
de Allende Village**

Left page: Looking down a cobblestone street
of San Miguel de Allende viewing
the San Miguel Arcángel towers

MIDDLE OF THE WINE REGIONS

San Miguel de Allende is both the name of the primary city and county located at the far eastern edge of the state of Guanajuato. San Miguel de Allende (San Miguel) city is in the middle of the **Guanajuato Wine Regions**, with vineyards and wineries immediately to its south, east and west. The wineries located central and east of the city are in the official San Miguel Wine Region county.

San Miguel de Allende, ground zero for Mexican independence, has positioned itself worldwide as a small cosmopolitan city; known for its friendly people, art, culture, security and pleasant climate within an exponential framework of colonial architecture; it is no wonder that for the second year in a row, it has been named Best City

in the World by Travel + Leisure magazine as a World Heritage Site by UNESCO.

San Miguel de Allende has a population of 75,000 (county population is 175,000). The central village (Centro) is the historic center of San Miguel de Allende, dating back to the sixteenth century with cobblestone streets and the magnificent church, San Miguel Arcángel, across from a large central park in the central plaza.

San Miguel de Allende derives its name from two people of the sixteenth century: a friar, Juan de San Miguel, and a martyr of Mexican independence, Ignacio Allende, who was born in a house facing the central plaza.

There is one winery central in the San Miguel de Allende Wine Region.

• Hacienda San José Lavista, page 183

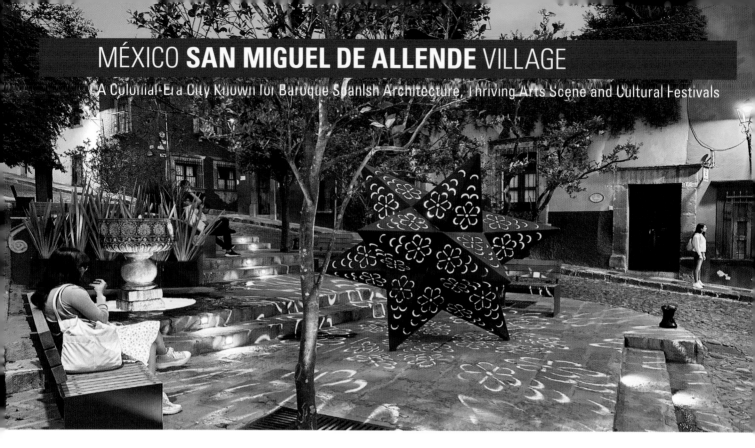

MÉXICO **SAN MIGUEL DE ALLENDE** VILLAGE

A Colonial-Era City Known for Baroque Spanish Architecture, Thriving Arts Scene and Cultural Festivals

I ♥ SAN MIGUEL DE ALLENDE

The village of San Miguel de Allende is a very special place. You will feel like you've transported yourself back to another time. And you have. This colonial-era village of cobblestone streets has been kept and restored to its original conditions of 250 years ago. It became a **UNESCO World Heritage Site** in 2008.

San Miguel hasn't always had it's lively atmosphere. It practically became a ghost town after an influenza pandemic hit at the beginning of the twentieth century. Afterwards, foreign artists moved in, discovering this very cool and creative environment in a village that cost them almost nothing to live in.

Art thrived here. Several art and cultural institutes were established. And the San Miguel artistic virtues got out. Famous artists moved here. Foreign art students were attracted from the United States and Canada. Today, artists of all types embellish this village.

Everywhere I walk in San Miguel de Allende makes me love this place. I love the super-narrow streets made of stone and cobblestones. Many streets have no cars. The colorful colonial buildings have been restored and are now filled with art galleries, cafés, restaurants and hotels. There are so many wonderful things to do here.

There are beautiful little sitting areas like in the photo above with many parks, including the central park in the right page photo. The shopping is excellent, both name-brand designer shops as well as local artisan boutiques. There are restaurants and bars, both simple and gourmet, throughout the village. I've heard there are over 500 restaurants now. This is a foodie's city.

The restaurants are tucked away in these beautiful ancient buildings as bold as the colors of the buildings. Some are in alluring hotels, others along the rooftops around the village. It's such a great way to see the city from the rooftops. And there are many rooftop restaurants.

San Miguel de Allende is a colonial-era city so attractive for its Spanish Baroque architecture, active art scene and cultural festivals that I am not the only one with the camera capturing the village. People are photographing each other, taking selfies, and posting on social media.

San Miguel is a cosmopolitan city, full of small cafes, shops and galleries. People from all over the world come to be tourists or even to live here.

In the historic center of the city is the neo-Gothic church **San Miguel Arcángel**, which has dramatic pink spires reaching high in the sky above the main plaza, **El Jardín**. These colonial spires can be seen from all over the village (photo right page). This active church rings its grand bells often, so captivating to this enchanting village. The nearby church **Templo de San Francisco** has a very cool eighteenth century churrigueresque facade.

The people here love to party, and have cultural festivals and celebrations in the streets on a regular basis.

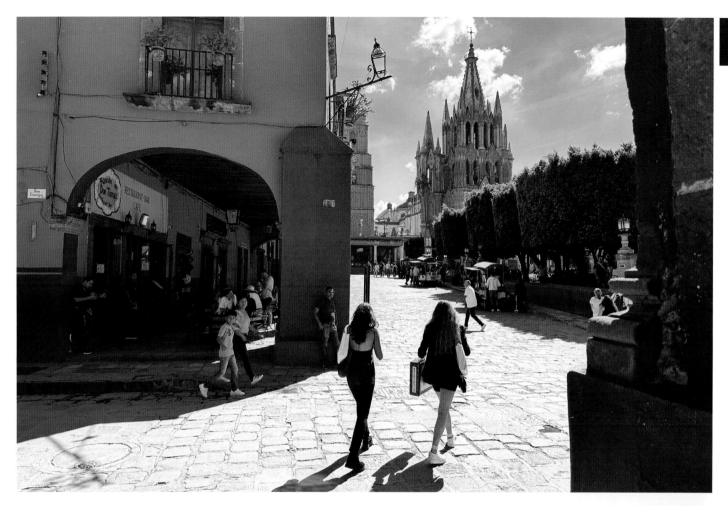

On both of my trips here I found myself in the middle of wonderful festivals.

La Alborada is one of San Miguel de Allende's most celebrated festivities. It is the day of Saint Michael, an archangel who fights against Lucifer. This "fight" is represented by a show of fireworks and pyrotechnics that lasts more than an hour or so on the eve of the Sunday following September 29. When I was there, San Miguel Arcángel fired off a massive display of fireworks for a couple of hours. It was magnificent. People everywhere were watching and photographing (photo right).

Día de los Muertos (Day of the Dead) is a four-day-long celebration in San Miguel de Allende of history and family, arts and culture, food and frolic referred to as **La Calaca**, a celebration in San Miguel.

As I found myself in a Mexican-inspired Spirit World, I ran into living skeletons everywhere.

Día de los Muertos celebrates the loss of family and friends during the year. The tradition surrounding them dates back to Aztec times when the dead would visit their loved ones on this day to eat and drink with them.

Many, many people had their faces painted as skeletons. On the streets were dozens of face painters, carrying out this craft. Large costumes of Catrina roam the streets. This was a festivity of grand proportions.

La Catrina dolls were everywhere. La Catrina translates to "the lady in the hat," a female skeleton wearing an elegant bright-colored dress with a large flowered hat.

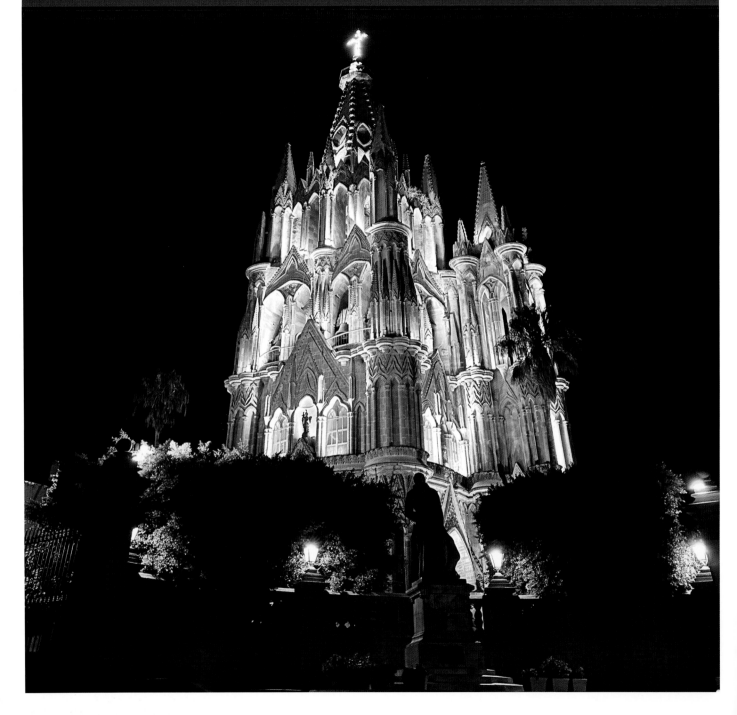

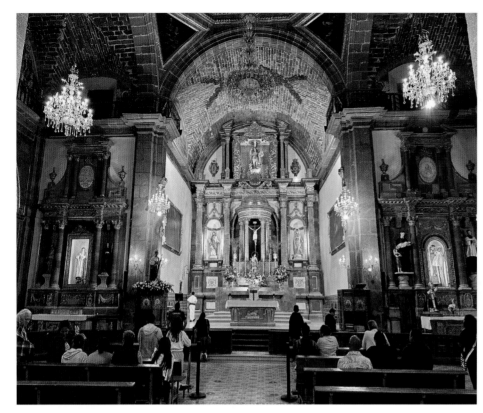

THE CENTERPIECE OF SAN MIGUEL

Parroquia de San Miguel Arcángel, as it is formally known, began as the sixteenth of California's twenty-one Spanish missions in 1797 (named after Saint Michael the Archangel). The mission raised a very large number of livestock. By 1821, the mission had more than 24,000 animals.

Throughout the decades, San Miguel Arcángel experienced wars, murders, takeovers, and was once a hotel, a saloon and retail shops. In 1859, the property was eventually returned to the Roman Catholic Church. Today it is an active parish.

In 1880, the master stonemason of the city, Don Zeferino Gutiérrez, made dramatic changes to the church by rebuilding it into a new Gothic style architecture of Medieval Europe for the parish of today. What is very interesting is that Zeferino was a self-taught mestizo architect who designed the church's façade based on postcards of European cathedrals. For construction, he mapped out each day's scope of work in the sand with a stick. He did not use blueprints because they would require reading and writing, two skills his craftsmen didn't possess.

You cannot miss the grand sound of La Luz, the largest of eight bells of the church, tolling each hour clearly radiating throughout the San Miguel village.

Today, San Miguel Arcángel is world-famous and iconic landmark, the most photographed church in México. It is the centerpiece of San Miguel. Its eclectic and neo-Gothic spires crown the city skyline. So finding San Miguel Arcángel is easy. Just look for its grand spires rising above the buildings.

With the church's dramatic pink towers reaching high in the sky above the main plaza and its El Jardin park, you can easily find your way back to the center of the village.

Inside San Miguel Arcángel is spectacular as well (photo above). The ornamentation is breathtaking. Even if you do not attend church, attending mass is worth its experience.

SAN MIGUEL DE ALLENDE **VILLAGE** ROMANCE

A Beautiful and Sexy Town for Couples

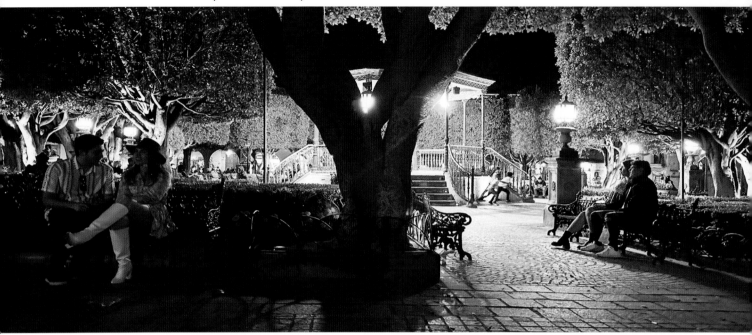

SAN MIGUEL DE ALLENDE **VILLAGE** SHOPPING

Numerous Designer Shops and Local Artisan Boutiques

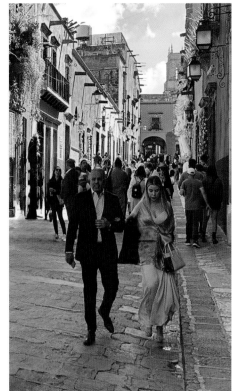

SAN MIGUEL DE ALLENDE **VILLAGE** PHOTOGRAPHY

San Miguel Is Very Well Photographed and Selfied

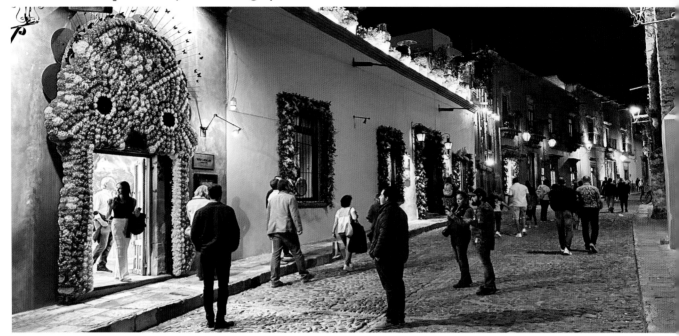

SAN MIGUEL DE ALLENDE **VILLAGE** CELEBRATIONS

Cultural Festivals and Celebrations on a Regular Basis Here

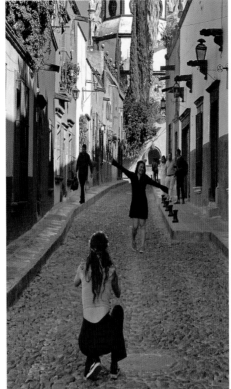

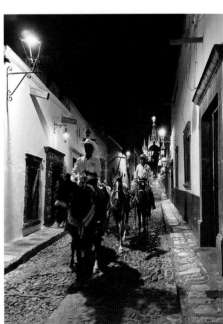

PRIMARY OR SECOND HOME

While San Miguel de Allende is a great tourist destination and a beautiful city amongst the Guanajuato Wine Regions, it is also an excellent place to live. And it's not just my opinion. Over 10 percent of the residents here are foreigners, primarily from the United States and Canada. As a result, English is a very common language here.

Why are there so many Americans in San Miguel? There are many reasons, starting with its obvious beauty and peaceful atmosphere.

We have already been discussing why it is such a beautiful tourism destination with its Spanish colonial buildings, narrow cobblestone streets, pastel-colored historic buildings, and now a UNESCO World Heritage Site. This is a great place to be whether a tourist or a resident.

San Miguel is rich in arts and cultural traditions, has a variety of shops, galleries, many beautiful parks and numerous excellent restaurants.

The population is comfortably small and yet not too tiny; 75,000 in the city, and 175,000 in the county. Querétaro is about an hour away with a population of 1.1 million, an international airport and some of the best healthcare in the country. The vibrancy of México City is a three-hour drive away.

The weather is outstanding. This is a high-desert semi-arid climate, with warm days and cool nights, with sunshine most days of the year (some rain comes in July and August). The year-round daytime temperatures are generally 75° to 85° every day.

This is a huge expat community representing sixty-three nationalities, and English is spoken by almost everyone.

San Miguel is consistently listed in the top five safest cities in all of México.

And yes, San Miguel is considered as one of the prettiest small towns in México.

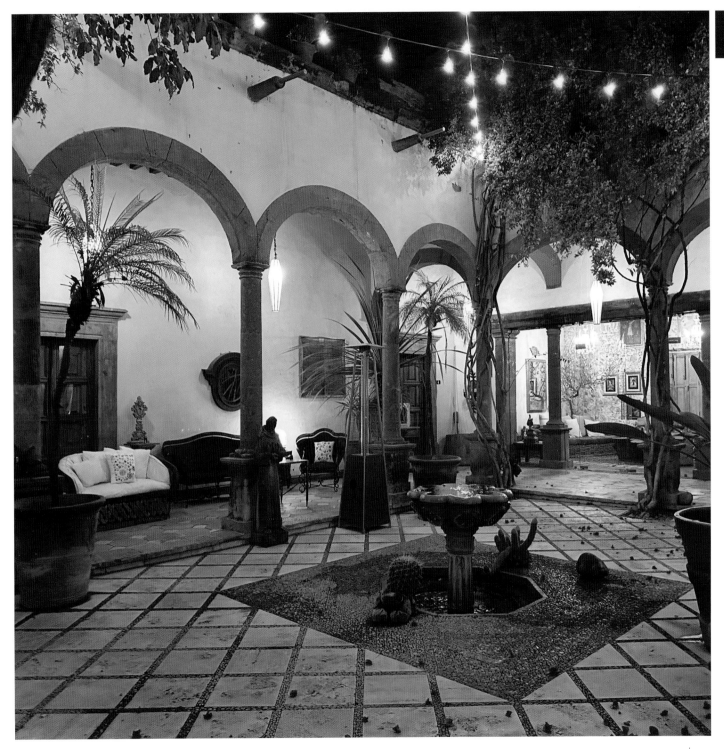

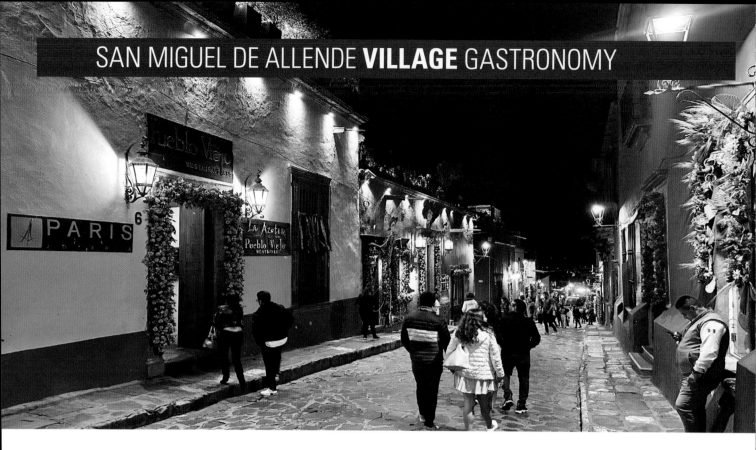

SAN MIGUEL DE ALLENDE **VILLAGE** GASTRONOMY

A MECCA OF GASTRONOMY

With only 75,000 people in San Miguel de Allende, it has attracted a delicious variety of talented chefs who have created over 500 restaurants throughout its cobblestone streets and inside the beautiful historical buildings.

The streets come alive with couples, family and friends roaming on the streets for their next culinary experience.

It is truly a gastronomic delight to wander on the streets here. Everything from delicious steaks, fresh seafood and traditional tacos, as well as gelaterias and cafés. The culinary creativity here is remarkable. Chefs are having way too much fun. And for our enjoyment as well.

And to directly combine the wine regions with the culinary arts, check out the Cabernet Sauvignon gelato served at the City Market (photo far right).

Cabernet Sauvignon Gelato at City Market

THE ULTIMATE SUPERMARKET

Upon arriving in San Miguel de Allende, the first thing I wanted to do was to go to this **City Market** and experience what I would call the ultimate supermarket.

The place is huge. And everything is organized in perfect position. And luxury or gourmet. Truly better than Whole Foods, Gelson's, Wegmans, Harris Teeter, and Erewon. I hope the photo below begins to show you the magnitude, cleanliness and perfection that goes into this amazing store.

Look at the perfection of the shrimp (photo top right) lined up on the ice. Fresh. Delicious. Perfect. In the produce section, I watched employees on stepladders placing each apple in its perfect location. This store is enough to make you want to live here.

Their wine department is larger than entire grocery stores (photo lower right of its entrance). Entire rows are devoted to specific wine regions of the world. For example, the big-name wines from Napa Valley are here. A full experience of Champagne. Of course Bordeaux is very well represented. And a big selection of Mexican wines too. Plus, numerous decanters. Beautiful designs.

And their gelateria has scrumptiously rich creamy flavors, including a Cabernet Sauvignon gelato (photo left page) to go with your wine region experience.

Plus, two restaurants and a café. A sushi restaurant and a steak house. The café has a large beautiful atrium for you to enjoy its many specialty drinks.

GUANAJUATO **SAN MIGUEL** VILLAGE
Supermarket, Café, Gelateria, Wine Shop
CITY MARKET

$-$$-$$$-$$$$-$$$$$

Located: Intersection of Hwy 51 & Hwy 111
Salida a Celaya 82, La Lejona
37765 San Miguel de Allende, Gto, México

+52 800 210 1010

CityMarket.com.mx

Open: Every Day, 7am-10pm

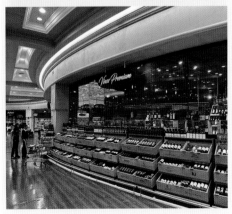

CLUBS & BARS

In the heart of San Miguel de Allende, at the intersection of Jesús and Cuadrante, just two blocks away from the central park (Jardín Allende) and church, is an epicenter of live music. **La 21Única** and **Baradero** bring in the perfect party atmosphere of live music every night.

 This authentic Mexican cantina and Cuban dance club have the same proprietor, a very talented restaurant architect, Alberto Hernandez, who has considered everything to make these places very cool authentic pubs. For example, the authentic saloon doors (photo right of La 21Única) with double swing wooden shutters as you would expect a western cowboy to push through for a shot of tequila.

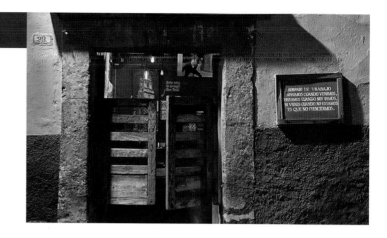

■ GUANAJUATO **SAN MIGUEL** VILLAGE
Bar, Live Music
LA 21ÚNICA CANTINA

Jesús 23 (at Northeast Corner with Cuadrante, Central Zone
+52 415 154 4001
Open: Wednesday-Sunday, 3pm-2am

This is a traditional Mexican cantina. Step up to the bar and order yourself a drink. Grab a table and enjoy a very talented guitarist who plays Rancheras Mexicanas every night. Leave him a big tip and ask him to keep playing because you won't be able to get enough of his great music.

■ GUANAJUATO **SAN MIGUEL** VILLAGE
Bar, Live Bands, Dance Floor
BARADERO CUBAN DANCE CLUB

Cuadrante 30 (at Southeast Corner with Jesús), Central Zone
+52 415 688 3074
Open: Wednesday-Sunday, 6pm-2am

The club is a beautifully designed, authentic Cuban dance club with different live bands every night. From the passionate flamenco to intimate bohemian, the bands are awesome! This is the place to party! The cocktails are awesome and the dance exciting. Salsa at its best. Watch or jump onto the dance floor and get your moves a-groovin'.

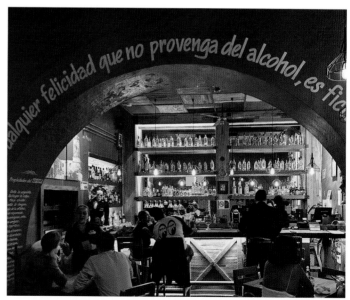

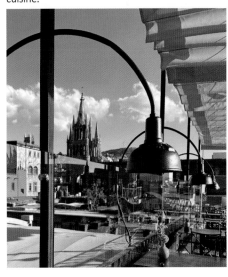

The rooftops in San Miguel de Allende have become quite popular in creating unique restaurants under the big beautiful blue skies, colorful sunsets and star-filled nights. Most of the rooftop restaurants also have indoor dining; however, the views are so spectacular, it begs to be outdoors. And the restaurants are equipped with large umbrellas and heat lamps.

These three rooftop restaurants are within one block of the central park and church.

GUANAJUATO **SAN MIGUEL** VILLAGE ∎
Rooftop Restaurant
ATRIO RESTAURANT & LOUNGE

Cuna de Allende 3, Central Zone
+52 415 688 1405
Open: Every Day, 1pm-10:30pm

The **Suckling Pig Tacos** (photo below) are as tender and mild as you can imagine. They slowly smoke the meat and top the tacos with onion curls and sesame seeds. A very nice salsa sauce is included.

On the rooftop, they have many cozy romantic tables to enjoy with your partner (photo below).

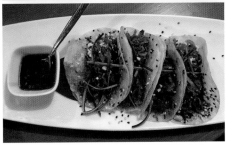

GUANAJUATO **SAN MIGUEL** VILLAGE ∎
Rooftop Restaurant
QUINCE ROOFTOP

Cuna de Allende 15, Central Zone
+52 415 154 9776
Open: Every Day, 1pm-10:45pm (Sat/Sun 10am)

Oh my favorite is the raw yellowtail, **Sashimi de Hamachi** (photo below) generously served here with large thin slices of Hamachi and yellow chili sauce, eureka lemon and soy reduction

Open rooftop to see the village skyline and the impresssive San Miguel Arcángel (photo below).

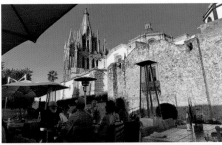

GUANAJUATO **SAN MIGUEL** VILLAGE ∎
Rooftop Restaurant
TRAZO 1810

Cuna de Allende 3, Central Zone
+52 415 121 3506
Open: Every Day, 8am-10pm (Sat/Sun 11pm, Sun 9am-2pm)

On the rooftop of **Hotel Boutique Casa 1810** is a beautiful night-time lit restaurant overlooking the grand San Miguel Arcángel church (photo below).

See the full review of this restaurant and hotel (on page 179) and is very creative and interesting cuisine.

Restaurant, Terrace and Rooftop
CASA NOSTRA

$-$$-$$$

Located: 3 1/2 Blocks From Jardín Allende
Terraplén 8, Central Zone
37700 San Miguel de Allende, Gto, México

+52 442 747 0860
Contacto@CasaNostraSanMiguelallende.com

CasaNostraSanMiguelAllende.com

Open: Wednesday/Thursday: 5:30pm-10pm
Friday/Saturday: 2pm-11pm
Sunday: 2pm-9pm

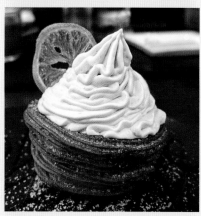

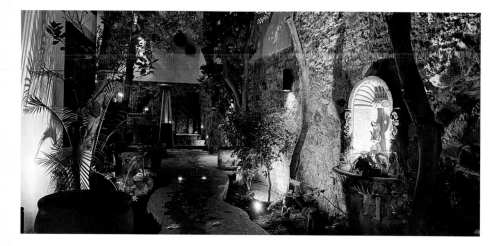

A SENSUAL CUISINE EXPERIENCE

I had the extra-special experience of dining at this restaurant with a couple of winery owners who eat here frequently. So, I got to taste their favorites on the menu (photos below).

One of the best aspects of this restaurant is the service. The owner, Marco Massarotti, is very active with his guests. And his servers are the same. He makes the dining experience here very special for everyone.

Marco's concept is to present international gourmet recipes, paired with wines and mixology and prepared freshly with local organic ingredients. The restaurant received Wine Spectator's Award of Excellence in 2023. Locally, it was chosen as one of the best six restaurants in all of Guanajuato state.

The place is beautifully sensual (photo above) with indoor and outdoor seating options. Everywhere is classy and cozy, including a terrace and rooftop dining to view the picturesque architecture of the village.

Lamb Chops (photo below right) are directly from France with a light marinade of olive oil and rosemary prepared on their Argentinian barbecue.

Truffle Pasta (photo below center) is black gold tagliatelle pasta on a brie cream sauce with black truffle reduction and topped with black summer truffle and thyme served in a copper casserole.

Churros (photo below left) is a homemade churro nest with supreme of oranges drunken in Grand Marnier and filled with cream of Spanish carajillo, Licor 43 and orange candy.

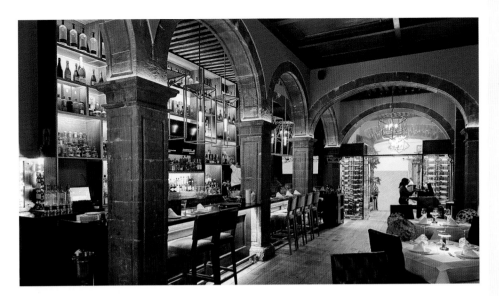

$-$$-$$$-$$$$-$$$$$

Located: 1/2 Block from Jardín Allende
San Francisco 11, Central Zone
37700 San Miguel de Allende, Gto, México

+52 415 688 3001
Reservations: opentable.com.mx

IG: SanFranciscoSteakhouse11

Open: Every Day,
Monday-Thursday 2pm-10pm (Fri/Sat 12am, Sun 8pm)

Extraordinarily delicious steaks, crabcakes, salads, and attentive personalized service.

While the **Rib-Eye Steak** (photo below) here was unbelievably delicious, as moist, tender, medium-rare Angus and flavorful as the photo presents, I must tell you that the **Crab Cake** (photo right top) is the best crab cake I have ever had. Tender, creamy, flaky soft crab, full of flavor and on a layer of apple dressing with swirls of teriyaki sauce puts the flavors over the top.

The finale, **Crème Brûlée** (photo right bottom) was live at the table, torch-side; it was an entertaining experience watching the sugar melt brown and get crispy for the texture we all know so well. This classic French dessert is infused with local lavender and served with homemade cinnamon ice cream. They have very attentive, personalized service from all the staff in this very classy restaurant.

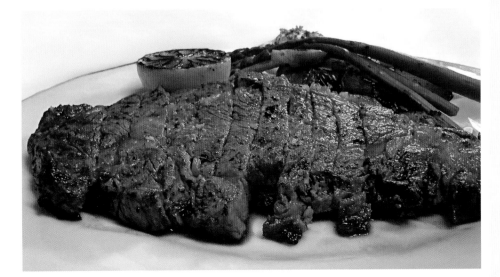

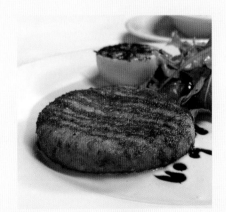

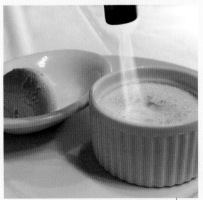

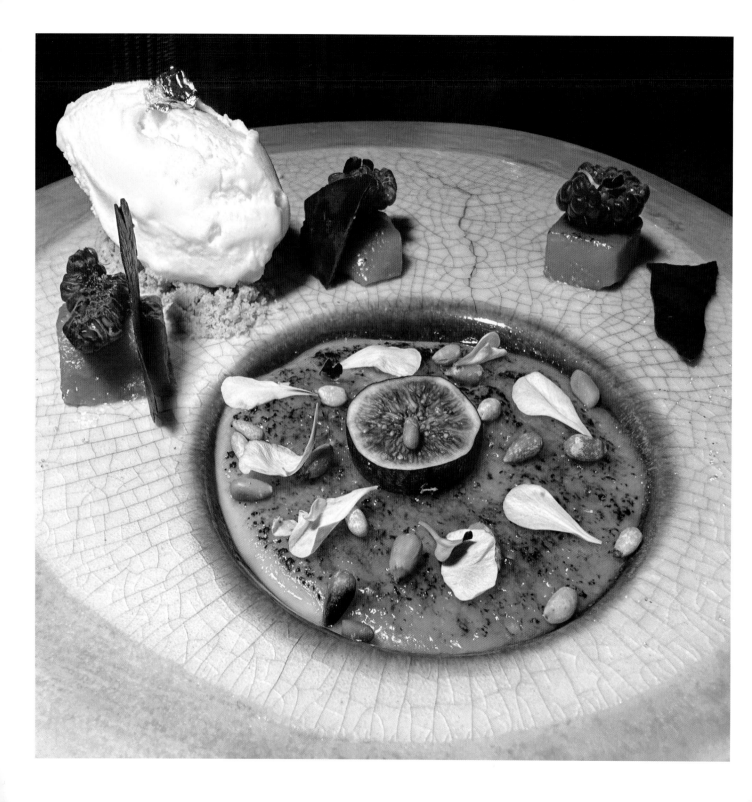

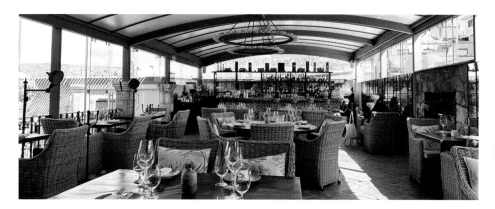

$$$

Located: 1/2 Block from Jardín Allende
Hidalgo 8, Zone Central
37700 San Miguel de Allende, Gto, México

+52 415 121 3501
WhatsApp: +52 415 124 5472
Trazo@Casa1810.com

Casa1810.com

English, Spanish

Open Every Day
Monday-Thursday, 8am-10pm
Friday/Saturday, 8am-11pm (Sunday, 9am-2pm)

INDOOR & ROOFTOP, INCREDIBLE FOOD EXPERIENCE

Let me introduce you to a wonderful restaurant that was introduced to me by one of the locals. The creativity in the cuisine is remarkable. The chef is having way too much fun (look at the photos on this spread).

Trazo 1801 is on the rooftop of the **Casa 1810 Hotel Boutique** in the middle of the village. It has both outdoor (photo page 175) and indoor (photo above) rooftop with views across the village.

I think the photos best express the passion and experimentation going on in this kitchen.

Mamey Crème Brûlée (photo left page) is a bowl of crème brûlée topped with a fig slice, pinion seeds and edible flowers, surrounded by chocolate pieces and caramelized crème brûlée squares topped with raspberries. Served with ice cream infused with pixtle seeds of the mamey sapote fruit on top of a vanilla crumble.

Beef Tongue Sopes (photo below left) on a thick corn tortilla-like masa cake (made from masa harina, water, salt, and oil) are ever-so-tender beef tongue slices and pickled onions, topped with a crispy cheese crust layered with avocado and pistachio cream sauce drips, cilantro and beautiful flower petals.

Tuna and Bone Marrow Tostada (photo below center) is a blue corn tostada covered generously with cured tuna and avocado slices, coriander, salt, pepper and paprika, with a side of roasted bone marrow inside the bone.

Short Ribs (photo below right) is wagyu short ribs braised for twenty-four hours with chilis, with delicious sweet potato and local lavender purée (San Miguel is a big producer of lavender), and a decorative bone with pickled onions on top.

Tres Leches (photo upper right) is a vanilla biscuit soaked with three kinds of milk, topped with miso toffee and blueberries. Served with sake ice cream on top of vanilla crumble.

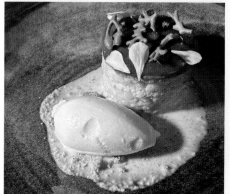

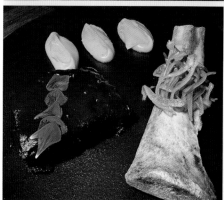

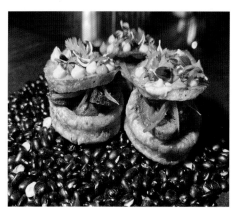

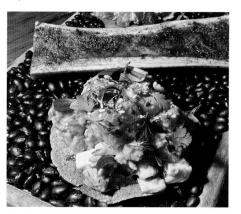

BEAUTIFULLY RESTORED HOTEL IN THE CENTER OF THE VILLAGE

In a beautiful historic building in the center of the San Miguel village comes **Casa 1810 Hotel Boutique** with all the opulence, luxuries and beyond. The building has been completely restored inside and out, with the sophistication of modern luxuries and fashionable design.

Look at the bedroom (photo below). Isn't that ceiling stunning? The style here sure is gorgeous. And the bathroom (left page) is so spacious for a historic building. That thick handmade stone wall is amazing? And the grand mirror, is so perfect to check out your partner.

I really love this hotel. The location is absolutely ideal. The food is amazing. Breakfast is included and it is scrumptious. And you must have dinner in its rooftop restaurant whether you stay in the hotel or not (see review on previous spread).

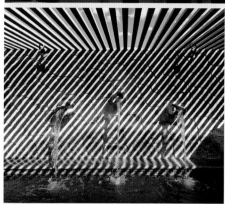

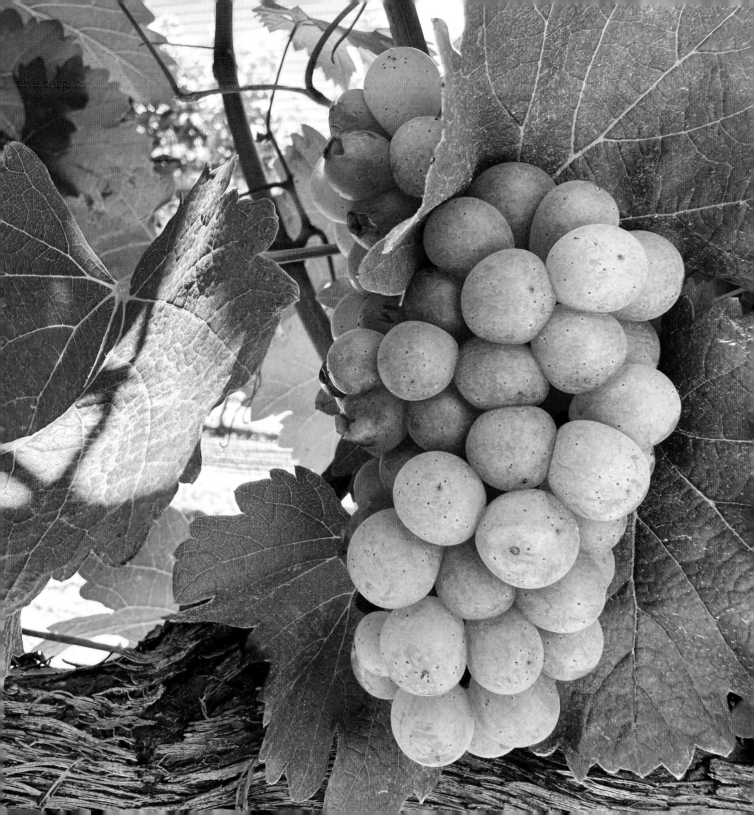

Winemaker: Champagne France

$$-$$$

Located: 10.2km/6mi East of San Miguel
KM 10.2, Nuevo Libramiento San Miguel, Centro
37700 San Miguel de Allende, Gto, México

+52 415 155 8502
Info@Tienda.HaciendaSanJoseLavista.com

HaciendaSanJoseLavista.com/en

Little English, Spanish

Open: Wednesday-Monday, 11am-5pm

A magnificent property for weddings, wine tasting and culinary experiences.

VERY BEAUTIFUL PROPERTY

This project started as a retirement estate for a very talented architect. This is why the property is so beautiful (photo above) because he made it for himself. Today, this property is used for beautiful weddings. And he has built a chapel on the property.

San Jose Lavista is located in the central San Miguel wine regions just outside the city with beautiful views back at the village.

It started in 2010 with the design and construction of a beautiful and traditional Mexican colonial architecture. After three years of construction, the vineyards were planted with Malbec, Merlot and Sauvignon Blanc directly from France. In 2022, they planted Chardonnay (photo left page) and Pinot Noir to make sparkling wines. The winemaker, Trini Jiménez Hidalgo is an expert at sparkling wine as he studied oenology and was trained in Champagne France.

The winery is state-of-the-art, and the aging cellar is a spectacular work of art that you would expect from a talented architect (photo on page 186).

Above the winery is a rooftop restaurant with an amazing chef and a great way to taste their wines and pair them with their foods (see next page).
• **Winery and Vineyard Tour & Tasting.** Tours are with their sommelier and a glass of sparkling rosé. Walk the vineyards, learn the terroir, visit the winery, and go underground to see their spectacular cellar (photo page 186). It includes a cheese and cold meat plate while tasting wines. I suggest their **Premium Tour** which tastes their three gold medal wines.
• **Picnic at the Vineyard with Panoramic Views.** Enjoy a bottle of wine on a blanket under a private tree with a picnic basket filled with sourdough bread made by their chef, olives, olive oil from their trees, cheeses, cold meats, grapes and dessert.
• **Oak's Duel: Oporto Style Wine.** A private tasting of their port wine right out of the barrels in their underground cellar. This will be a comparative tasting of the same wine from different barrels, and paired with sweet appetizers.

Collection of Wines

Lavista Assemblage (Merlot, Malbec)
Lavista Malbec Reserva
Lavista Malbec
Lavista Merlot
Porto Fortificado (Malbec)

Lavista Rosé (Rosé of Syrah, Chenin Blanc)
Lavista Sauvignon Blanc

Lavista Espumoso Rosé (Sparkling Rosé of Syrah)
Lavista Espumoso Blanco (Sparkling Chenin Blanc)

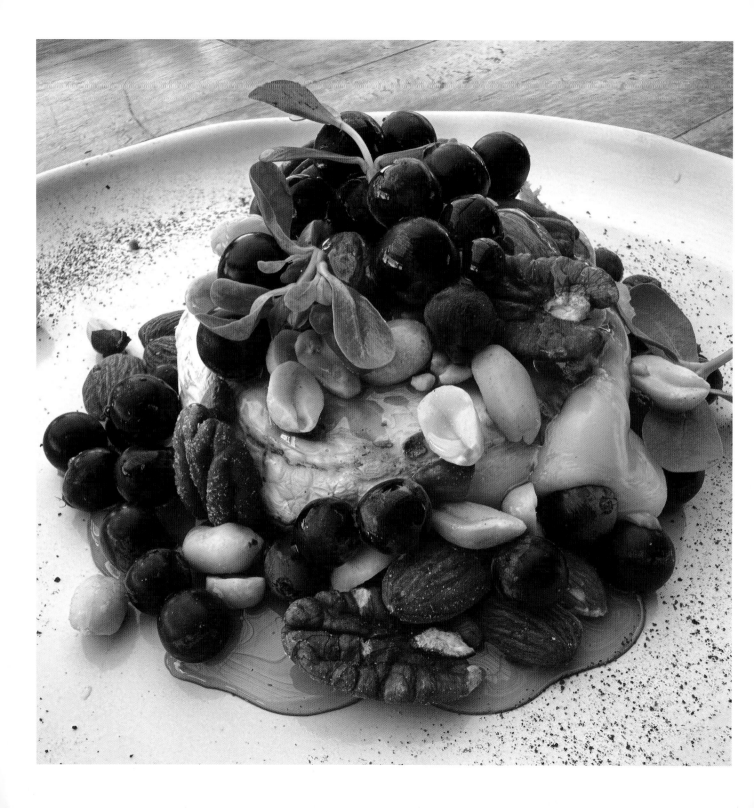

ROOFTOP RESTAURANT

Tarragon restaurant is located on the rooftop of the winery and outdoors, open to the stars surrounded by vineyards. This restaurant has a very cool concept; it is without walls and is rebuilt every morning and it disappears every night. It is a momentary experience whereby the staff celebrates the human connection with its guests.

The menu is based on local farm fresh produce and the kitchen has an open fire for cooking. The food is amazing. Look at the photos. Delicious! Now let's hear from the chef.

The Ultimate Cheese Plate (photo left page) is a baked camembert cheese served warm and smothered with local honey, sprinkled with a mix of nuts and grapes.

Mushroom Risotto (photo below) is made with a variety of seasonal mushrooms, gualillo chili and a holy leaf.

Margarita Pizza (photo below right) with thick sourdough breaded pizza crust, homemade tomato sauce, fresh mozzarella cheese, heirloom tomatoes and basil.

Caesar Salad (photo upper right) is made of heart of baby lettuce covered with a thick layer of grated Parmesan cheese tuile, homemade Caesar-style dressing and honey.

$-$$-$$$

Located: 10.2km/6mi East of San Miguel
KM 10.2, Nuevo Libramiento San Miguel, Centro
37700 San Miguel de Allende, Gto, México

Reservations: WhatsApp +52 415 126 4595
Administracion@RestauranteTarragon.com

RestauranteTarragon.com

Little English, Spanish

Open: Thursday-Sunday, 12pm-8pm

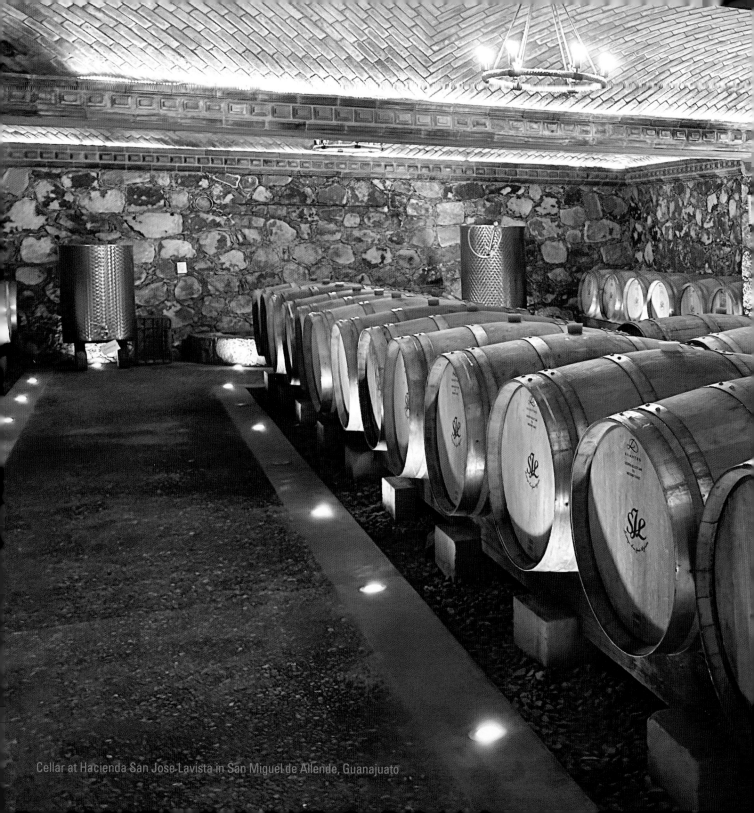

Cellar at Hacienda San Jose Lavista in San Miguel de Allende, Guanajuato

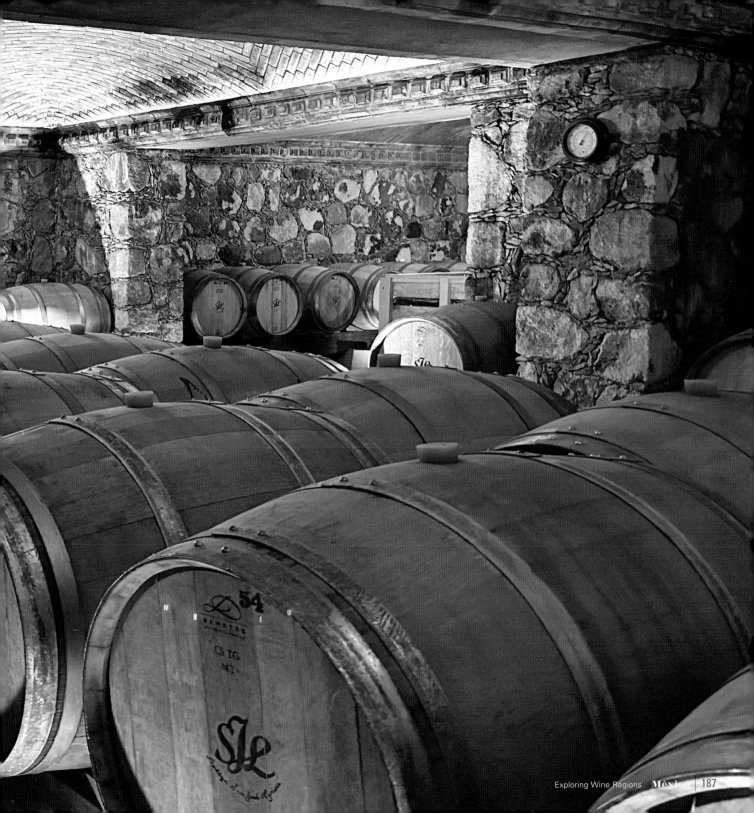

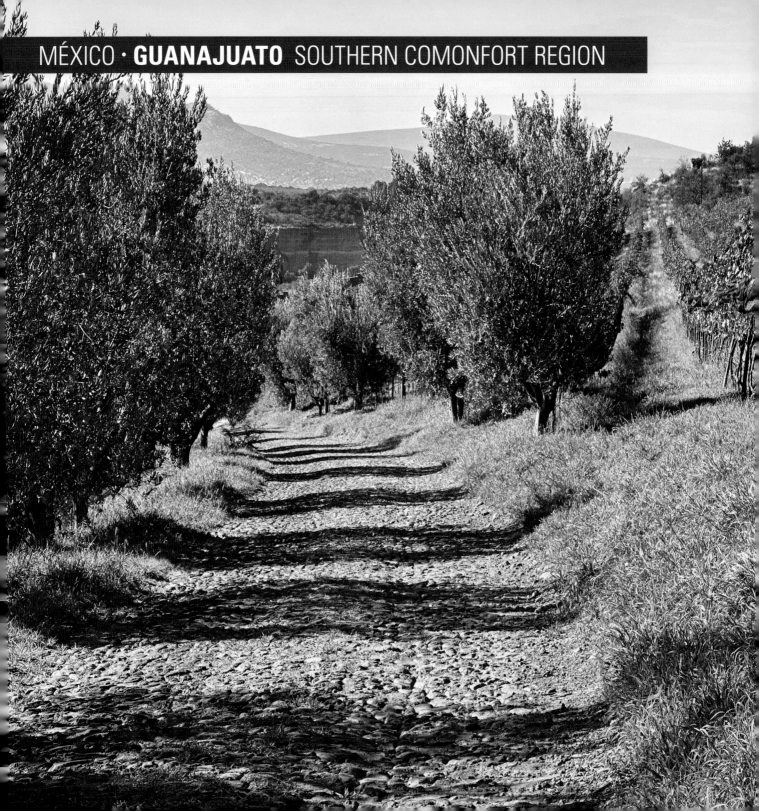

MÉXICO · **GUANAJUATO** SOUTHERN COMONFORT REGION

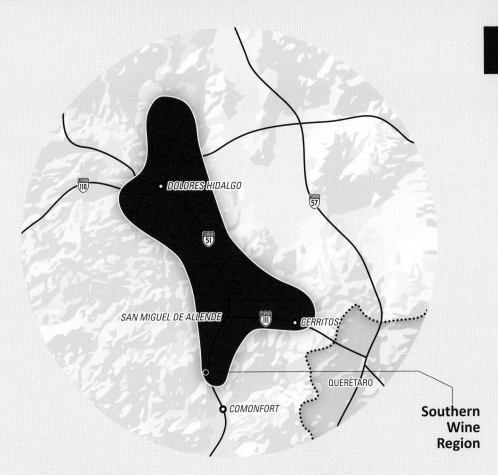

DOLORES HIDALGO

110

57

51

SAN MIGUEL DE ALLENDE

111

CERRITOS

QUERÉTARO

COMONFORT

Southern Wine Region

Left page: Cobblestone road through the olive orchards and vineyards of Viñedo San Miguel

SOUTHERN REGION

The distance to the first winery on Hwy 51 is...
14km/8.5 miles (11 minutes)

Let's start with the wine region south of San Miguel de Allende. It is located just before the town of Comonfort on Highway 51. It is a very well maintained road; however, be extra careful of the large speed bumps on the road. These are huge bumps created by the government to slow traffic. You must approach them slowly!

There are only two wineries in this region right now. They are almost next to each other. And both have chefs on the premises. Rancho Los Remedios also has lodging in their hacienda.

The two wineries are very different from each other. **Viñedo San Miguel** is a very large, mature property, with a modern design; it is much more formal and luxurious. **Rancho Los Remedios** is a newer project on a historic property with renovated architecture. This is a much more relaxed, unpretentious environment with residential opportunities as well.

Here are the wineries for you to explore.
• Viñedo San Miguel, page 191
• Rancho Los Remedios, page 195

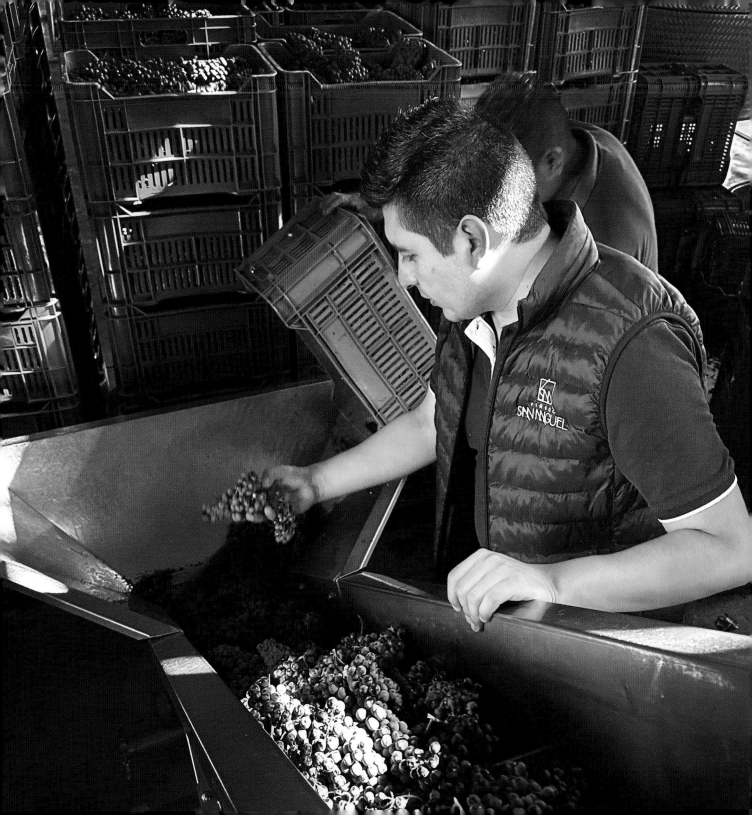

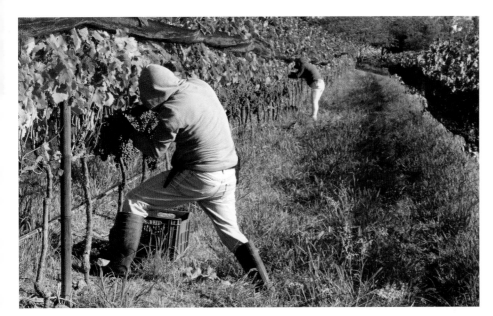

Winemaker: Spain

$$

Located: 14km/8.5mi South of San Miguel
Carretera Comonfort - San Miguel de Allende 1, México 51
38206 Comonfort, Guanajuato, México

+52 477 289 1368
Bodega@VinedoSanMiguel.com.mx

VinedoSanMiguel.com.mx/en

English, Spanish

Wineshop, Boutique, Tasting: Wed-Sun, 10am-8pm
Tour/Tasting: Wed-Sun, 10:30am, 12pm, 2pm, 4pm
Restaurant: Thursday-Sunday, 2pm-Midnight

Collection of Wines

Blend & Blend Reserva (Syrah, Merlot, Cabernet
Sauvignon, Cabernet Franc, Malbec)
Piedra de Oro (Cabernet Sauvignon, Malbec)
Carbonico Blend (Malbec, Cabernet Sauvignon)
Latinedo (Malbec, Syrah, Merlot)

Malbec & Malbec Reserva
Cabernet Sauvignon, Merlot, Syrah

Rosé (Malbec, Cabernet Franc, Cabernet Sauvignon)
Blancs (Sauvignon Blanc, Chardonnay, Semillón)
Aida Sparkling (Trebbiano, Malvasia, Vermentino)

E
Everything here is about art in a very beautiful property where you spend a special day.

AN EXPERIENCE OF HIGH QUALITY

It all started when four friends, very successful businessmen from the Guanajuato capital city, came together to create an extraordinary winery property. This place is beautiful. And large, one of the largest wineries in Guanajuato. You will be impressed!

The vision here is for everything to be about **art**. And their philosophy is four very simple concepts... Everything is **handmade**, only the highest of **quality**, a dedication to **perfection**, and a deep care for all their **people**. As a lover of art, this place is special.

When you step inside, the beauty of art and architecture embraces you everywhere. Their boutique is more than just wine; dozens of very talented artisans sell their work here, along with a beautiful presentation of the luxury Cuadra brand (from one of the founding partners).

Viñedo San Miguel is likely the first winery here to sell residential real estate in the middle of the vineyards. They have stunning estate homes throughout the vineyards, which financially helped in developing the massive vineyards for 220,000 bottles annually. As a result of their success, you will find many wineries here offering this opportunity to live within the vineyards. I will show you several.

They have extensive tours. Each includes a walk through the vineyards, visiting the tank area of the winery, going underground to the cellar of aging wines in barrels, and several different types of tastings of your choice.

• **San Bartolo Experience.** Vineyard, winery and cellar tour, and tasting of three wines.

• **Petriolo Experience.** Vineyard, winery and cellar tour, and tasting of four wines accompanied by a delicious charcuterie and cheese board.

• **San Miguel Experience.** Vineyard, winery and cellar tour, and tasting of five wines in their VIP tasting room overlooking the cellar, pairing them with five delicious gourmet treats from their chef, and ending with a special olive oil tasting.

The winery is very impressive to see as it is capable of handling a huge amount of grapes, making hundreds of thousands of bottles of wine. Their philosophy of being handmade, quality and perfection is implemented by their winemaker Abisaí Vargas as he inspects the grapes that have entered the winery (photo left page).

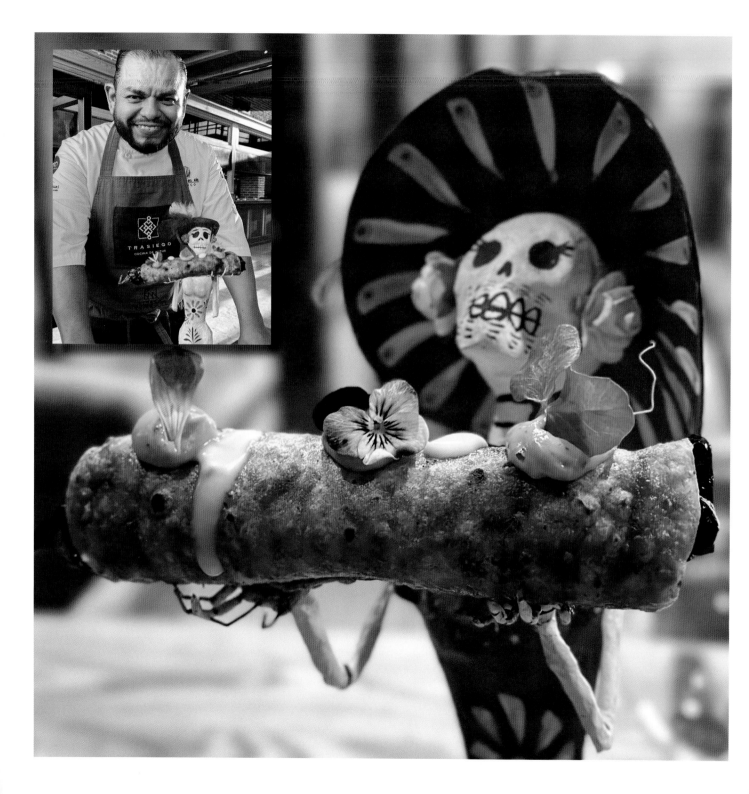

GUANAJUATO **COMONFORT** SOUTHERN ◼
Winery, Vineyards, Restaurant
VIÑEDO SAN MIGUEL

$-$$-$$$$

Located: 14km/8.5mi South of San Miguel
Carretera Comonfort - San Miguel de Allende 1, México 51
38206 Comonfort, Guanajuato, México

+52 477 274 4404
Bodega@VinedoSanMiguel.com.mx

VinedoSanMiguel.com.mx/en

English, Spanish

Restaurant: Thursday-Sunday, 2pm-Midnight

INNOVATIVE CUISINE

We should start with the creativity of their chef, David Quevedo (photo left page), and his unique dishes and exciting presentations. In 2021, David won the highly competitive international *World Tapas Competition* with a distinctive dish he calls *El Taco Ceremonial* (Catrina taco).

El Taco Ceremonial (photo left page): is a small snack comprising a dried chile stuffed with stewed wild rabbit wrapped in a small ceremonial tortilla traditional to the Otomí community here where they print different figures and symbols on the tortilla surface to bless the food and connect with the divinities. See what is printed (left page)?

The taco (taquito) is deliciously decorated and presented by a Catrina, a well-dressed aristocratic symbol of the famous Day of the Dead celebration in México. She is the traditional tall skeleton wearing an elegant turn-of-the-century dress, a hat full of flowers, and draped with a feathered boa.

There are many ways to enjoy the cuisine here as Chef Quevedo has a full restaurant (photo above). Light snacks are available during tastings, food and wine pairing can be enjoyed in their VIP tasting room overlooking the cellar, or a gourmet menu is available in the restaurant, including an extraordinary tasting menu, complete with wine pairing if you choose.

Dry Noodles (photo below left) are cooked in tomato sauce and dried chipotle chili, accompanied with seasonal vegetables, panela cheese, avocado and pea sprouts.

Pork Fillets (photo below middle) are grilled in goat cheese, mirror bathed in red fruit sauce with garambullo (blue myrtle cactus). Salad dressed with orange and tomato vinaigrette.

How To Get Drunk (Dessert) (photo below right) is a garambullo sorbet, quince ate, tequila granita, cajeta, avocado sorbet, strawberry sorbet, avocado sorbet and edible flowers.

Gift Shop (photo upper right) has handmade leather masterpieces of the Cuadra luxury brand.

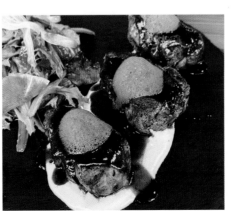

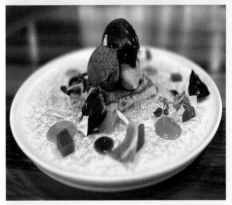

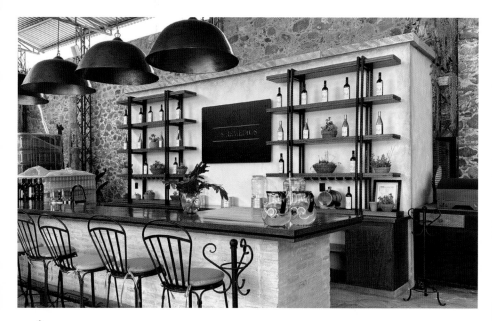

Winemaker: Argentina

$$

Located: 15km/9.5mi South of San Miguel
Hacienda Rinconcillo de los Remedios,
38206 Comonfort, Guanajuato, México

+52 415 140 0607
Visitas@RanchoLosRemedios.com

RanchoLosRemedios.com

English, Spanish

Open: Thursday-Sunday, 12pm-6pm
Tours/Wine Tasting: Thur-Sun, 12pm, 2pm, 4pm
Picnic: Thur-Sun, 12pm, 1pm, 2pm 3pm, 4pm

A relaxing and unpretentious setting.

HISTORIC ENVIRONMENT

With the successful completion of Viñedo San Miguel (previous pages), two of the partners wanted to keep going and create another amazing project. Practically next-door, they purchased 300 acres of land with a historic 1800s hacienda, two ancient chapels and mature avocado, peach and lime orchards.

Renovations began. Vineyards were planted. A winery was constructed. And a beautiful residential plan for large parcels along the vineyards and orchards was developed. A model home was designed, built and furnished to show the luxury of having a home here.

They hired an excellent winemaker from a prestigious winery in Argentina. She brings a very high level of quality to their wines. Plus, being from Argentina, they planted an all-new Malbec vineyard (photo left page). Expect some great Malbec wines here soon.

If you are looking for a non-formal, unpretentious, relaxing environment, this is the place.

They offer several experiences. Each includes a historic tour of the hacienda, chapel and gardens.
• **Cata Joven Experience.** Tour and tasting of three of their young wines with a delicious charcuterie and cheese plate. "Cata" means "tasting" in Spanish.
• **Cata Reserva Experience.** Tour and tasting of four wines with a delicious charcuterie and cheese plate.
• **Cata Gran Reserva Experience.** Tour and tasting of five wines, including their premium Gran Reserva, along with a charcuterie and cheese plate.
• **Cata Extra Gran Experience.** Tour and a very special food and wine pairing and tasting on the hacienda patio. Check out the food photos on the next page for an example of this amazing experience.
• **Picnic Experience.** A great way to enjoy a tranquil afternoon in their gardens. They provide the picnic basket (filled with tapas, cheese, meats, and a bottle of wine), blanket, cushions, and wine glasses.

Collection of Wines

Gran Reserva (Cabernet Franc,
Cabernet Sauvignon, Merlot, Petit Verdot)
Blend (Cabernet Sauvignon, Cabernet Franc, Petit Verdot)

Cabernet Franc

Rosado (Rosé of Merlot)
Moscatel (Moscatel)

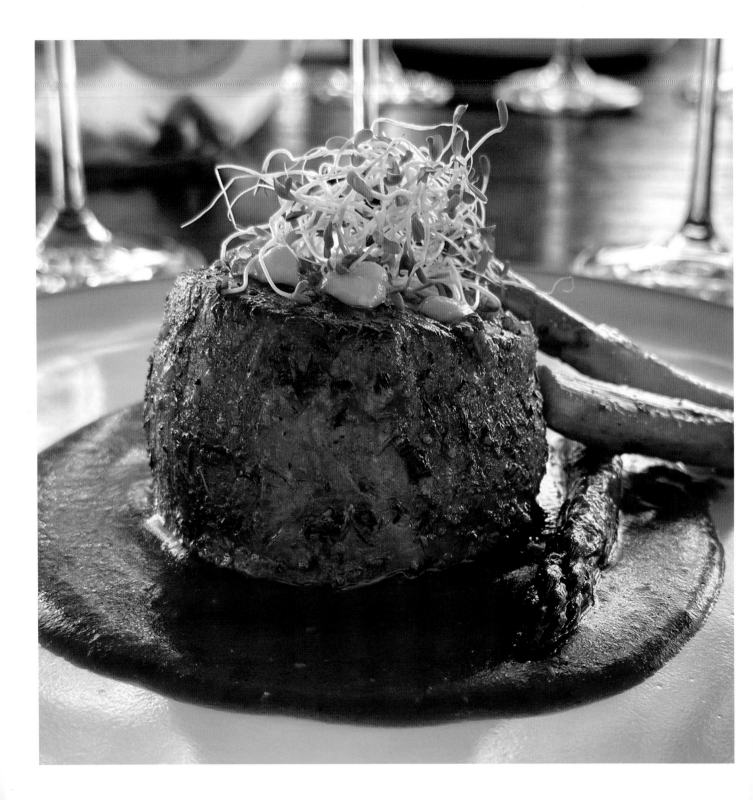

FOOD AND WINE PAIRING, EXTRAORDINARY EXPERIENCE

It is so nice when a winery has a restaurant. More than just meat and cheese, gourmet foods with premium wine are a great way to enjoy an experience at a winery. Here at Rancho Los Remedios, Chef Adrian Rocha (photo right) puts together a very impressive menu, as you can see on these pages.

And if you simply want meat and cheese, Rocha has a very impressive display, actually, in a beautiful bowl so to enhance the wine experience.

I highly recommend their pairing menu. Chef Rocha has worked with their on-premises sommelier to pair the perfect foods to match the wines that have been created in this winery. And an excellent pairing it is. The pairing menu experience is a four-course tasting menu served on their beautiful outdoor dining area on the historic hacienda patio.

$$$

Located: 15km/9.5mi South of San Miguel
Hacienda Rinconcillo de los Remedios,
38206 Comonfort, Guanajuato, México

+52 415 140 0607
Visitas@RanchoLosRemedios.com

RanchoLosRemedios.com/visits.html

English, Spanish

Open: Thursday-Sunday, 12pm-6pm

A Wonderful Pairing Menu Experience

Filet Mignon (photo left page) is seared with bone marrow sauce, sautéed asparagus and blue cheese dots. Topped with alfalfa sprouts. It's outrageously delicious. Paired with Los Remedios Rosado (Rosé of Merlot).

Fresh Salad (photo below left) of a variety of mixed greens, seasoned with brown butter vinaigrette, seared peaches, orange segments, and topped with fresh-grated pecorino romano cheese. Paired with Los Remedios Moscatel.

Shrimp Medly (photo below center) are grilled with lightly spicy guajillo chiles and grilled oyster mushrooms rubbed with garlic and topped with olive oil and salt. Topped with fresh arugula leaves and basil oil. Paired with Los Remedios Gran Reserva (Cabernet Franc, Cabernet Sauvignon, Merlot, Petit Verdot).

Creme Brulée (photo below right) of mamey is an orange-fleshed fruit native to México with a taste similar to brown sugar-covered sweet potato, with notes of pumpkin, caramel and cantaloupe. Topped with strawberry, kiwi and mint. Paired with Los Remedios Cabernet Franc.

Outdoor Dining (photo upper right) in a beautiful setting of the historic hacienda patio.

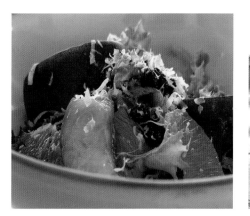

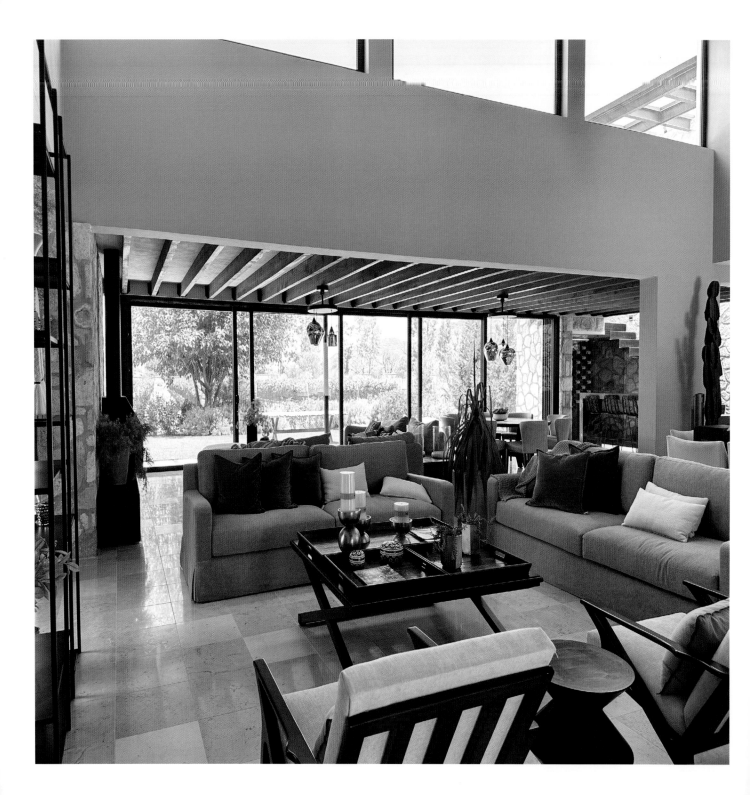

HOME IN THE VINEYARDS AND AVOCADO ORCHARDS

With a very successful completion of beautiful residences in the vineyards of Viñedo San Miguel, two of the partners acquired an additional 300 acres of land with a historic 1800s hacienda, two ancient chapels, mature avocado, peach and lime orchards a couple of minutes away.

Vineyards were planted in 2018. A winery was constructed as the vines matured. They created a beautiful residential plan for large parcels along the vineyards and orchards. Only eighty-nine lots were designed either inside an orchard or next to a vineyard (.40 acres to 1.1 acres). A model home was designed, built and furnished to show the luxury of having a home here (photo left page). With two-story homes, the views across the landscape and vineyards are stunning (photo below).

They have a large infinity pool on the property available for the residents and their guests. The infinity pool is surrounded by fruit orchards and adjacent to a beautiful lake (photo below right). This is a wonderfully natural environment to relax and enjoy the setting of this private residential community.

All these are with close access to the UNESCO San Miguel de Allende historic village.

$$

Located: 15km/9.5mi South of San Miguel
Hacienda Rinconcillo de los Remedios,
38206 Comonfort, Guanajuato, México

+52 415 124 5301
Ventas@RanchoLosRemedios.com

RanchoLosRemedios.com/residential.html

English, Spanish

Open: Every Day, 10am-6pm

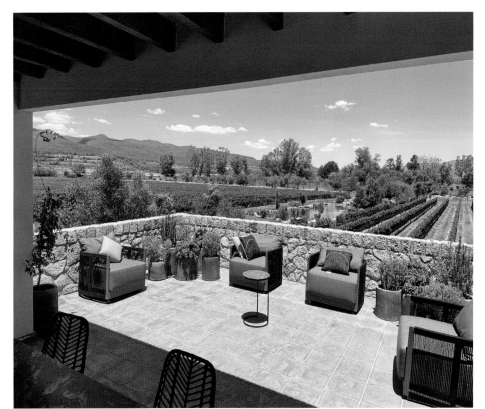

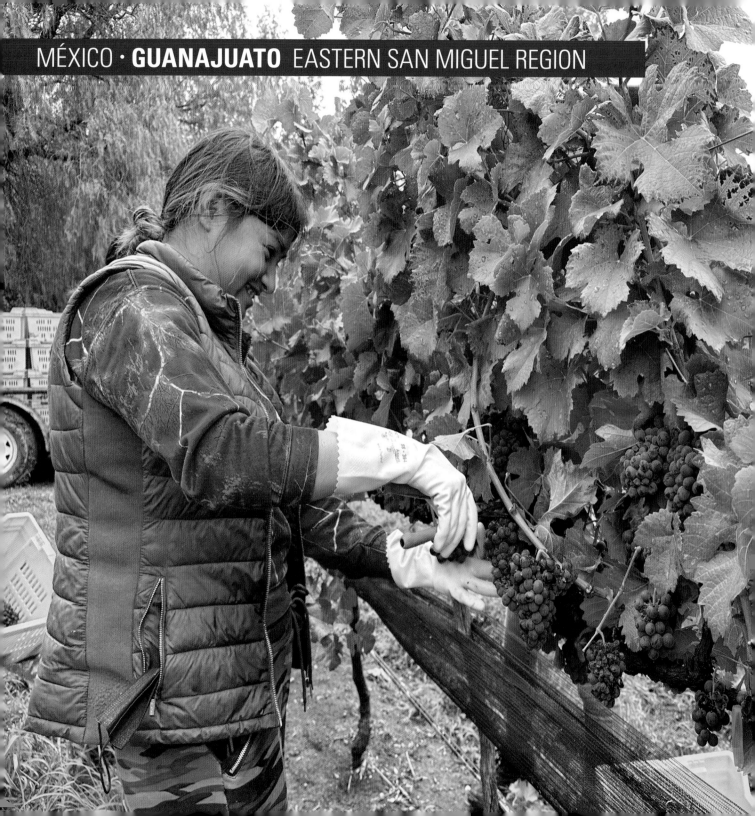

Eastern
Wine
Region

Left page: A very happy harvest
in the vineyards of Viñedo San Lucas

EASTERN SAN MIGUEL REGION

The distance to the first winery on Hwy 111 is...
6.3km/4 miles (8 minutes)

To get to the eastern wine region, it is necessary to traverse through winding city streets, and some traffic, before getting out of town to the wineries. If you drive from Querétaro (Airport) to San Miguel de Allende, this is the Highway 111 you will use.

The first winery you reach is **Dos Buhos**, the closest winery to San Miguel, and they have a restaurant.

The next three properties are together off the same unnamed dirt road from Hwy 111 (exactly 10km/6mi from San Miguel): **Toyan, San Lucas** and **San Francisco**. The dirt road is not in very good

condition, and you will have to be patient, as the drive is 1.5km to the entrance of Toyan and 2.5 km to the entrance of San Lucas and San Francisco, respectively.

Santa Catalina is just another two miles down Hwy 111 and **Casa Anza** is a little farther on a horse ranch (17km from San Miguel to the dirt road with the exit in Cerritos). It is a very relaxing, casual place.

San Lucas, San Francisco and Santa Catalina have gourmet restaurants and luxury lodging.

Here are the properties.

- Viñedo Dos Buhos, page 203
- Viñedo Toyan, page 209
- Viñedos San Lucas, page 211
- Viñedos San Francisco, page 219
- Viñedos Santa Catalina, page 223
- Casa Anza, page 227

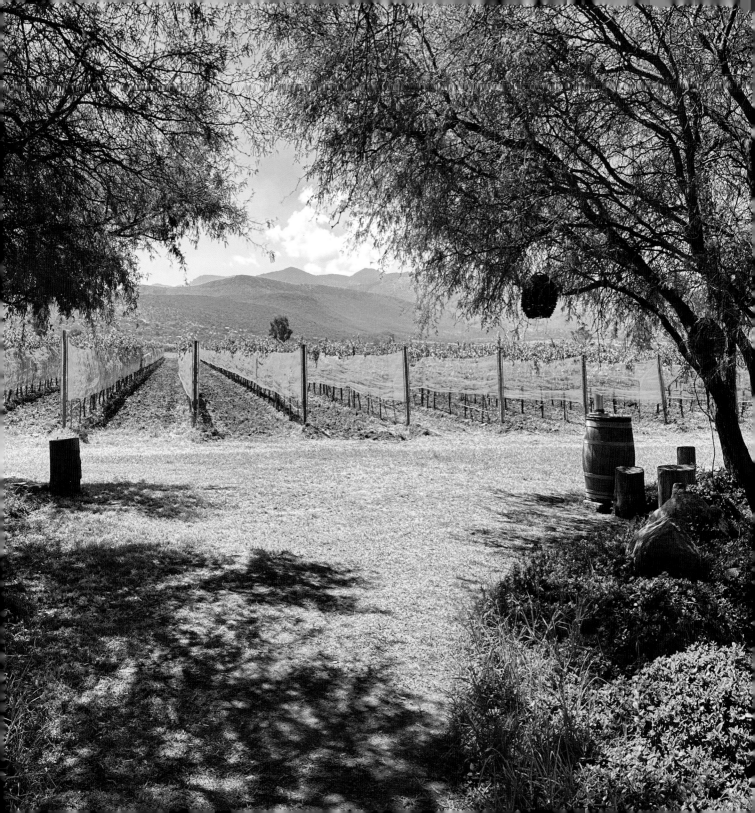

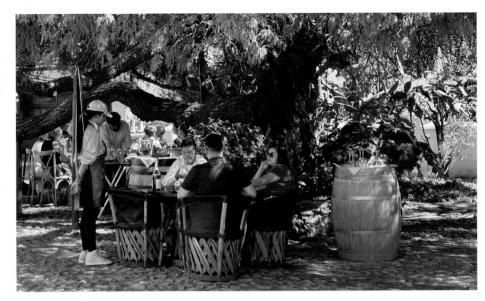

Winemaker: Spain

$$-$$$

Located: 6.3km/4mi East of San Miguel
Carretera San Miguel de Allende - Buenavista,
San Felipe Km. 2.8
37880 San Miguel de Allende, Gto, México

+52 415 124 7583
Reservaciones@DosBuhos.com

DosBuhos.com/en

English, Spanish

Open: Wed/Thur, 11am-5pm (Fri-Sun 6pm)

A beautiful farm very close to the San Miguel Village

COME CASUAL TO RELAX

This is the closest winery to the San Miguel de Allende village, only four miles east of San Miguel. It is in the San Miguel Wine Region.

This is a family business with multiple generations contributing to its success since 2006. The son is the architect who has built this beautiful property. His wife is the artist who has brought much creativity inside and outside the buildings. Dad is the farmer who has planted and cared for these special organic vineyards. And mom is the creative force, fearless in pursuing the success of this property.

Dos Búhos ("two owls" in Spanish) is a farm that goes way beyond the vineyards. Fruit orchards of olives, lemons, oranges, kumquats, pomegranates, wild cherries and loquats. They have extensive vegetable gardens, mini sheep, donkeys, a lazy cat named Dorito, and beautiful exotic chickens that roam around the property (photo right).

This is a casual place, a farm, nothing pretentious, where you can relax, have fun, eat gourmet foods, and drink excellent wines.

• **Guided Visit/Tasting.** An educational tour of their property learning how grapes transform into wine, visiting their organic vineyards, the production areas of the winery, and the aging cellar, followed by a tasting of four of their wines.

• **Five-Course Food & Wine Pairing.** Their chef creates a special prix fixe tasting menu that is paired with their wines carefully chosen for this experience. The photos on the next page represent this pairing experience.

• **Picnic.** Enjoy nature under their trees with a delicious picnic prepared by their chef, choose a bottle of their wine, and even bring your dog. Reservation is required 24 hours in advance.

• **Sparkling Wine & Petanque (French Bocce Ball).** Play petanque in one of their beautiful gardens while sipping sparkling wine and enjoying snacks from the chef.

Collection of Wines

Aglianic Gran Reserva (Aglianico)
Cabernet Franc
Grenache
Tempranillo
Cabernet Sauvignon

Special Selection (Cab Franc, Cab Sauvignon, Aglianico)
Blend Oak (Cabernet Sauvignon, Grenache, Aglianico)

Rosé (Rosé of Grenache)
Sparkling Rosé (Tempranillo, Syrah)
Sauvignon Blanc

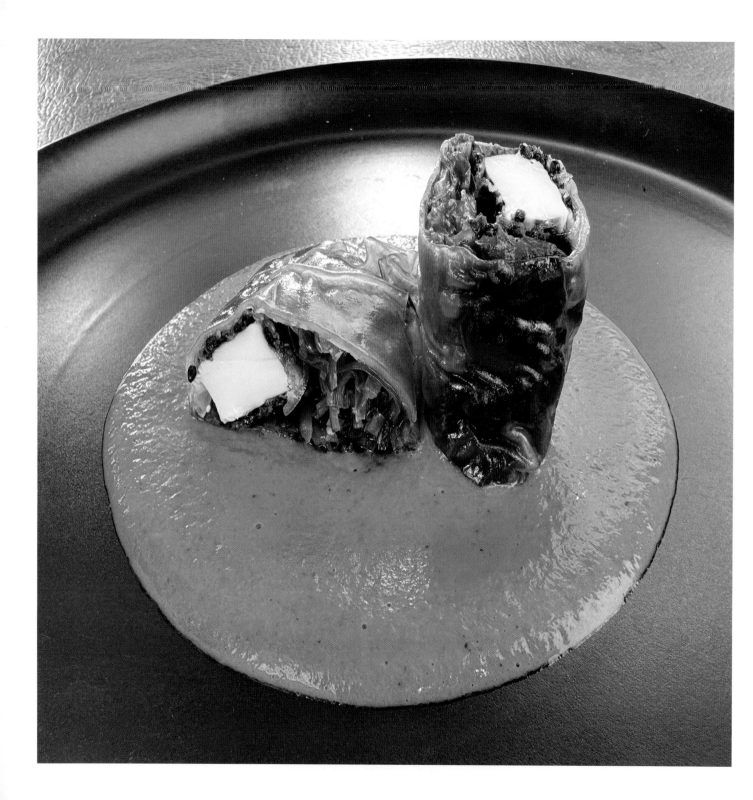

CASUAL ENVIRONMENT, GOURMET CUISINE

Don't let the casual farm-like atmosphere here get in the way of believing that Dos Búhos doesn't have a gourmet restaurant. Just look at the photos on these two pages and expect nothing short of creativity in delicious Epicurean cuisine.

If you want a cheese and meat board, they have a very large platter filled with so much yumminess. Further, though, they have an excellent chef, husband and wife team, to create an extensive menu as well as prix fixe tasting course that is very well paired with their wines (see previous page for description). This food and wine experience is an excellent choice, and the photos on these two pages come from this experience.

Tofu Roll (photo left page) is a vegan tofu roll with mushrooms, fresh wakame seaweed and aromatic herbs, accompanied by a delicious harissa sauce (dried red chiles, garlic, citrus, extra virgin olive oil, and warm spices of cumin, coriander and caraway seeds). Paired with Tempranillo.

Duck Breast (photo below) of juicy slices of seared duck breast with hazelnut crust on the rind, accompanied by red quinoa and chopped vegetables, and a hazelnut mole. Paired with Cabernet Franc.

Shrimp Trio (photo below right) marinated in roasted garlic and mint, accompanied by a scrumptiously aromatic citrus broth. Paired with Sauvignon Blanc.

Cheesecake (photo upper right) with ricotta cheese and passion fruit sauce, topped with sliced kumquats. Paired with sparkling rosé.

GUANAJUATO **SAN MIGUEL** EASTERN ■
Winery, Vineyards, Farm, Restaurant
VIÑEDOS DOS BÚHOS

$$-$$$-$$$$

Located: 6.3km/4mi East of San Miguel
Carretera San Miguel de Allende - Buenavista,
San Felipe Km. 2.8
37880 San Miguel de Allende, Gto, México

WhatsApp: +52 415 124 7583
Reservaciones@DosBuhos.com

DosBuhos.com/en

English, Spanish

Open: Wed/Thur, 11am-5pm (Fri-Sun 6pm)

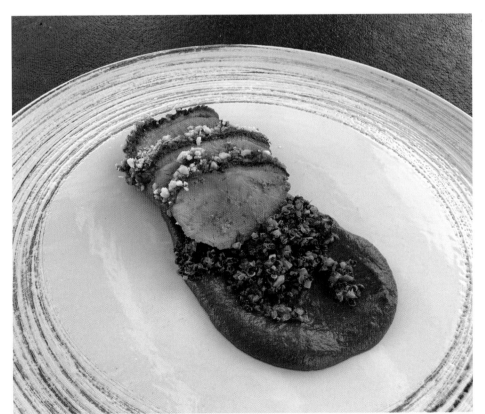

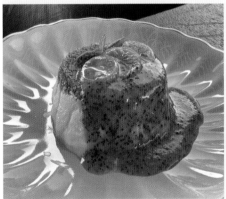

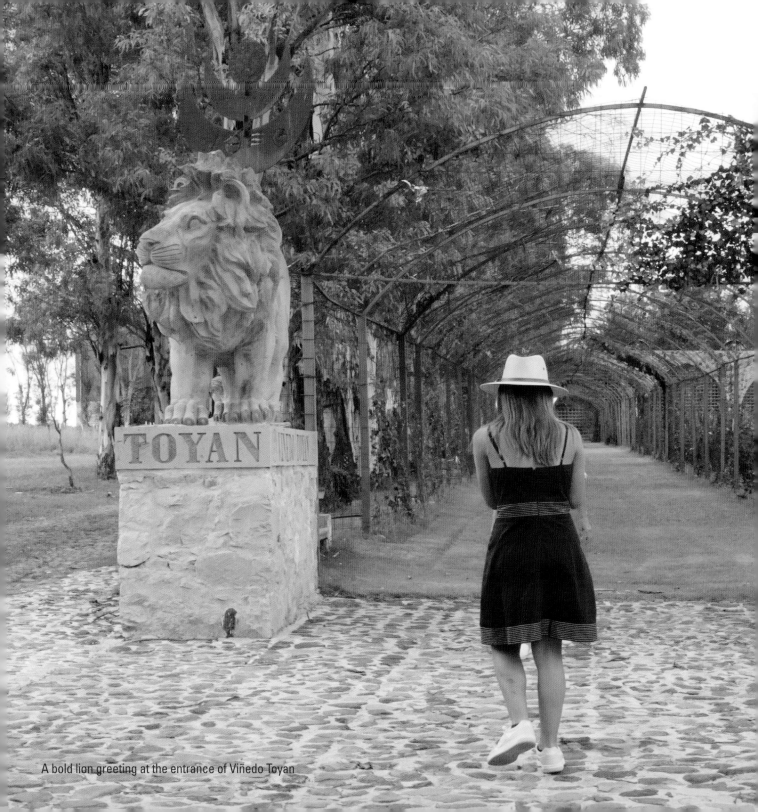

A bold lion greeting at the entrance of Viñedo Toyan

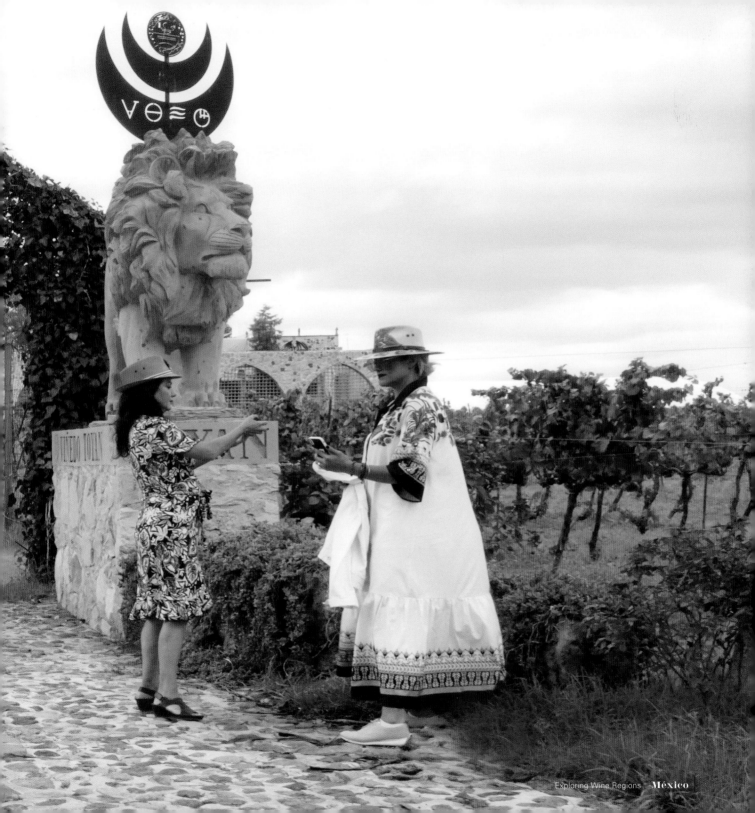

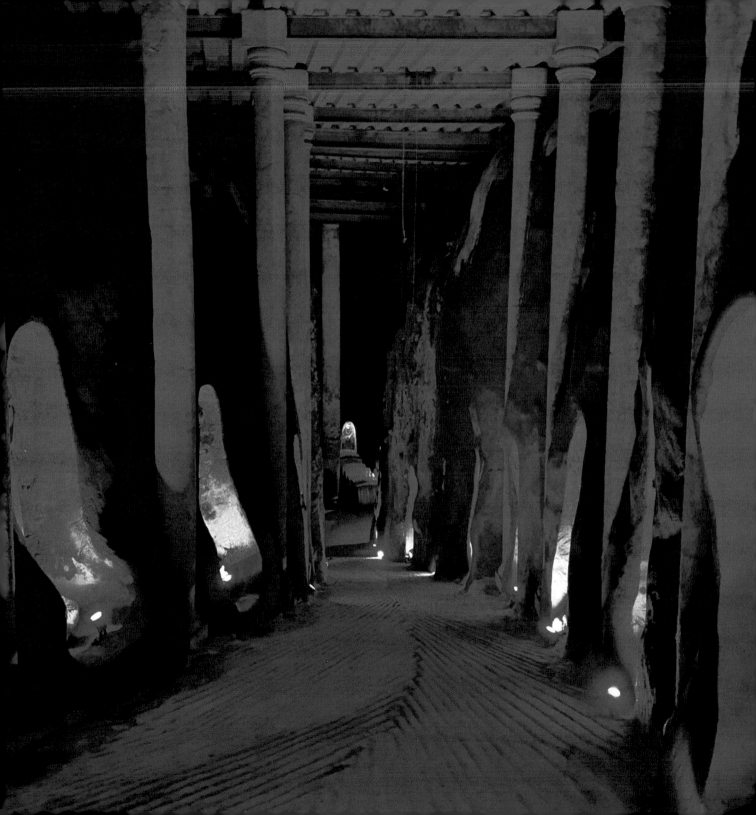

Winemaker: Mexico

$$

Located: 11.5km/7mi East of San Miguel
Km 8.5 en la Carretera San Miguel a, Querétaro
37884 San Miguel de Allende, Gto, México

+52 555 502 4747
ReservacionesToyan@gmail.com

VinicolaToyan.com

Little English, Spanish

Open: Monday-Saturday, 11am-4pm

A mystical blue place of medieval energy, artifacts and sculptures.

MEDIEVAL

Here we find one of the earliest vineyards planted in Guanajuato in 2000. While most of their vineyards, organically farmed, are sold to winemakers around Guanajuato, they do make a little wine for themselves; however, the tour experience here is everything upon the arrival.

At the front gate, you are met by two large lions, and sculptures guarding the entrance to a long green channel wrapped with ivy (photo previous page). At the end of the channel, you will reach massively tall walls surrounding the property, where you will notice dozens and dozens of gargoyles along the top of the walls.

During the tour, they take you outside the walls where you are watched by the gargoyles. This is where you will see their vineyards and understand the quality of their viticulture.

Just wait until you enter the building and go down the steep path to forty-six feet underground. Everything is blue like you enter a world of the medieval. Now entering the cellar, there are artifacts and sculptures surrounding all aspects of this wine dungeon cellar.

In the left page photo, you see the steep walkway, descending into this super deep cellar. Awesome lighting along the walls to show the medieval sculptures. Oak wine barrels are found throughout these depths as they are the perfect environment of temperature and humidity to age the wine. And the wine is protected by the various medieval characters.

The tasting room is at these depths as well (photo above) where you can taste their nine different wines and enjoy them with cheese platters. You will feel the mystery and odd energy.

• **Silver Tour.** A forty-five minute tour through the cellar and tasting of four of their wines.

• **Gold Tour.** An hour and a half tour of the history and symbolism of the ranch and descending into the 46 foot deep cellar with a tasting of four wines.

• **Diamond Tour.** An hour and a half tour of the history and symbolism of the ranch and descending into the forty-six foot deep cellar with a tasting of five of their best bottles, with gourmet treats to pair with the wines.

Collection of Wines

Gran Reserva Especial (Cabernet Sauvignon, Merlot)
Merlot Reserva Especial
Cabernet Sauvignon
Cabernet Franc
Pinot Noir

Rosada (Rosé of Pinot Noir)
Vino Naranja (Orange Wine of Chardonnay)
Vino Blanc (Sauvignon Blanc)

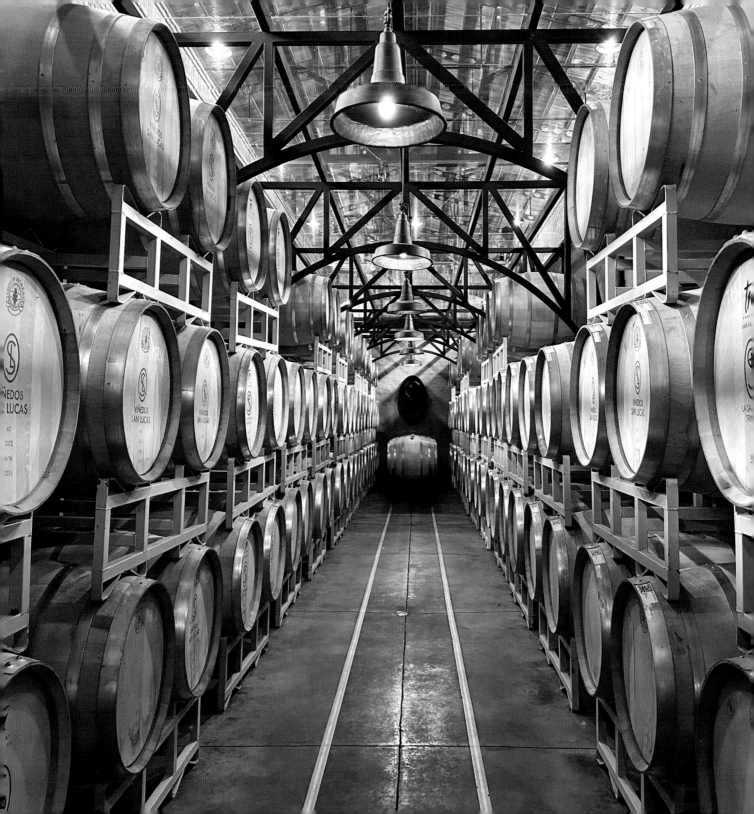

Winemaker: Argentina

$$-$$$

Located: 13.4km/8.3mi East of San Miguel
Lugar de trabajo en Carretera San Miguel de
Allende a Querétaro km 6.2
37884 San Miguel de Allende, Gto, México

+52 415 688 2210, x208
Vinicola@VinedosSanLucas.com

VinedosSanLucas.com

English, Spanish

*Tastings: Sunday-Thursday, 11am, 1pm, 3pm
Friday/Saturday, 11am, 1pm, 3pm, 5pm*

Winery, restaurants, hotel, residential real estate, equestrian, polo, biking, spa, yoga, etc.

A BEAUTIFUL LARGE ESTATE

This is a 245-acre property that has been landscaped into a paradise so that you really do not have to leave. Everything is here. Starting with the winery and wine tastings. And they have more than just delicious cheeseboards, they have a full restaurant at the winery as well as at the hotel. And the hotel offers luxurious boutique lodging.

And you really do not have to leave if you would like to have a home here. The existing homes are large and beautiful on their own two-and-a-half acre parcels. This estate is filled with numerous vineyards, olive orchards and lavender fields. Trees and country roads are everywhere within this property.

There are numerous activities, outside of wine tasting, food and wine experiences. There is a complete equestrian center along with polo fields. Bicycling and hiking along the beautiful well-maintained dirt roads that go on forever as you can stay within the property. They also have a spa and a yoga center with private yoga classes.

Everything here leads to refreshing your mind,

body and spirit in an atmosphere so beautiful you will not want to leave.

They have extensive tours through their winery and some unique experiences to enjoy.

• **Sensory Wine Tasting & Tour.** A detailed tour of their winery, production areas, barrel cellar and their beautiful wine rack for a tasting experience of their wines paired with a plate of cheese, nuts, red fruits, honey, olive oil and homemade bread.

• **Blind Tasting Experience & Tour.** A blind wine tasting experience through their best wines with a small plate of regional cheeses, nuts, red fruits, honey, olive oil and homemade bread. Plus their detailed tour of the winery, production areas, and barrel cellar.

• **Gourmet Food & Wine Pairing.** Their chef and winemaker work together to create a four-course prefix gourmet dining experience with each course perfectly paired with one of their best wines.

• **Lavender & Olive Oil Workshop.** Experience a lavender and olive oil workshop with a detailed education of the history and process in their olive oil and lavender productions.

Collection of Wines

San Lucas Red Blend (Malbec, Syrah)
San Lucas Reserva (Pinot Noir)

San Lucas Brut Rosé (Sparkling of Pinot Noir, Cinsault)
San Lucas Blancs (Sparkling of Caladoc)

San Lucas Sauvignon Blanc Crianza

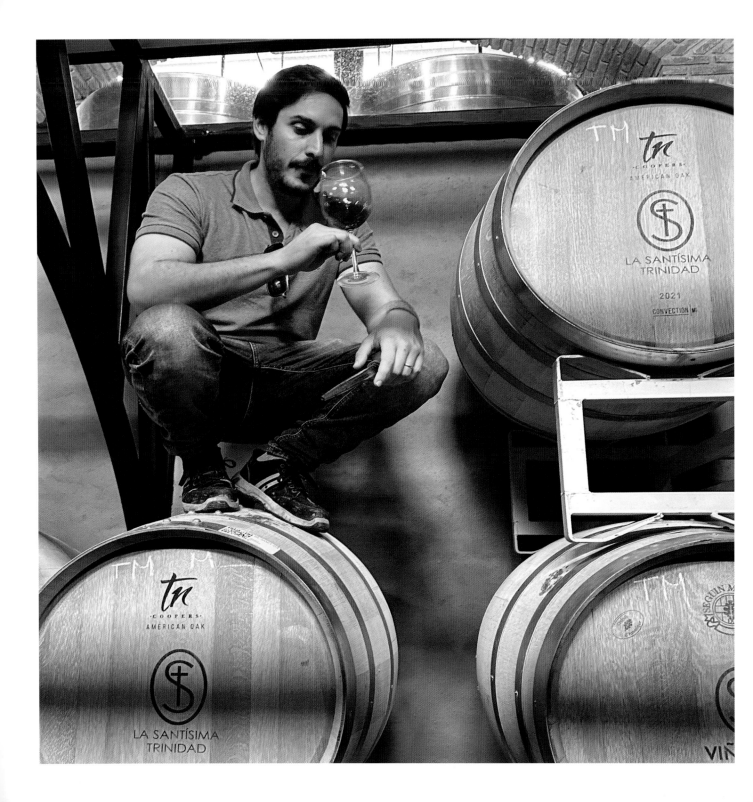

Winemaker: Argentina

$$-$$$

Located: 13.4km/8.3mi East of San Miguel
Lugar de trabajo en Carretera San Miguel de
Allende a Querétaro km 6.2
37884 San Miguel de Allende, Gto, México

+52 415 688 2210, x208
Vinicola@VinedosSanLucas.com

VinedosSanLucas.com

English, Spanish

SPARKLING EXPERT

Oenologist Germán Calvo (photo left page) is the winemaker here at Viñedos San Lucas. Germán is Argentinian and had a sparkling wine business in Argentina. He shipped his specialized sparkling wine equipment (photo below) from Argentina to Guanajuato México for a much better opportunity as socialism has hurt Argentina's economy.

At first, he made a business deal with the owner of San Lucas to run his sparkling wine business here. It did not take long though for the owner to realize that Germán has great talent to dramatically improve all his winery operations and now Germán is the winemaker for all his properties.

And speaking of properties, Germán has been an excellent ambassador for this organization of wineries, restaurants and hotels. He has arranged some excellent introductions that I have reviewed in the following pages of this book.

Here are their properties.
• Viñedos San Lucas (page 211)
• Viñedos San Francisco (page 219)
• Santa Catalina (page 223)
• La Santísima Trinidad (page 249)

San Lucas Brut Rosé (photo right): a delicious Pinot Noir and Cinsault sparkling made by Germán using the French Champenoise method.

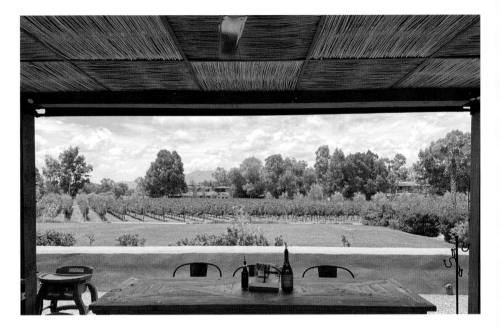

Winery, Vineyards, Restaurant, Lodging
VIÑEDOS SAN LUCAS

$-$$-$$$

Located: 13.4km/8.3mi East of San Miguel
Lugar de trabajo en Carretera San Miguel de
Allende a Querétaro km 6.2
37884 San Miguel de Allende, Gto, México

+52 415 688 2201, x206
WhatsApp +52 559 198 7577
VentasHotel@SanLucas.com.mx

VinedosSanLucas.com

English, Spanish

Hotel Restaurant Open: Thursday-Sunday, 8am-10pm
Winery Restaurant Open: Every Day, 12pm-5pm

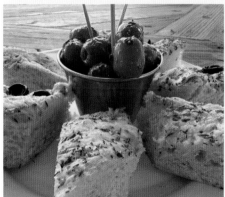

PICTURE-PERFECT IS EXACTLY RIGHT

The view above is the picture-perfect landscape from their outdoor restaurant at the winery. You will want to be here all afternoon, and they have a lot of delicious foods and wines to make it worth your while.

Coconut Shrimp (photo left page) is soaked in sambal sauce (an Indonesian chili sauce) with grilled pineapple, sweetened with mesquite honey.

Skirt Steak Burrito (photo below) is made of peppers and grilled mushrooms, served with guacamole and French fries.

Crème Brûlée (photo below right) is a lavender crème brûlée topped with berries.

Artisanal Focaccia Bread (photo upper right) with olives marinated in olive oil and crushed red pepper.

$$$

Located: 12.9km/8mi East of San Miguel
Lugar de trabajo en Carretera San Miguel de
Allende a Querétaro km 6.2
37884 San Miguel de Allende, Gto, México

+52 415 688 2210
WhatsApp +52 415 566 7173
Hotel@VinedosSanLucas.com

VinedosSanLucas.com

English, Spanish

Open: Thursday-Sunday
Open: Every Day, 3/25-4/5, 7/25-8/30, 12/15-1/5

LUXURY HOTEL IN THE VINEYARDS

This is a very special hotel. Only fourteen rooms, and it doesn't even seem like they have that many rooms. The suites are incredibly spacious with separate bedrooms and beautiful home-style living rooms.

The bathrooms will make you want to stay inside with beautiful big tubs in such a romantic atmosphere (left page photo).

Excellent luxury details are everywhere!

ON A LAKE

All rooms have king beds with the highest quality of comfort that you will savor as you sink in for the night.

One of the best parts of the rooms is the large private balcony overlooking the lake (photo above).

The mornings are extra special with in-room French press coffee to enjoy on the balcony in your warm bathrobe.

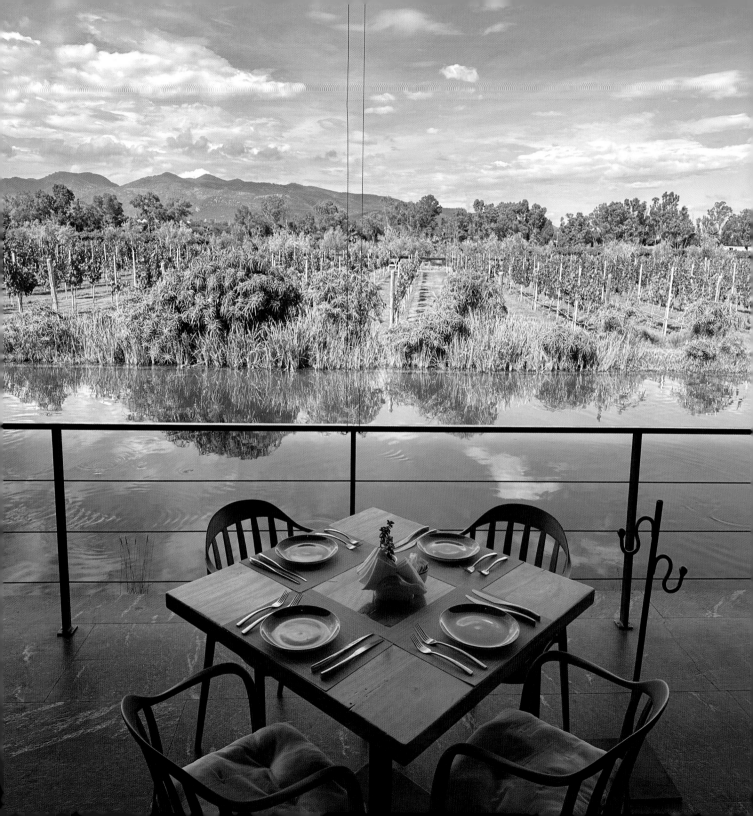

$$$

Located: 15km/9.3mi East of San Miguel
Carr. Querétaro - San Miguel De Allende, Km. 26
37884 San Miguel de Allende, Gto, México

+52 415 688 2209
WhatsApp +52 415 688 2209
Hotel@VinedosSanFrancisco.com

VinedosSanFrancisco.com

English, Spanish

Open: Thursday-Sunday
Open: Every Day, 3/25-4/5, 7/25-8/30, 12/15-1/5

REMOTE HOTEL IN THE VINEYARDS

Continue through the extensive Viñedos San Luis property (previous eight pages), and you will come to Viñedos San Francisco. This is a remote hotel in the middle of the vineyards, bringing beautiful modern designs and luxury in a hotel and restaurant (photo above). Both properties have the same proprietor and offer residential real estate.

In this main hotel building (photo above), are fourteen two-story luxury suites overlooking a small lake and vineyards (photo left page). Within the property are beautiful villas that have six luxury rooms each (photo below left of a villa building and swimming pool, and photo below center of a desk and closet in one of the rooms).

The restaurant is in the main hotel building overlooking the tiny lake, vineyards (photo left page) and the beautiful landscape of the property. The restaurant has live music nightly (photo below right) and incredibly delicious breakfasts (photo right of a very creative and delicious huevos rancheros).

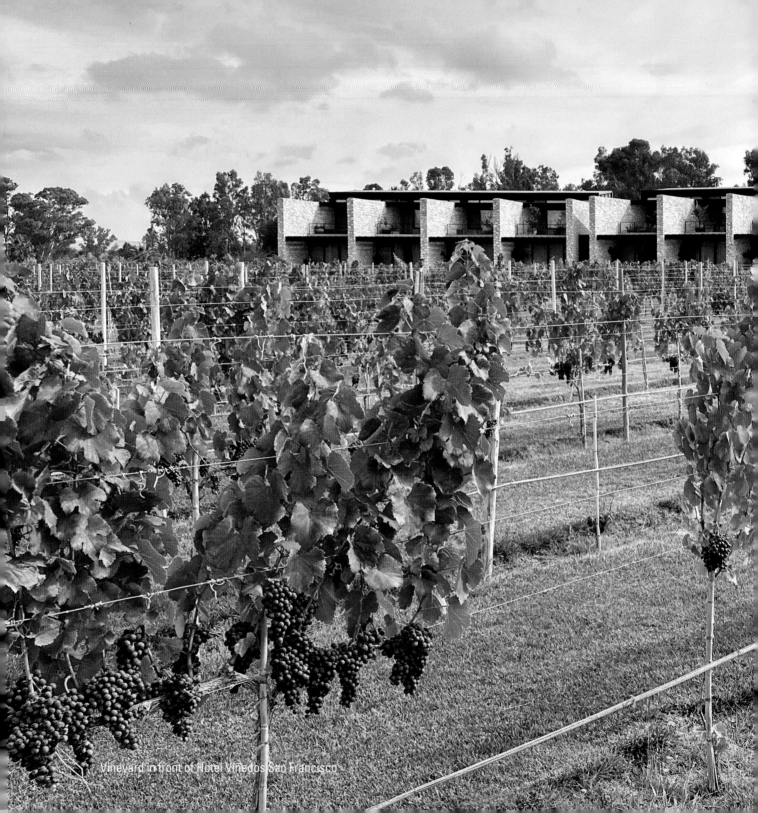

Vineyard in front of Hotel Viñedos San Francisco

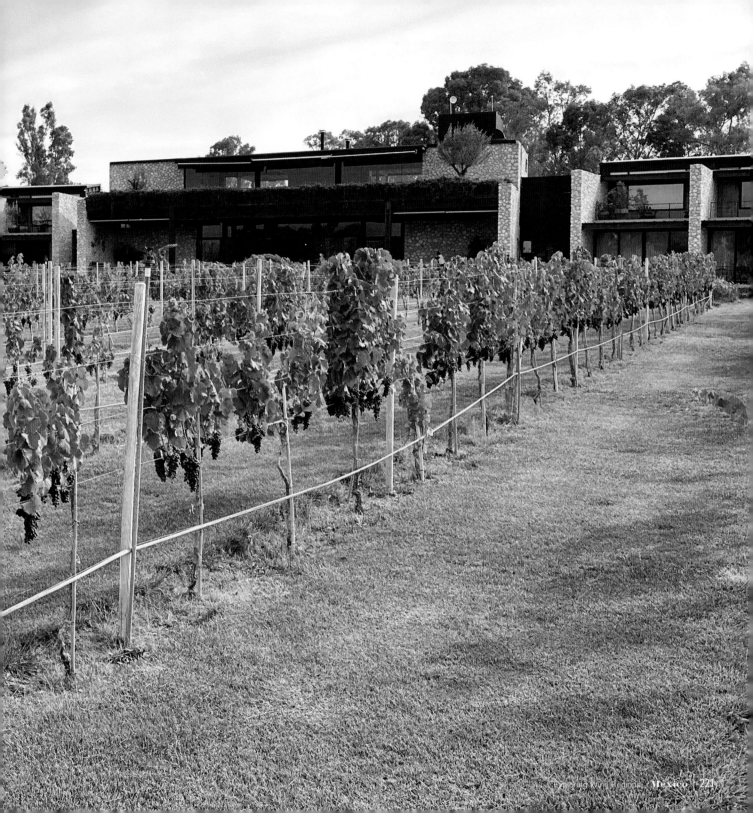

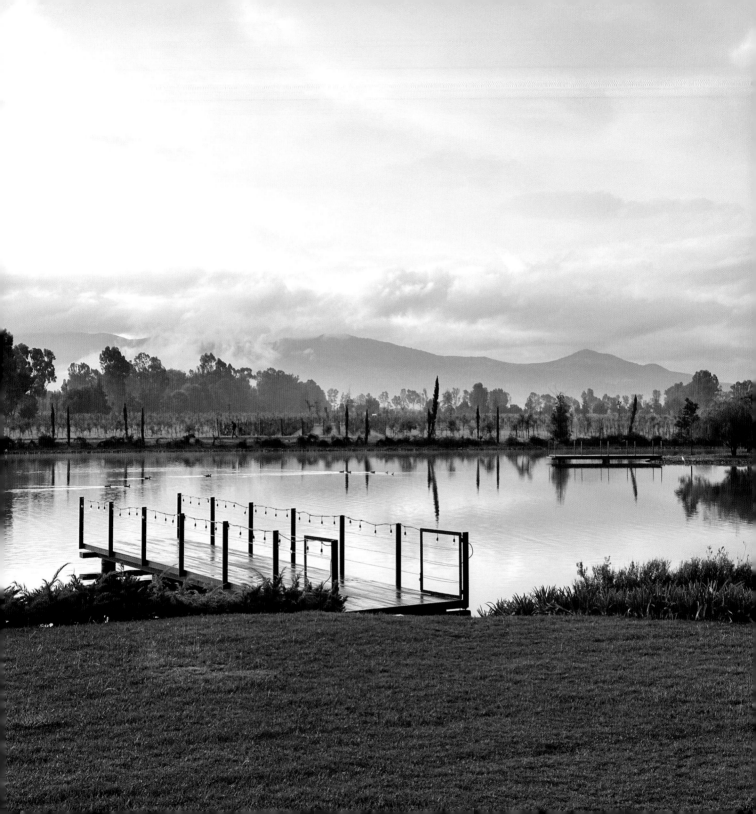

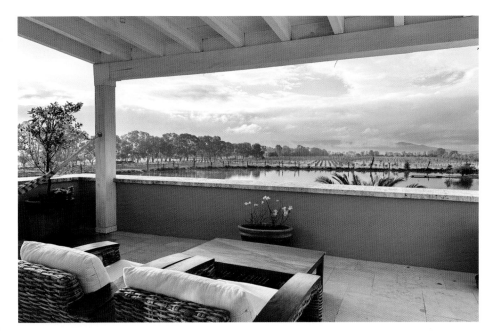

$$$

Located: 18km/11mi East of San Miguel
Carretera a Corral de Piedras Km 3
37888 San Miguel de Allende, Gto, México

+52 415 154 6481
WhatsApp +52 415 101 2105
Hotel@VinedosSantaCatalina.com

VinedosSantaCatalina.com

English, Spanish

Open: Thursday-Sunday
Open: Every Day, 3/25-4/5, 7/25-8/30, 12/15-1/5

TRANQUILITY

The peace and quietness at this new boutique luxury hotel sooth your soul. The views are breathtaking (room view above and restaurant view left page). This is a place to unwind and experience true tranquility. And to add to that, they have a spa with a special aromatherapy massage of rosemary and lavender with the most perfect hands caressing your body. When you leave here, you will be a new person.

This is a brand-new hotel with only ten luxurious suites. They are not just super comfy, they are spacious and some have outdoor patios upstairs (photo above).

This is a private 250-acre property with its own lake and island, often enjoyed by the ducks and white herons that love living here (photo left page).

Santa Catalina is part of the same proprietorship of San Lucas and San Francisco (previous pages), just a few miles farther east.

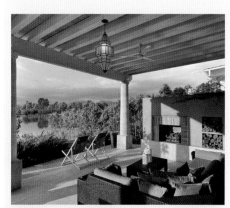

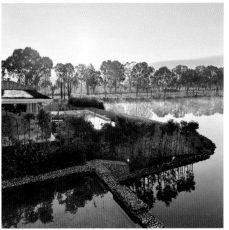

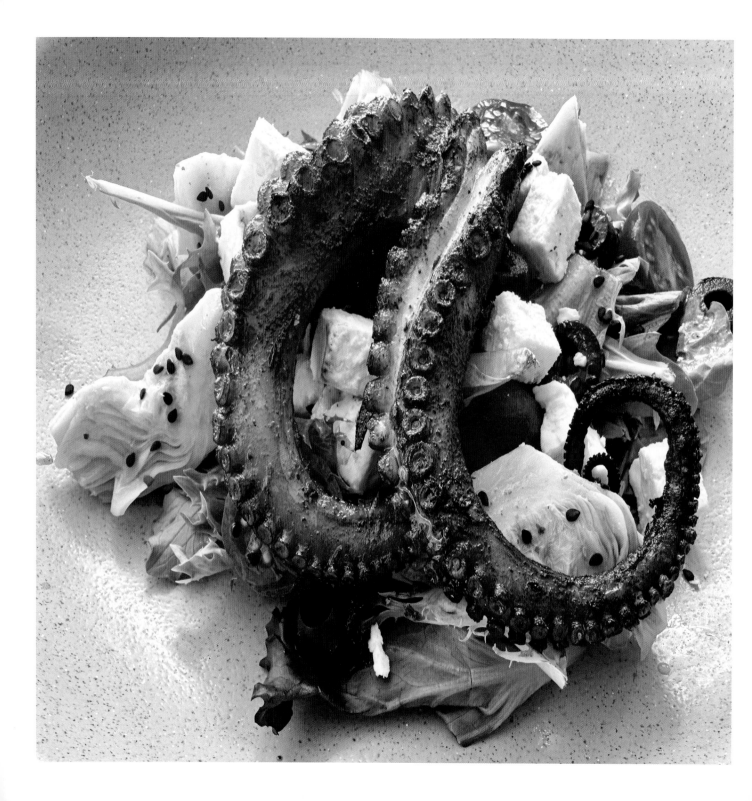

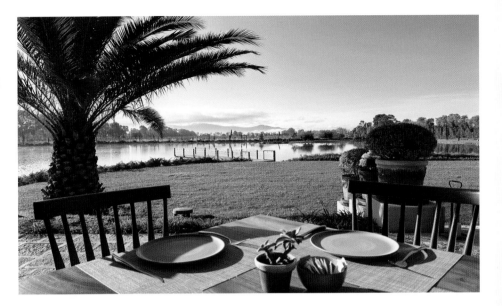

$$-$$$

Located: 18km/11mi East of San Miguel
Carretera a Corral de Piedras Km 3
37888 San Miguel de Allende, Gto, México

+52 415 154 6481
WhatsApp +52 415 101 2105
Hotel@VinedosSantaCatalina.com

VinedosSantaCatalina.com

English, Spanish

Restaurant Open: Thursday-Sunday, 8am-9pm
Open: Every Day, 3/25-4/5, 7/25-8/30, 12/15-1/5

GOURMET ITALIAN CUISINE

One of the best parts of Viñedos Santa Catalina is its restaurant with indoor and outdoor patio seating (photo above). Chef Emmanuel Muños makes a huge difference here in pleasing our culinary delights.

I stayed here for a few days and had breakfast, lunch and dinner, and this was one of the best restaurants I have experienced in all Guanajuato. Even if you're not staying at the hotel, this is a delicious restaurant you must try. Just look at the pictures!

Grilled Octopus (photo left page) is served with lettuce mix, artichoke, cherry tomato, black olives, feta cheese, bathed in lemon, Italian herbs and honey vinaigrette, and sprinkled with black sesame seeds.

Roasted Red Pepper (photo below) is in a red pepper cream sauce, accompanied by crispy crouton, goat cheese, black olives, and fine herbs.

Artisanal Granola (photo below right) is with seasonal fruits and berries, and natural yogurt.

Cappuccino (photo upper right) is with cinnamon, coffee beans and locally produced lavender perfume.

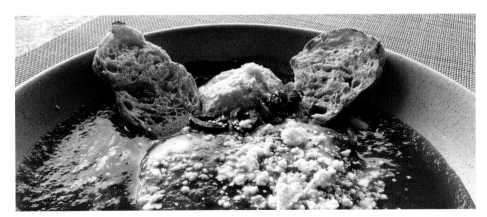

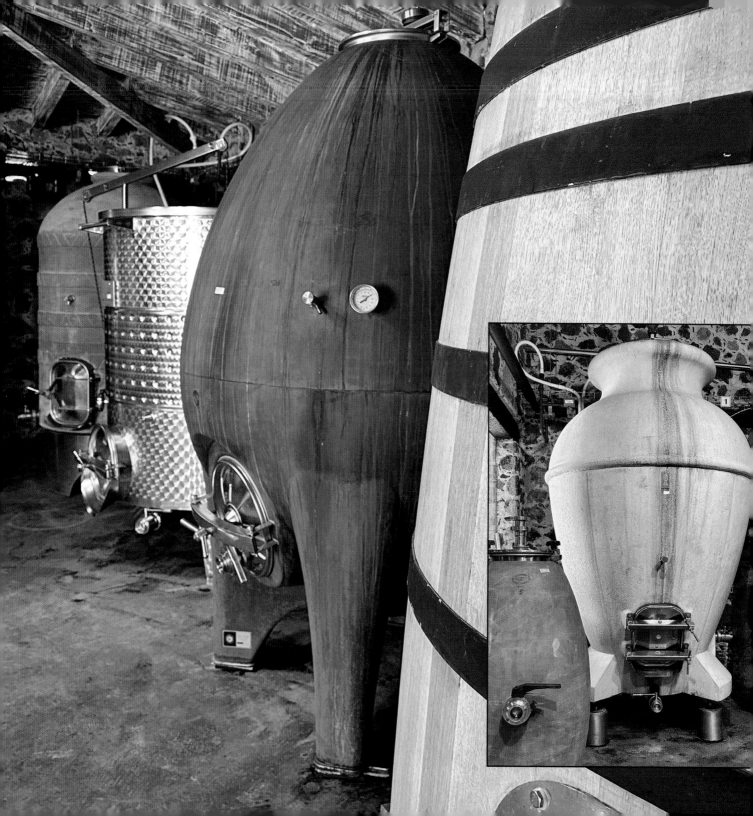

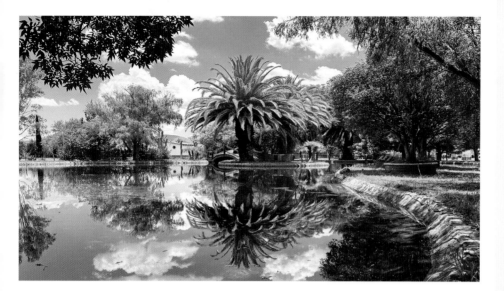

Winemaker: Bordeaux France

$$-$$$

Located: 18.6km/11.6mi East of San Miguel
Winery: VCF4+FH9 La Chingada
1km to Gate Entrance: VCG3+6WP La Chingada
37734 Guanajuato, México

+52 442 594 3608
Contacto@Casa-Anza.mx

Casa-Anza.mx

Spanish

Open: By Appointment Only
Monday-Saturday, 11am-4pm

T his is a family project with an estate focused on the very best of quality.

WINES OF PASSION

It was a dream come true for brothers Hugo and Ruben Anzures when they bought a horse ranch in 2002 with the dream of making the ultimate quality wine for themselves. Yes, a personal project.

Since the wine was for themselves, they made the best choices in every step appealing to their love of excellent wine.

The ranch itself is magical. It is at almost 7,000 feet elevation, with a microclimate protected by a nearby mountain, has loamy clay soils and limestone perfect for Bordeaux varietals. So they acquired French grafts from the distinguished Mercier in Bordeaux. And hired a Bordeaux oenologist.

They were truly after the best. And it doesn't stop there. The tanks they acquired are as unique as it gets in a winery. Costly, yet the plan is to have the best wines ever. Left page: tanks from left to right.

Terracotta Amphora (first tank): this is one of the most artisanal products of the Tuscany region that respects the characteristics of the grape grafts and improves the earthy characteristic of the wine.

Stainless Steel (second tank): provides an airtight environment, minimizing oxygen exposure during aging and helps preserve the wine's freshness, vibrant fruit flavors and natural acidity.

Black Concrete (third tank): It's an oval shape that helps circulate the wine freely in a natural way keeping it in greater contact with the must.

French Oak (fourth tank): provides more body, structure, smoothness, and longer life in the bottle.

Cocciopesto (inset tank): the material is created in ancient Rome, adds texture, brilliance, complexity, making for more elegant wines. Its porosity provides excellent micro-oxygenation as well.

The results? Excellent Bordeaux style wines. They are winning numerous awards in important competitions. With this much success, they had to take the wine public. Distribution is primarily to restaurants and wine shops. Visiting the property is by advanced reservations only. And you must be serious about quality wines.

Getting there can be tricky. While the address top right is accurate, these directions will help. Traveling east on Hwy 111, driving through the town of Cerritos, turn right at the very last road. This is a pretty beat up road; however, go 1km and after the long white wall, you will see a gate with 1997 on the wall. This is when you call them to open the gate.

Collection of Wines

Gran Reserva De La Familia
(Cabernet Sauvignon, Tempranillo, Malbec)
Gran Reserva (Cabernet Sauvignon, Tempranillo, Malbec)
Reserva Anza (Cabernet Sauvignon, Tempranillo, Malbec)
Cabernet Sauvignon
Malbec

Rosado (Rosé of Cabernet Sauvignon, Malbec, Syrah)

Reserva (Sauvignon Blanc, Semillón)

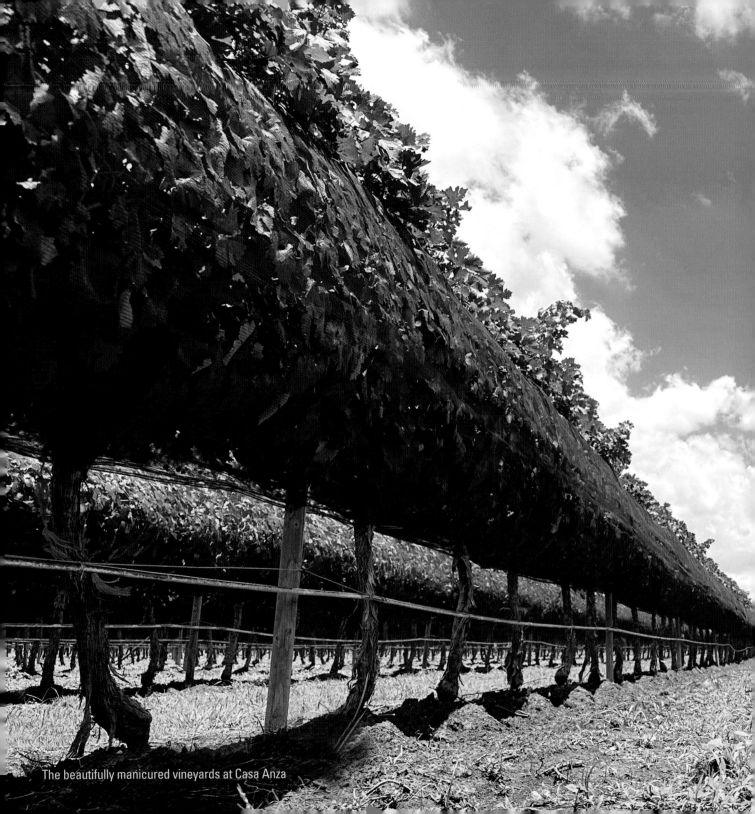

The beautifully manicured vineyards at Casa Anza

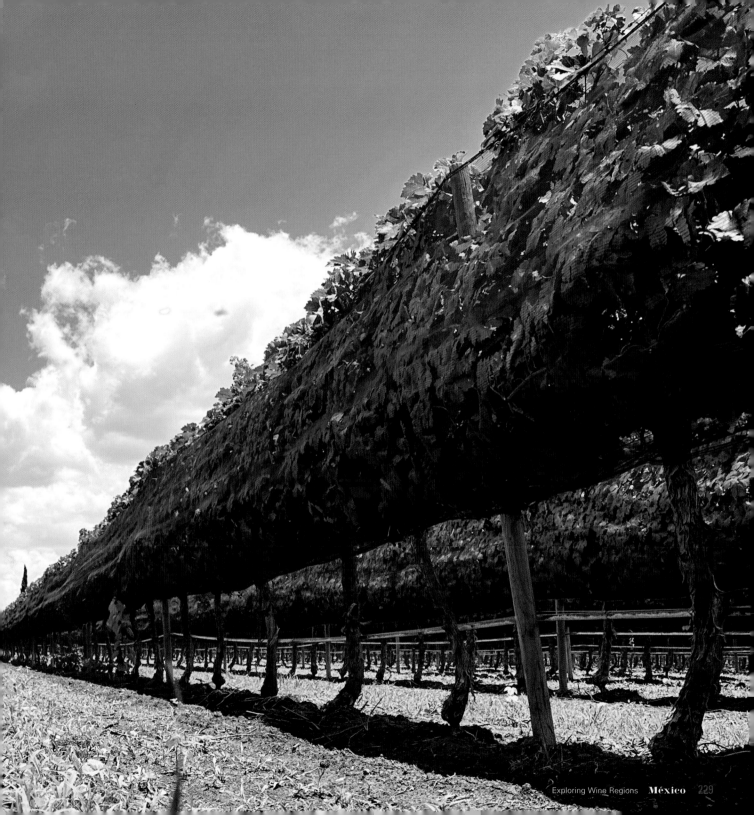

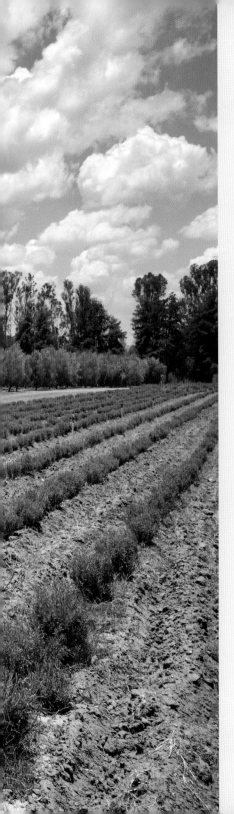

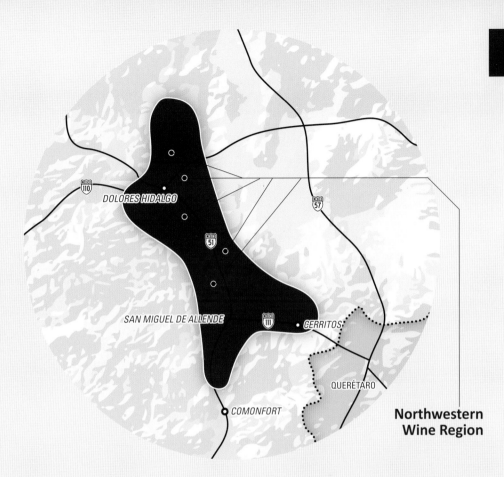

Dolores Hidalgo · San Miguel de Allende · Cerritos · Querétaro · Comonfort

Northwestern Wine Region

Left page: Lavendar fields, olive orchards and vineyards at La Santísima Trinidad

NORTHWESTERN REGION

The distance to the first winery on Hwy 51 is...
25km/16 miles (23 minutes)

To get to the northwestern wine region, it is necessary to transverse through winding city streets, and some traffic, before getting out of town to the wineries. This is Hwy 51, which connects the two primary cities here of San Miguel and Dolores Hidalgo. A new four-lane highway, with center strip, and separate bicycle lane is under construction.

While this wine region is farther away from San Miguel, there are very nice hotels and restaurants in this region, many of which are at the wineries I reviewed for you.

Both Nirvana and Omún have excellent lodging and restaurants convenient to these wineries.

Here are the properties.

- Hotel Nirvana Restaurant & Retreat, page 233
- Viñedo Tres Raíces, page 241
- Viatura Omún, page 245
- La Santísima Trinidad, page 249
- Viñedos & Hacienda San Bernardino, page 253
- Viñedo Los Arcángeles, page 261
- Viñedo Cuna de Tierra, page 263
- Cavas Manchón, page 269

$$-$$$

Located: 14.4km/8.9mi from San Miguel
Camino Antigua Via, del Ferrocarril 21, Cortijo
37893 San Miguel de Allende, Gto, México

+52 415 185 2194
WhatsApp +52 415 105 6641
Ventas@HotelNirvana.mx

HotelNirvana.mx

English, Spanish

Open: Every Day

HEAVEN ON EARTH

As their name suggests, this place is really heaven on Earth. A peaceful retreat just a short distance from the San Miguel Village and on the way to the northwest wine regions. Nirvana is a nice distance from the highway in a lush quiet environment where you can enjoy a piece of heaven.

Nirvana started as a gourmet restaurant in the San Miguel Village and later moved to this beautiful paradise and boutique hotel (see next page).

Their rooms are very special as you can see in the photos (photo left page and below).

This countryside refuge is on the banks of the Laja River under centuries-old mesquites, acacia trees and various cacti. Beneath them are hot mineral waters which they bring up into their outdoor thermal pool (photo page 237). They also have a spa with massages.

Do you love horseback riding as I do? This is an excellent location to ride into the wilderness as well as through the little cobblestone-street villages (see page 239).

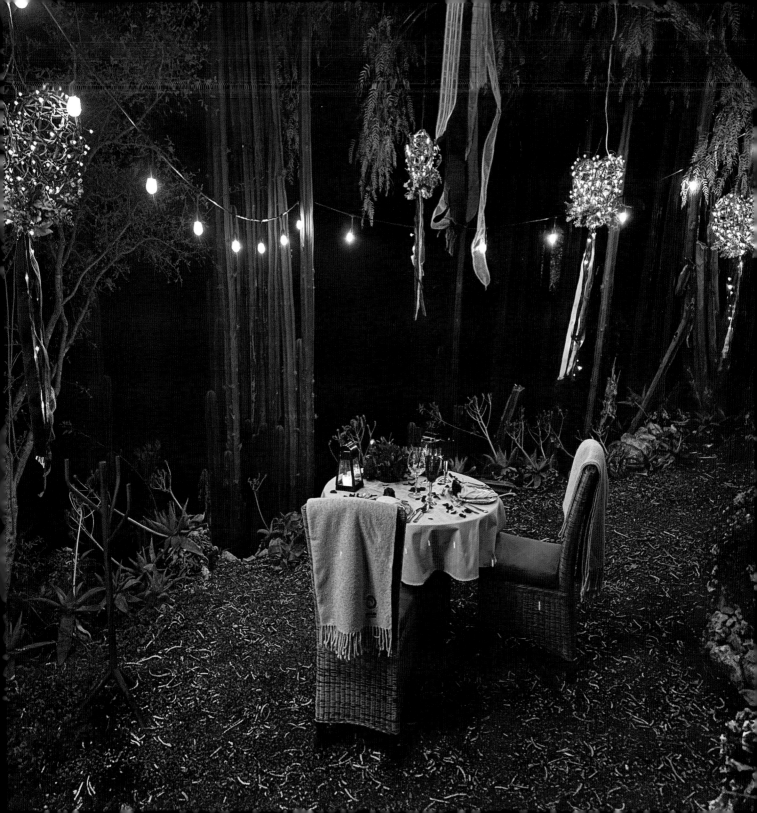

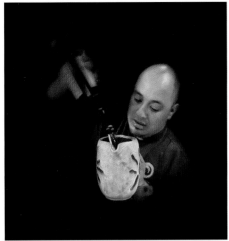

ROMANTIC ESCAPE

Look at the dining setting on the left page. Is this about the most romantic setting for a special dinner date that you have ever seen? At Nirvana, they deliver romance or escape. Love or peace. Delights or solitude. Or you can have it all here. Nirvana is a place to disappear for solitude, romance, health, and culinary joy.

The mixologist here will enlighten your sense of taste. I was always surprised by his next creation. Miguel (photo left top) was always in a creative mood. Don't the drinks make your mouth water just by looking at them? I could not get enough, and he kept making new experiences for me.

La Caipiroska (photo left middle) is Brazil's national cocktail in Nirvana creative fashion. It is bright, refreshing and with complex flavors. Vodka, Licor 43, pineapple juice, lime juice, topped with sugar and a lime slice garnish.

Fresh Guava Beer (photo left bottom) is a refreshing Taquila cocktail. Tequila Tradicional reposado and lager beer, guava juice, lime juice, natural sugar syrup and a mint garnish.

Rack of Lamb (photo below) is in a mint and pine nut pesto with rustic mashed potatoes.

Mexican Breakfast (photo below right) is prepared in a Veracruz style of enchiladas and eggs.

GUANAJUATO **DOLORES HIDALGO** NorthWest ■
Lodging, Restaurant, Spa, Retreat
HOTEL NIRVANA

$$-$$$-$$$$

Located: 14.4km/8.9mi from San Miguel
Camino Antigua Via, del Ferrocarril 21, Cortijo
37893 San Miguel de Allende, Gto, México

+52 415 185 2194
WhatsApp +52 415 105 6641
Ventas@HotelNirvana.mx

HotelNirvana.mx

English, Spanish

*Restaurant Open: Every Day,
8:30am-10pm (Sunday 8pm)*

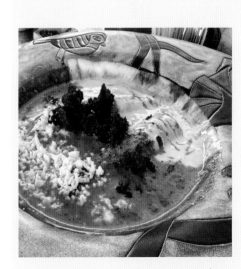

Located: 14.4km/8.9mi from San Miguel
Camino Antigua Via, del Ferrocarril 21, Cortijo
37893 San Miguel de Allende, Gto, México

+52 415 185 2194
WhatsApp +52 415 105 6641
Ventas@HotelNirvana.mx

HotelNirvana.mx

English, Spanish

Open: Spa, Every Day, 9am-5pm
Thermal Pool, Every Day, 8:30am-10pm

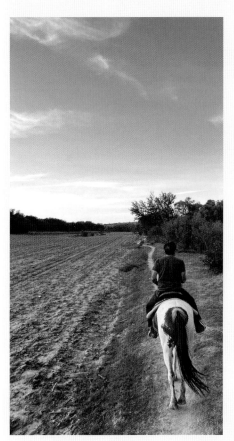

HORSEBACK RIDING

There is extensive open space here to horseback ride across the plains (photo left page), through the hillside trails with views of San Miguel de Allende (photo below center), and along the banks of the Laja River (photo right). Also, ride on the cobblestone roads through the village of Atotonilco and see the famous church Santuario de Jesús Nazareno de Atotonilco (see next page).

SPA & THERMAL POOL

A significant attribute to Nirvana is the hot mineral water deep below the resort. This special water is pumped to the surface and into their thermal pool to soak and enjoy (photo above). It is a large pool, yet cozy and warm, and instills health aspects. They also have a spa with excellent massage services to add to your pampering experiences at this retreat (photo below left).

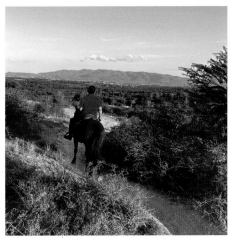

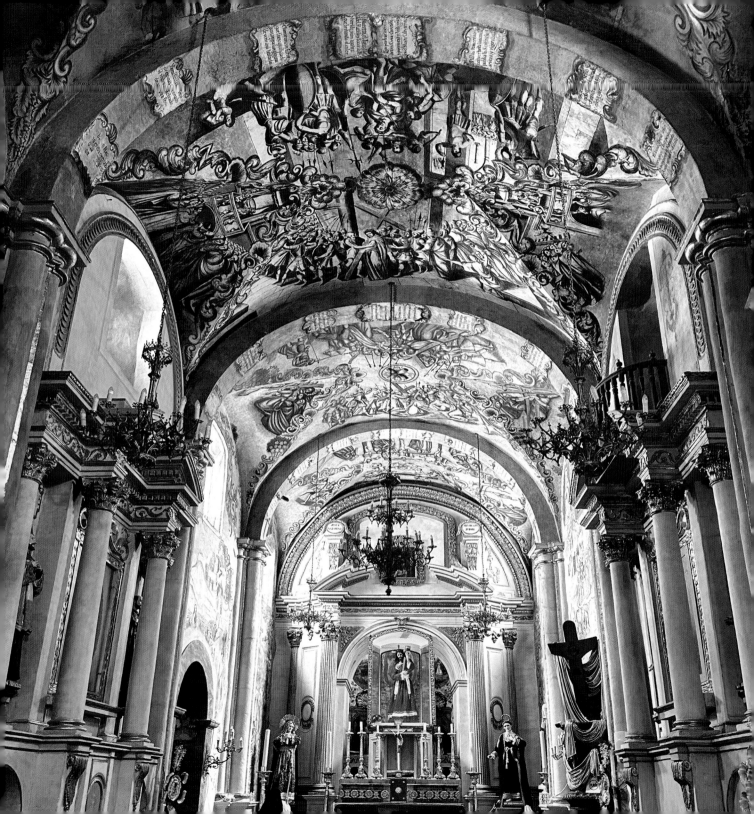

Located: 13.9km/8.6mi from San Miguel
Calle Principal Atotonilco
37893 Atotonilco, Gto, México

+52 415 185 2160

SantuarioDeAtotonilco.org

Spanish

Open: Every Day, 10am-6pm (Sat/Sun 7pm)

INDEPENDENCE OF MÉXICO

Santuario de Jesús Nazareno de Atotonilco is a very important church for México as this is the Roman Catholic Church where Priest Miguel Hidalgo presided. Miguel Hidalgo was the revolutionary leader of the **Mexican War of Independence** and is recognized as the **father of the nation**. This is a special place for this country as the cradle of independence. Further, it has now become a **UNESCO World Heritage site** along with the San Miguel de Allende Village.

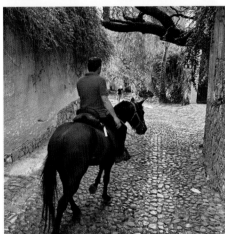

Santuario de Nazareno is a historical site you do not want to miss. It is located in the little village of Atotonilco (population 600) with cobblestone streets and local craft vendors along the road. **Hotel Nirvana** is very close (0.3 miles), walkable or horseback ride.

Santuario de Jesús Nazareno de Atotonilco is an active church, open to the public every day and free to enter.

I felt the outside of the church was rather plain compared to other churches (photo above); however, inside the church it is spectacular. Look at the immense detail on the walls and ceilings. This is one very impressively beautiful church inside (all photos on these two pages are at the church).

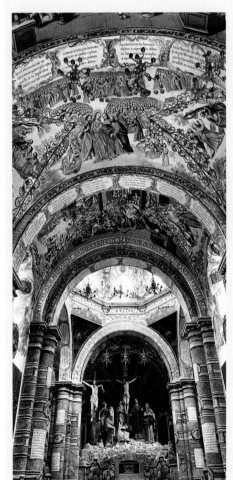

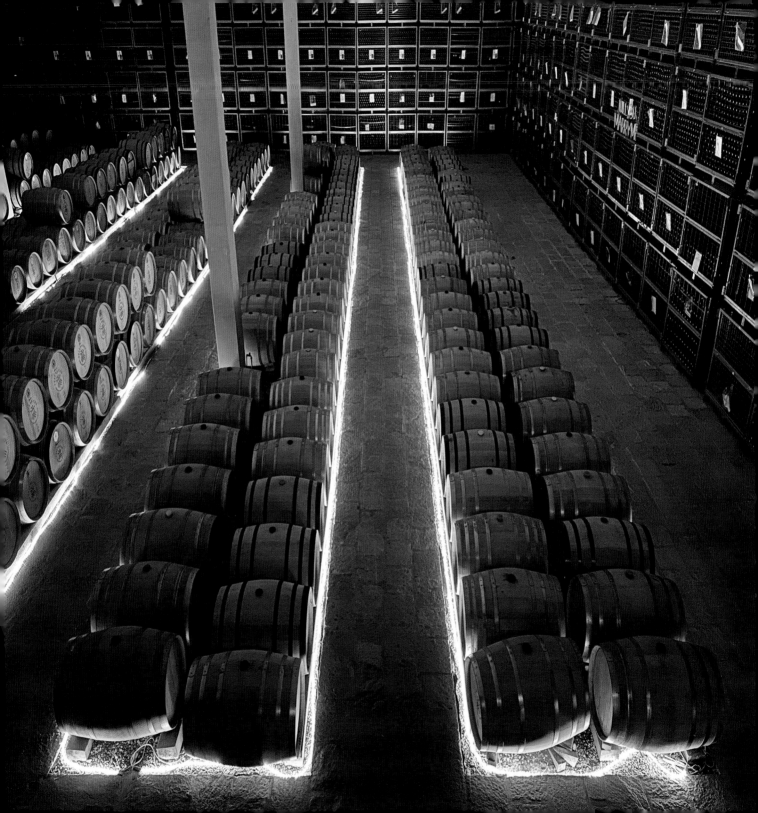

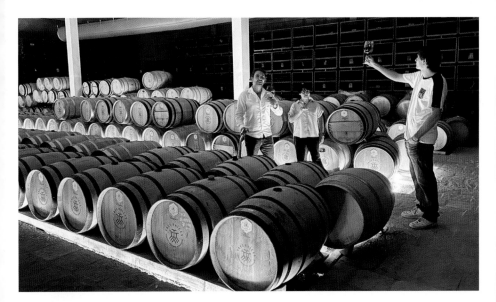

Winemaker: La Rioja, Spain

$-$$-$$$-$$$$

Located: 25km/16mi from San Miguel
Carretera San Miguel de Allende a Hidalgo, km 73
37806 Dolores Hidalgo, Gto, México

+52 415 113 5250
WhatsApp +52 415 113 5250
Enoturismo@TresRaices.com.mx

VinedoTresRaices.com

English, Spanish

Open: Every Day, 9am - 10pm
Experiences: 9am, 11am, 1pm, 3pm, 5pm

Collection of Wines

Gran Reserva (Cabernet Sauvignon, Merlot)
Terruño (Cabernet Sauvignon, Tempranillo)
Blend (Cabernet Franc, Merlot)
Ensamble Tinto (Cabernet Sauvignon, Syrah, Tempranillo)
Nebbiolo - Sangiovese
Tempranillo
Tré Sangiovese
Pinot Noir
Malbec
Merlot

Rosé (Rosé of Grenache, Caladoc)

Sauvignon Blanc Joven (Young Vines)
Sauvignon Blanc Crianza (Aged In Oak)

M assive underground cellar, lookout post in the middle of the vineyards, gourmet restaurant.

LOTS OF EXPERIENCES

It started in 2012 when they planted vines and then opened their doors in 2018 for the release of their first wines. This place is very modern in architecture and design. And they have an awesome restaurant overlooking the vineyards (see next page).

You will love this place. They have a towering overlook (Mirador Lookout) in the middle of the vineyards where you can see across the landscape and their mini lake filled with hot mineral water pumped deep from the earth. They let it cool in the lake before feeding this special water to the vines.

They claim to have the largest aging cellar in Guanajuato, and it is massive (photo above and left page for partial views of the cellar).

They have an extensive number of tours and tasting opportunities. Each can be with or without a tour; however, I highly suggest the tour, especially to see their massive underground cellar.

• **Tour, Tasting & Sensory Experience.** An expert guide will tour you through the winery property: vineyards, Mirador Lookout, vinification area, and underground cellar. Develop your senses while wine tasting; a sensory experience led by an expert

in sight, smell and taste sensory exercises. Tasting can be either **three or five wines** or **three or five premium wines**. Plus, you can add **food**: cheeses & charcuterie boards, fruits and honey, truffled potatoes, raw tuna toast, braised octopus tacos, burrata salad, salmon pizza, caprese shrimp risotto, and Terruño roast steak.

• **Food & Wine Pairing.** Pairing foods with wine tasting is the ultimate way to experience a winery. Tres Raíces has a gourmet chef on premise to orchestrate this experience. Enjoy a **Three-Course Pairing**: appetizer, main course and dessert, orchestrated with their wines. Or enjoy a **Seven-Course Pairing**: an exclusive food and wine experience in a seven-course menu with exclusive seasonal dishes of the distinctive signature cuisine of Tres Raíces. Reservation required at least 24 hours.

• **Make Your Own Bottle of Wine.** Be a winemaker for a day. They have all the ingredients for you. This is a specialized tour of the production and underground cellar where they will explain the winemaking and aging process. You will taste wines directly from the barrels that you will use for this workshop, then creating your own blend, bottle and label for your wine that you will take home.

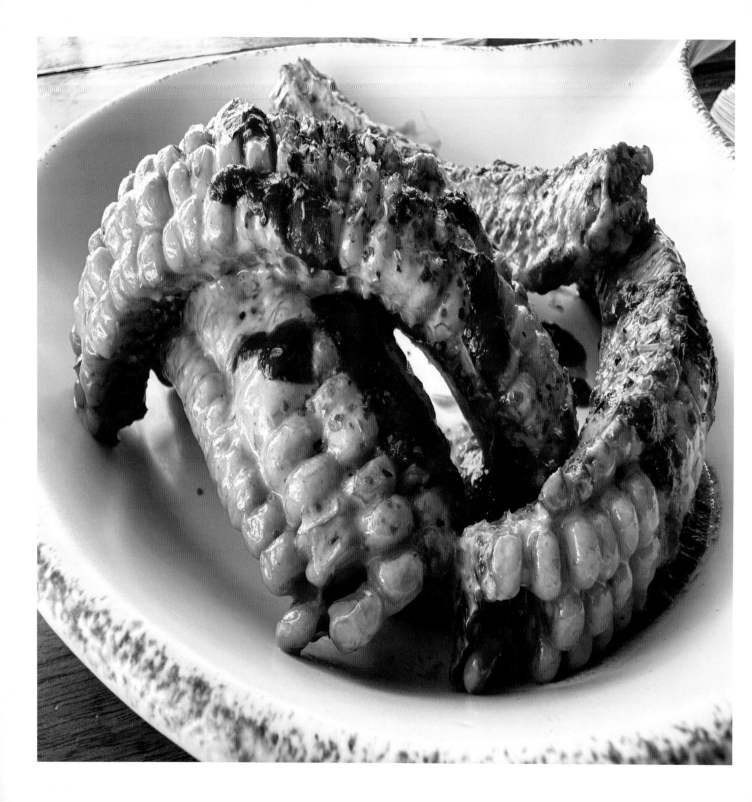

CREATIVE GOURMET CUISINE

My experience at Tres Raíces started by sitting down with the winemaker as he ordered these outrageously amazing corn ribs (photo left page). He knew what he was doing, and it was impressive! It was rich and slightly spicy with interesting contrasts of salty, sour, sweet and spicy flavors all in one. Remembering, I am salivating now. Chefs Antonio Arriaga and Omar Nahed are on top of their game. When I met him in his kitchen, I saw everything being made by scratch. This restaurant is a great treat even if you are not here for wine tasting.

Here are some of their extraordinary dishes...

Costillas de Elote (Corn Ribs) (photo left page) are yellow corn strips, bathed in spicy mayonnaise and guajillo chile dressing (a sweet, fruity, tangy, smoky flavor profile with notes of berries and tea) and sprinkled with chili powder.

Vineyard Cheesecake (photo below) is a handmade cheese cake with fresh and quality ingredients, with a compote of regional fruits of strawberries, raspberries and blackberries.

Linguini Terruño (photo below right) is a fresh homemade linguini pasta prepared at your table in a wheel of parmesan cheese. Watch as the fresh hot pasta melts the cheese as they swirl it around for a savory delicious experience.

Beet Salad (photo upper right) is made with roasted beets served warm on jocoque (a Mexican buttermilk) prepared with chiltepin peppers and chives, then finished with arugula, pistachios and balsamic vinegar.

$$-$$$

Located: 25km/16mi from San Miguel
Carretera San Miguel de Allende a Hidalgo, km 73
37806 Dolores Hidalgo, Gto, México

+52 415 113 5250
WhatsApp +52 415 113 5250
Restaurante@TresRaices.com.mx

VinedoTresRaices.com

English, Spanish

Open: Every Day, 1pm-9:30pm

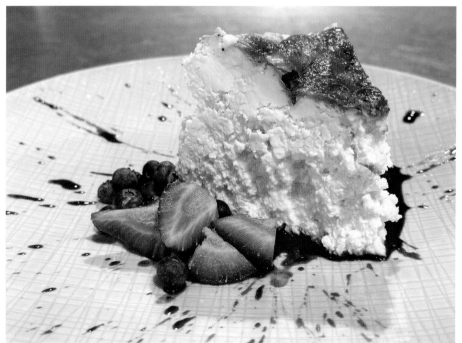

GUANAJUATO **DOLORES HIDALGO** NorthWest
Lodging, Restaurant, Spa, Experiences
VIATURA OMÚN

$$$

Located: 32km/20mi from San Miguel
Predio Rustico ahora El Bajío Sin Numero
37817 Comunidad La Venta, Gto, México

+52 442 628 7456
WhatsApp +52 563 364 9392
Stay@HotelOmun.com

HotelOmun.com

English, Spanish

FIVE-STAR CAMPING

This is a luxury tent resort beyond what you can imagine. Huge, double-tent size (photo left page), full-size living room, dining room, wet bar, double-sink bath (photo bottom center), and spacious bedroom (photo above). There is a huge deck that circles the tent with multiple seating areas and a hammock.

Nighttime is magical here. The sky is pitch black filled with stars as this resort is in a remote location and other tents are at least a 100 feet away. You have privacy and serenity. The outdoor spa (photo bottom right) is a great way to indulge the night here. Ask for sticks and marshmallows to cook on your outdoor fireplace (photo upper right).

REJUVENATING EXPERIENCES

Omūn is a place to rejuvenate your mind, body and soul. It has many outdoor experiences designed to help you create a new you. You decide exactly how you would like to experience this retreat and they will customize your activities.

For example, by day, choices could include **hiking**, **beekeeping**, **ice bathing**, **painting & red wine**, etc.

Or at night, **stargazing** with a telescope, making **s'mores**, or a **romantic dinner** staged on your deck or in the wilderness under a tree. Everything is at your choice on how you would like to experience the magic here.

An extensive **spa** is being built to provide a full variety of rejuvenating experiences.

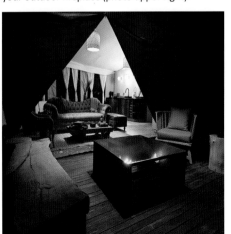

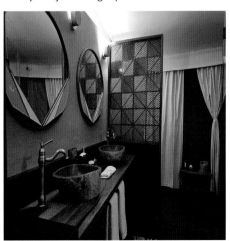

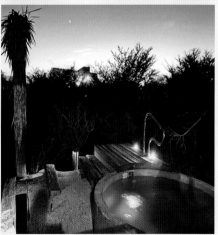

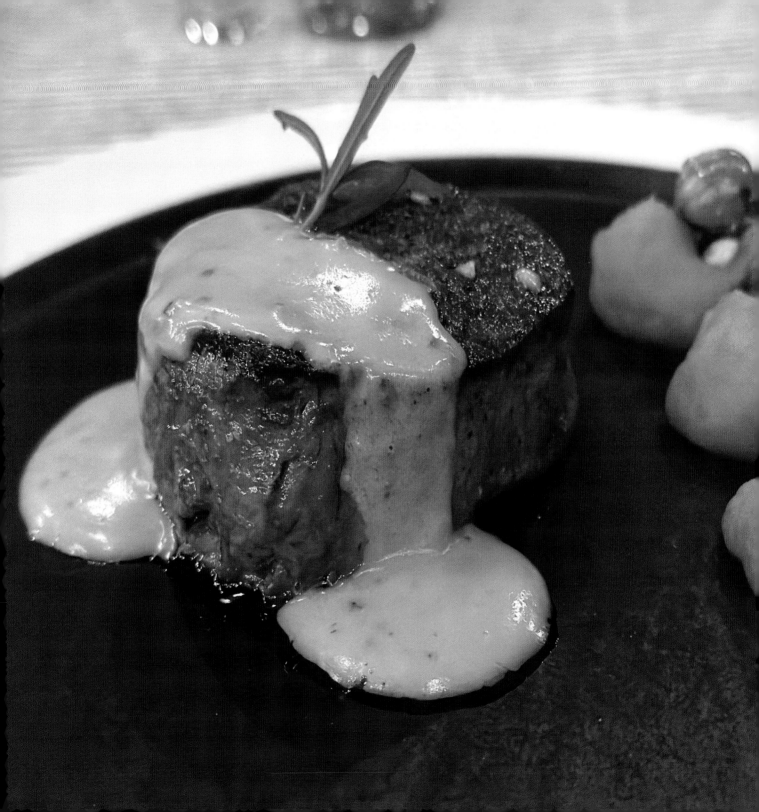

NOT CAMPSITE FOOD

Okay, so it might be easy to conclude that food at a campsite with tents may not be overly luxurious. Let me change your mind. Look at the photos on these two pages. This is the quality, creativity and gourmet deliciousness that you can expect at this luxury tent resort. I was here in the very beginning stages of this resort, and I understand they are going to be putting in an amazing restaurant, open to non-guests, which will only elevate what we see now.

Beef Filet (photo left page) bathed in creamy blue cheese sauce and accompanied by mashed yellow sweet potato with caramelized hazelnuts.

Breakfast Fruit (photo top left) accompanied by Greek yogurt and points of red fruit compote with walnut and coconut granola.

Panela Cheese (photo bottom left) wrapped in holy leaf on a bed of beans from the pot with pieces of pickled onion and mashed avocado.

Carrot Cake (photo top right) with walnuts and cream sorbate

Enchilada (photo bottom middle) stuffed with chicken bathed in a sautéed and gratin crystal chili sauce.

Fettuccine (photo bottom right) in black truffle sauce accompanied by veal sausage and cheese mix.

$$$

Located: 32km/20mi from San Miguel
Predio Rustico ahora El Bajío Sin Numero
37817 Comunidad La Venta, Gto, México

+52 442 628 7456
WhatsApp +52 563 364 9392
Stay@HotelOmun.com

HotelOmun.com

English, Spanish

Restaurant Open: Every Day
Reception, 9am-9pm
Breakfast, 9am-11am
Lunch, 3pm-5pm
Dinner, 8pm-10pm
Pool Bar, 12pm-4pm

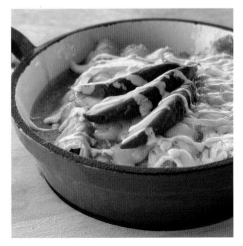

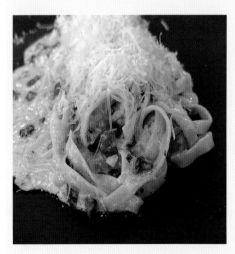

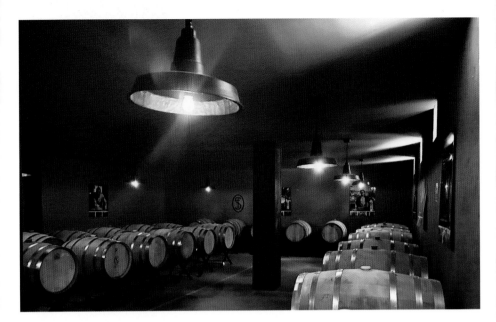

Winemaker: Argentina

$$

Located: 35km/22mi from San Miguel
San Miguel de Allende Highway - Dolores km. 81
37814 Dolores Hidalgo, Gto, México

+52 415 152 1964
WhatsApp +52 418 688 2467
Vinicola@VinedosSanLucas.com

LaSantisimaTrinidad.com.mx

English, Spanish

Open: Every Day
10am, 11:30am, 1pm, 2:30pm, 4pm
(Friday/Saturday, 5:30pm 7pm)

Collection of Wines

Gran Reserva Petit Verdot
Reserva Malbec
Reserva Cabernet Sauvignon
Reserva Merlot
Crianza Tinto Blend (Cabernet Sauvignon, Malbec, Syrah)

Rosados (Rosé of Syrah)
Sparkling Rosé (Malbec, Syrah, Tempranillo, Pinot Noir)

Sauvignon Blanc
Blanco Joven (Chardonnay, Macabeo, Moscatel)

Ruby Port
Tawny Port

A unique winery with vineyards from the owners of estate homes on the property.

VERY BEAUTIFUL PROPERTY

What you will notice first when you arrive at this property is its lush landscape and beautiful architecture (photo left page). They even have a lake on the property with a beautiful deck for the restaurant. It is a great way to enjoy dining and wine tasting in an awesome environment (photos and restaurant on the next page).

The winery here is rather unique. The property was developed into a residential community with beautiful estate homes surrounded by vineyards, olive trees, and lavender fields (photo on page 231). These vineyards provide the winery excellent grapes for both commercial production and for the owners of these homes. Cool concept, isn't it?

They also produce olive and lavender oil, and they offer workshops if you would like to learn and make some yourself.

This is a very big property where you can wander and enjoy nature. They have bicycles if you wish to ride. Bicycling and hiking along the beautiful well-maintained dirt roads go on forever so you can still stay within the property. Plus, an equestrian center along with polo fields. They also have a spa and hotel.

They have tours of their winery and cellar, and some unique experiences to enjoy.

• **Sensory Wine Tasting & Tour.** A detailed tour of their winery, production areas, barrel cellar and their beautiful terrace for a tasting experience of their wines paired with a plate of cheese, nuts, red fruits, honey, olive oil and homemade bread.

• **Blind Tasting Experience & Tour.** A blind wine-tasting experience through their best wines with a small plate of regional cheeses, nuts, red fruits, honey, olive oil and homemade bread. Plus, their detailed tour of the winery, production areas, and barrel cellar.

• **Gourmet Food & Wine Pairing.** Their chef and winemaker work together to create a four-course prix fixe gourmet dining experience with each course paired perfectly with one of their best wines.

• **Lavender & Olive Oil Workshop.** Experience a lavender and olive oil workshop with a detailed education of the history and process in their olive oil and lavender productions.

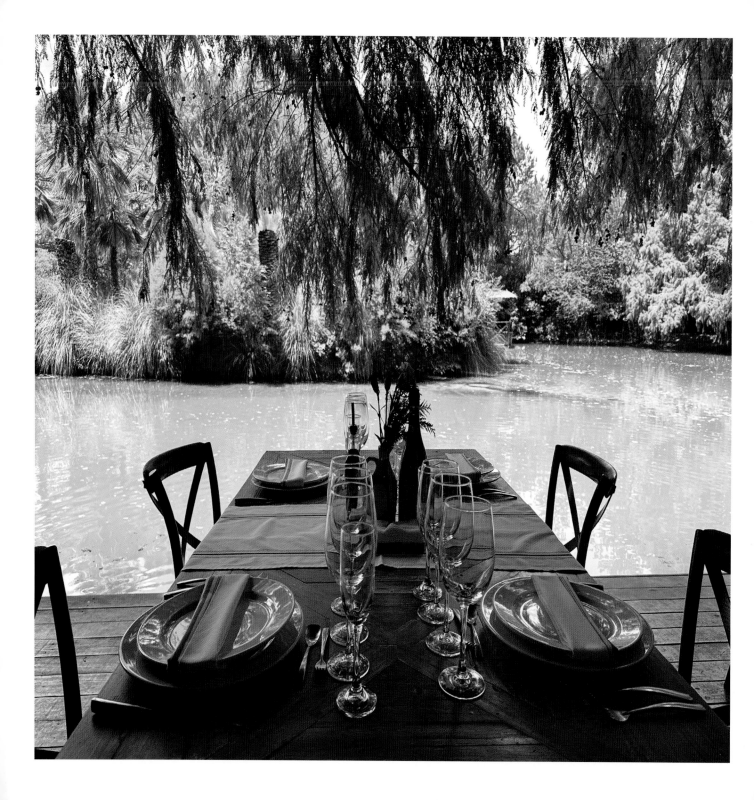

MEDITERRANEAN CUISINE

Sitting by the side of the lake, letting time roam on by...
That was my afternoon, on the dock, in the cool shade of the trees, taking in the lake and jungleous view. Can it get any better than this? Well, yes, it did. The winemaker joined me for lunch. Nothing was like tasting his wines in this setting, paired with their delicious food.

Now for the extraordinary cuisine...
Traditional Brownies (photo below) made with dark chocolate and nuts, flavored with lavender essence from their lavender fields, accompanied with berries and artisanal lavender ice cream.
Chilean Salmon Fillet (photo upper right) is marinated in fine herbs, served with pesto fettuccine pasta, made with basil from their organic garden, with a touch of pine nuts.
Grilled Rib Eye (photo below right) is accompanied by rustic mashed potatoes with fresh rosemary and a mixed lettuce salad harvested from their organic garden, dressed with honey and mustard vinaigrette.

GUANAJUATO **DOLORES HIDALGO** NorthWest
Winery, Vineyards, Lake, Restaurant
LA SANTÍSIMA TRINIDAD

$$-$$$

Located: 35km/22mi from San Miguel
San Miguel de Allende Highway - Dolores km. 81
37814 Dolores Hidalgo, Gto, México

+52 418 120 3089
WhatsApp +52 437 134 1086

LaSantisimaTrinidad.com.mx

Open: Friday/Saturday, 8am-10pm
Thursday 1pm-6pm, Sunday 8am-5pm)

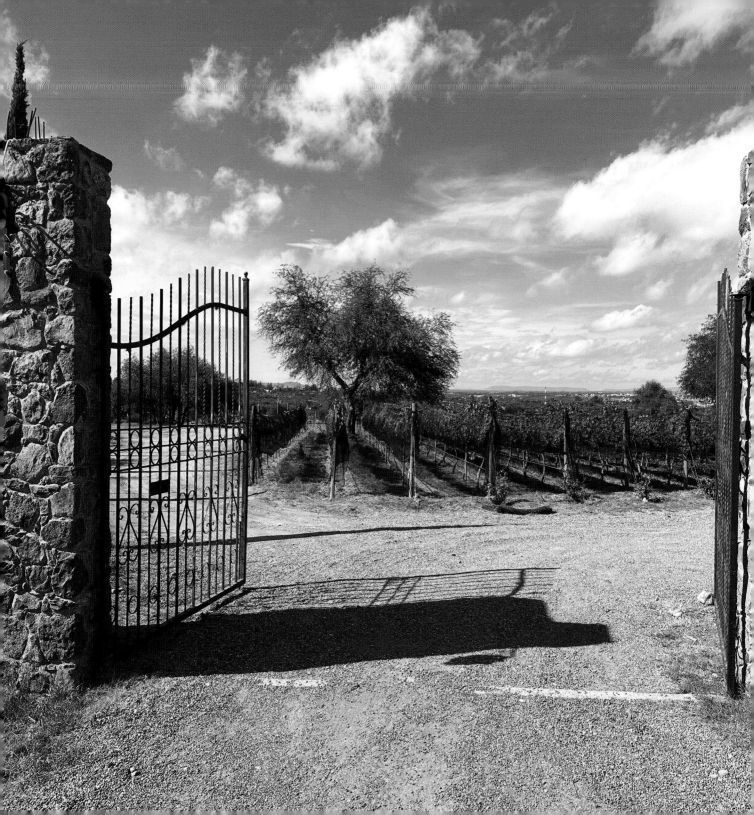

A casual ranch with many things to do. Wine. Food. Lodging. Horses. ATVs. Spa. Relaxing.

A WONDERFUL FAMILY BUSINESS

This is a very casual ranch where you will feel especially comfortable. Nothing fancy. Just good people in a nice place.

This is truly a family business, led by Juan Rendón Lopez, who is also the winemaker making some nice wines, and who did not go off to a foreign country to learn his skills. His son Juan Miguel is the chef and runs the restaurant. His two daughters Ángeles and Liliana run the spa. His wife, Rosy, well, we know, keeps a good eye on the business.

On the following pages, you will discover that this ranch is a great getaway to relax and have lots of fun. There is a small hotel on the property where you can stay at very reasonable prices. They have horseback riding and all-terrain vehicles to ride outside the ranch in the open spaces.

Nothing fancy when it comes to wine and tours.

• **Wine Tasting.** When you would like to do wine tasting, it's as simple as telling them what you would like to taste. And they will bring it out for your enjoyment. Nothing more complicated than that.

• **Property Tour.** Tour is just as simple. When you want to see the vineyards, you can wander yourself around or they can give you an educated tour. And a full property tour is certainly in order to see all the activities available.

Winemaker: Mexico

$$

Located: 43km/27mi from San Miguel
San Bernardino, Dolores Hidalgo
37814 Delores Hidalgo, Gto, México

+52 418 148 1660
WhatsApp +52 418 148 1660
VinedosSanBernardino@Gmail.com

HaciendaSanBernardo.com.mx

English, Spanish

Open: Wine Tasting: Tuesday-Sunday, 11am-6pm
Spa: Tuesday-Sunday, 10am-6pm
Restaurant: Tuesday-Sunday, 12pm-7pm (Sun 10am)

Collection of Wines

SB Oro (Cabernet Sauvignon, Malbec, Syrah)
SB Plata (Malbec, Cabernet Sauvignon, Syrah)
Madre Tierra (Malbec)
T'ixu (Syrah)

Rosy (Rosé of Syrah)

AQUA SPA

This place has a pretty large spa facility with an incredible **indoor swimming pool** with windows and skylights (photo left page), along with a **hot jacuzzi** and **cold splash pool**. In addition to **facials**, **body scrubs** and **wraps**, and **therapeutic massages**, an excellent **sauna aromatherapy experience** is offered.

Starting with a wet sauna and a large pitcher of cold tea, your pores are opening up and you begin to sweat it out. Then into the freezing cold splash pool, followed by a hot dry sauna. Splash pool again and you are now in the aromatherapy sauna, breathing eucalyptus and other herbs as you complete this sauna detox. Follow that with a therapeutic massage, and it feels like life begins all over again.

SMALL HOTEL

They have only three hotel rooms. The rooms are large and spacious, simple, affordable, very clean and comfortable.

$$

Located: 43km/27mi from San Miguel
San Bernardino, Dolores Hidalgo
37814 Dolores Hidalgo, Gto, México

+52 418 148 1660
WhatsApp +52 418 148 1660
VinedosSanBernardino@Gmail.com

HaciendaSanBernardo.com.mx

Little English, Spanish

Spa Open: Tuesday-Sunday, 10am-6pm

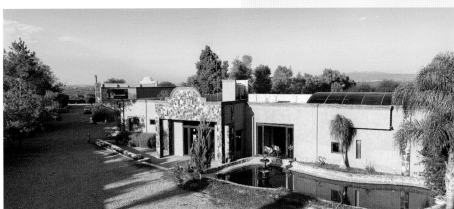

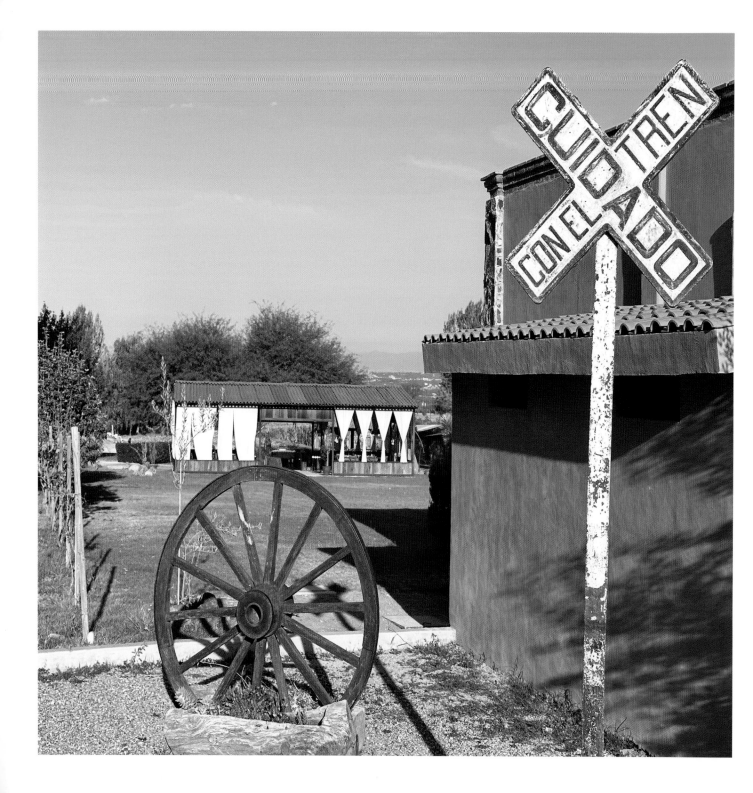

CASUAL OUTDOOR RESTAURANT

Sabores de mi Tierra means "Flavors of my Land" in Spanish. And across the beautiful lawn, there is this casual outdoor restaurant, surrounded by floor-to-ceiling white draperies that you can open and close as you wish (photo left page). They have a big menu, with their specialty being Mexican-style steaks. Ever so delicious (photo bottom).

As a family-run property, son Juan Miguel Rendón is the master chef making a variety of simple yet very delicious cuisine. **Molcajete Mar Y Tierra** is a land and sea dish served in Aztec mortar and pestle: perfectly grilled flank steak, tender chicken breasts, pork sausage chorizo, and butterflied shrimps served with cactus, chambray onions, jalapeño pepper, gratin with grilled cheese, and bathed in the green sauce of the house and avocado slices (photo bottom). **Lavender Ice Cream** is ever so deliciously creamy. This lavender ice cream is homemade at the restaurant using the lavender flowers on the ranch (photo below center).

The ranch grows lots of fruits and vegetables besides the grapes for the winery and the lavender for the ice cream, for example, there are apple and peach trees (photos right).

Not to forget some delicious outside restaurants along the road from other families who create some of the best **Carnitas** you will ever taste. It's a great stop while riding their ATVs in the neighborhood. I stopped at *Carnitas Vicente* and enjoyed some incredibly amazing carnitas tacos (photo below left).

$-$$-$$$

Located: 43km/27mi from San Miguel
San Bernardino, Dolores Hidalgo
37814 Delores Hidalgo, Gto, México

+52 418 148 1660
WhatsApp +52 418 148 1660
VinedosSanBernardino@Gmail.com

HaciendaSanBernardo.com.mx

English, Spanish

Restaurant: Tuesday-Saturday, 12pm-7pm
Sunday, 10pm-7pm

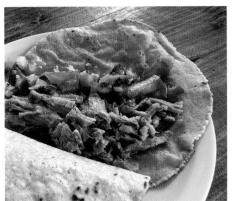
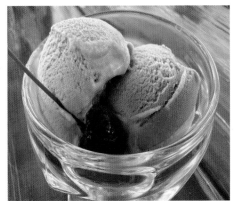

A RANCH FILLED WITH ACTIVITIES

The San Bernardino ranch offers a lot of activities from active sports to just kicking back and relaxing.

Horses: Visit the barn and corral (photo below), take in their beautiful horses, pet their soft coats, and scratch their necks. Better yet, ask them to saddle them up and go for a ride through the vineyards or off the property in the open spaces.

ATVs: Now here's a chance to have a whole lot of fun. There are many roads and trails outside the ranch to take these all-terrain vehicles (photo left page). You can even stop at a local carnitas restaurant along the roadside and taste some of the best carnitas ever (photo previous page).

Relaxation: Kick your feet up on a hammock and enjoy the afternoon (photo below right). The restaurant will bring you a cold drink and you can read a book or just nap away.

Animals: If you are an animal lover, like me, there are numerous different kinds of animals on this ranch, including beautiful peacocks (photo right).

GUANAJUATO **DOLORES HIDALGO** NorthWest ■
Winery, Vineyards, Lodging, Restaurant, Activities
VIÑEDO & HACIENDA SAN BERNARDINO

Located: 43km/27mi from San Miguel
San Bernardino, Dolores Hidalgo
37814 Dolores Hidalgo, Gto, México

+52 418 148 1660
WhatsApp +52 418 148 1660

VinedosSanBernardino@Gmail.com

HaciendaSanBernardo.com.mx

English, Spanish

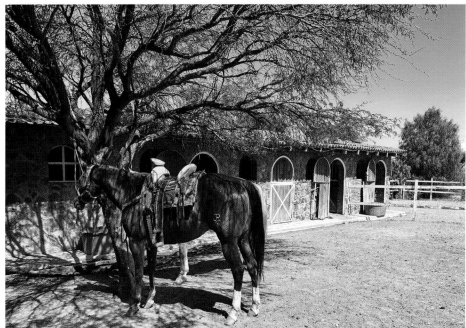

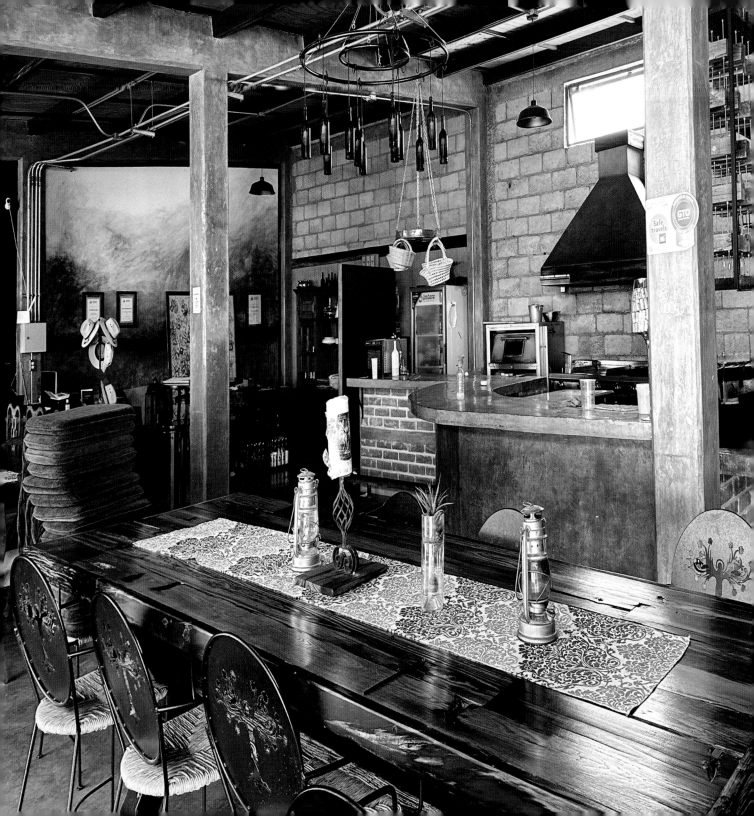

Winemaker: Montpellier, France
$$-$$$

Located: 53km/33mi from San Miguel
Carr Dolores Hidalgo, San Diego de la Unión Km13
37823 Dolores Hidalgo, Gto, México

+52 418 134 7118
Info@VinedoLosArcangeles.com

VinedoLosArcangeles.com

English, Spanish

Open: Thursday/Friday, 12pm-8pm
Saturday/Sunday, 11am-6pm

Family business, boutique vineyard, super casual relaxing environment.

HAND-MADE WINES

The founder and winemaker Ulises Ruiz created Viñedos Los Arcángeles in 2016 after studying viticulture in France, Germany and the United States. He wanted more than a sustainable property; he became focused on minimal intervention so the wines best represent the terroir of the property.

This is an all-family project, with no investors. And no pesticides, no herbicides, keeping everything alive in the vineyards.

The terroir is a bit different here. Sand on the surface with under layers of limestone rock. Deep under the limestone is mineral water they use to irrigate the vineyards. Ulises uses natural yeast fermentation from the yeast in the air in the winery. Different yeasts are active at different times adding further uniqueness to his wine. He wants his wine to reflect his unique property. And he recently won three gold medals in an important competition.

Speaking of yeast, his kitchen makes delicious pizza using Malbec grape skins to make the flour for the crust with Malbec yeast they get from his vineyards (photo above).

Enjoy many fun activities here in addition to tours and tastings.

• **Mermaid Tasting.** A technical tasting and sensory analysis of three of their wines.

• **Guided Tour & Tasting.** Tour the property with a wine-in-hand starting rooftop of the winery for panoramic views, walk the vineyards, visit the winery, and underground cellar, tasting three wines while learning the history of the winery and the philosophy of their project. The last wine is paired with a cold meat and cheese plate.

• **Picnic.** Enjoy a picnic by their reflection pool with a picnic blanket, wooden table, cushions, umbrella and a picnic basket filled with a bottle of wine, baguette made with their original grape flour bread, seasonal fruit, croissant, homemade jam and a bottle of water.

• **BBQ & Rosé.** Rent one of their grills and share a bottle of rosé with your party.

• **Cooking Class.** Discover the culinary culture of Mexican gastronomy in a workshop with their chef, Maricela Rangel, preparing your own seasonal plate.

• **Wine & Movies.** Outdoor movie night with their big screen, wine and special snacks.

Collection of Wines

Canto de Sirenas - Cabernet Sauvignon
Canto de Sirenas - Cabernet Franc
Canto de Sirenas - Syrah
Canto de Sirenas - Pinot Noir
Canto de Sirenas - Malbec

Canto de Sirenas - Malbec Rosé

Canto de Sirenas - Sauvignon Blanc

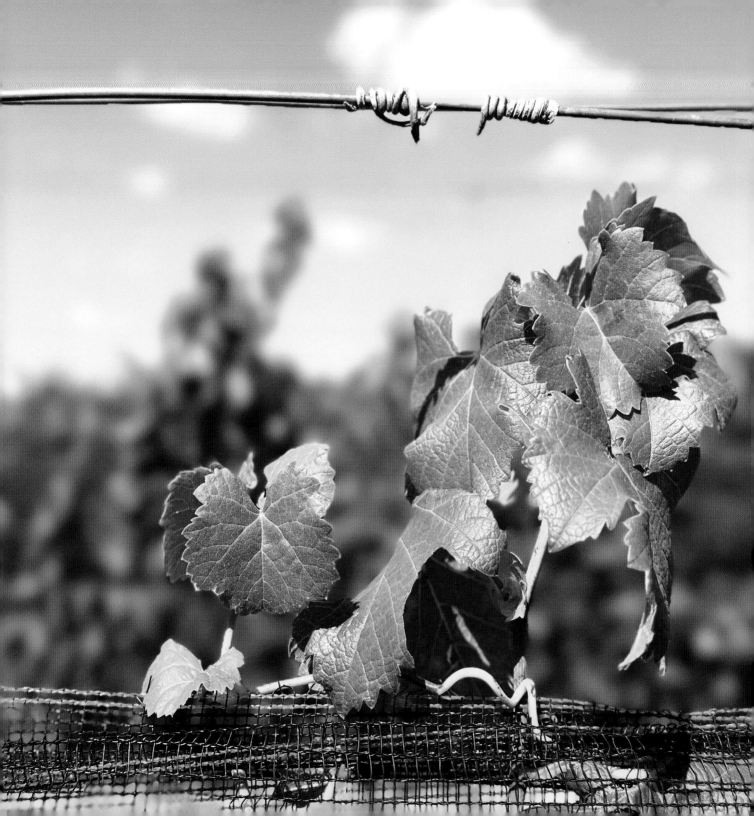

T rue Pioneers. The First Winery In Guanajuato.

EXCELLENT WINES

It all started in 1987 when Ricardo Vega planted some wine grapes on his property and his partner Juan Manchón went to Spain to study oenology, both with a vision that Guanajuato could be an excellent wine region.

When Juan returned, they started making wine from the now six-year-old vineyards. And the wine was good. Very good. Today, these vines are mature and produce remarkably high-quality grapes. Their wines are excellent. The top-three international wine competitions have already honored their wines with over 100 prestigious medals.

The success of these two pioneers has inspired over forty other wineries to commence, and the Guanajuato Wine Region became a reality.

Personally, I absolutely love their Pago de Vega wine as it comes from these old vines and really shows off how well this new wine region has evolved (photo right). Cheers to Ricardo and Juan.

This is a must-visit winery when you are in Guanajuato to see where this wine region began. The wines are extraordinary and the gastronomy is amazing. The architecture is unique and interesting. The various outdoor patios are perfect for enjoying an afternoon of food and wine with beautiful views of the vineyards and winery (photo above).

They offer an excellent variety of tours, wine tastings, food and pairings, and other activities.

• **Tours & Wine Tastings.** Tour the vineyards, production areas and barrel room. The tasting is with four wines and charcuterie, and there is a choice of basic or premium wines.

• **Food & Wine Pairings.** Start with the tour above, and then a four-course food and wine pairing created by their on-site gourmet chef.

• **Romantic Encounter.** Same tour except this is a five-course food and premium wine pairing created by their on site gourmet chef.

• **Winemaker.** Make your own blend of wine using four grape varietals at the winery. Cheese and charcuterie are included in this winemaking.

• **Cooking Lessons.** Classes are with their gourmet chef, Ricardo Luna, and of course, lots of great wine to enjoy with the foods you make.

Winemaker: Valencia Spain
$$-$$$

Located: 42km/26mi from San Miguel
Carr Dolores Hidalgo - San Luis de la Paz Km.11
37800 Dolores Hidalgo, Gto, México

+52 415 152 6060
WhatsApp +52 415 181 7691
Enoexperiencias@CunaDeTierra.com.mx

CunaDeTierra.com

English, Spanish

Open: Every Day, 10am-7pm

Collection of Wines

Gran Pago de Vega (Old Vines of Cab Sauv, Cab Franc, Merlot, Syrah in French oak for 24 months)
Pago de Vega (Old Vines of Cab Sauv, Syrah, Merlot, Cab Franc)
Gran Nebbiolo (Nebbiolo in French oak for 24 months)
Nebbiolo (Nebbiolo, Malbec, Tempranillo)

Vino Tinto (Cab Sauv, Syrah, Merlot, Cab Franc)
Cuna de Tierra Malbec
Cuna de Tierra Syrah (Syrah, Merlot)
Cuna de Tierra (Cabernet Sauvignon, Merlot, Petite Sirah)
Torre de Tierra (Tempranillo, Cabernet Sauvignon)
M Cúbica (Malbec, Merlot, Marselan)

Torre de Tierra Rosado (Rosé of Granache)
Torre de Tierra Blanco (Semillon)
Vino Blanco (Semillon, Sauvignon Blanc)
Lloro de Tierra (Moscatel, Ruby Seedless, Rosa del Perú, Cardenal Table Grapes)

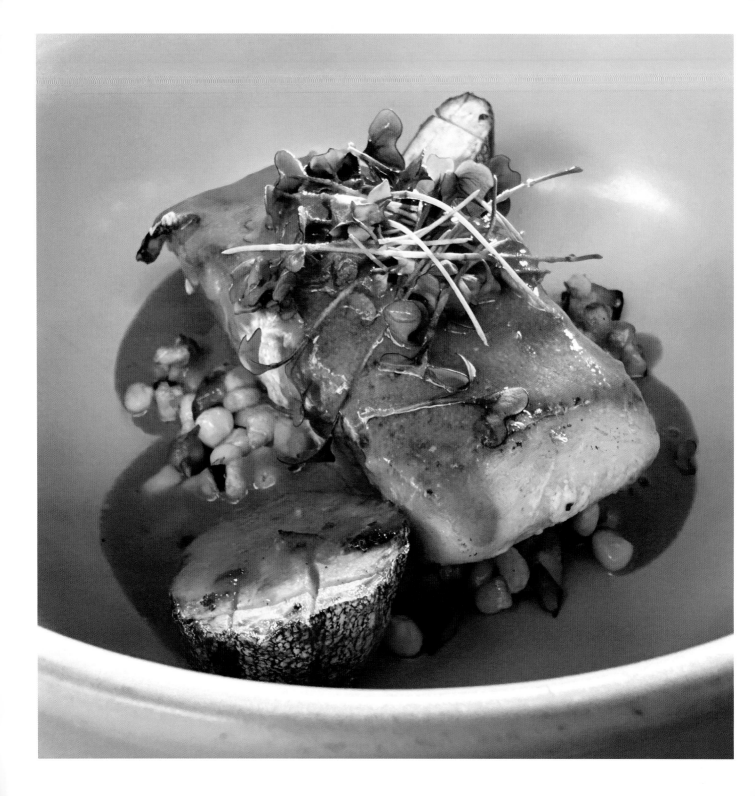

$$

Located: 42km/26mi from San Miguel
Carr Dolores Hidalgo - San Luis de la Paz Km.11
37800 Dolores Hidalgo, Gto, México

+52 415 152 6060
WhatsApp +52 415 181 7691
Enoexperiencias@CunaDeTierra.com.mx

CunaDeTierra.com

English, Spanish

Open: Tuesday-Friday, 11am-5pm
Saturday 11am-6:30pm
Sunday 11am-5pm

CONTEMPORARY MEXICAN CUISINE

Food and wine experiences are very much what Cuna de Tierra is all about. They have talented sommelier and chef to make great gastronomic experiences. As I commonly say, you can't drink wine without eating food, and you can't eat food without drinking wine. Or better said, you can't drink excellent wine without having extraordinary food to go with it. Cuna de Tierra takes this to heart.

Their chef, Ricardo Luna, brings unique culinary expertise to the kitchen here. Just look at the photographs on these two pages and you'll begin to see the talent that we get to experience with the wines here. Ricardo credits his grandmother for his inspiration on seasoning, and his unique contemporary Mexican cuisine comes from incorporating techniques he has learned from other countries.

Now for a few of his extraordinary dishes...

White Cove Fish (photo left page) on cremini mushroom esquite, bathed with huatape with red chili, purple cabbage sprouts and butter calabacitas.

Fried Octopus Gordita (photo below) is smothered in spicy tomato sauce, fried pumpkin seeds, habanero ash and red onion finished with pea sprout.

Thousand Leaves (photo right) is filled with chocolate ganache and vanilla pastry cream, garden strawberries and grape leaves.

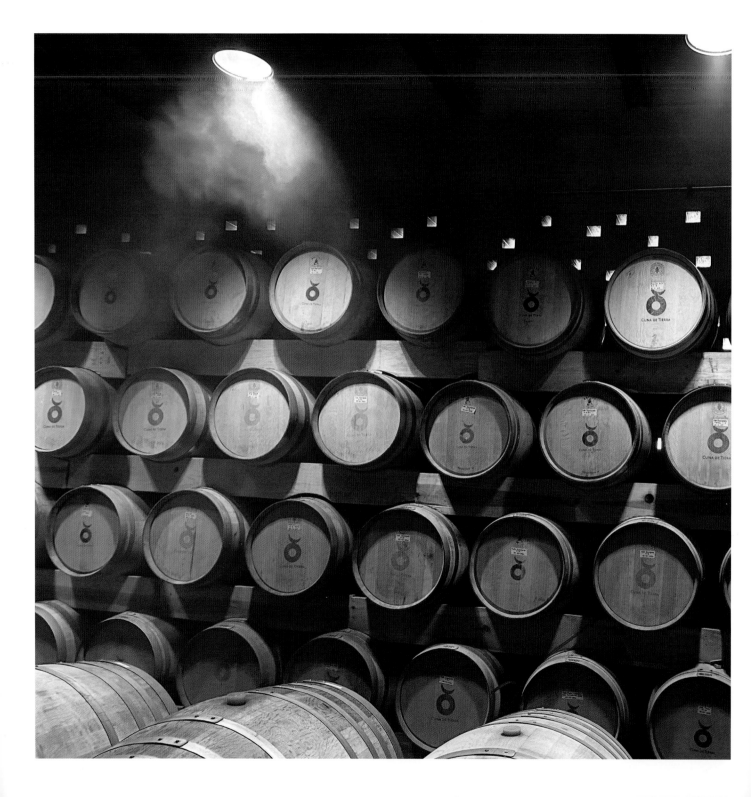

BEST OLIVE OIL, EVER!!!

It was a beautiful fall morning when I was sitting with Ricardo Vega, founder of Cuna de Tierra. We were drinking his Pago de Vega (Cabernet Sauvignon blend) that has aged so beautifully in oak. While enjoying this wine together, he opened a bottle of his new olive oil from this year. I was there during harvest time a few months earlier and saw the olives being crushed (photo below) and tasted what I thought was superior to what he had in the bottle. He said wait, just wait until we're finished and it's in the bottle. Well, now was that time; the bottle was opened and fresh bread was served to enjoy this experience.

The more I savored his new olive oil, the more I began to realize that this was the best-tasting olive oil I had ever tasted in my life. No joke! Ricardo said it's not just the best olive oil he's ever tasted, it's the best olive oil he has ever made. To take it one step further, I spoke with Professor Marisa Ramos, who wrote the Foreword for this book, and she has this new olive oil at her university to study its quality. What she told me was that they can't find another olive oil that's even in the same league of quality as this olive oil, which they need for comparative analysis. They continue their examination. In the meantime, it's vintage 2023, and I promise you, you will love it.

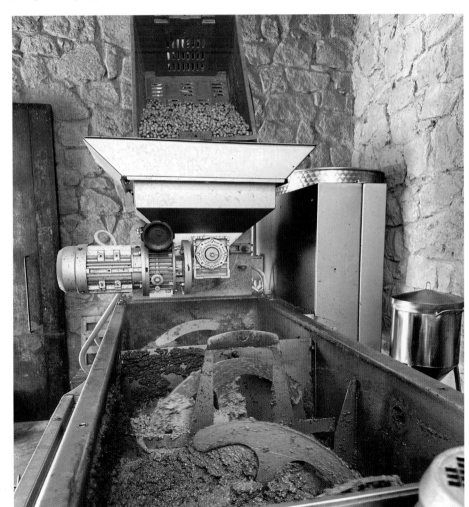

GUANAJUATO **DOLORES HIDALGO** NorthWest
Winery, Vineyards, Restaurant
CUNA DE TIERRA

$$

Located: 42km/26mi from San Miguel
Carr Dolores Hidalgo - San Luis de la Paz Km.11
37800 Dolores Hidalgo, Gto, México

+52 415 152 6060
WhatsApp +52 415 181 7691
Enoexperiencias@CunaDeTierra.com.mx

CunaDeTierra.com

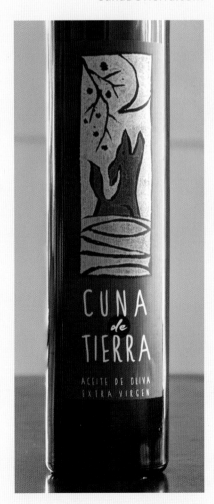

Winemaker: Valencia Spain

$$

Located: 42.2km/26.1 from San Miguel
Carr Dolores Hidalgo - San Luis De La Paz Km12
37800 Dolores Hidalgo, Gto, México

+52 418 688 0023
ManchonDH@gmail.com

Cavas-Manchon.Negocio.site

Little English, Spanish

Open: Monday-Saturday, 8am-5pm (Sat 3pm)

Next door to Cuna de Tierra, is the personal winery of their famous winemaker.

PERSONAL ENDEAVOR

Cavas Manchón is translated from Spanish to mean the Cellar of Juan Manchón. With the previous winery in this book, **Cuna de Tierra** (page 263) you read about Juan Manchón as the cofounder and winemaker of this historic winery pioneering the Guanajuato Wine Regions into its success today.

What does a winemaker do when he becomes famous for his oenology expertise? Well, he starts to make some personal wine in his basement. Except, Juan has a very large basement!

Just a few buildings down the street from the entrance to Cuna de Tierra is the Cavas Manchón winery. It is in an industrial building with a wine shop and tasting room in the front. Behind is a full-size winery and an underground cellar. And behind the building are his beautiful vineyards.

Expect only the best from Juan Manchón for his personal wines. It has his personal name on it, and he cares. The wines are excellent. Juan also tastes and sells many of his Cuna de Tierra wines here.

*The Wine World
is simply my life and my passion.*

— **Juan Manchón**

Collection of Wines

Incauto (Merlot, Malbec, Tempranillo,
Cabernet Sauvignon)
Beso Tinto (Syrah)
Beso de Miel (Moscatel, Rose de Perú,
Ruby Seedless, Cardinal)
Blancá Dolores (Blanca Dolores, Moscatel)
Arrels (Merlot, Malbec, Syrah, Moscato)

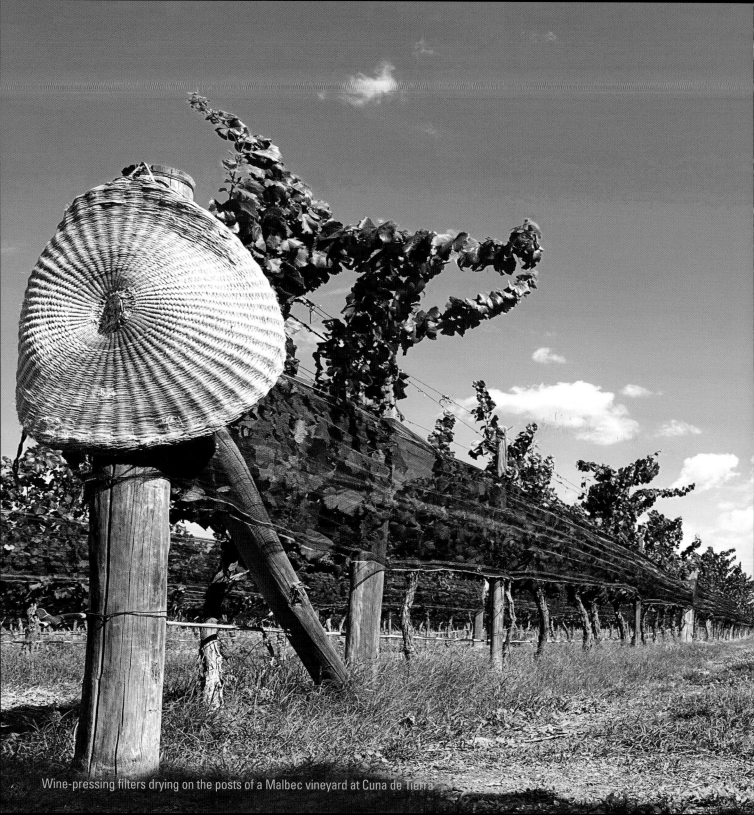
Wine-pressing filters drying on the posts of a Malbec vineyard at Cuna de Tierra

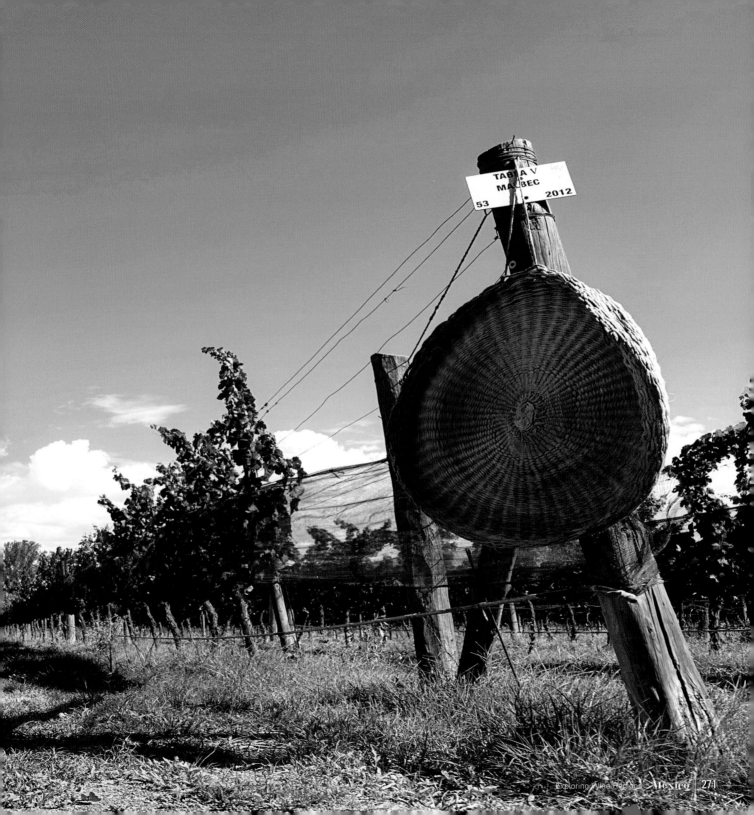

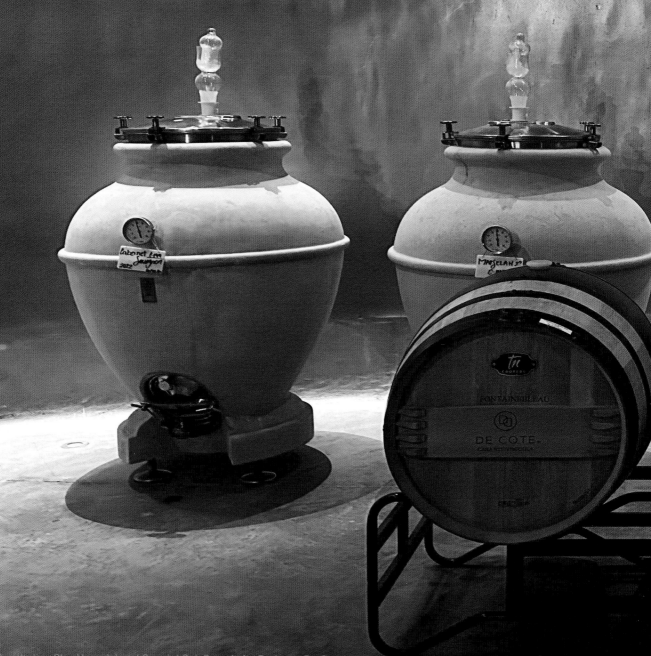

Drunk Turtles (Italian Clay Vessels) and Special Oak Barrels for Bodegas De Cote's most premium wines

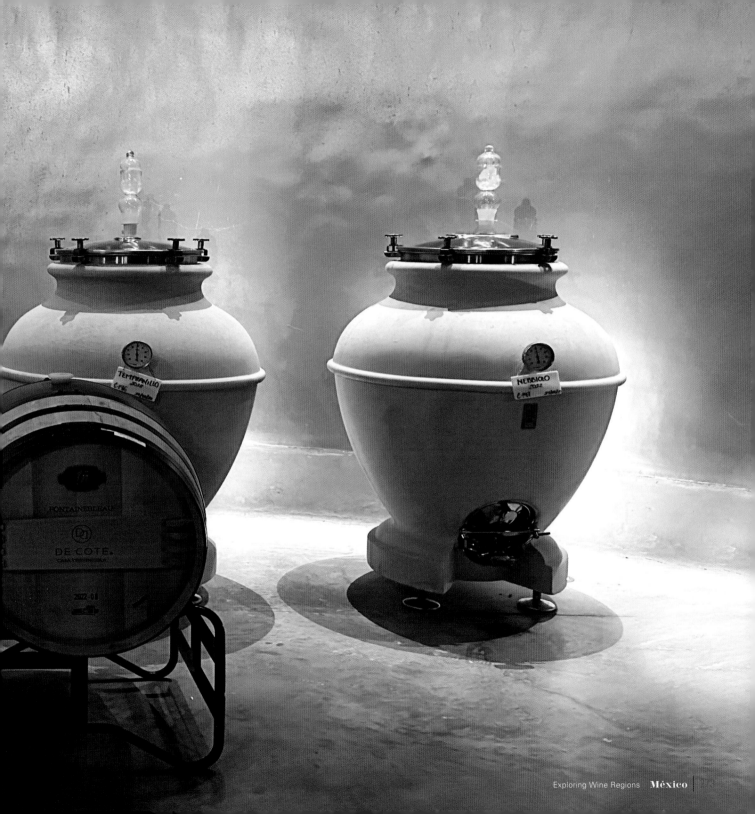

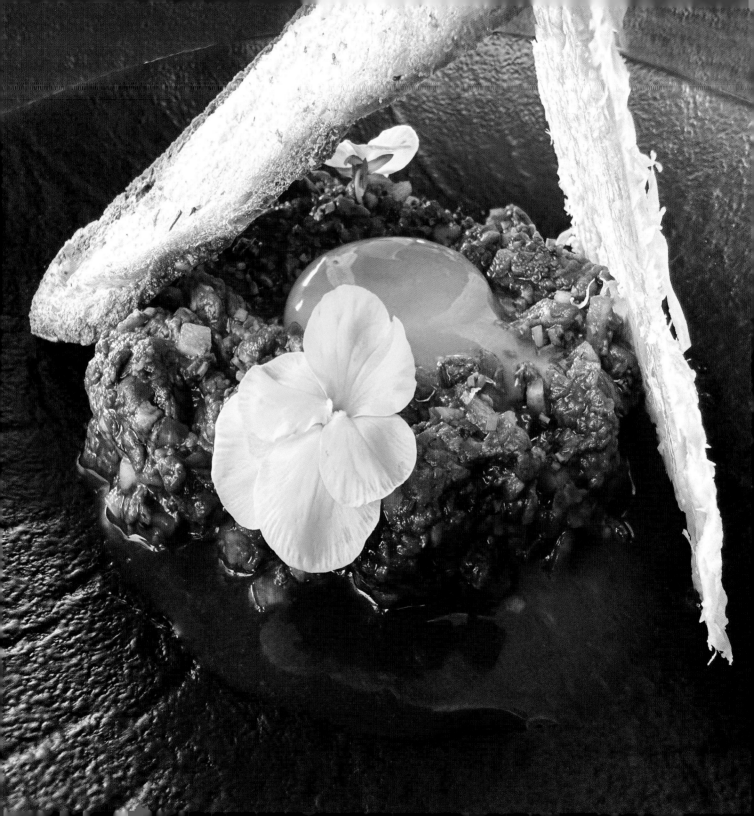

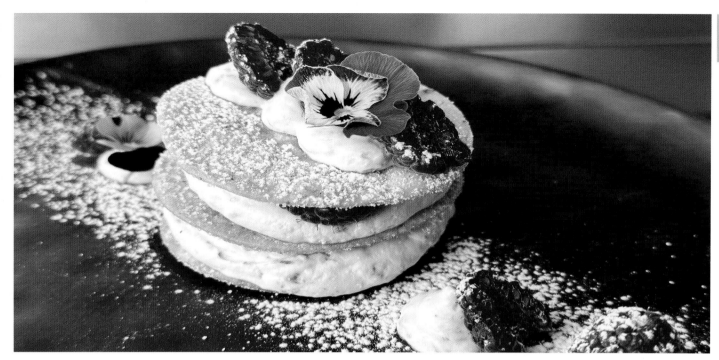

W ine, especially sparkling wine, gastronomy, history, and culture, are the many reasons to be attracted to travel here.

THE STATE OF QUERÉTARO

Querétaro is a name of two meanings. Querétaro is a state, one of México's smallest states, two and a half hours north of México City and adjacent to the east of Guanajuato state. Querétaro is also in the Sierra Madre Oriental Mountains. The base here is 6,000' elevation. Peaks reach 12,000'.

Santiago de Querétaro is the state's capital and the largest city in the state with a population of almost 1.5 million as the fastest growing city in México (that is not a resort or border city). This is understandable considering its beautiful and well preserved Spanish colonial architecture, excellent wine regions and just two and a half hours drive from México City.

Much historical significance happened here. Querétaro is an Aztec City that was conquered by the Spanish in 1531. The revolution against Spain was planned in Querétaro in 1810. This Mexican Independence War continued for eleven

years to 1821 when Querétaro served as the headquarter for the revolutionaries. México gained its independence from Spain in 1821, and in 1824, Querétaro became an official state.

Also in 1824, a constitutional convention was held in Querétaro where the Constitution of México was written. Querétaro City also became the temporary capital of México for two years when military troops invaded México City in 1846 during the Mexican/American War.

In 1996, the historic center of Querétaro was declared as a UNESCO World Heritage Site.

Querétaro Intercontinential Airport (QRO) This is the best airport to use to fly into Querétaro City and to the Querétaro Wine Regions. Clearly, it is the closest, most practical and has flights from numerous cities in the United States and México.

México City International Airport (MEX) is the second closest airport to Querétaro City. There are

excellent culinary and cultural opportunities in México City that could be added to your trip where this airport could be valuable.

Driving Distance to Querétaro City from...
- **Querétaro Airport** 15 mi (35 min)
- **México City Airport** 135 mi (2 hrs, 45 min)

Gastronomy is an exciting part of the experiences at the wineries here in Querétaro. Puertas de la Peña is an incredible restaurant worth visiting. Their food and wine experience is top-level.
Short-Rib Tartare (photo left page) is a raw minced short rib with anchovies, onion and chives, served with a mix of Dijon mustard, Worcestershire sauce, balsamic vinegar and other seasonings, topped with a raw egg yolk and accompanied with a bread ficelle and a crust of parmesan cheese.
Mille-Feuille (photo above) is a Mexican mille-feuille with yellow corn crunchy fritters, raspberry whipped cream, fresh raspberry and pansy flowers.

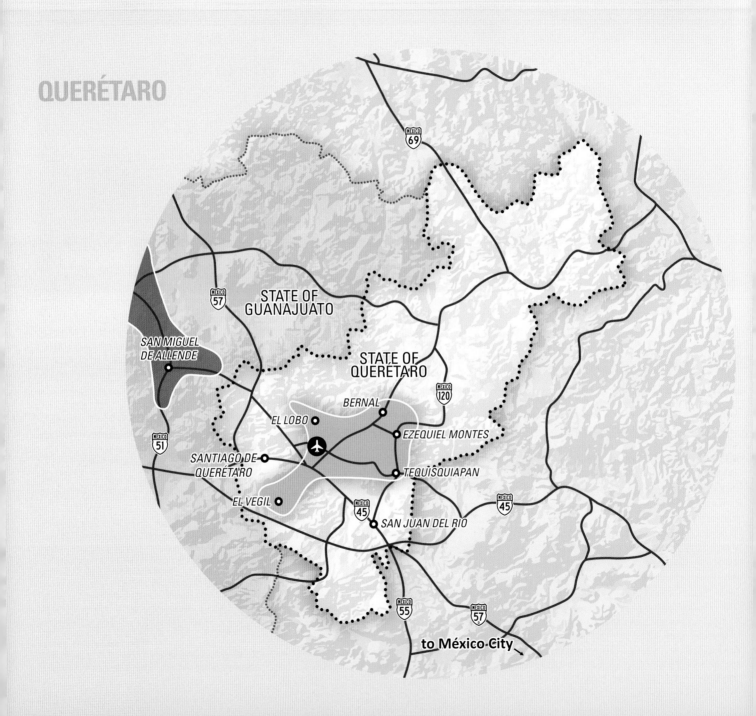

QUERÉTARO

STATE OF GUANAJUATO

STATE OF QUERÉTARO

SAN MIGUEL DE ALLENDE

BERNAL

EL LOBO

EZEQUIEL MONTES

SANTIAGO DE QUERÉTARO

TEQUISQUIAPAN

EL VEGIL

SAN JUAN DEL RIO

to México City

Q

Querétaro is known for producing excellent sparkling wines in México's southernmost wine region.

TERROIR OF QUERÉTARO

You must easily be thinking, Querétaro, just like Guanajuato, is outside the wine-growing latitudes. It is almost always necessary for Vitis vinifera (the grape variety that makes virtually all quality wine) to be growing in the wine-growing latitudes in order to make good wines. The Querétaro Wine Regions are an exception.

Vitis vinifera grows best in two relatively narrow bands that circle earth... between latitudes 30° and 50° in both the northern and southern hemispheres. For example, Napa California is at latitude 38°. Bordeaux France is 45°. In the south, Mendoza Argentina is at 33°. This is one of the reasons why these wine regions produce excellent wines.

The northern hemisphere is by far the largest producer because the band covers a lot more land. In the southern hemisphere, it has much fewer vineyards because so much of this band is over oceans. The closer you get to the equator, the hotter and more humid it becomes, and as you go farther away from the equator, the reverse happens and it gets too cold. This is not conducive to growing excellent wine grapes.

So here we are, in Querétaro, where the latitude is 21°, far outside the wine band. It is México's southernmost wine-producing state, and it defies almost every norm for winemaking.

Querétaro has factors though that give the grapes what they require. The largest benefactor is it has a high elevation, 6,500 feet, bringing the grapes closer to the sun. This gives them the higher solar radiation they need in order to mature and ripen properly. This mountain desert makes the temperatures hot during the day and cools at night, giving the diurnal effect essential for quality grape growing.

The increased solar radiation also produces thicker skins on the grapes. As we know, grape skins play a pivotal role in producing red wines, as the phenolic compounds found in them will contribute key coloring compounds as well as flavor, mouthfeel and structure to the finished wine. Plus, resveratrol, the antioxidant that helps protect us against cardiovascular diseases, cancer, liver diseases, obesity, diabetes, Alzheimer's disease, and Parkinson's disease. Cheers to the thick skins of Querétaro!

Querétaro also has calcium-rich clay soil which encourages higher acidity, retaining water during the long dry spells and drains when it's too wet.

This is a semi-arid desert, with a mild climate, and low humidity. Rainfall is unusual here. Generally there is no rain in winter or spring, hail occurs during the summer months, and rain happens during the harvest months. This is a benefit to the vines, as well as a challenge to the farmers with rain during harvest.

In the end, all these factors, make for a magical terroir for growing excellent grapes to make high quality wines.

The Querétaro Wine Regions are most known for producing excellent sparkling wines. I was fortunate to be introduced to three of the top sparkling winemakers here. These oenologists were trained in Europe's most famous sparkling wine regions in Champagne France and Cava Spain.

If you are into bubbles, Querétaro will be your candy store. Each of these three wineries is dramatically different from the other, yet the expertise of the winemakers will impress you.

- **Trini Jiménez Hidalgo, Puertas de la Peña**
- **Fernando Cortez, Casa Vegil**
- **Lluis Reventós, Freixenet México**

All three of these wineries are included in the following pages of this book.

With the region's heritage, Spanish grapes are well planted here for their Cava sparklings, with vineyards growing varietals of Xarel·lo, Macabeo and Parellada in the style of Spanish Cava.

With the introduction of French-style sparkling, vineyards have added Chardonnay, Pinot Noir and Pinot Meunier in the style of French Champagne.

Not to forget reds, I found excellent Tempranillo, Malbec and Cabernet Sauvignon.

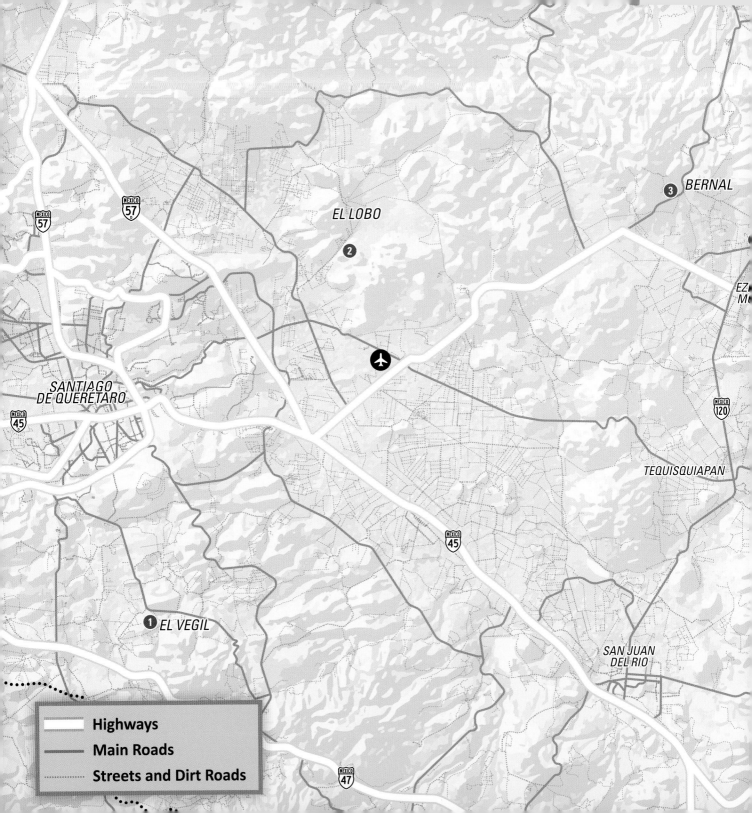

QUERÉTARO WINERIES

	Number of Wines	Red Wines	White Wines	Rosé Wines	Sweet Wines	Sparkling Wines	Wine Shop	Boutique	Accommodations	Restaurant	Food Options	Food & Wine Pairings	Tours	Educational Workshops	Fun Activities	Italian Wines	Spanish Wines	French Wines	Other	
El Vegil Region																				
❶ Casa Vegil	5	√	√		√		√		√	√	√		√	√	√			√		
El Lobo Region																				
❷ Puerto Del Lobo	13	√	√	√		√	√	√		√	√		√	√	√		√	√		
Valle De Bernal Region																				
❸ Puertas De La Peña	5	√	√	√	√	√	√		√	√	√		√	√		√	√	√		
❹ Bodegas De Cote	14	√	√	√	√		√	√		√	√		√	√			√			
❺ Freixenet México	27	√	√	√	√	√	√	√		√	√	√		√	√	√		√	√	√

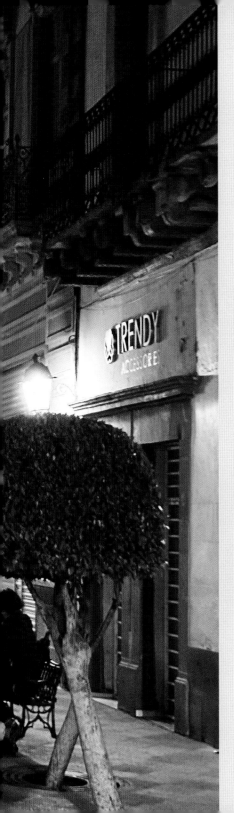

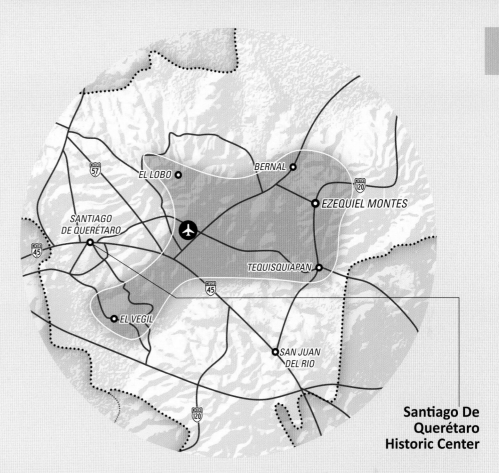

THE CAPITAL OF QUERÉTARO

Querétaro is both the capital city (Santiago de Querétaro) and one of México's smallest states located east of the Guanajuato state in the center of the mountainous region of central México.

Santiago de Querétaro is located on the western edge of the Querétaro state with a metro population of 1.5 million people and an elevation of 5,971'. The Querétaro Intercontinental Airport (QRO) is perfect for accessing to both the Querétaro Wine Regions and the Guanajuato Wine Regions.

The closest winery to Santiago de Querétaro is **Casa Vegil**, just a fifteen minutes drive, which makes staying in downtown Querétaro a convenient location.

Santiago de Querétaro was named after the **Apostle Santiago**. Apparently there was a battle, without weapons, in which the Indians and Spaniards were called to peace by visions of the Apostle Santiago holding a shining cross.

What's interesting is Querétaro's importance of wine from the beginning as its coat of arms contains a shield with three sections: a horseman representing Santiago, the Patron Saint of Spain, and the other section is a **Grape Arbor** that commemorates the state's wineries.

Querétaro is known for its well-preserved Spanish colonial architecture, notable baroque buildings, and numerous churches. Querétaro Regional Museum displays pre-Hispanic, colonial and republican artifacts.

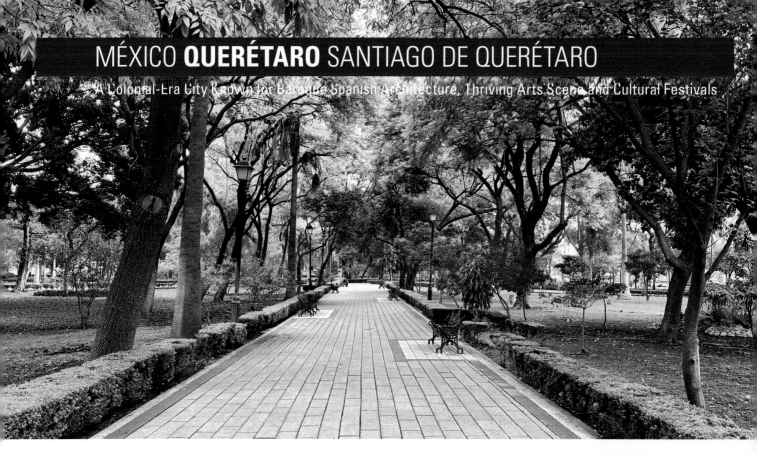

SANTIAGO DE QUERÉTARO

Santiago de Querétaro and Querétaro City are simply called Querétaro by the locals. It is very much an undiscovered city in México by tourists. You will feel like you are in an out-of-the-way Mexican town. No street hustlers after the tourists. English is not so common. It is a safe place to walk about day and night. The parks are beautiful. It is a big city though with 1.5 million people where you can see real life and all the happenings.

Downtown Querétaro is a Historic Monuments Zone and became a **UNESCO World Heritage Site** in 1996 as the old colonial town is unusually having retained its geometric street plan of the Spanish conquerors, side-by-side with the twisting alleys of the Indian quarters. The Indians and Spanish lived here together peacefully during the seventeenth and eighteenth centuries.

There are many gardens throughout the city. The most significant one is **Alameda Hidalgo** (photos above and right). It is massive, and covers four very large square blocks. It is open 6am-7pm, closed Wednesdays.

As you can see in the above photo, there are large wide walkways throughout the park with beautiful landscaping and large mature trees providing beautiful soft light and shade. Park benches are everywhere.

The park has many interesting sculptures. In the very center of the park, where all the paths join, there is a shiny gold sculpture high in the air of revolutionary priest, Miguel Hidalgo (remember, the revolution against Spain was planned by Hidalgo in Querétaro in 1810).

To the right (photo) is a musical serenade of the immortal *Canción Mixteca* representing the essence of romanticism and the musical heritage of the Mexicans.

The park has formal entrances with security guards to keep the park safe without vendors.

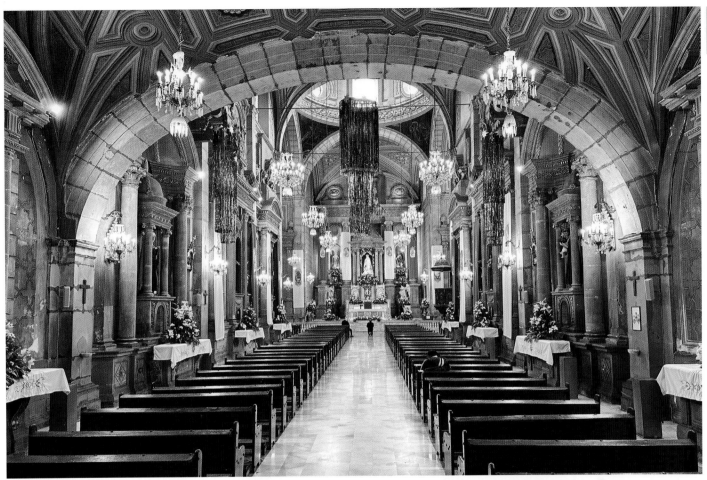

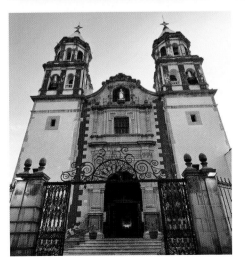

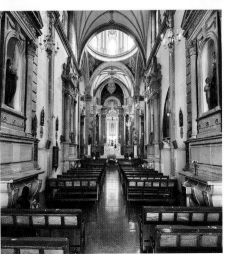

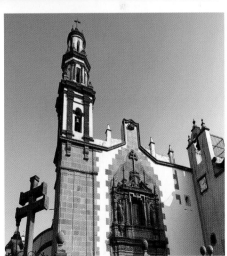

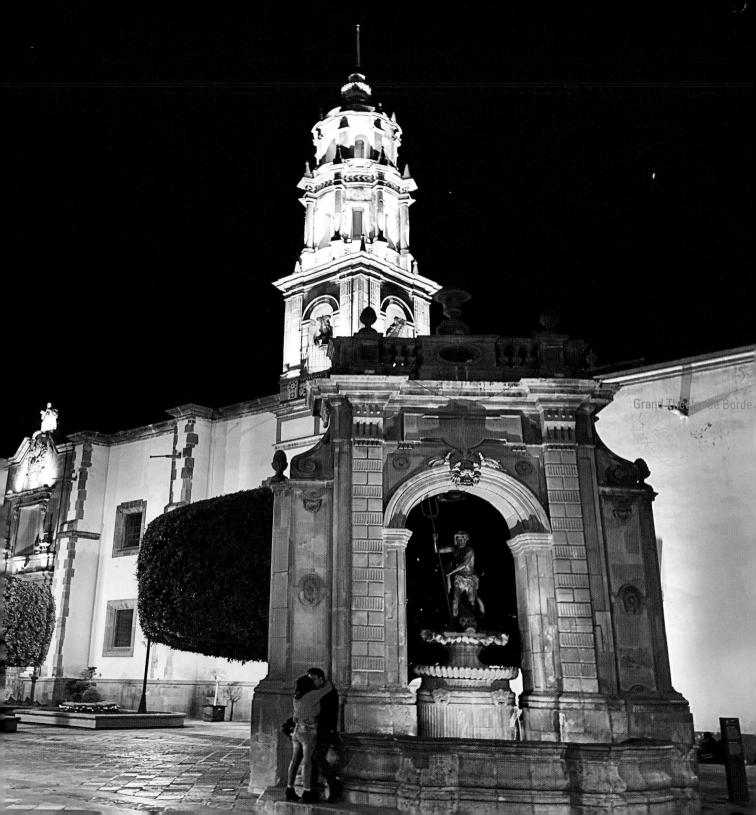

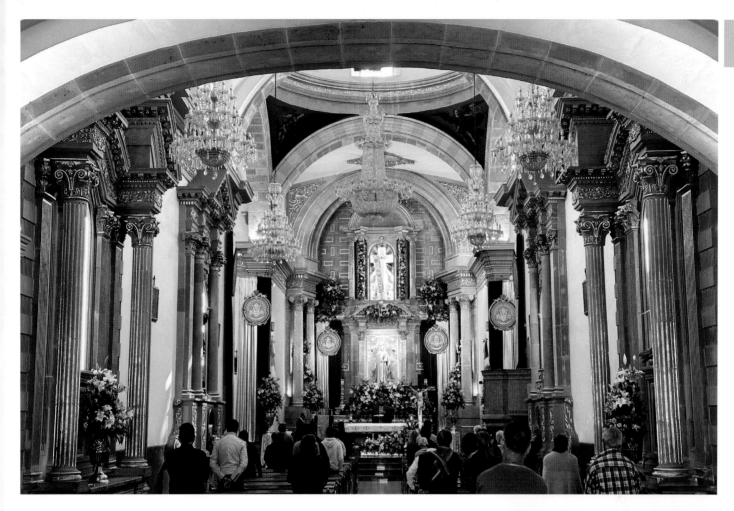

Querétaro's Historic Center has many magnificent colonial buildings, squares, fountains and churches once backdrops to many dramatic events from the state's past. Two buildings, **La Casa de la Zacatecana** and **La Casa de Don Bartolo** are enshrouded in mysterious legends. **Querétaro Museum of Art** exhibits work from the seventeenth century to modern times. **San Agustin Convent** is a museum, also home to several masterpieces that reflected various national and foreign art movements.

Downtown is full of romance, finding lovers everywhere, kissing under the **Neptune Fountain** (photo left page) and holding hands walking down the street (photo page 280).

What I noticed most in this downtown historic center, which is such a wonderful place to walk around, is that it is filled with churches. Practically every couple of blocks there is a church. And they are all active. My best guess is that as the city grew, it needed more churches and they continued to build them. Today they are part of the beautiful architecture of the city. The churches are spectacularly beautiful.

Above is **De La Santisima de los Milagros** built in 1683 standing ever so exquisitely gorgeous in the city. On the previous page (top) is **Templo de San Francisco de Asís**, the first religious building built in Querétaro around 1540 and became the center of the most important urban development in New Spain. Adjacent is the **Regional Museum of Querétaro**. Previous page (lower left and center) is **Santuario de la Congregación de Nuestra Señora de Guadalupe**.

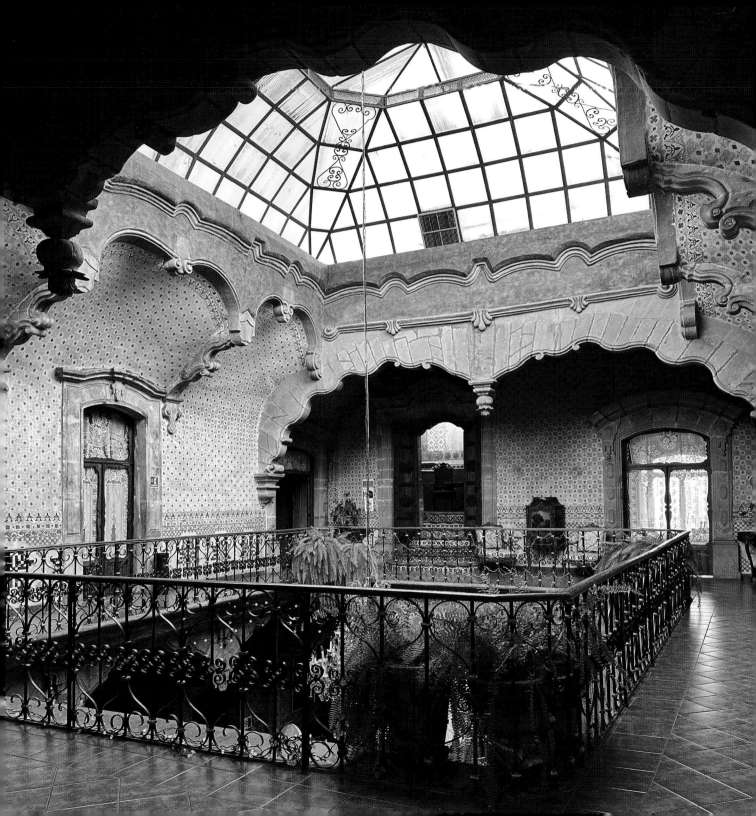

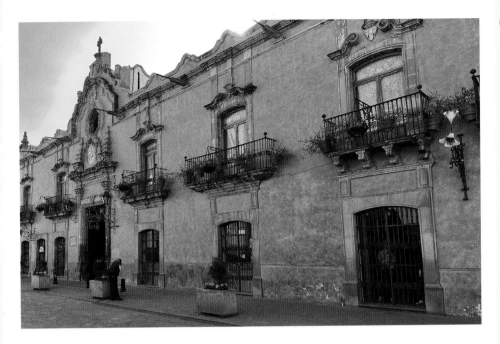

$$

Located: Historic Center of Querétaro
33km/20mi West of Querétaro Airport
C. Francisco I. Madero 41, Centro
76000 Santiago de Querétaro, Qro, México

+52 442 227 0500
WhatsApp +52 442 230 3603
Reserva@LaCasaDeLaMarquesa.mx

LaCasaDeLaMarquesa.mx

Some English, Spanish

Open: Every Day

HISTORIC HOTEL

La Casa de la Marquesa was entrusted to Querétaro's great architect Cornelio, an expert of the baroque style in the seventeenth century who was ordered by Monarch Don Francisco Antonio Alday to build a residence for his consort Josefa Paula Guerrer.

In actuality, he was in love with a nun and built a home for her. Through the centuries, it stayed a residence for dignitaries of different types.

Ultimately, La Casa de la Marquesa became a luxurious hotel with thirteen elegant suites, particularly decorated with objects from different parts of the world. It is a four-star hotel with excellent prices.

The first floor of the hotel is a restaurant, open for breakfast, lunch and dinner for its guests and the public. I had breakfast here every morning with the delight of a very talented pianist (photo below). He made my mornings and set a great mood for the day.

You can see from the pictures inside and out that this is one of the oldest and most beautiful estates in the city of Querétaro.

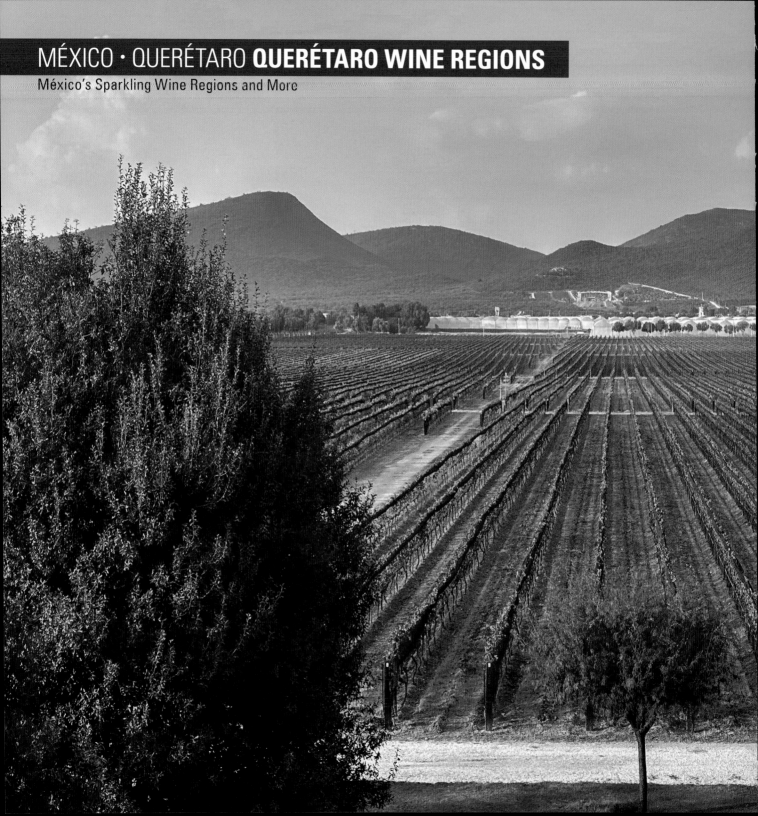

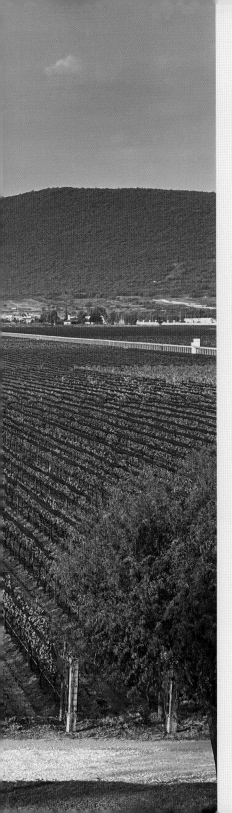

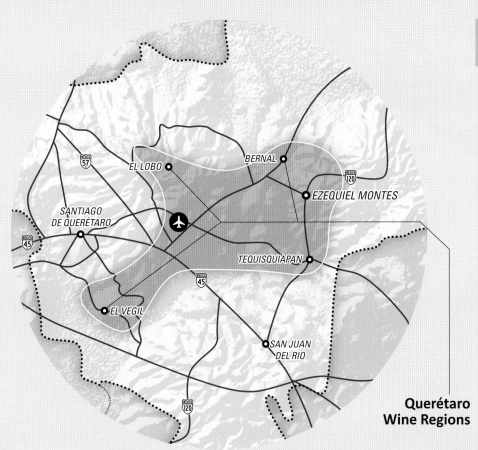

**Querétaro
Wine Regions**

Left page: The Beautiful vineyards
of Bodegas De Cote

MOUNTAINOUS WINE REGIONS

Wine lovers from México City have discovered the Querétaro wineries as it's not a far drive for them to be in wine country. And the wine is very good here. So is the cuisine. All of the five wineries I reviewed for you have restaurants. When you see the pictures of the food, you will be ready for some awesome food and wine experiences.

To put geography in perspective, Santiago de Querétaro is located at the southeast corner of the Querétaro state. The wine regions are primarily to the east and the northeast of the city. I have separated these five wineries into three different regions you can explore. The Guanajuato Wine Regions are adjacent to the west and not a far distance to visit.

The Querétaro Wine Regions are most known for producing excellent sparkling wines. Three of the wineries below specialize almost exclusively in sparkling wines. Their winemakers were trained in Europe's most famous sparkling wine regions of Champagne France and Cava Spain.

Here are the three regions and five wineries I reviewed in the Querétaro Wine Regions.
El Vegil Region
• Casa Vegil, page 291
El Lobo Region
• Puerta Del Lobo, page 293
Valle de Bernal Region
• Puertas De La Peña, page 297
• Bodegas De Cote, page 305
• Freixenet México, page 309

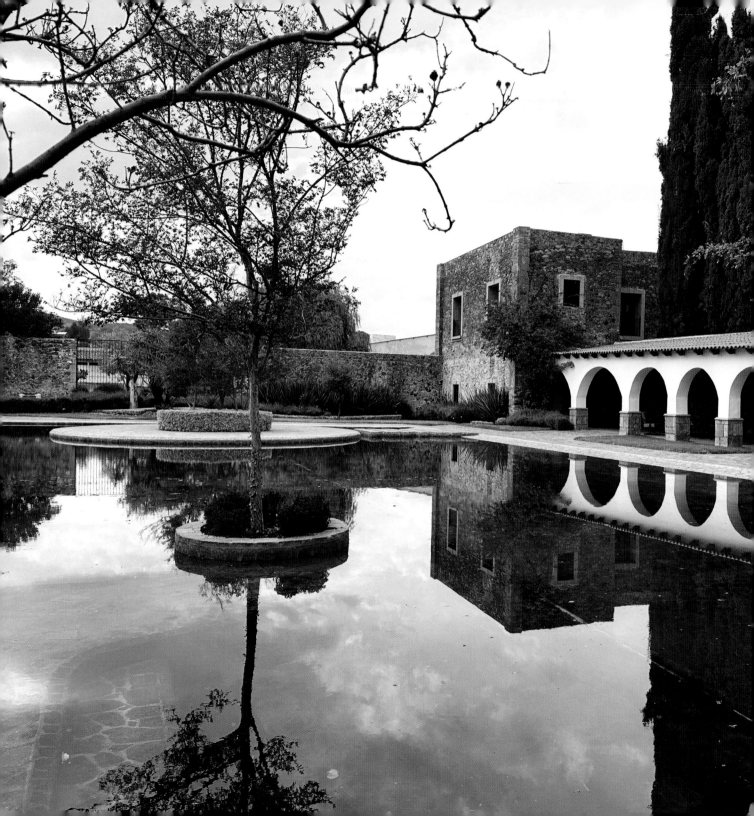

Winemaker: Catalonia, Spain

$$

Located: 25km/15mi South of Querétaro
San Luis, Taponas
76951 El Vegil, Qro, México

+52 442 879 6473
Info@CasaVegil.com

CasaVegil.com

English, Spanish

Open: Every Day, Advanced Reservations Only
Open For Full Property Takeover

An all-inclusive hacienda and ranch takeover, with a winery, horseback riding and an awesome pool.

HACIENDA EXPERIENCE

This is not your typical winery to visit. It is by advance reservations only. Moreso, this is a large horse ranch with a nine-bedroom hacienda, which is available exclusively for complete takeover of the ranch. Such a perfect opportunity for a big family, a bunch of couples, or a corporate retreat.

Everything is included for one price: All **nine bedrooms** with their own **private baths**. **Breakfast, lunch** and **dinner**, with **wine** of course. A full **spa** with all services. The most **awesome pool** (photo left page). A **church**, **art gallery**, **lake**, and so much more.

A big attraction is the **horse ranch**. Both **Western** and **English riding** are available, including an arena with an English show jumping course. The property is huge so there is much western riding available on the property, or endless off-property adventures.

We cannot forget the **winery**. Isn't that why we came to the wine region? This winery specializes in sparkling wines. Almost exclusively. (Sparkling, Chardonnay and Pinot Rosé). The winemaker and general manager of the property, who you will meet, learned his sparkling skills in the famous Cava regions of Spain.

Of course, there is a tour of the winery and vineyards. Wine tasting is with the winemaker. This is a very special winery because the owner puts most of his money into the press. The press allows no oxygen to hit the juice. It has a nitrogen bag that allows 0% oxygen and CO_2 is in every line to remove all oxygen away from the wine. They harvest at night, use dry ice, and do small pumpovers. Every step is a perfect step for the highest quality.

Here, you can actively **participate** in any of the activities that are currently happening in the winery and vineyards. Remember, this is a full property all-inclusive experience. They also have an experience where you can **make your own** style of sparkling wine.

Or, you can just **chill out** in the pool with a glass of one of their best sparklings!

This is the closest winery I could find to the city of Querétaro. It is only a 15-minute drive on excellent brand new roads through an upscale community to reach the winery. After the winery, is the little village of El Vegil, which is currently under renovation.

Collection of Wines

Fügi (Sparkling of Chardonnay, Pinot Noir)
Casa Vegil (Chardonnay Crianza)

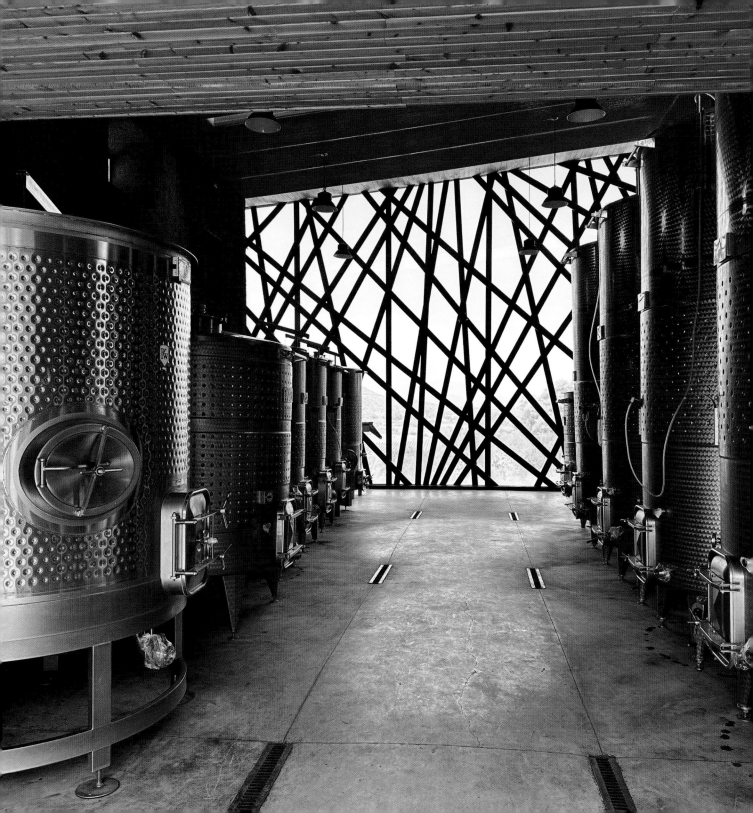

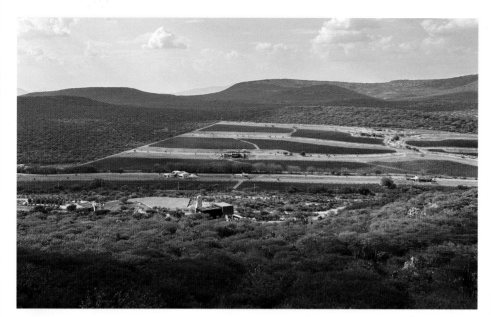

Winemaker: Canary Islands, Spain
$$-$$$

Located: 28km/17mi Northeast of Querétaro
Carretera La Griega – El Lobo, Kilómetro 4.5
76249 El Lobo, Qro, México

+52 442 454 5470
Info@PuertaDelLobo.mx

PuertaDelLobo.mx

English, Spanish

Open: Every Day, 10am-5pm

Collection of Wines

Reserva Tío Neto (Malbec, Tempranillo, Merlot)
Reserva Ábora (Cabernet Sauvignon, Merlot, Syrah)
Reserva Emilia (Syrah)

Finca Ensamble de Barricas (Malbec, Tempranillo)
Finca Verdejo (White Grape of Rueda Region of Spain)
Finca Vino Naranja (Orange Wine of Verdejo)
Finca Sauvignon Blanc
Finca Brut (Sparkling of Xarel-lo, Macabeo, Parellada)
Finca Brut Nature (Sparkling Xarel-lo, Macabeo, Parellada)

Lobo Tinto Joven (Malbec, Merlot, Tempranillo)
Lobo Verdejo (White Grape of Rueda Region of Spain)
Lobo Rosado (Rosé of Syrah)
Lobo Sauvignon Blanc

B
eautiful valley, with careful attention to a total gastronomic experience.

VERDEJO ANYONE?

In the El Lobo Valley comes a very special high-quality wine and culinary operation. The photo above is from their mountain peak outlook, viewing over the valley of the winery in the foreground and vineyards in the background. Beyond the beauty, the passion here is to create the greatest quality of wine from the special terroir of the valley.

The soil is predominately clay, combined with silt, limestone and gravel. This valley is a micro-climate, with lower elevation, hotter days, colder nights, no hail and organic farming. They only select their very best grapes, sometimes no grapes at all if they are not good enough. This winery is passionate about quality.

They grow a unique grape here that you may not have heard of before. Verdejo. It is a dry and fragrant white wine. Could be compared to Sauvignon Blanc with great acidity, grapefruit and green apple flavors; however, Verdejo takes on a richer, nuttier feel.

I found out about Lobo's Verdejo from another winemaker in the region, who was impressed with its unique quality, insisting that I try this wine.

Verdejo comes from the Rueda region of Spain and Lobo is winning awards for the quality of this wine.

They have tours of their large property, winery, vineyards, cellar and some other excellent experiences.

• **Recorrido Vid, Vida Y Tierra (Life & Land, Wine Route).** A guided tour of their vineyards, winery tanks and barrels room, followed by corking and labeling a bottle of wine with your own customized label.

• **Cata De Vino Con Dulces (Wine Tasting with Sweets).** A sensory analysis tasting of three different wines; pink, white and red, and accompanied by special Mexican sweets.

• **Cata De Vinos Tintos (Red Wine Tasting).** A red wine lover experience tasting a young red wine, barrel tasting and their Reserve Tío Neto.

• **Cata De Lo Mejor (Tasting Their Best Wines).** A sommelier-led experience of their most awarded wines: Sauvignon Blanc, Naranja and Tío Neto.

• **Embotella Tu Vino (Bottle Your Own Wine).** A sommelier-led tour of their vineyards, winery tanks and barrels room, followed by creating your own wine by tasting and blending three wines that are in barrels.

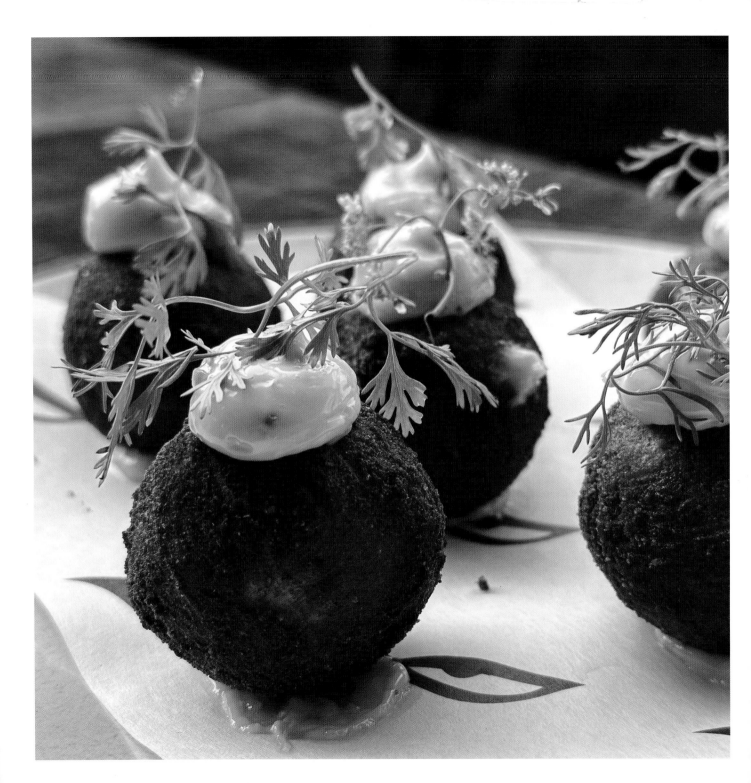

GOURMET DINING IN ANCIENT RUINS

Restaurante Ruinas, the restaurant at Puerta del Lobo, offers outdoor dining, covered outdoor dining, and dining inside ancient ruins. Ruinas means "Ruins" in Spanish. These are well preserved ruins from the ancestors who lived long ago in this valley.

The chefs at this restaurant are super talented, working together in an open kitchen where you can see the magic happen. They are passionate about using local ingredients and transforming them into interesting gourmet dishes that are memorable, both in their creative presentations as well as their unique delicious flavors.

There are two more restaurants here. One midway up the hill is **Restaurante Sarmiento**, which is open seasonally with a fixed-menu presentation. Top of the hill is **El Mirador** with the most incredible views across the valley (photo previous page). This is a casual environment with burgers and pizza, wine and cocktails.

Now for their unique dishes...

Rabbit Croquettes (photo left page) is a mix of Mediterranean and Mexican cuisine, using local products of rabbit and serrano chili aioli.

Beef Tartare (photo below) and parmesan cheese on a brioche bread, garnished with a sprig of cilantro and a slice of radish, plus a special homemade serrano pepper and mustard aioli dipping sauce.

Pork Shoulder Sandwich (photo upper right) is smoked with mesquite and sarmiento for eight hours and then slow cook for twelve hours at a low temperature and mixed with a beer sauce, accompanied with port pickle for acidity, garlic aioli for creaminess and sweet onions.

Fresh Salad (photo lower right) of a variety of local lettuce mixed with roasted pears and blue cheese and yogurt dressing, drizzled with balsamic vinegar and topped with a scoop of goat cheese ice cream.

QUERÉTARO **QUERÉTARO** EL LOBO ■
Restaurant at Puerta Del Lobo
RUINAS RESTAURANTE

$$-$$$

Located: 28km/17mi Northeast of Querétaro
Carretera La Griega – El Lobo, Kilómetro 4.5
76249 El Lobo, Qro, México

+52 442 454 5470
Info@PuertaDelLobo.mx

PuertaDelLobo.mx

English, Spanish

*Restaurant Open: Wednesday-Friday, 12:30pm-6pm
Saturday 12:30pm-8pm, Sunday 12:30pm-7pm)*

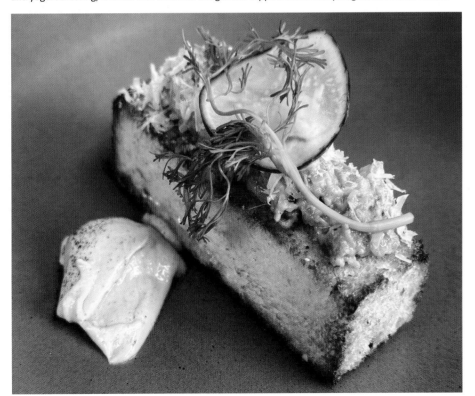

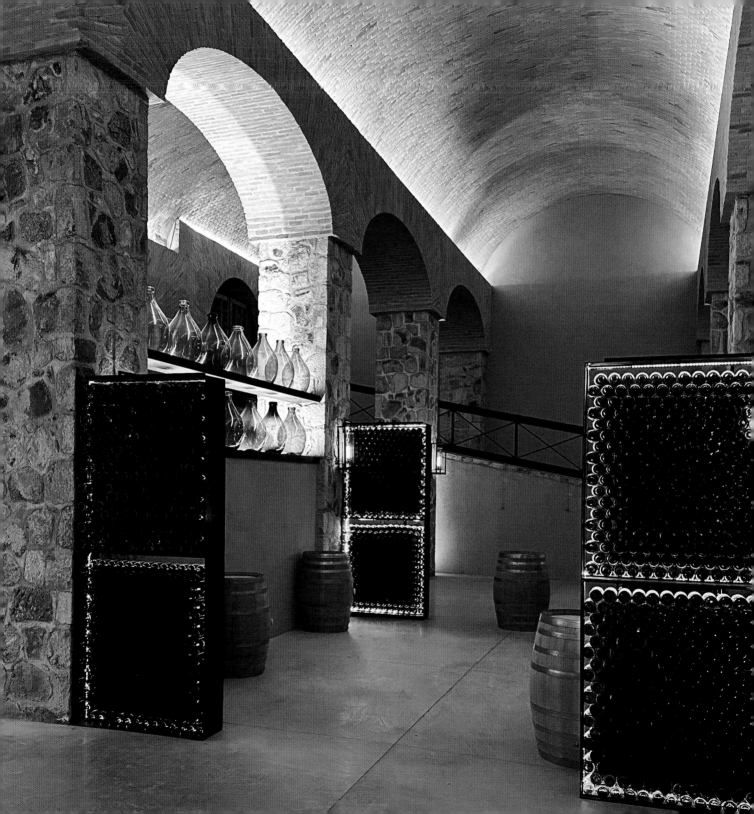

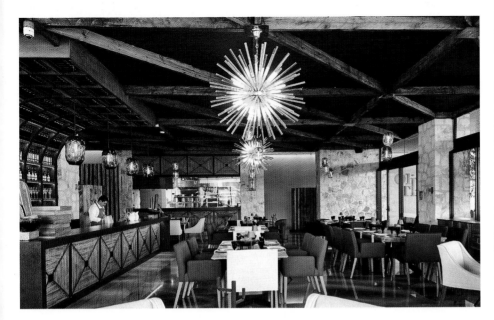

Winemaker: Champagne France

$$

Located: 58km/36mi Northeast of Querétaro
Carretera Estatal 100 El Colorado, Higuerillas No Km.35
76680 Bernal, Qro, México

+52 442 119 8268

PuertasDeLaPeña.com

English, Spanish

Open: Tuesday-Thursday, 2pm-8pm
Friday/Saturday, 1:30pm 10pm
Sunday, 1:30pm 6pm

Abeautiful property with winery, vineyards, chapel, restaurant, and event center.

A BEAUTIFUL VISION

The countryside and our passion. Wine and other pleasures of life. A place of dream and origin, where every dream becomes reality. Stories, new beginnings and a path to eternity emerge here. We are peace, serenity and joy.

We are the door to a place full of energy, tranquility and calm. The entrance to an ancient monolith full of mystery.

— The Founders, Puertas de la Peña

And so the mystery begins. I hear there are **special waters** that flow out of this monolith that allow people to live into their hundreds. I also hear that there is **magical energy** within its presence. And what I see from the vineyards of Puertas de la Peña is this **eight-million-year-old monolith** viewing the property as it stands 1,421' tall, one of the tallest monoliths in the world (photo page 303).

Puertas de la Peña means "Doors of the Rock" in Spanish. It is located just one mile from **Peña de Bernal**, a monolith rock and it's historic village (see page 303). Puertas de la Peña is now the first vineyard property planted at the monolith.

The winemaker here, Trini Jiménez, was trained in Champagne France. He is a sparkling wine expert. I would expect a lot more sparkling wines to be coming at this winery in the years to come. To start with, his sparkling rosé, Encuentros (photo right), is made in the French Champenoise Méthode. It is both fresh and very creamy on the head. It had twenty-eight months of aging on the lees. This was my favorite and you will definitely be impressed.

• **Tasting Experiences & Tour.** A full tour of the property, including the vineyards, lake, railroad bridge, chapel, winery, cellar and tasting of wine and cheese.

- Three wines with cheese platter.
- Five wines with cheese platter.
- Five wines with five appetizers from their restaurant Olivo Tinto (next page).

Collection of Wines

Ocho Apellidos (Merlot, Malbec, Cabernet Franc)
Abuelo Julian (Malbec Reserve)

Hortensias Y Rosas (Rosé of Merlot)
Encuentros (Sparkling Rosé of Syrah)

Cuarto Motivos (Macabeo, Xarel-lo, White Muscato)

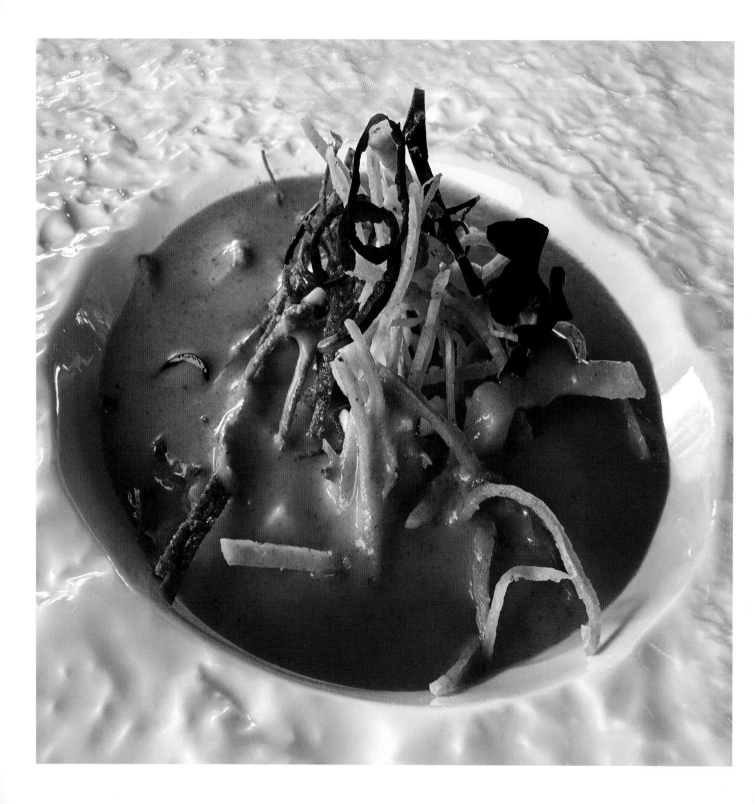

ANCESTRAL MÉXICAN CUISINE

This is a very special restaurant to have a winery. Just look at the photos on these pages (and page 275) and realize this is a gourmet extraordinaire, and yet these are culinary techniques of ancestral Mexican recipes passed down from generation to generation, enhanced by the touch of a Mexican chef to make them unique.

And now for this extraordinaire...

Tatemada Sauce Soup (photo left page) is a new style of tortilla soup made with a base of charred tomatoes, green tomatoes, onion, garlic, serrano chili pepper and cilantro. Served with blue and yellow corn fried tortillas, avocado, queso fresco and dried guajillo chili pepper.

Duck Ravioli (photo below) is cooked with tamarind, covered with black mole and cream, and topped with candied sesame and radish sprouts.

Chocolate Clay Pot (photo upper right) of dark chocolate fondant is cooked in clay for mineral notes.

Tortilla Crusted Short-Rib (photo bottom right) is cooked for ten hours in its own juice, covered in a crunchy yellow corn tortilla crust, served over a bayo beans hummus and coated with a tortilla and beef broth thick sauce. Topped with pea sprouts for a final touch of flavor.

QUERÉTARO **QUERÉTARO** VALLE DE BERNAL ■
Restaurant at Puertas de la Peña
OLIVO TINTO RESTAURANTE

$$-$$$-$$$$

Located: 58km/36mi Northeast of Querétaro
Carretera Estatal 100 El Colorado, Higuerillas No Km.35
76680 Bernal, Qro, México

+52 442 119 8268
OlivoTinto@gmail.com

PuertasDeLaPeña.com

Open: Tuesday-Thursday, 2pm-8pm
Friday/Saturday, 1:30pm 10pm
Sunday, 1:30pm 6pm

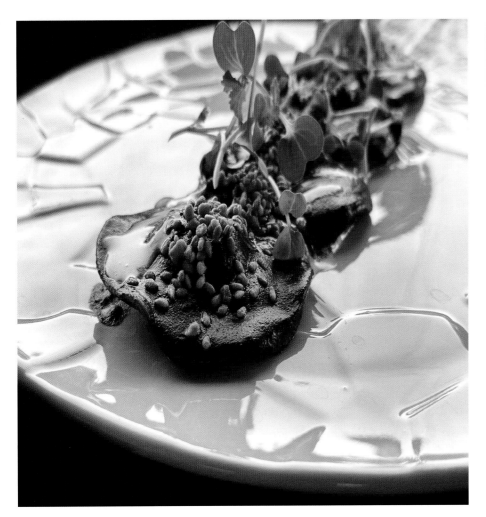

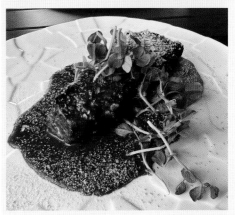

THE ULTIMATE WEDDING

It was at this beautiful lake with a railroad bridge, next to a new modern building, I had no idea what was inside (photo below). It was at this beautiful terrace between the building and the lake, and at that time, it was set up for what looked like a wedding ceremony. Then I found out, across the lake was this stunningly beautiful chapel (photo left page). A marriage was about to happen.

The entrance to this building was so interesting, creativity in abundance (photo below top left). I had to peek inside. Look what I found (photo below top right). It was under decoration. The most unbelievable wedding reception was getting created. I met the florist. See all those amazing flowers? The budget for the flowers alone was $500,000 Mexican Pesos (USD $30,000 of flowers at the time). The entire wedding was estimated to be $5 Million Mexican Pesos (USD $300,000). This was the ultimate wedding! Interested?

QUERÉTARO **QUERÉTARO** VALLE DE BERNAL ■
Event Center at Puertas de la Peña
PUERTAS DE LA PEÑA

$$$$$

Located: 58km/36mi Northeast of Querétaro
Carretera Estatal 100 El Colorado, Higuerillas No Km.35
76680 Bernal, Qro, México

+52 442 592 7492
A.Ventas@PuertasDeLaPena.com

PuertasDeLaPeña.com

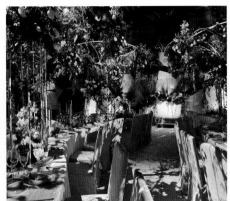

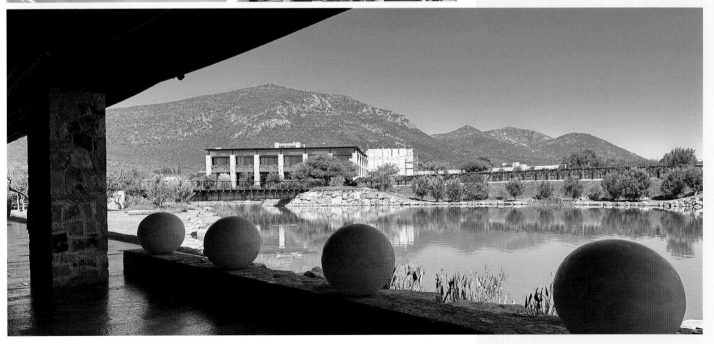

THE MOUNTAIN OF MAGICAL WATER

Peña de Bernal (photo left page) is one of the tallest monoliths in the world (1,421 feet). The elevation of the peak is 8,235'. It is located in **San Sebastián Bernal**, a small village (photo below) thirty-seven miles from downtown Santiago de Querétaro and just one mile from **Puertas de la Peña**. It is one of the most touristic sites near the state capital of Santiago de Querétaro.

The monolith was originally considered to be sixty-five million years old, formed at the end of the Jurassic period; however, recent chemical analysis by researchers at the National Autonomous University of México has now determined that it is considerably younger, only 8.7 million years old. Amazing that 56.3 million years can be mistaken.

A monolith is a geological feature consisting of a single massive rock. This rock is the exposed core of an ancient volcano after its extinction. The lava in the interior was solid rock, while the rest of the volcano eroded over millions of years. The solidified magma that remained is what constitutes and shaped this monolith. Pretty cool, isn't it? And worth your visit. You can walk through the village right up to the base as you can see in the photo on the left page. And if you are really adventuresome, you can climb all the way to the peak.

As the legend goes... I met a local when I was there. He told me that Peña gives off positive energy, and is considered mystical by many Mexicans. During equinox, thousands converge on the rock to take in its positive energy. He also told me that there is special water inside the monolith coming from deep inside earth. When consumed, people could live into the hundreds. Locals have blocked off the entrance to this water. And I must say, it looks quite beautiful. So maybe it has its magic.

Located: 60km/37mi Northeast of Querétaro
P3X2+7H Bernal
76680 San Sebastián Bernal, Gto, México

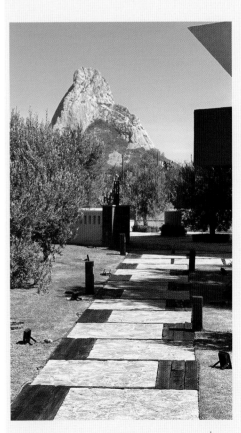

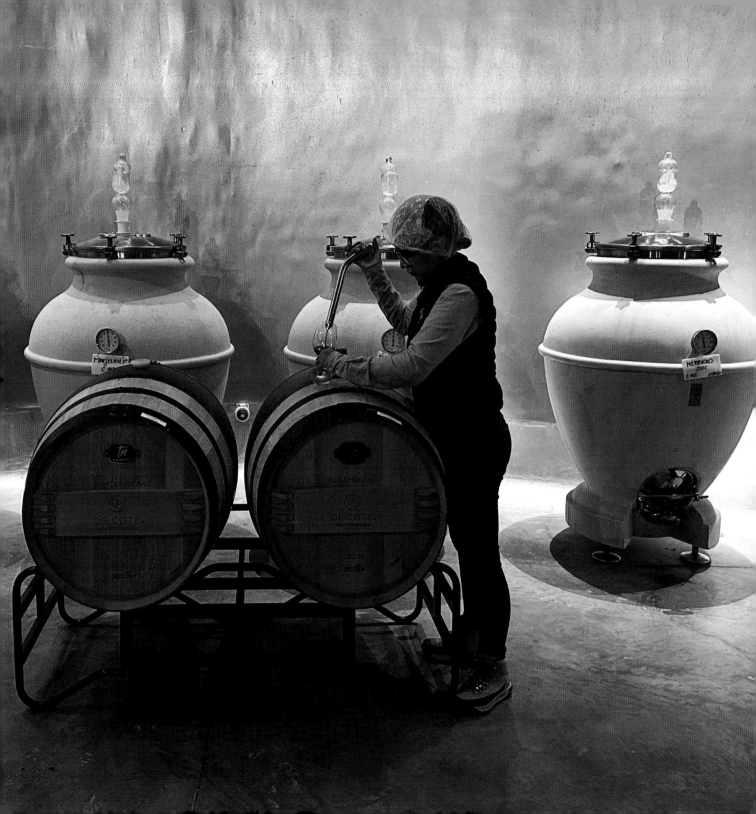

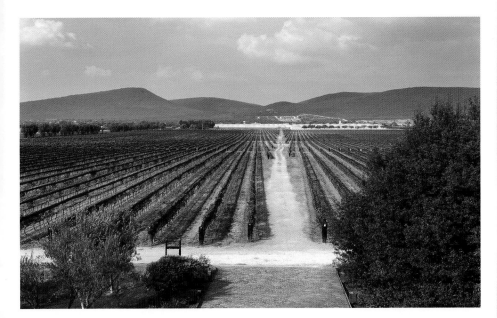

Winemaker: UC Davis, California

$$-$$$

Located: 64km/40mi Northeast of Querétaro
Libramiento Norponiente Km 5
76685 Tunas Blancas, Qro, México

+52 441 277 5000
Reservaciones@DeCote.mx

DeCote.mx

English, Spanish

Open: Every Day, 11am-6pm

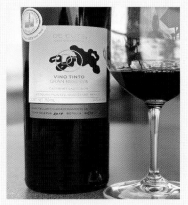

High-quality wines from excellent terroir, agronomy and winemaking.

HOBBY INTO PROFESSION

What do you do when wine is your hobby? Well, for the Calderón brothers, they purchased the very best vines from France, superior oak barrels from a notable cooper, etc. until... everyone wanted the great wine they were making. The brothers needed to get serious about their hobby, then De Cote was born.

Every year thereafter, including today, they keep planting additional hectors of vines. Ignacio Calderón is an agronomist, so he knows perfection in farming, including capitalizing on the unique terroir here. They only make wine from grapes off their property, because it is special.

Being in the Bernal Valley with a view of the **Peña de Bernal** monolith (page 303), imagine the result of erosion over millions of years. Volcanic stone is extremely resistant to the elements and rich in nutrients such as iron, magnesium and zinc. So as time went by, erosion, bacteria and fungi made the soils of this valley more arable, producing a large amount of nutrients, perfect for producing the excellent quality grapes De Cote thrives upon.

• **Tours: Walk, Bike or Tram.** Get to know the vineyard differently with an incredible view (you choose the transportation). Visit the winery, cellar and tank room, including an exquisite tasting.

• **Atempo Wine Tasting.** Enjoy whites, reds and reserves from their Atempo line of wines.
• **Gran Reserva Wine Tasting.** Sommelier-led tasting of their exclusive limited-edition wines; the result of selecting the very best wines from their barrels and aging them longer to perfection.
• **Grape Crushing.** Experience the ancient process of turning grapes into wine; crushing grapes with your feet. Available during harvest.
• **Sensory Workshop.** Learn the process of proper wine tasting. It is a sensory experience of viewing the wine in the glass, swirling the wine, smelling its aromas and tasting the wine by understanding its flavors and components in your mouth.

Collection of Wines

Gran Reserva Marselán
Gran Reserva Cabernet Sauvignon
Gran Reserva Merlot
Gran Reserva Merlot-Cabernet Sauvignon
Gran Reserva Tempranillo
Gran Reserva Tempranillo Syrah

Atempo Tempranillo Syrah
Atempo Merlot
Atempo Generoso Dulce (Fortified Port-Type)
Atempo Viognier
Atempo Sauvignon Blanc

Atempo Rosé (Rosé of Tempranillo, Merlot)
Atempo Espumoso Brut Rosé (Rosé of Xarel-lo, Grenache)
Atempo Espumoso Brut (Sparkling Xarel-lo, Albariño 10%)

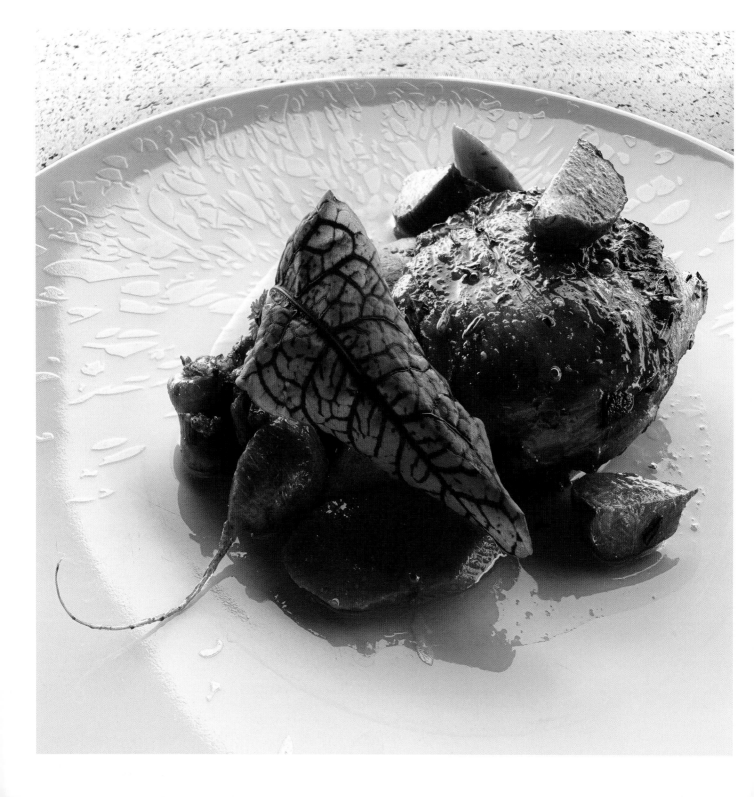

MEDITERRANEAN CUISINE

Above the winery is a massive deck overlooking their vineyards with mountains in the background. This is their restaurant and boy, is the view incredible (photo previous page).

In addition to the deck view, they also have indoor dining. And what's even better is their chef. Chef Adán Flores came from Polanco, México City's prestigious neighborhood with upscale international restaurants. See his cuisine on these pages, and I promise you the taste is even better. They also do food and wine pairings.

Now for his delicious cuisine...

Pollito de Libre Pastoreo (photo left page) is a roasted free-range baby chicken in a pepper and rosemary butter sauce accompanied with purple sweet potato puree and glazed baby carrots from their garden.

Galletas de Avena (photo below) are freshly baked oatmeal cookies with honey, raisins and cinnamon.

Selección de Quesos de la Región (photo upper right) is a variety local cheeses from cow, goat and sheep milk accompanied with local mezquite honey and freshly baked bread from their De Cote oven.

Ensalada de Higos (photo below right) is made of fresh caramelized figs, mix of lettuces and fresh basil from their orchard/garden, with a touch of roasted almonds and fresh regional cow cheese.

QUERÉTARO **QUERÉTARO** VALLE DE BERNAL ◼
Winery, Vineyards, Restaurant
BODEGAS DE COTE

$$-$$$-$$$$

Located: 64km/40mi Northeast of Querétaro
Libramiento Norponiente Km 5
76685 Tunas Blancas, Qro, México

+52 441 277 5000
Reservaciones@DeCote.mx

DeCote.mx

English, Spanish

Winery Open: Every Day, 11am-6pm
Restaurant Open: Every Day, 11am-6pm

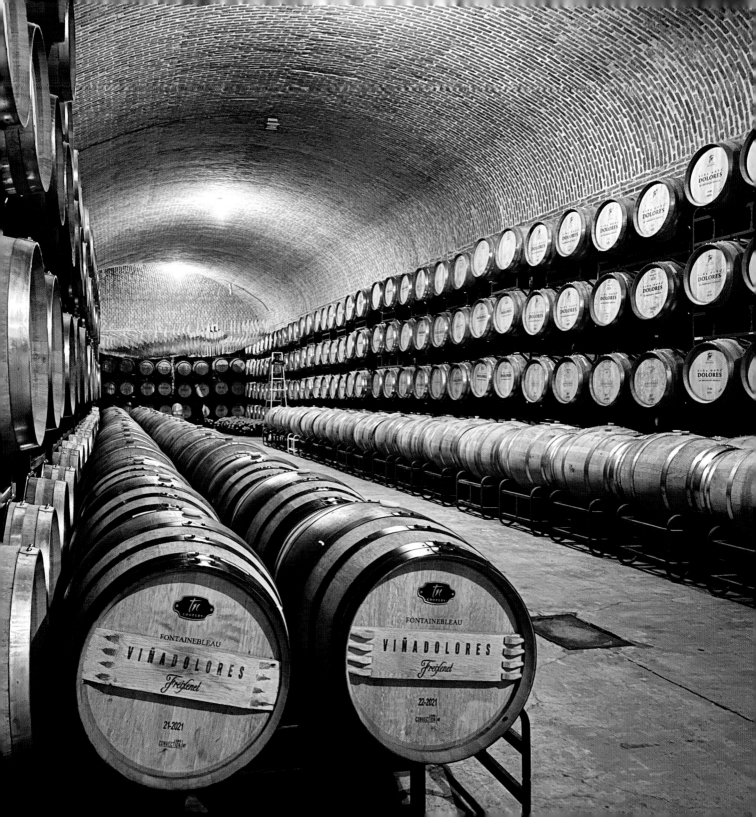

Winemaker: Catalonia, Spain

$$

Located: 64km/40mi Northeast of Querétaro
Cadereyta Km.40.5 Los Perez, Ezequiel Montes
76685 Tunas Blancas, Qro, México

+52 441 277 5100
Recepcion@FreixenetMexico.com.mx.com

FreixenetMexico.com.mx

English, Spanish

Open: Every Day, 11am-5:30pm

Collection of Wines

Sala Vivé
Brut (Pinot Noir, Chardonnay, Ugni Blanc)
Sala Vivé Brut Rosé (Pinot Noir, Chardonnay)
Sala Vivé Semi Dry (Pinot Noir, Chardonnay, Ugni Blanc)

Viña Doña Dolores
Brut Nature Gran Reserva (Macabeo, Xarel-lo, Ugni Blanc)
Brut Reserva (Macabeo, Xarel-lo, Ugni Blanc)
Semi Dry (Macabeo, Xarel-lo, Ugni Blanc)
Sweet (Macabeo, Xarel-lo, Ugni Blanc)
Chardonnay Brut Nature (Chardonnay)
Brut Rosé (Syrah, Merlot, Macabeo)
Muscat (Late Harvest Sweet Muscat)
Syrah (Late Harvest Sweet Syrah)

Many Additional Wines

The Largest Sparkling Wine Producer in all of Latin America in México Since 1979.

BUBBLES EVERYWHERE

Freixenet (pronounced: Fresh-ah-nay) is one of the largest wineries in México, definitely the largest in Querétaro, and most certainly the largest sparkling winery in Latin America. Freixenet specializes in sparkling wines, and they do them very well.

Lluis Raventós, the general manager and winemaker of Freixenet México, is a master at bubbles. He studied oenology in Catalonia Spain, the origin of the famous Cava sparkling wines. His parent company, The Freixenet Group produces 350 million bottles of wine annually from seventeen of its wineries around the world, with Freixenet México being a special endeavor (only two million bottles).

Freixenet arrived in México in 1979 introducing its first sparkling line **Salva Vivé** in 1984. They next created the **Viña Doña Dolores** and **Vivante** labels introducing still wines to their collection in 2000 with reds, rosés, whites, and sweets. A total of twenty-five different labels. Viña Doña Brut Reserva obtained the first **Grand Gold** as a Mexican sparkling wine at the **Concours Mondial de Bruxelles** (a global wine competition with stringent standards).

Salva Vivé

This is their first brand in México with three labels of premium sparkling wines. These wines are made from French varietals, which are used to make **Champagne**; primarily Chardonnay and Pinot Noir.

Viña Doña Dolores

This is their second brand with both sparkling and still wines, among ten labels. These wines are produced using Spanish varietals which are used to make **Cava**. The primary Spanish grape they use is Xarel·lo (pronounced shah-RELL-lo), a white grape variety of Spanish origin specially grown in Catalonia Spain. Xarel·lo, along with Macabeo and Parellada, are the three traditional varieties used to make the famous sparkling wine Cava.

Freixenet México produces Viña Doña Dolores sparkling in dry, semi dry, sweet, and rosé. By the way, Dolores Sala Vivé is the founder's wife, an excellent oenologist and businesswoman, who became extremely influential in the quality of the wines and leadership of the company worldwide.

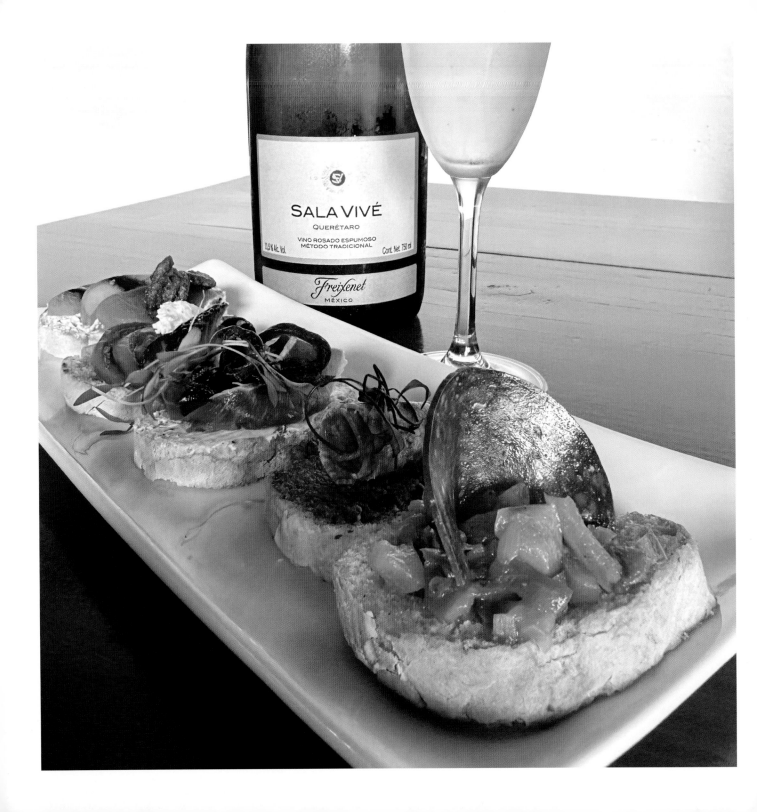

MOST VISITED WINERY IN MÉXICO

Imagine this, Freixenet México is one of the most visited wineries in the world. Three hundred thousand people annually! Why? The tourism experiences are excellent, interesting and educational.

Yes, they are! The deepest wine cellar in Latin America is here at Freixenet. Eighty-two feet deep. The stairway alone is a dramatic tunnel. All of their tours revolve around going deep underground. Their guides are knowledgeable and will explain their winemaking process, the history of Freixenet México and why they are experts at sparkling wines.

In 2024, they opened four takeout restaurants in their park (photo below). Spanish, Mexican, Italian, and seafood, all with the full array of Freixenet wines.

• **Classic Tour.** Go eighty-two feet underground and tour their famous cellar (deepest in Latin America) and learn why Freixenet is the expert in bubbles. Of course, enjoy a sparkling wine tasting.

• **Grape Bus Tour.** Tour their vineyards by tram (photo upper right) and learn about the cycle of the vine, see the Peña de Bernal monolith. It includes touring the deep cellar and sparkling wine tasting.

• **Wine Tasting.** A sommelier-led tour of their deep cave along with a sensory experience (flavors and aromas) of three of their best wines paired with an exquisite plate of seasonal tapas (photo left page).

• **Horseback Riding in the Vineyards.** Bring your boots, hat and riding clothes to embark on a horseback riding adventure of their 125 acres of vineyards (photo bottom right). The view of the vineyards is amazing and educational. It includes a bottle of sparkling wine you uncork and toast at the end of your ride.

• **Pairing** (photo left page) on sourdough bread, from right to left... Sautéed pepper with tomato and slice of chorizo de Salamanca; tapenade (traditional Middle Eastern preparation based on olives and capers) with salami and beet sprouts; jamón serrano with caramelized onions and coriander sprouts; caramelized peaches with fresh cheese and honey; apples in white wine reduction and caramelized walnuts.

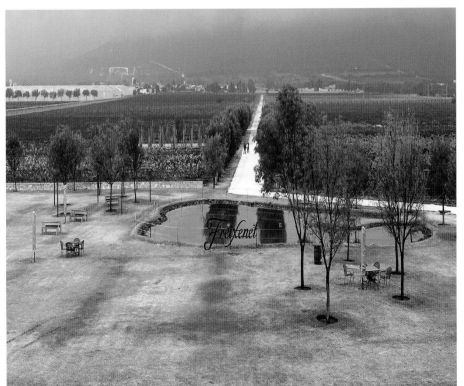

QUERÉTARO **QUERÉTARO** VALLE DE BERNAL ■
Winery, Vineyards, Restaurant
FREIXENET MÉXICO

$$-$$$-$$$$

Located: 64km/40mi Northeast of Querétaro
Cadereyta Km.40.5 Los Perez, Ezequiel Montes
76685 Tunas Blancas, Qro, México

+52 441 277 5100
Recepcion@FreixenetMexico.com.mx.com

FreixenetMexico.com.mx

English, Spanish

Open: Every Day, 11am-5:30pm
Tours: Monday-Friday, 11am-12pm, 1pm, 3pm, 4pm
Tours: Sat/Sun, 11am-5pm (Every Half Hour)

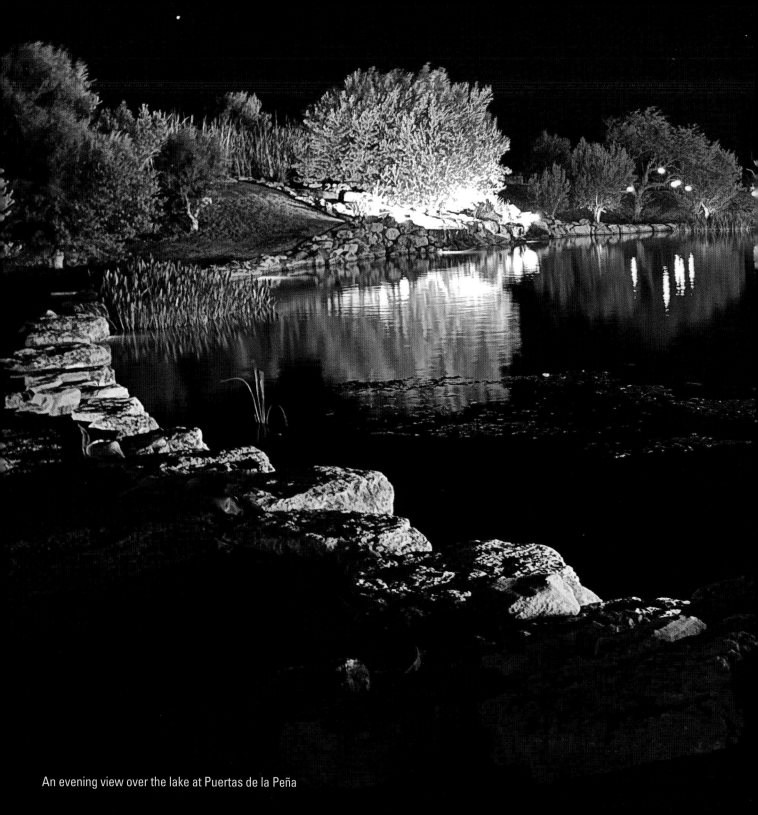
An evening view over the lake at Puertas de la Peña

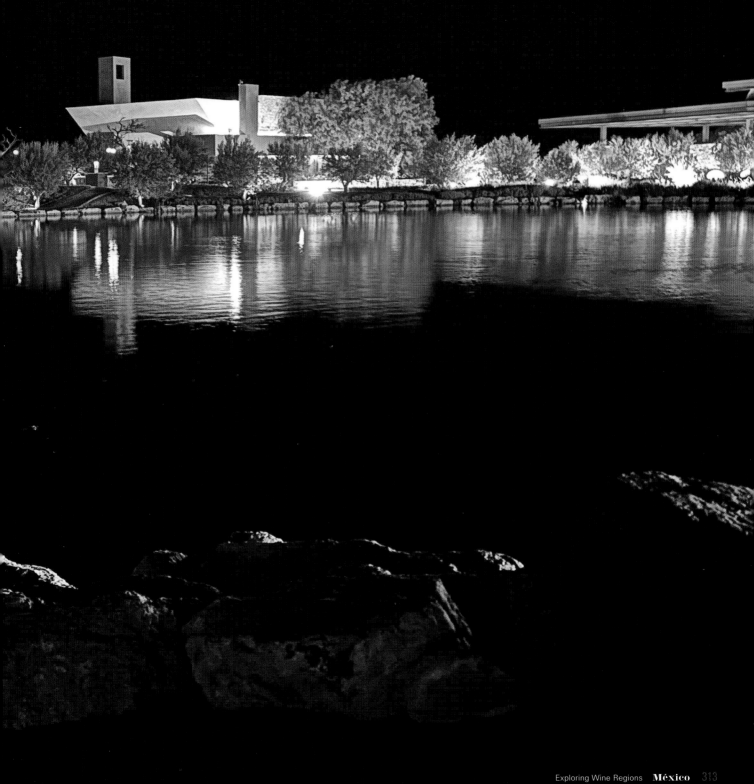

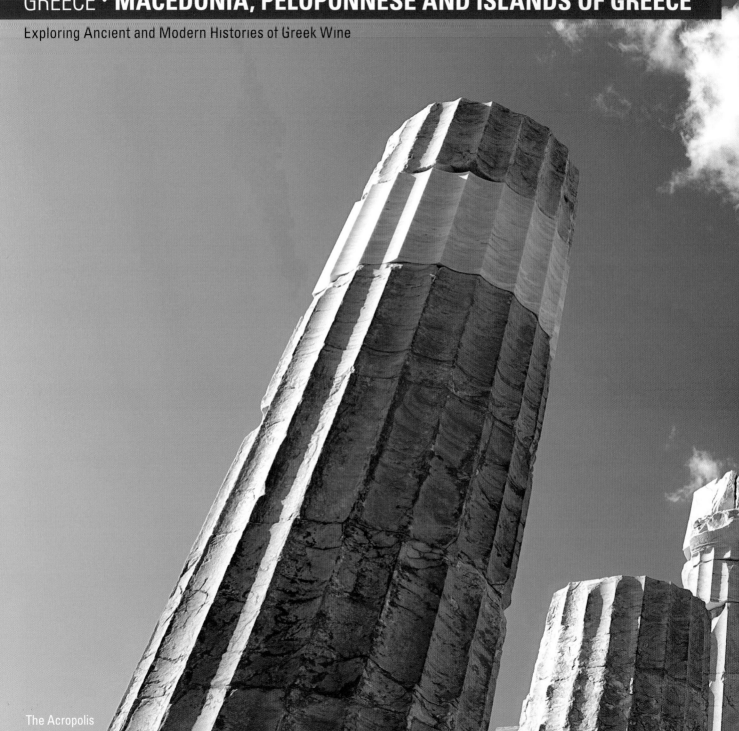

The Acropolis

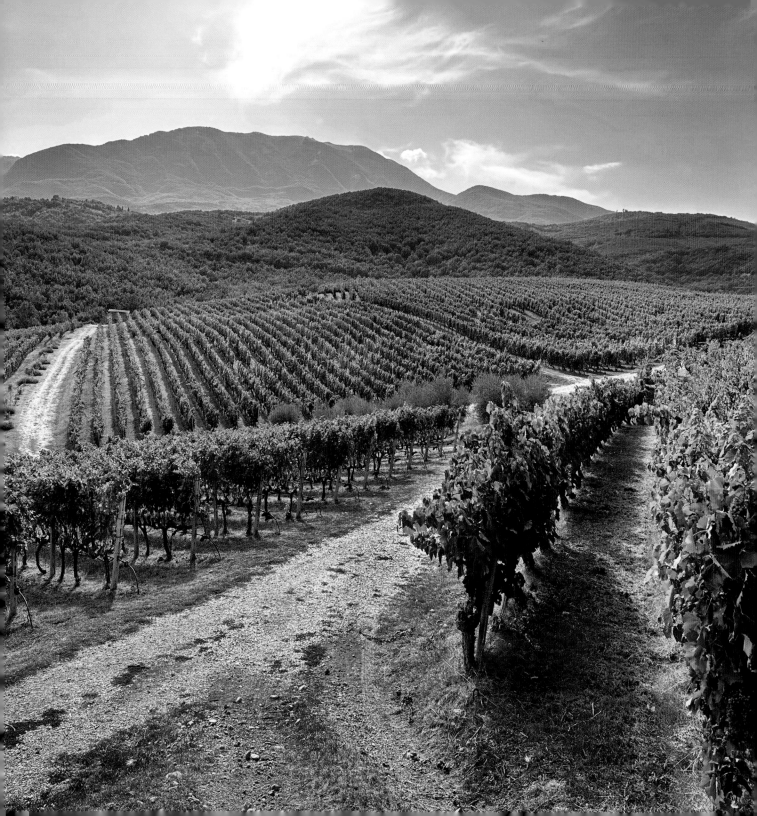

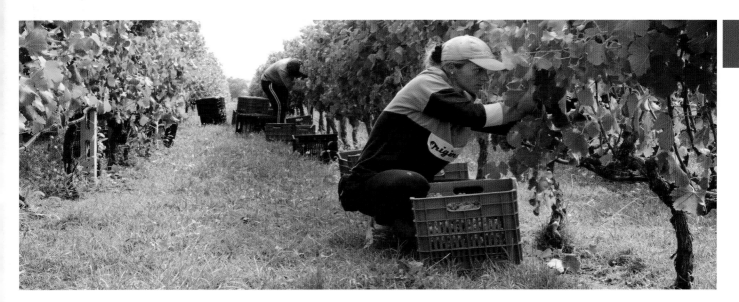

E xploring Greece is an adventure in ancient history, gorgeous landscapes, super-nice people, and an extraordinary scene of delicious food and excellent wine.

WHY GREECE

Have you ever tasted Greek wines? Until recently, I did not have the opportunity to try them. Being approached to do our next book on the Greek Wine Regions, I was told to go to a wine shop and see what Greek wines they have. I went to a big one, and I was surprised that there were fifteen different bottles of Greek wines. I purchased the most expensive bottles thinking that they may be the better wines, since I had no idea how to choose.

Next, I went to a local Greek restaurant that has been in my city for decades, and I've enjoyed many meals there. I showed the owner the wines and asked him to pair the food. The next day I came back for a great array of Greek food to take home and pair with the wines. What an excellent way to start my experience with Greece.

I put off visiting Greece because I was busy researching and producing our California and México books. I wanted to get these completed first and then focus on Greece.

Not knowing anything about Greek wines, I had on my mind that going to Greece would at least be a spectacularly beautiful experience. The place is gorgeous, and the food is amazing. I thought these two factors were enough for an amazing time in Greece.

I made my initial Greece exploration trip while completing this México book. And it is true. Greece is beautiful and the food is amazing. What I discovered though is that the wines are excellent as well. And the people are super nice. This is a place you want to go and enjoy yourself.

In the Greece book, I will help you understand their wines. The grape names are difficult to pronounce. I plan to solve that. And show you where to find the wineries with the best wines and excellent tourism.

And before I forget, a wine that I tasted at one of the wineries on this initial exploration trip showed up on the *Wine Spectator* **Top 100 Wines of 2023**. Believe me, you will enjoy the wines here.

Now that the México book is published, please know that I am in Greece exploring their wine regions. I am currently looking for **Dionysus**, the mythical god of wine and pleasure. I am sure he has a lot to tell me that I can share with you in our Greece book.

As a romantic myself, I am also looking for **Aphrodite**, the Greek goddess of love, desire, sexual pleasure, fertility, beauty, and grace. Now this is a goddess to love!

In the northern mainland of Greece is the Macedonia Wine Regions and the appellation of Naoussa. The left page photo is in this appellation at the Ktima Kir-Yianni winery. Isn't the landscape stunningly beautiful? This is your view at the winery while you taste the wines and enjoy the restaurant on their patio.

Also in the Macedonia Wine Regions, now in the appellation of Amyndeon, is the winery Alpha Estate (photo above). It is harvest time picking their beautiful grapes for another award-winning vintage.

GREECE

BULGARIA

NORTH
MACEDONIA

ALBANIA

TURKEY

MACEDONIA

○ THESSALONIKI

GREECE

IONIAN
ISLANDS

ATHENS
○

AEGEAN
ISLANDS

PELOPONNESE

TURKEY

*Mediterranean
Sea*

CRETE

THE NEXT BOOK
Exploring Wine Regions – Greece

MACEDONIA

Macedonia is the northernmost wine region in Greece, bordering Albania to the west, Republic of North Macedonia and Bulgaria to the north and north east, respectively.

The capital city of this Macedonia Region is Thessaloniki. It was founded in 300 BC and is the second-largest city in Greece today with over one million in population in its metropolitan area. I find this city very exciting. It is young and vibrant. There is a major university here which brings a great number of young people into the city.

During my first two weeks in Greece, I visited three wine regions; one close to **Thessaloniki**, plus the appellations of **Naoussa** and **Amyndeon**. As you venture towards the west to these appellation, the landscape is beautiful with picturesque mountains and valleys.

ATHENS

Visiting the city Athens is definitely a great part of exploring Greece. This capital city is the largest city in Greece with a population of more than four million people. It is also the fifth largest urban area in the European Union.

Athens is filled with history. Ancient history, with records spanning over 3,400 years. It is one of the world's oldest cities. The city was named after Athena, the ancient Greek goddess of wisdom.

The famous **Acropolis** is located here on top of a 500-foot butte in the middle of the city. It was built as a citidel (a fortified area of Athens to defend the many attacks received thousands of years ago). This fortress is still in excellent condition and you can climb the many steps to see it (photo on page 314).

There are a couple of wineries near the city that I visited and they will be in the Greek book. Departing Athens west by car will take you to the Peloponnese Wine Regions, which is worth visiting.

PELOPONNESE

Peloponnese is a gigantic peninsula directly located west of Athens, which becomes the southernmost part of mainland Greece. It is connected to the mainland by an isthmus, which has a canal built through it. Since it is now completely surrounded by water, I consider Peloponnese a man-made island. A huge island though, covering over 8,000 square miles.

There are four appellations on Peloponnese. I visited two of them (**Nemea** and **Mantinia**) when I was there on my initial visit. The wines were excellent, the landscape beautiful and the people extraordinarily nice.

I visited Nafplio, a beautiful seafront promenade here with a historic center of ancient architecture and quaint restaurants.

And there are more regions to explore, so look out for the next book.

MY MÉXICO DISCOVERIES?

Let's just get right down to it. México has extraordinary wine regions! You must go.

Living in Southern California all my life, México has always been a frequent destination for me. The beaches and resorts are extraordinary in all parts of the country. I love visiting and have flown myself to many different and wonderful locations in México. Yet, little did I ever think of México for wine. You probably haven't either. It is easy to expect that their vineyard landscapes must be beautiful, because wine regions are some of the most beautiful places on earth, and México is a beautiful country. And it is all true.

The little surprises are the best. The finest olive oil I have tasted in my entire life came from a winery in México (page 267). The most stunningly romantic tasting room I ever experienced was in México (photo right and page 81). It is so good that I have been back three times! The quality, creativity and uniqueness of the international cuisine are off the charts. The cuisine here is what you would find in large culinary cities like New York and Paris, at a fraction of the big-city cost.

It is amazing that México's independence, its revolution against Spain, came as a result of México making excellent wines. That was a big surprise to me. When you think of all the independence throughout Southern, Central and Northern America against European countries, who would have ever thought that a revolution would be caused by wine, and that it would create freedom and independence for the entire country. I must say though, wine sure is an excellent cause.

The three wine regions I visited for this book are truly remarkable. You have to go. The food is amazing, the people are wonderful and the wine will surprise you. The winemakers know what they are doing, and they are producing French, Italian and Spanish style wines.

The book includes one wine region with terroir just like what the California Wine Regions have so special, and two mountainous wine regions with terroir similar to what Argentina has so special. Everything about the Mexican Wine Regions makes sense, and as a result, they have attracted winemakers from the most prestigious wine regions around the world.

As usual, everything I cover in this book is from my own personal experiences. I was there. The photos are authentic from my camera and my eye. Everything I write is from my journeys.

So now it is time to go explore and go enjoy the journey.

Happy Tasting,

Michael C. Higgins, PhD

Michael C. Higgins, PhD
Author, Photojournalist & Publisher

What's next...

Greece. When you are invited to explore the wine regions of such a beautiful country as Greece, how do you say no? And when they contacted me, I had to say no at first, as I was busily working on the California and México books. Eventually I gave in and went to a see what is going on with Greek wines.

I had no experience with Greek wines, its wineries, wine regions or terroir. So, I went for two weeks to get my feet wet. The wines were excellent. Still can't pronounce them, but that's easy to get over. The food is extraordinary. And the place is ever so beautiful. Aren't all wine regions stunningly beautiful?

Now that I am finished with the México book, I'm ready to go full-fledged into exploring the Greek wine regions. I hope to meet Dionysus, you know, the mythical god of wine and pleasure. There has to be some magic that can come out of that.

I can't wait to get there and share everything with you.
2026 - Exploring Wine Regions – Greece

THE INDEX
Finding Your Way Around Easily

THE INDEX
Finding Your Way Around Easily

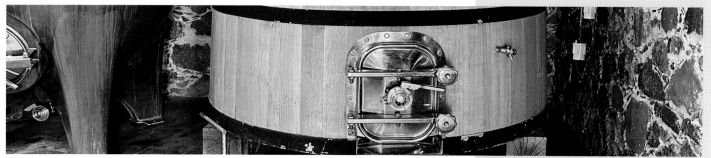

Casa Anza (page 227), in Guanajuato México, is known for the diversity and uniqueness of tanks in their winery. Here, photos left page top and bottom, respectively: clay, concrete, stainless steel, and terracotta fermentation tanks; and photo above: concrete and wooden fermentation tanks.

The oval-shaped tanks help circulate the wine freely in a natural way keeping the juice in greater contact with a must. Stainless steel provides an airtight environment to minimize the oxygen exposure during aging to help preserve the wine's freshness, vibrant fruit flavors and natural acidity. Terracotta improves the earthy characteristics of the wine. Oak tanks provide for more body, structure, smoothness and longer life in the bottle. Each of these tanks offers a concept and method to provide the best in each type of wine.

DEFINITIONS
Glossary of Wine Terminology

Origins of the Grapes in this Book

BORDEAUX GRAPES
Red – Cabernet Sauvignon, Cabernet Franc, Merlot, Malbec, Carménère, Petit Verdot
White – Muscadelle, Sauvignon Blanc, Sauvignon Gris, Sémillon

BURGUNDIAN GRAPES
Red – César, Gamay Noir, Pinot Gris, Pinot Noir
White – Aligoté, Chardonnay, Melon de Bourgogne, Pinot Blanc, Sacy

RHÔNE GRAPES
Red – Counoise, Cinsault, Folle Blanche, Grenache, Marselan, Mataro, Mourvèdre, Muscardin, Petite Sirah, Syrah, Terret Noir, Vaccarèse
White – Bourboulenc, Clairette Blanche, Grenache Blanc, Marsanne, Picardan, Picpoul Blanc, Rousanne, Viognier

CROATIA GRAPES
Red – Dobričić, Plavac Mali, Refosco, Terrano, Zinfandel
White – Grk Bijeli, Malvasia, Pošip, Welschriesling

ITALIAN GRAPES
Red – Aglianico, Barbera, Corvina, Dolcetto, Falanghina, Grignolino, Lagrein, Lambrusco, Montepulciano, Nebbiolo, Nero d'Avola, Rondinella, Sangiovese, Teroldego
White – Arneis, Catarratto, Fiano, Friulano, Greco, Moscato (Muscat), Pigato, Ribolla Gialla, Teroldego, Trebbiano (Vigni Blanc), Verdicchio, Vermentino

SPANISH GRAPES
Red – Alicante Bouschet, Bobal, Carignan, Garnacha, Graciano, Mencia, Mission (Misión), Monastrell, Tempranillo
White – Airén, Albariño, Garnacha Blanca, Getariako Macabeo, Txakolina, Godello, Palomino, Rías Baixas, Txakoli, Verdejo, Vijariego, Viura, Xarel·lo

GREEK GRAPES
Red – Agiorgitiko, Moschofilero and Xinomavro
White – Assyrtiko, Malagousia, Malvasia, Moschorlero, Muscat (Moscato), Savatiano

WORDS

Acidity – A tartness that makes wine refreshing and your tongue salivate to want another sip. Harvesting early increases acidity. Acidic wines tend to go extra well pairing with food.

Appellation – A legally defined and protected geographical area used to identify where wine grapes are grown. Also known as an AVA.

Clone – A twig, a separate vine genetically identical to its mother vine, certified like a pedigree.

Tannins – Naturally occurring molecules extracted from the grape skins, seeds, stems, and oak barrels. They impart flavor to red wines, contain antioxidants, yet have no smell or flavor itself. They constitute a basic building block of red wines, contributing much to texture, balance and aging potential. Tannins have a dry chalkiness in your mouth.

Terroir – Soil, climate and people

Toast – Burnt wood inside the wine barrel

Varietal – Type of grape used in making wine

Vat – Tank (stainless steel, concrete and wood)

Vinification – Fermenting the grape juice

Vintage – Year of harvest

Vintner – The winery owner

Alcoholic Fermentation – Biochemical process in which sugar is converted into alcohol.

Malolactic Fermentation – The process in winemaking in which tart-tasting malic acid, naturally present in "grape must," is converted to softer tasting lactic acid.

Meniscus – Is the edge of the wine in the glass; the color determines the vintage/age of the wine.

CONCEPTS

Pruning – Pruning changes the form and growth of a plant. Pruning can also be considered preventive maintenance for both insect and disease damage. Grapes vines should be pruned during their dormancy, usually in late winter. Mature vines should be pruned yearly to remove all growth except new one-year-old fruiting canes and renewal spurs which is where the new fruit will grow.

Tipping – Removing new growth at the top of the vines so the energy can flow to the grape clusters.

Leaf Removal – Removing leaves so more air flows into the vines and more sun shines on the grapes.

Green Harvest – Removing some of the green clusters of grapes so the other clusters get more nutrition and energy from the plant.

Veraison – Onset of the grapes ripening, as grapes turn from green to red, as grapes change from growing to ripening.

Stages of winemaking – Harvest, sort, crush, ferment, press, clarify, age, and bottle.

ACTIVITIES IN THE VINEYARD

January – Pruning
February – Till soil and remove vine shoots
March – Staking and tying (to the training wires)
April – Bud break and till soil (at vine base)
May – Bud pruning
June – Flowering and tipping (removing tops)
July – Fruit sets and leaf thinning
August – Veraison, green harvest and leaf thinning
September – Monitor ripeness and harvest
October – Harvest and fermentation
November – Plowing vineyards
December – Pruning

TRAVEL EASIER
WITH OUR
E-BOOK TRAVEL EDITIONS
On Apple Books and Amazon Kindle

THE BENEFITS

I get it. The books are too nice and you do not want to get them damaged while traveling. Plus, they are big, take up space, and weigh down your bag. I understand, as I carry the books with me when I travel. So we have created a great solution... **eBOOK TRAVEL EDITIONS**. They go on your smart phone and tablet. They have all the exact same contents and are more convenient than the printed books for traveling. And more...

In these digital Travel Editions, we have made the websites, phone numbers, emails, and physical addresses as *live links*, so you can easily click and directly go to the page of the winery, restaurant, resort, attraction, etc.

- Time to navigate? Click on the *address link.*
- Want to call them? Click on the *phone number link.*
- Need more information? Just click on their *website link.*
- Want to email with questions or book a visit? Click on the *email link.*

For me, the **eBook Travel Editions** are indispensable. Easy. Handy. Everything is at my fingertips. And no added weight. All this is available on Apple Books.

Available on
Amazon Kindle
and **Apple Books**

OUR OTHER BOOKS
The Exploring Wine Regions Book Series

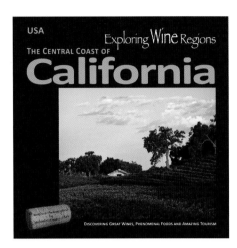

EXPLORING WINE REGIONS – ARGENTINA
A Culinary, Agricultural and Interesting Journey Through Argentina

Exploring Wine Regions – Argentina is our debut book that has won "Best Travel & Wine Book 2016" and "Best Travel Book 2017." This first book of the series sprung from my personal quest. Will I ever meet a Malbec I don't like? What is Argentina's secret to producing the best Malbec?

Argentina offers so much more than just Malbec. Our journey unveiled Bonarda, Tempranillo and Torrontés wines just to name a few. Torrontés is indigenous to Argentina. And Asado, delicious steaks cooked slowly over live wood embers. Tango! The most beautiful dance to go with the beauty of their people and landscape. There is so much to see and do here. Jump into all the adventures Argentina has to offer.

Follow us to this magnificent country's top three wine regions: Mendoza, Salta and Patagonia. Mendoza produces extraordinarily great Malbec that puts Argentina on the map as the fifth largest wine country in the world; Salta boasts the world's highest elevation vineyards; and Patagonia makes delicious Pinot Noir thanks to its cool climate.

A must-have book for those wanting to explore one of the world's top wine regions and learn the answer to my question.

EXPLORING WINE REGIONS – BORDEAUX
Discover Wine, Food, Castles, and The French Way of Life

Exploring Wine Regions – Bordeaux France is the second book in the series and has won ten awards. It takes you on a journey of the long and fascinating history of wine, gastronomy, castles, and *joie de vivre*, the French way of living life.

Bordeaux is complicated, so I have worked meticulously to make Bordeaux comprehendible for you. The wines are presented by each region separately to better appreciate their nuances. Exploring the Left Bank of the Médoc, Graves and Sauternes, as well as the Right Bank of Saint Émilion, Pomerol and Fronsac, lead us to a greater understanding and distinction of the regions here. Plus, a side trip to Cognac and the Entre-Deux-Mers wine regions.

We help you navigate your own way through this historic wine region with detailed maps and insider tips. We highlight the châteaux worth visiting, including the ones where you can stay in their castles, as well as excellent restaurants and unique tourism experiences.

Everyone can learn how to develop a palate to appreciate the finest wine and food the French have to offer. A must-have book for expanding your knowledge of Bordeaux and its wine.

EXPLORING WINE REGIONS – CALIFORNIA CENTRAL COAST
Discovering Great Wines, Phenomenal Foods and Amazing Tourism

Exploring Wine Regions – California Central Coast is the third book in the series exploring the lesser-known areas of the wine regions in California. Most everyone knows of Napa Valley and Sonoma County; however, the Central Coast Wine Regions are producing top-level, high-quality wines, and the tourism is extraordinary.

Twenty million years ago, the Pacific Plate arose from the ocean hitting the North American Plate (Canada, United States and México) leaving a sliver of land above the water along California's coast south of San Francisco. This sliver of land has its own very special terroir highly conducive to making high-quality wines. This book takes you on a journey to discover these amazing wines.

Also, the tourism along the central coast of California is unmatched. The beaches, mountains and valleys are ever so enchanting. The wineries are engaging, have lots of tourism activities available, and are especially inviting and friendly, unlike other wine regions. It's not uncommon to find the vintner or winemaker at the tasting room wanting to share their stories and their love of wine with you.

OUR OTHER BOOKS
The Exploring Wine Regions Book Series

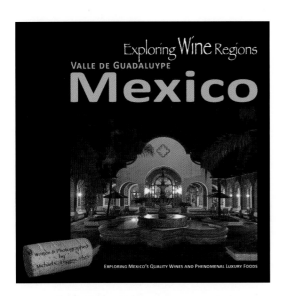

EXPLORING WINE REGIONS – MÉXICO
Exploring México's Quality Wines and Phenomenal Luxury Cuisine

Exploring Wine Regions – México is the fourth book in the award-winning series, now exploring the México Wine Regions. Does México make wine? Yes. Any good? Very good. While México is famous for producing tequila, this book opens our eyes to high-quality Mexican wines, phenomenal cuisine and extraordinary tourism. This book takes you on a journey to discover these amazing wines; combining wine education, an insider travel guide and spectacular photography. Higgins again dazzles his audience with another informative and beautiful book.

Tourism in México is outstanding and we all know it. And the Mexican wine regions are no exception. Wine regions are always very beautiful places. Here, the mountains and valleys are ever so enchanting. The wineries are engaging, have lots of tourism activities available, and are especially inviting and friendly with their warm Mexican hospitality. Both connoisseurs and novices turn to this book series for insider information and inspiration. It is a must-have book for expanding your knowledge of México and its wine.

With 340 full-color pages and over 600 photographic images, this fourth edition explores México's regions of Valle de Guadalupe (including Ensenada), Guanajuato (including San Miguel de Allende) and Querétaro (with its rich history). With breathtaking photography and personal commentary, readers will be mesmerized by the world of wine, food and travel. Extensive resources are provided for wine lovers who want to know where to go, what to look for, and how to discover their favorite wines.

NEXT BOOK
EXPLORING WINE REGIONS – GREECE
Ancient Times in Greece, Spectacular Islands, Beautiful Wines

I must admit, I have never tasted any wines from Greece. You? I did not know if they were good or not good. And I wondered why they had been off my radar all this time. All I knew is the country is beautiful, the islands stunning.

We received an email from Greece asking if we would consider doing our next book on Greece. We started with them shipping a couple of good bottles of wines to try. I went to the owner of a local authentic Greek restaurant and asked him to make food to pair with the wines. From here we had a four-hour Zoom food and wine pairing experience together. I was hooked, and ready to complete the current book so I could begin this journey to Greece.

Have you seen the names of their grapes? For example, Xinomavro, Assyrtiko and Moschofilero. The first thing I realized was that I needed to learn how to pronounce their wines, especially how to properly spell the grape names.

Apparently, the Crete Island is one of the best destinations for us wine lovers, with about thirty-five wineries on the island primarily producing the indigenous varieties of Vidiano, Vilana, Malvasia, and Kotsifali. They have 4,000 years of Cretan winemaking tradition that will be interesting to discover.

What I do know for sure is that the food is incredibly delicious, the islands are stunningly beautiful, and the Greek people are warm and friendly, with an ancient history of winemaking and mysticism that will be so fascinating to uncover.

We are expecting a two-year journey to complete this book, with an estimated publishing date of 2026.

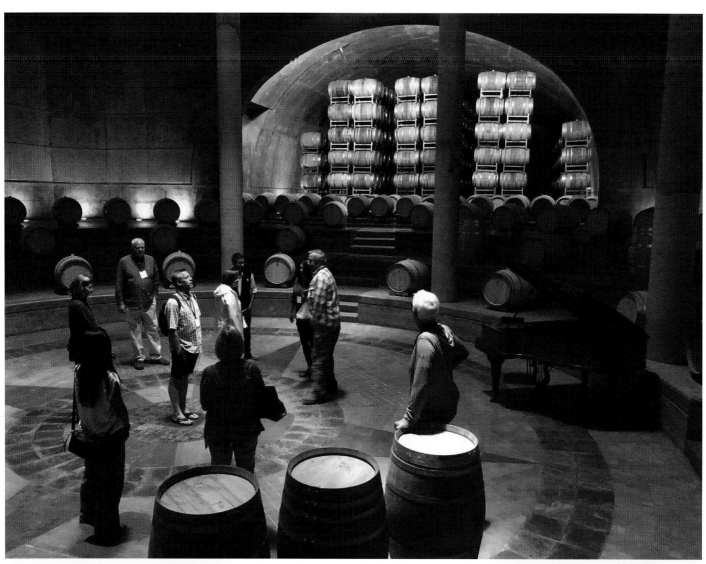

SPECTACULAR WINE CELLARS
We take you into the most
amazing wine cellars.

INSIDER WINE TASTINGS
We introduce you to notable winemakers
and special wine tastings.

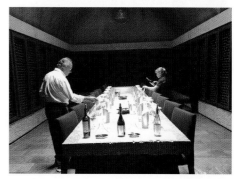

TRAVEL WITH US

ACTIVITIES

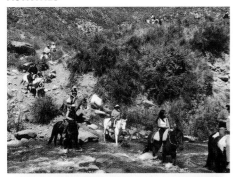

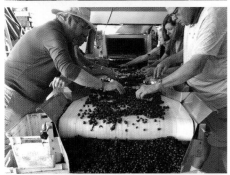

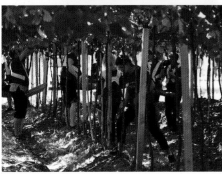

COME JOIN US...
on extraordinary trips of
exploring wine regions all over the world!

We put together over-the-top trips that are unforgettable! Our groups are small and intimate, carefully selected, to ensure the best possible experience for everyone. Our events are exclusive and unlike anything available to the general public.

We go in the back-door, so-to-speak, as our friends are the "who's who" in wine and travel. They create the most amazing experiences for us.

Our trips are unique. We have been organizing special trips since 2005, ranging from spectacular to luxurious.

If you would like to be on our special private invite list, please email us at: JoinUs@ExploringWineRegions.com

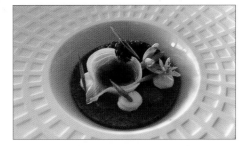

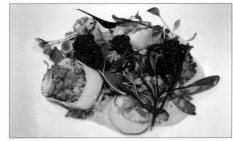

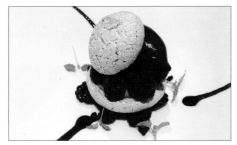

TESTIMONIALS

"The best part about Michael organizing our tour: all the hard work was already accomplished, the best locations were chosen. There was nothing left to do but enjoy. Being on a tour with other wine lovers was extra enjoyable because we already had something in common with everyone else and could share stories of other trips and wine experiences."
– Lee and Carolyn Jones

"Dr. Higgins does everything 1st class or not at all!"
– Mike Goering

More testimonials on our website:
ExploringWineRegions.com/testimonials

OUR WEBSITE
ExploringWineRegions.com

FOLLOW US ON SOCIAL MEDIA

FACEBOOK: Exploring Wine Regions

INSTAGRAM: @ExploringWineRegions

exploringwineregions Edit Profile

869 posts **26.3k** followers **846** following

Exploring Wine Regions
🍷 INSIDER TRAVEL GUIDES 🍷 to exploring the world's wine regions... sharing the lifestyle of extraordinary food and wine experiences. #ewr
ExploringWineRegions.com/books

GIVE AUTOGRAPHED BOOKS

Personally autographed by the author, including customized messages if you desire.

Perfect for gifts!

ExploringWineRegions.com/Books

Bring Wine Home Safely with Wine Luggage

To Get Autographed Copies of the Books
$10.00 off, use code: 10$OFF

GET EXTRA CHAPTERS – FREE
There is more and more to share with you!

As of the printing of this book, I have already written more chapters to share with you. There are so many more things to tell you about. I have discovered additional interesting places to stay in the vineyards that I did not get to review in time for the book. I have organized my favorite hot spots and romantic places. I share some of my valuable travel tips. And so much more! I will send them to you digitally at no extra charge. Just ask, as I am happy to share. Here are a few of the chapters...

> **Receive Extra Chapters (for free)**
>
> Send us your full name, email, zip code, and where you purchased this book to:
>
> **Extra@ExploringWineRegions.com**

SHIP WINE HOME... FOR FREE

This is not a list of wineries that will ship for free when you buy their wines. Some wineries will do that though, if you buy enough of their wine. I am referring to how to ship multiple bottles from many different wineries, all for free.

International shipping can be very expensive, especially for wine because it weighs a lot. Discover my little secret in how to ship dozens of bottles for free. I will also give you important packing tips to protect your precious wines.

HOW TO PACK A CARRY-ON LUGGAGE FOR LONG TRIPS

YES! It really is possible to travel for a month or more with only carry-on luggage. I do it. All the time! It works so well that this is now the only way I travel.

A carry-on is so much easier at the airport. Fewer lines. Less cumbersome. Shorter and advanced arrival time. You move through with ease and grace.

I know you might not believe me, as I was initially doubtful if I could do it. And ladies, I promise you can do it too. I have seen it firsthand.

This includes casual clothes, business clothes and nice evening wear, as well. At first, I did it for three weeks. Then for five weeks, a couple of times. Last year, I did it for two months. Twice! That's right, just one carry-on luggage piece.

There are numerous techniques to make this all possible. I detail everything in this extra chapter.

TOP TEN ROMANTIC PLACES

Would you like to know the most magical places to share a kiss? How about the most romantic places to dine? Inside, outside, or underground in caves? How about the best places to cuddle up with your sweetheart?

This chapter is for the lovers of the heart, those with passion and desire. I am insatiable and never miss discovering those magical romantic settings.

I was there. Took pictures. Indulged. And now I am sharing them with you.

ROMANTIC HOT SPOTS

SECRET BEDROOMS

ACCOMMODATIONS IN THE VINEYARDS

HOW TO GET INTO A PREMIER GRAND CRU

SPECIAL SUB-APPELLATIONS

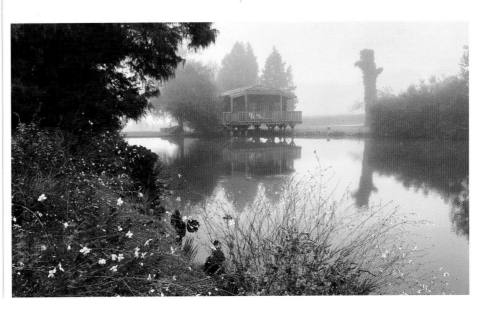

ACKNOWLEDGEMENTS

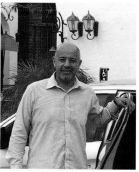

The Exploring Wine Regions Team

Michael C. Higgins, PhD
Author, Photojournalist & Publisher

Li Wu, CPA
Research Chief & Travel Director

Danielle Ballantyne
Copy Editor

John Irvin
Proofreader

Gregory Franco
Map Design & Production

Arlind Rexhmataj
Web Development & Administration

Baker & Taylor Publisher Services
Worldwide Distribution

**María Isabel Ramos,
Ricardo Vega Cámara
and Camillo Magoni**
The Foreword

Reach us through our website at:
ExploringWineRegions.com/Contact
Or call us at: +1 626.618.4000

International Exploration Society
Box 93613 • Pasadena, CA 91109 USA

It Takes a Team...

This book is the culmination of many individual's efforts. Extensive or tiny, each person has had a meaningful mark on the quality of this book. I am endlessly appreciative and thank you all. Three people have been on this journey with me all the way and I would like to give them some extra acknowledgment.

Agustin Perzabal was an amazing surprise in Valle de Guadalupe. My first itinerary was created by Luis Martinez, of whom I am very appreciative for his insights and direction in helping me explore this valley. When Luis was no longer able to participate and not able to be in Valle de Guadalupe on my initial visit, I was introduced to Agustin. Agustin has been my personal driver on every move here. He knows this valley well. He is bilingual (I sure needed that). More so, Agustin was endlessly helpful on all my subsequent visits. He knew wineries and restaurants that should be reviewed in the book. And he was right on with everything. When I could not reach people, he would call locally for me. Or even better, he would just show up at a winery and make things happen. When I did not know the owner of a winery or restaurant, Agustin knew them. These introductions were invaluable to creating the Valle de Guadalupe section of the book. Agustin has become a good friend as we have shared many personal and family sides during all these journeys.

I met **Lizy Bordin** in Mendoza, Argentina. She was the winemaker at a very important winery that I included in my Argentina book. She made excellent wines there. We became friends. Lizy is the person who introduced me to Guanajuato. It was a funny intro. I was in Valle de Guadalupe when I received a message from Lizy that she was in México making wine. I thought perfect, and I responded, "Where are you, Lizy? I am also in Valle de Guadalupe right now and I will come see you." She said she was not in Valle de Guadalupe, she was in Guanajuato. My odd reply was, what is a Guanajuato? Long story short, my decision to go to explore the Guanajuato Wine Regions was based on knowing Lizy is an excellent winemaker from a great winery in Mendoza. She would never leave that if Guanajuato wasn't an excellent place to make quality wines. So I went, and Lizy introduced me to many of the vintners and winemakers in this book. She knows quality and she knew where I needed to be. Thank you, Lizy.

Another important thank you is to **Trini Jiménez**. I met Trini at one of the Guanajuato wineries where he is the winemaker. Trini is a consulting winemaker to several wineries in México. Trini is the person who insisted I explore Querétaro and he offered to arrange my itinerary. And what a great itinerary he created! This made a huge difference because now we have an excellent choice of the best wineries here. Plus, Trini knew all the winemakers in Querétaro. This was significant. Thank you, Trini.

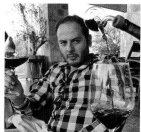

My appreciation and gratitude go out to many people who made this book a reality. I thank you all very much!

- **Martía Isabel Ramos, PhD** - Professor, Universidad Anáhuac México and Le Cordon Bleu México City • **Ricardo Vega Cámara** - Founder/General Director, Cuna de Tierra winery
- **Camillo Magoni** - Founder/Winemaker, Bodegas Magoni • **Agustin Perzabal** - Perzabal Vineyard & Winery Tours • **Fernando Perez** - Owner, Finca la Carrodilla, Restaurante Lunario
- **Lizy Bordin** - Oenologist, Guanajuato & Argentina • **Javier Valverde** - Director, Guanajuato Tourism Development • **Luis Martinez** - VCR México • **Tru Miller** - Owner, Adobe de Guadalupe
- **Trini Jiménez** - Consulting Oenologist, Hacienda San Jose Lavista and Puertas De La Peña • **Germán Calvo** - Winemaker, Viñedos San Lucas, La Santisima Trinidad

NEED A PROFESSIONAL SPEAKER
Fun and Entertaining Education

EXPERIENCES WITH MICHAEL
Michael is a natural storyteller... engaging, charismatic and full of personality! With his immense knowledge of wine and wine regions around the world, Michael is the ideal speaker for your event, no matter its size. Whether it is a corporate function or fun social gatherings for connoisseurs or novices, he is guaranteed to entertain and educate your group! Pick from one of the options below or we can easily come up with something perfectly suited for your group.

An Evening of Exploring Wine Regions. Choose Argentina, Bordeaux, California, México or Greece! Michael offers a fun, entertaining and educational evening with an amazing food and wine pairing from the subject country. Learn about what makes the particular wine region special and how to choose its wines. Enjoy authentic cuisine, excellent wines and engage in fascinating conversations.

How to Find Your Wine. Michael will show you how to find wines you like in a fun and approachable way. It's very common for people to not understand their preferences. They are intimidated by the restaurant wine list and end up simply ordering the house wine. They walk into a wine shop and are completely overwhelmed. Michael can help! He will teach you easy ways to sift through the long lists and unfamiliar options to uncover the wines you love! Let Michael help you taste your way to success.

Send us an email at: Booking@ExploringWineRegions.com or call us (626-618-4000) for more ideas or to book your event.

MEDIA RESOURCE
Television, Newspapers, Magazines, Radio, Podcasts, and Blogs

Need editorial? Need content for the development of your story? Need some spectacular photography? Need a good interview? On or off camera, Michael makes for a very interesting interview. With his vast knowledge of travel, wine and wine regions, he is the perfect resource for everything you may need to know.

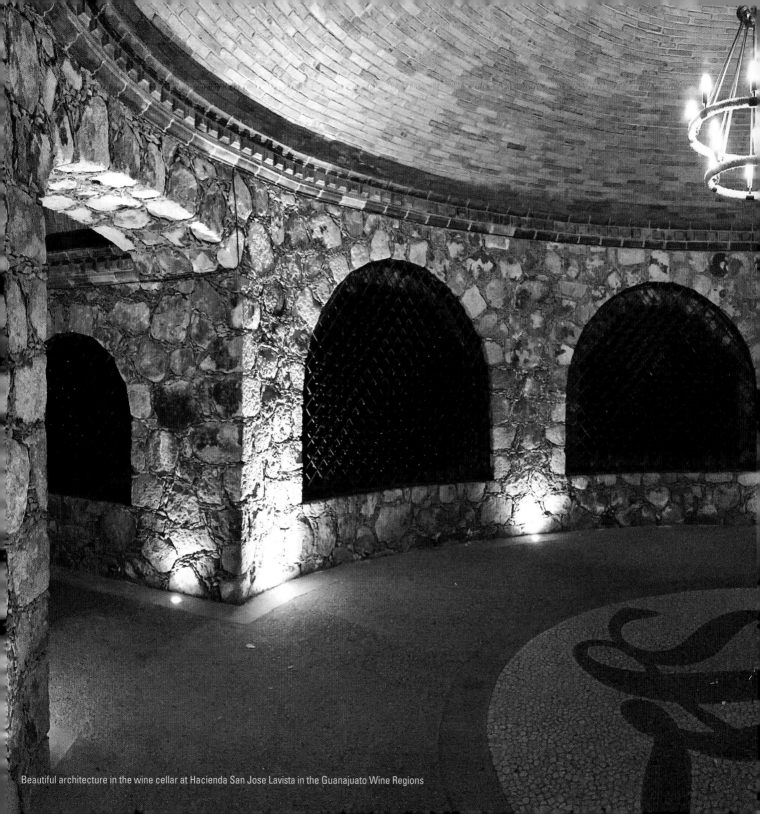

Beautiful architecture in the wine cellar at Hacienda San Jose Lavista in the Guanajuato Wine Regions

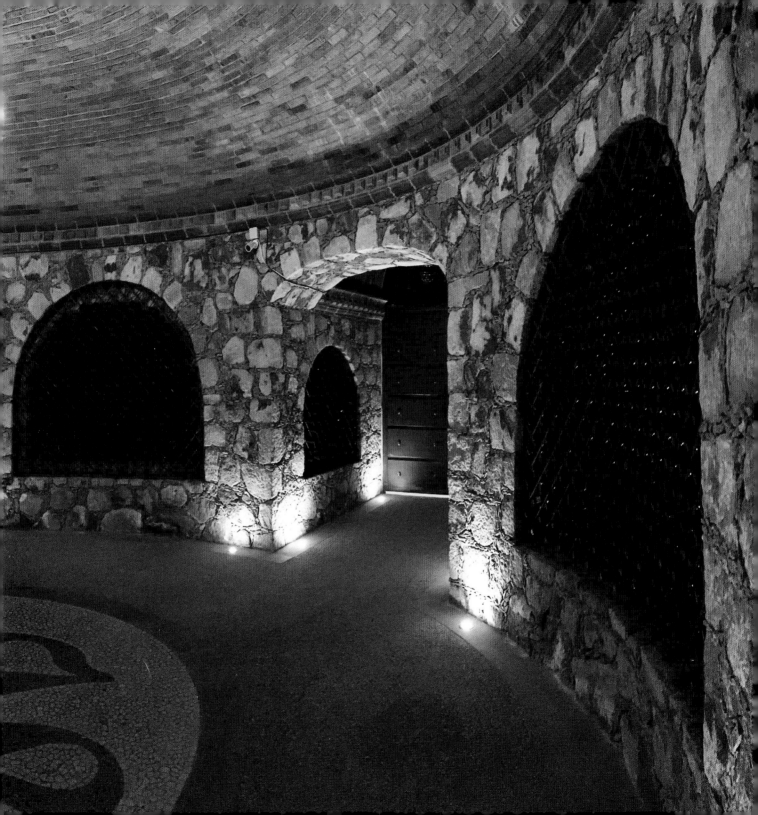